# GUSTAV KLIMT

## FROM DRAWING TO PAINTING

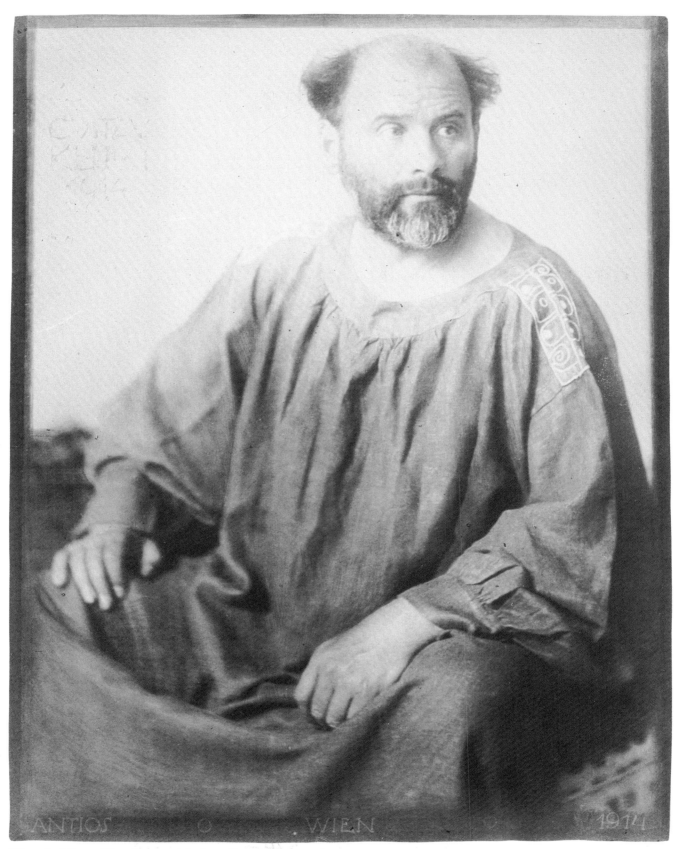

*I Portrait of Gustav Klimt. Photograph by Anton Trcka (Antios), 1914.*

# FROM DRAWING TO PAINTING

## CHRISTIAN M. NEBEHAY

Harry N. Abrams, Inc., Publishers

This book is dedicated to my father Gustav Nebehay, who, in the last year of Gustav Klimt's life, gained his confidence and was entrusted with the sale of his estate.

Translated from the German by Renée Nebehay-King

The choice of illustrations and the layout of this book were the work of Christian Brandstätter Verlag, Vienna.
The endpapers show signets which Gustav Klimt designed between 1908 and 1913 for the book Das Werk Gustav Klimts printed by the k. k. Hof- und Staatsdruckerei (Hugo Heller Kunstverlag, Vienna-Leipzig 1918).

Sources of illustrations

Original works by Gustav Klimt and other artists that are to be found in public collections and museums are as indicated in the captions to the illustrations. All other paintings and graphics by Klimt are in private collections.
Gustav Klimt's paintings are indicated in both the text and captions of this book by the letter D followed by a number. This refers to Johannes Dobai's catalogue raisonné of the paintings (Fritz Novotny/Johannes Dobai, Gustav Klimt, Friedrich Welz (ed.), Galerie Welz, Salzburg 1967). The drawings are indicated by the numbers of Alice Strobl's catalogue raisonné of the drawings (Alice Strobl, Gustav Klimt. Die Zeichnungen (4 vols.) Vol.I: 1873–1903. Vol.II: 1904–1912. Vol.III: 1912–1918. Vol.IV: Supplement 1878–1918. Galerie Welz, Salzburg 1980, 1982, 1984 and 1989). They are indicated by the word Strobl or AS.
The publishers acknowledge the assistance of Verlag Galerie Welz, Salzburg and the following public and private institutions and persons for the kind loan of illustration material: Österreichische Galerie, Vienna; Kunsthistorisches Museum, Vienna; Österreichisches Museum für angewandte Kunst, Vienna; Historisches Museum der Stadt Wien; Graphische Sammlung Albertina, Vienna; Bildarchiv der Österreichischen Nationalbibliothek, Vienna; Österreichisches Theatermuseum, Vienna; Wiener Stadt- und Landesbibliothek; Archive Prof. Christian M. Nebehay, Vienna; Austrian Archives, Vienna; Archive Werner J. Schweiger, Vienna: Archive Erich Lessing, Vienna; Galerie Würthle, Vienna; Galerie Hassfurther, Vienna. All remaining illustration material comes from the Christian Brandstätter archive.

Library of Congress Cataloging-in-Publication Data
Nebehay, Christian Michael, 1909–
Gustav Klimt : from drawing to painting / by Christian M. Nebehay.
p.   cm.
Includes bibliographical references and index.
ISBN 0–8109–3510–4
1. Klimt, Gustav, 1862–1918 — Criticism and interpretation.
2. Klimt, Gustav, 1862–1918 — Influence.   3. Wiener Secession.
4. Wiener Werkstätte.   I. Klimt, Gustav, 1862–1918.   II. Title.
N6811.5.K55N42   1994
709′.2—dc20          94–1415

Printed and bound in Austria

# CONTENTS

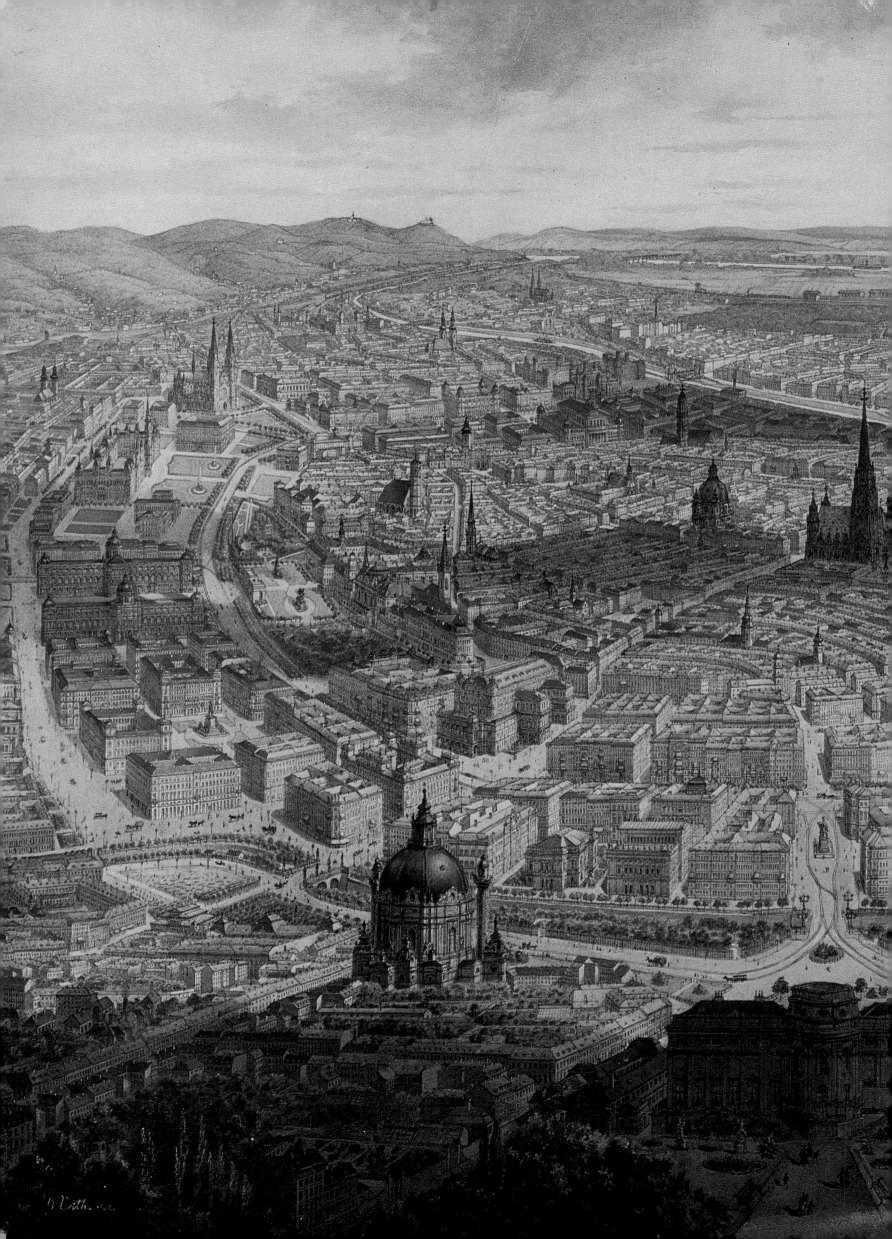

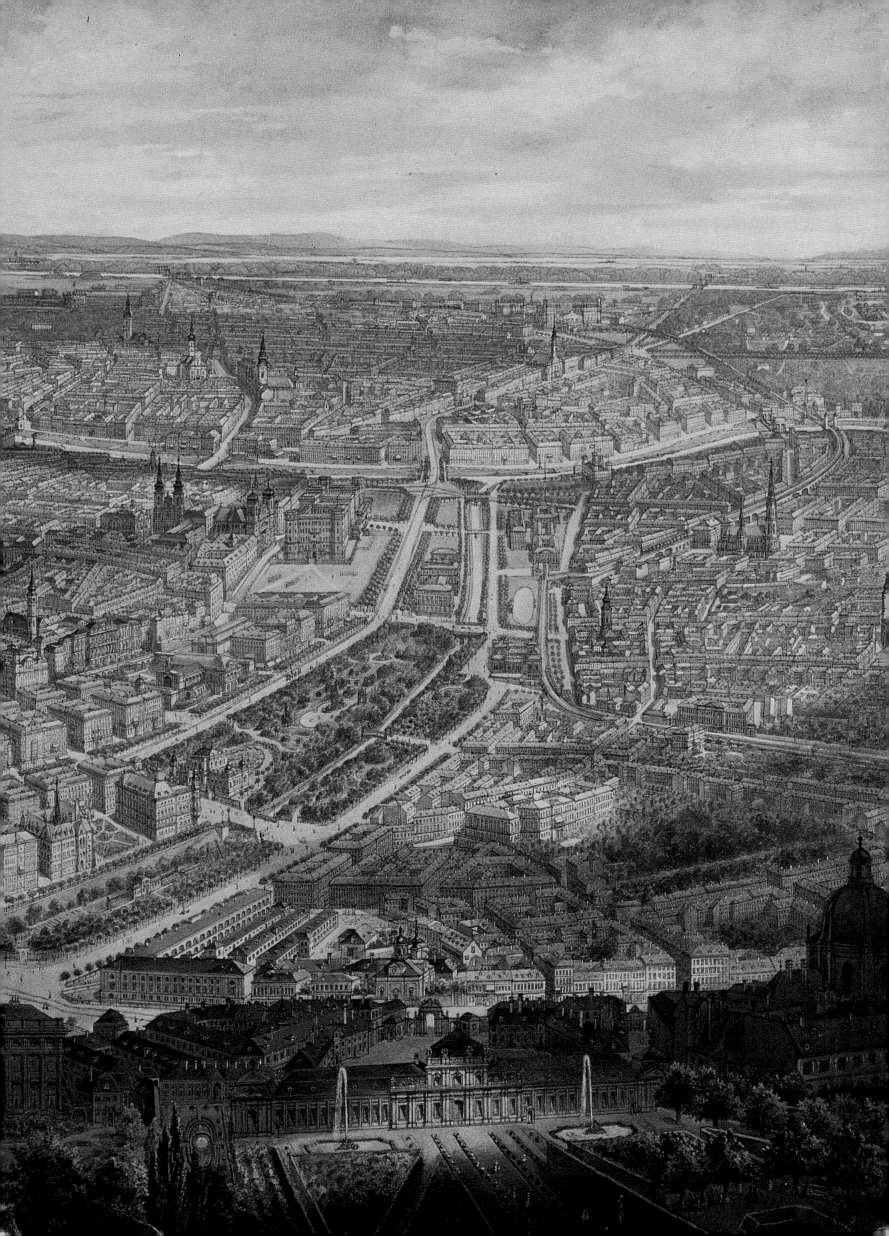

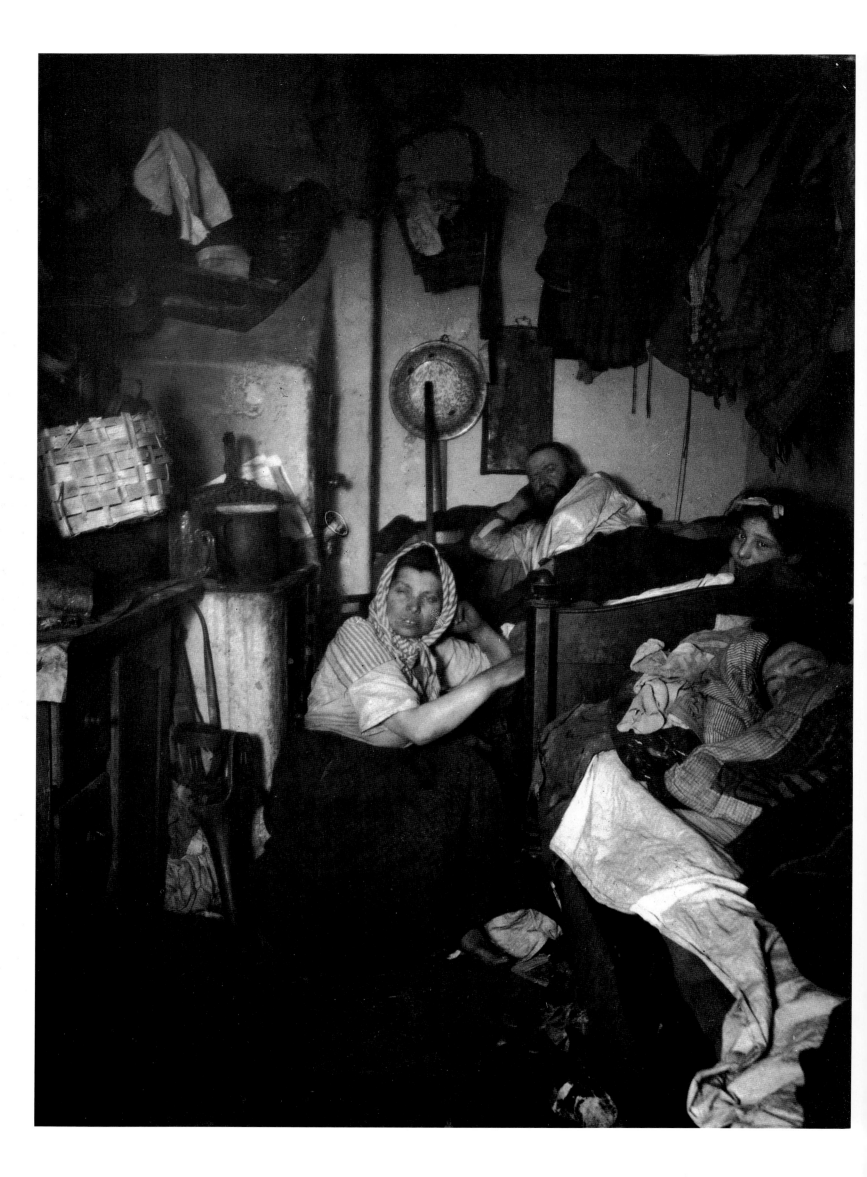

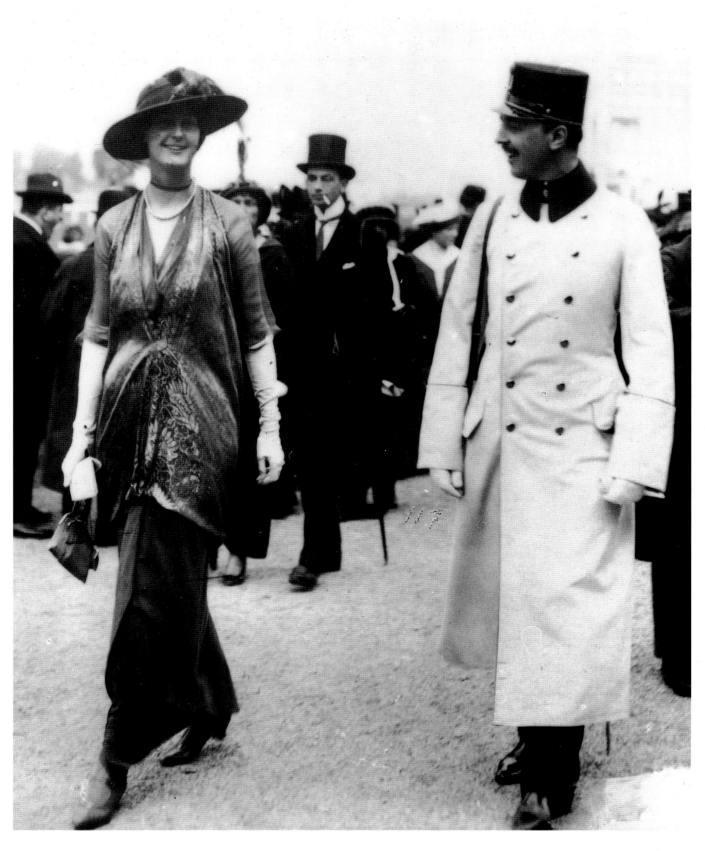

Preceding page:
*2 Panorama of Vienna seen from the South, with the Ringstrasse area in the year of the World Exhibition. In the foreground the Karlskirche, the Schwarzenberg Palais and the Lower Belvedere. Pen and sepia by Gustav Veith, 1873. 57.7 × 91.4 cm. Historisches Museum der Stadt Wien.*

*3 Left: Social contrasts in the capital of the Austro-Hungarian monarchy: Kitchen in a slum dwelling in the Leopoldstadt district of Vienna. Photograph by Hermann Drawe, 1904.*

*4 Right: An elegant crowd on the racecourse at the Freudenau, Vienna – Prince Ferdinand Auersperg in the uniform of an officer of the Guards with Countess Draskovich. Photograph, about 1912.*

Following pages: *5 The Court Ball, 1906. Watercolour by Wilhelm Gause. 49.8 × 69.3 cm. Historisches Museum der Stadt Wien.*
*As opposed to the 'Ball at Court', which was exclusively reserved for the high aristocracy, the 'Court Ball' was annually attended by as many as 3,000 guests.*

9

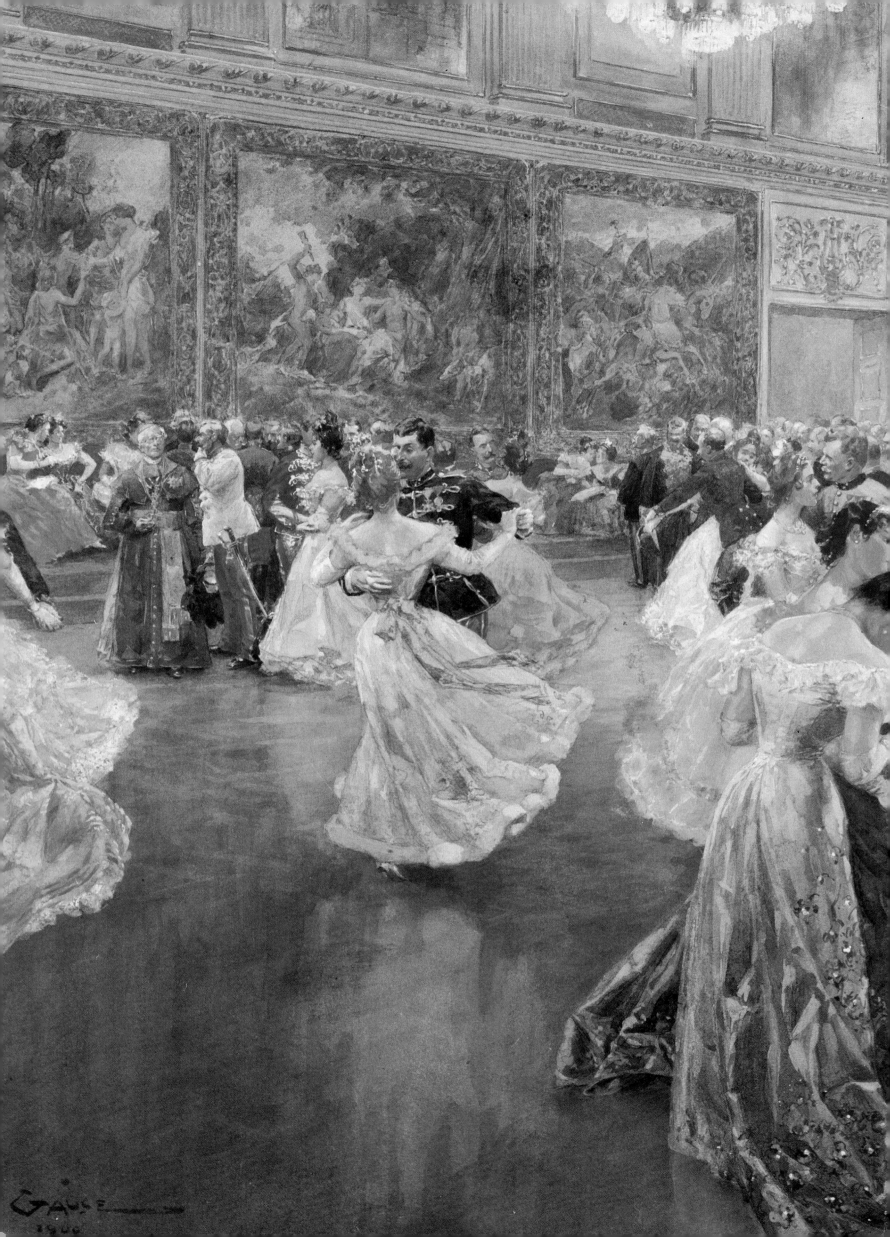

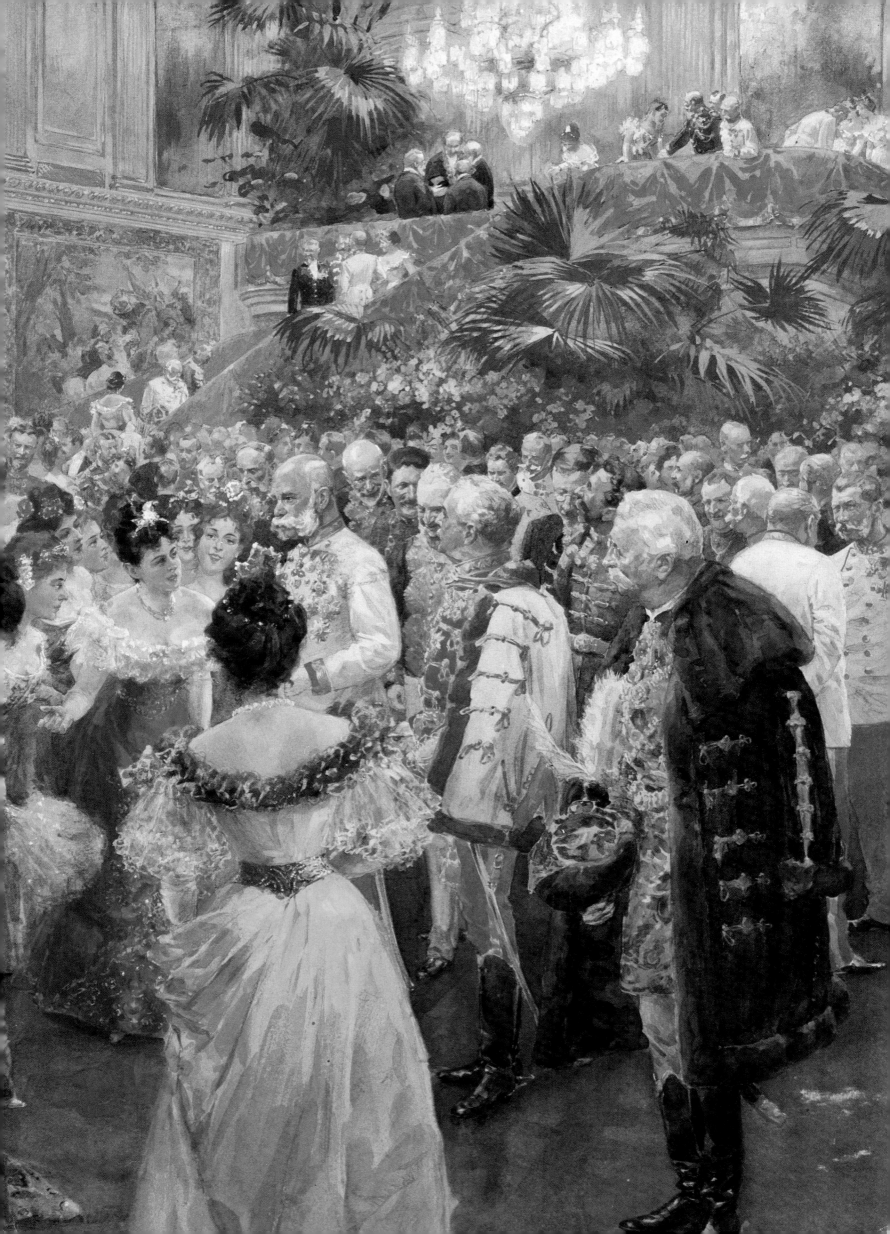

# INTRODUCTION

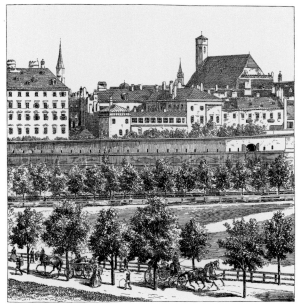

Until 1918, Vienna was the capital of Austro-Hungary, an empire with more than 50 million inhabitants of varied ethnic backgrounds. It was also the only remaining fortified capital in Europe until 1857, when the Emperor Franz Joseph I ordered the destruction of the fortifications and the elimination of the military cordon that had surrounded the medieval city centre. The resulting new plots were sold and the money put into the so-called 'City Expansion Fund', by which all public buildings were subsequently financed. The 'Ringstrasse' took shape, with magnificent buildings in the historicist style – the architects included celebrities such as Gottfried Semper, Theophil Hansen and Carl Hasenauer – and handsome parks were laid out.

*7  The Franzenstor. Unsigned woodcut from the* Wiener Illustrirtes Extrablatt, *1893.*
*The view is of the former glacis between Mölkerbastei and Löwelbastei (on a level with the present University).*

*6 Opposite:  View from the Vienna Ringstrasse. Woodcut by A. Kronstein from the* Neue Illustirte Zeitung, *1886.*
*The view is from the Kärntnerring to the Karlskirche; on the right is the rear façade of the Musikverein and the side façade of the Hotel Imperial.*

The population rose dramatically: in 1869 it stood at 600,000, after 1910 it had grown to about 2 million. A further increase of 500,000 was foreseen and the city was correspondingly planned on generous lines. The suburbs were drawn into the city precincts but retained their rural character. There was a green belt where building was prohibited, a feature that is unique in Europe to this day.

Franz Joseph I, a respected symbol of the monarchy and commander-in-chief of the armed forces, was no art lover, but he furthered the fine arts to the best of his ability. Some of the most important buildings of the time – the Opera, the Burgtheater, the Kunsthistorisches Museum and the Naturhistorisches Museum – were financed and maintained from his private income.

In the second half of the nineteenth century the whole country seemed to awake from a long sleep. There was a stirring in every sphere of the arts. Vienna had long been famous for its music, but now, after Mozart, Beethoven and Schubert came Anton Bruckner, Johannes Brahms, Johann Strauss the younger, Hugo Wolf, Arnold Schönberg and Gustav Mahler; not forgetting the composers of first-rate operettas, led by Franz Lehár. In the field of medicine the city was a Mecca to which students from all over the world flocked: the surgeon Theodor von Billroth performed sensationally daring and revolutionary operations, Sigmund Freud founded psychoanalysis, Alfred Adler founded individual psychology, and in 1927 Julius Wagner von Jauregg won the Nobel Prize for discovering the therapeutic importance of malaria inoculation in the treatment of progressive paralysis.

Literature also blossomed. Hugo von Hofmannsthal, Arthur Schnitzler, Stefan Zweig and Peter Altenberg produced world classics. The satirist Karl

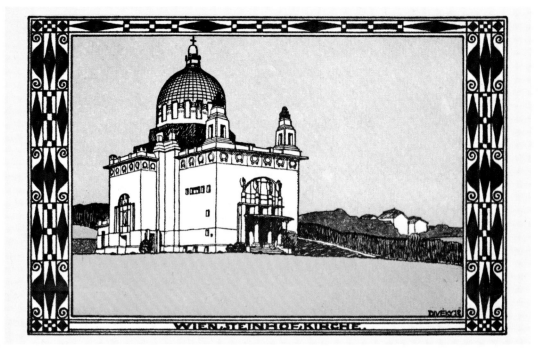

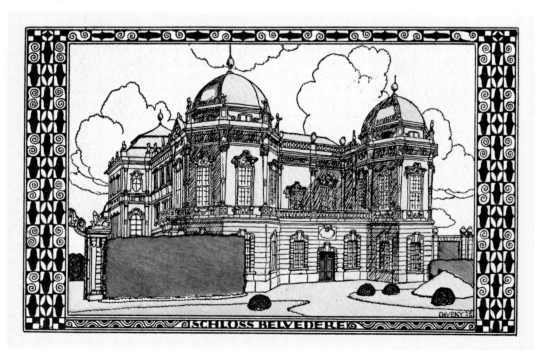

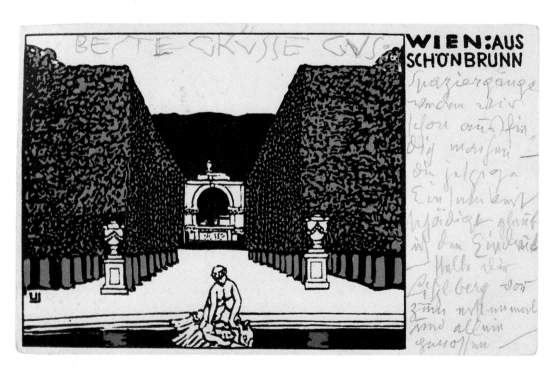

Viennese views on Wiener Werkstätte postcards:
8 Above: 'Vienna, church at Steinhof'. Postcard No.
405 by Josef Diveky, 1912.

9 Centre: 'Vienna, View from Schönbrunn'. Postcard
No. 137 by Urban Janke. About 1907.
Klimt sent this postcard on 8 July 1908 to Emilie Flöge,
who was staying at Kammer on the Attersee, where Klimt
also spent his summers. The text reads: 'We'll find walks
all right – loneliness spoils the impression just now. Just
imagine, for the first time I was alone in the Litzelberg
cellar and enjoyed it BEST WISHES GUS.'

10 Below: 'Schloss Belvedere'. Postcard No. 317 by Josef
Diveky, 1912.

11 Right: Egon Schiele. Gustav Klimt in his blue
working smock. About 1912. Pencil and gouache.
52.5 × 28 cm.

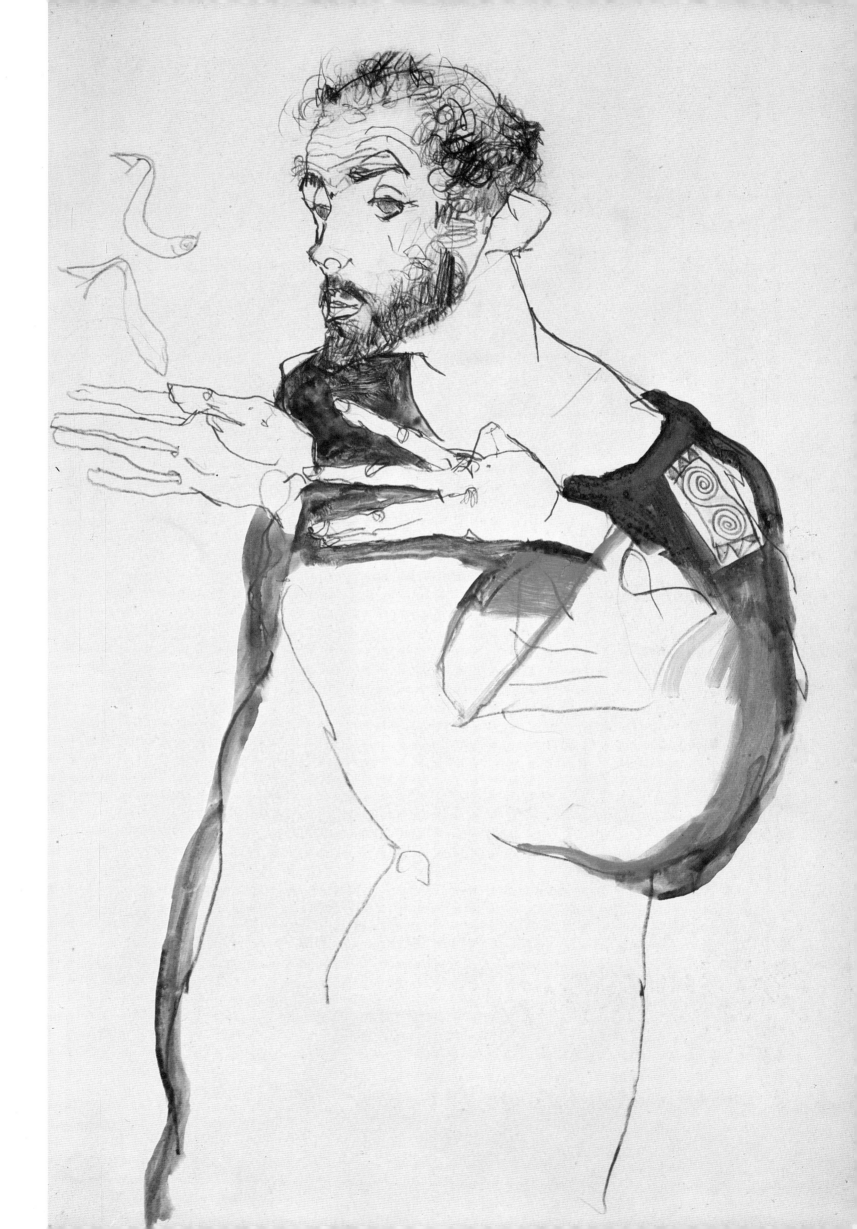

Kraus, writing in his famous polemical journal *Die Fackel*, aimed relentless criticism at all evils. And in 1896 Theodor Herzl, a feuilletonist on the staff of the *Neue Freie Presse* and a playwright, wrote *Der Judenstaat*, thereby initiating the founding of a Jewish national state.

No less important were Austrian engineers, who raised rapidly growing industry to European prominence. Skilled artisans came to Vienna from all parts of the Empire; and when the handicrafts of the Secession years came to full bloom, artists were able to draw on a rich fund of talent.

The visual arts had already reached a high-water mark at the beginning of the century, but towards the middle of the century the historicist style was established under the influence of the Academy.

In the second half of the nineteenth century two Austrian artists triumphed in two of the world's capitals: Paris was for years under the spell of Alfons Mucha, whose Sarah Bernhardt posters were the talk of the town; and in Vienna, Hans Makart from Salzburg received more ovations than the Imperial couple, for whose silver wedding anniversary in 1879 he had designed and made many floats and hundreds of historical costumes. Both artists met with the same fate: they rocketed to dazzling heights of fame, only to sink into subsequent oblivion. Gustav Klimt also visited Makart's studio, which was a Viennese attraction – but he was careful not to follow in Makart's footsteps.

From around 1900 until his untimely death in 1918, Klimt dominated the Viennese art scene, although he himself attached no great importance to being the centre of public attention. The young artists who had left the Künstlerhaus with him flocked around him on account of his exemplary friendliness and unselfish support. Other artists who enjoyed equal regard were Otto Wagner, Josef Hoffmann, Joseph Maria Olbrich and – despite his opposition – Adolf Loos. Not only did the Secession attract the best artists from different spheres and of varying styles, but it astonished the very conservative Viennese with remarkable exhibitions of French Impressionism and Belgian Naturalists. Two

12 *The Vienna Secession building; in the foreground are stalls in the central market, which then extended as far as the Karlsplatz. Photograph by Bruno Reiffenstein, 1899.*

Following pages: *Klimt portrays elegant society ladies:*

13 Left: *Study for Portrait of Fritza Riedler (AS 1244). 1904–05. Black crayon. 44.5 × 31.5 cm.*

14 Right: *Portrait of Fritza Riedler (D.143), 1906. Oil on canvas 153 × 133 cm. Detail. Österreichische Galerie, Vienna.*

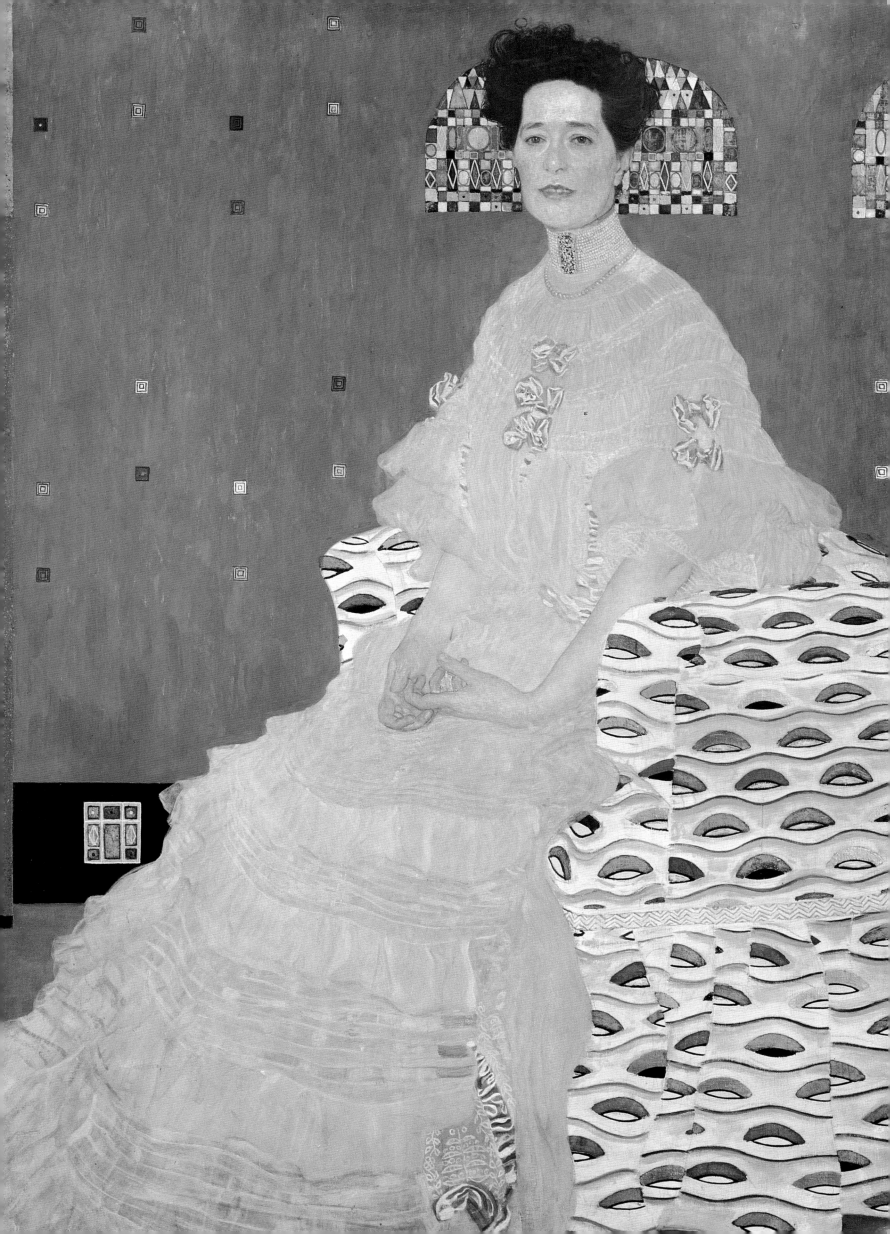

artists owed their international recognition to the Secession: the sculptor George Minne (whose *Kneeling Youths* greatly influenced both Kokoschka and Schiele in their youth) and the Swiss painter Ferdinand Hodler.

In an effort to acquire Max Klinger's over-lifesize (and overrated) statue of Beethoven for Vienna, the Secession put on the most remarkable show of young artists to be seen at the time: its fourteenth exhibition, to which each of its members contributed – regardless of whether they might sell – a sculpture or a sample of applied art. Klimt's contribution, painted in 1902, was his 34-metre long Beethoven frieze, which must be considered his crowning achievement; his other masterwork, the three paintings destined for the Great Hall in the University of Vienna, was destroyed by fire in Schloss Immendorf in 1945.

The Secessionists, as we have seen, valued Klinger's statue highly. Auguste Rodin, on the contrary, never succeeded in making an impression in Vienna, although he repeatedly sent his sculptures to the Secession's exhibitions.

Never was art more written or quarrelled about in Vienna than in those years of the Vienna Art Spring. The Secession owed many of its successes to the kindness of the critics, first and foremost that of Ludwig Hevesi, who faithfully recorded every exhibition; also Hermann Bahr and Berta Zuckerkandl, who upheld the cause of modern art. The first two, incidentally, were the objects of biting scorn from the pen of Karl Kraus in *Die Fackel*.

The Secession's own mouthpiece was its periodical, *Ver Sacrum* (sacred spring), which appeared from 1898 to 1903. Of the highest artistic and literary quality, it took the lead among similar publications in the German-speaking world; it is moreover of interest here since Klimt, aside from the two posters he designed for the Secession itself, limited his illustration work to *Ver Sacrum*.

In 1903 the Wiener Werkstätte was founded by Josef Hoffmann and Kolo Moser and financed by Fritz Waerndorfer. It was counted, especially in its opening years, among the best-known enterprises in the art world; but it was commercially unsuccessful and ruined three financiers. The Wiener Werkstätte gave even the most modest handicrafts renewed vigour. It was never Hoffmann's intention to design luxury articles: in his jewelry, for instance, he used only semi-precious stones. Perfection was his aim in all he undertook.

During his lifetime Gustav Klimt – as important a painter of portraits as of landscapes – did not achieve the international recognition now due to him and his protégé, Egon Schiele. Klimt was also one of the finest draughtsmen of his time. The drawings that lay about in heaps in his studio were used merely as memoranda in his careful preparation of his portraits. Sometimes there were as many as 150 drawings for one painting, each showing a particular detail of clothing for instance, or jewelry, or a certain gesture. The model's features were mostly only sketched out. Over 3700 such drawings are to be found in the recently published catalogue raisonné, and doubtless more will come to light. On the other hand, however, not a single landscape drawing has been found, and only a few landscape sketches.

As fifty of Klimt's sketchbooks were destroyed by fire in Emilie Flöge's apartment (only three sketchbooks survived), it has not been possible to refer back to the sketches.

From the great number of Klimt's pencil and chalk drawings, the ones chosen here are those that are directly connected with his paintings. For the first time, studies – some of them hitherto unpublished – are shown in direct comparison with the finished paintings. Preference has been given to those drawings that characterize a particular period in Klimt's development: an example is the spectacular recently discovered studies for the famous Stoclet frieze in Brussels, executed on transparent paper and enhanced in bronze and gold. Some of Klimt's finest nude drawings, occasionally with a touch of colour, have also been chosen; they are works of art in their own right and established Klimt's reputation as a draughtsman.

20

Since the publication of my book *Gustav Klimt: Dokumentation* (1969), much new information has come to light about Klimt's discreet and withdrawn private life. In this book an attempt will be made to

later to marry Gustav Mahler. A first attempt is also made to compare over 400 autograph postcards sent by Klimt to Emilie Flöge, which came to light in 1983 and are curiously lacking in any tenderness or affec-

trace, on the basis of the latest research, the decisive stages of his life and work: his meetings with artists, friends, collectors and personalities who played an important part in the artistic and cultural scene around 1900.

New consideration is also given to the women with whom he was on intimate terms: for the first time, for instance, evidence has emerged that Klimt had taken a passing fancy to the young Alma Schindler, who was

tion, with his correspondence with Maria Zimmermann, which divulges how close this carefully concealed relationship was.

This book is therefore not only an attempt to honour Gustav Klimt as a great painter and draughtsman, but also to value him as the leader of a movement and a sponsor of young talent.

Vienna, September 1992

21

# THE KLIMT BROTHERS AND THE FLÖGE FAMILY

*17 Study for the fair drawing* Opera *for the samples collection* Allegories and Emblems *(AS 69), 1883. Pencil. 53 × 38 cm.*

*16 Opposite: Gustav Klimt (presumably with Ernst Klimt and Franz Matsch). Study for a theatre curtain. About 1884. Oil on canvas. 52 × 41.3 cm.*

Gustav Klimt's background, life and works are the subject of this book. In order to appreciate the magnitude of his achievement, we have to bear in mind that he was born in 1862 in a Viennese suburb, the second of seven children of a small engraver. Although he never attached any importance to fame, there is no doubt that he was the outstanding personality on the Viennese art scene around the turn of the century.

When Ernst Klimt,[1] Gustav's younger brother by two years, proposed marriage in 1890 to Helene, the youngest daughter of Hermann August Flöge,[2] her father must have found it difficult to give his consent.

Hermann August Flöge, the son of a wood-turner from Hanover, had succeeded, over the years, in expanding his father's modest workshop into a well-known firm specializing in the manufacture and export of meerschaum pipes. A Viennese speciality sold all over the world, these were especially popular in England, but the export business had decreased in recent years.

Flöge had four children, of whom Hermann, the eldest, took over the workshop. But there were also three daughters – Pauline, Emilie and Helene – whose chances on the marriage market must not have seemed very high to their father.

In 1895, at the age of twenty-nine, the eldest daughter, Pauline, started a school for dressmakers at 18 Westbahnstrasse, in Vienna's VIth district. She never married, but of the three sisters – who later joined up to found the salon 'Schwestern Flöge' (Flöge Sisters) – Pauline was the cleverest with her hands. The story goes that the three had together taken part in a competition for the design of batiste uniforms to be worn in a Viennese exhibition on cooking. They won first prize, and a considerable order. That, apparently, laid the foundations of their later success as the 'Schwestern Flöge' (see p. 239).

Although Ernst Klimt came in for less attention than his elder brother, he too had outstanding talent. When the three young artists Gustav Klimt, Ernst Klimt and Franz Matsch[3] joined up to form the 'Künstlercompagnie' in 1883, it was at first difficult to tell their work apart. A number of fine works by Ernst bear witness to his talent, and it was only when the team executed their second imperial commission – the decoration of the staircase in the Kunsthistorisches

23

*18 Shakespeare's Theatre (D.39). 1886–88. Oil on stucco base. About 280 × 400 cm. Burgtheater, Vienna. The ceiling painting on the right-hand (south) staircase of the Vienna Burgtheater shows Gustav Klimt standing in the lower box and wearing a ruff – his only self-portrait; behind him is Ernst Klimt, in front of him Franz Matsch.*

Museum (1891) – that Gustav's greater importance became apparent.

The first imperial commission – the decoration of the staircases in the newly built Burgtheater (1886–1889) – brought the three artists praise and recognition from Franz Joseph I and, no doubt, a good fee. So Ernst Klimt, when asking Flöge for his daughter's hand, could not only look back on this success, but also announce that a second imperial commission was on the way. He had, strictly speaking, no 'steady job', but one must not forget what an imperial commission meant in those days.

Ernst's marriage into a respectable middle-class family meant much for the Klimt brothers, whose origins were, as we have seen, modest. Meanwhile their father had moved from the suburb of Hütteldorf to the city, where he presumably found better work. Until his death in 1892 he lived at 47 Burggasse in the VIIth district, an apartment subsequently occupied by his widow, Anna, who in 1900 moved to 36 Westbahnstrasse in the VIth district, where she died.

Gustav Klimt went on living in his mother's apartment with his two unmarried sisters, and it was there that he was to suffer a stroke on 11 January 1918, from which he would not recover.

It is not known how the Klimt brothers came to make the acquaintance of the Flöge sisters. It is certain, however, that they were very well received and thereafter moved in bourgeois circles.

1 Ernst Klimt, painter (1864–1892)

2 Hermann August Flöge was then living at 74 Gumpendorferstrasse in the IVth district.

3 Franz Matsch, painter and sculptor (1861–1942)

19 *Franz Matsch (seated) and Ernst Klimt, both in their costumes for the painting reproduced on the previous page. Photograph, about 1886.*

Following pages: *20* Left: *Love (D.68), 1895. Oil on canvas 60 × 44 cm. Historisches Museum der Stadt Wien.*

*21* Right: *Bust portrait of Emilie Flöge (AS 247), 1891. Crayon on cardboard. 67 × 41.5 cm.*

25

GVSTAV: KLIMT:
MDCCCXC

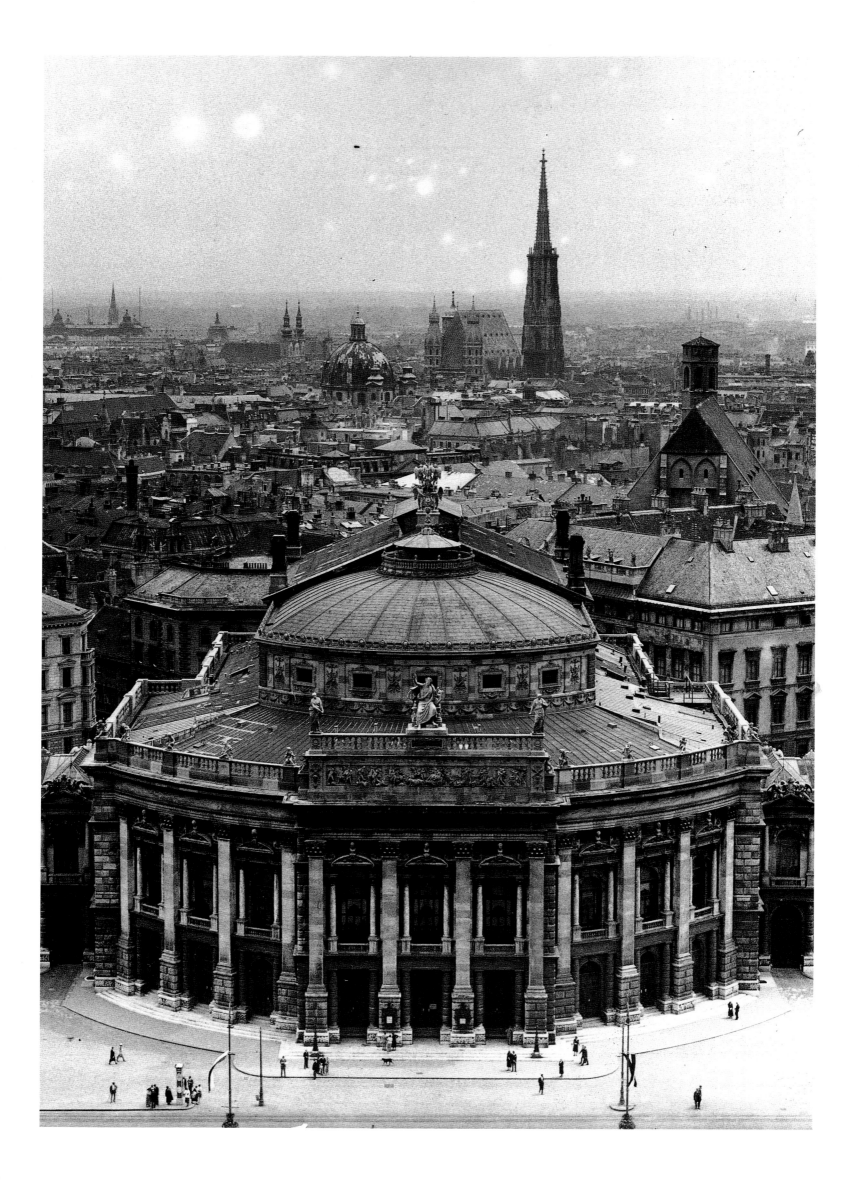

# GUSTAV KLIMT AND THE EMPEROR FRANZ JOSEPH I: THE IMPERIAL COMMISSIONS 1886–1891

*23 Emperor Franz Joseph I. Photograph by Carl Pietzner on stamped cardboard, 1898.*

*22 Opposite: View from the tower of the Town Hall on the new Burgtheater and the inner city. Photograph. About 1890.*

In 1888, the Emperor Franz Joseph I awarded Klimt the Golden Order of Merit for his work on the staircase of the newly built Burgtheater.[1] The theme of the decorations was 'the history of the theatre' and was set by Adolf von Wildbrandt,[2] director of the theatre from 1881 to 1887 and the author of numerous novels, novellas and plays. The work was divided between the three artists, Gustav Klimt, Ernst Klimt and Franz Matsch.[3] They worked in oils directly on to a roughcast surface consisting of marble dust and lime. The work lasted two whole years, from 1886 to 1888, and the Klimt sisters, Emilie Flöge's sisters and the artists themselves all acted as models. Numerous photographs from this time are still in existence (Pl. 19).

In 1890 the Künstlercompagnie was entrusted with the decoration of the spandrels and intercolumnal spaces in the staircase of the Kunsthistorisches Museum: a thankless task, but one which they solved brilliantly. The entire decoration of the staircase had originally been entrusted to Hans Makart,[4] but his untimely death in 1884 prevented him from completing more than the twelve lunettes with portraits of great artists. He had left behind sketches of the ceiling from which the Künstlercompagnie could have worked, but the ceiling was entrusted to Michael von Munkáczy,[5] who painted his *Apotheosis of the Italian Renaissance*. The programme for the Künstlercompagnie was set by Albert Ilg,[6] who had been director of the museum since 1884: it called for precise study of historical costumes and of those objects belonging to the Museum's collections. As in the case of the Burgtheater – and indeed following the practice in the Baroque days, when the abbots had the say – the programmes were set by the senior officials. Lots were drawn as to who should paint what: according to Ilg, three representations of the Roman and Venetian Renaissance, one of classical Greece, two of Egyptian and two of early Italian art fell to Klimt. In his painting of Glykene, a courtesan type from ancient Greece, Klimt for the first time shook off his academic style and, unnoticed, painted a modern girl of his day (Pl. 31, 32). It was in the Kunsthistorisches Museum, incidentally, that it first became possible to distinguish one artist from the other.[7]

29

*24* Above: *Study for the watercolour* Auditorium in the old Burgtheater *(AS 222). 1888–89. Black crayon. 44 × 30 cm.*

*25* Right: Auditorium in the old Burgtheater *(AS 191), 1888–89. Watercolour, gouache, heightened with gold. 91.2 × 103 cm. Historisches Museum der Stadt Wien.*
*In this miniature-like painting each person is recognizable. The theatre's regular visitors crowded into the studio in order to be immortalized. Klimt enlivened the scene by including young girls of his acquaintance. Ernst Klimt is standing in the third row in the left foreground.*

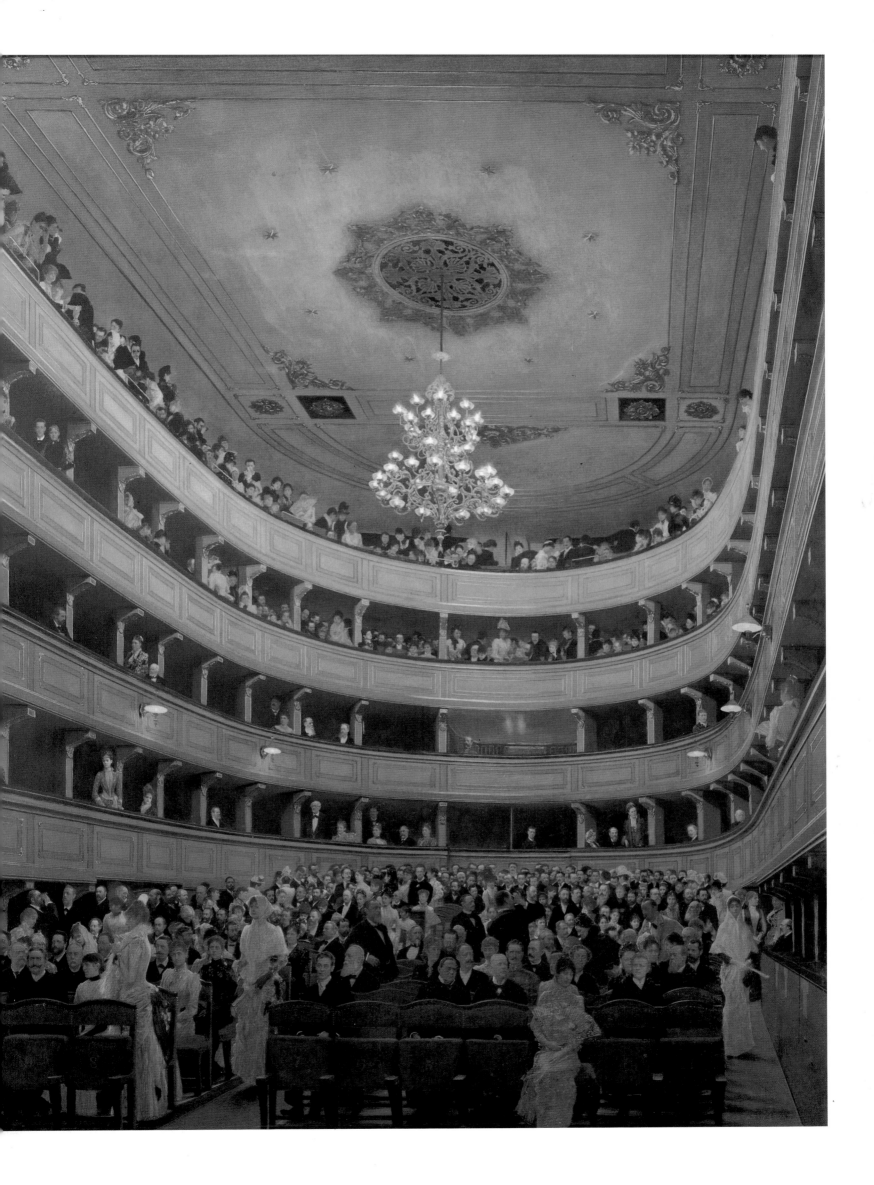

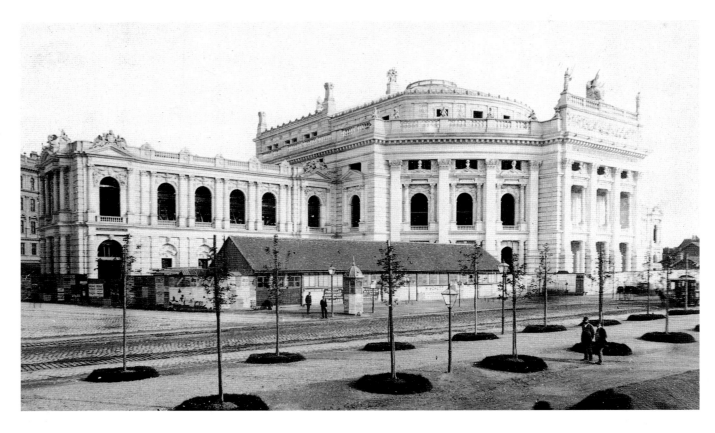

The year 1891 marked the end of the work in the Museum. Again the artists were presented to the Emperor (Pl. 29). On October 1891 the *Neue Freie Presse* wrote:

> When the Emperor started up the stairs from the vestibule and saw the impressive architecture and the rich decor, he stepped back and, evidently deeply impressed, said: 'Fantastic! Wonderful!'
>
> He then walked up the stairs, accompanied by Baron Hasenauer,[8] who answered his questions about the artists. He greatly admired Makart's lunettes, likewise the frieze by Matsch and the Klimt brothers, and, addressing the three gratified young artists, said: 'That must have been an extraordinarily difficult job. I always like to see your work!'

As regards the Emperor's personal taste, a visit to the hitherto unaltered Imperial villa in Bad Ischl makes it clear that, dutiful as he was – he opened countless exhibitions – none of the artists ever appears to have interested him. The walls of the Ischl villa are hung with the dreariest paintings by worthy academic artists. Nor was he very fond of the opera. His passion for the theatre

was another matter: he had his personal box at the Burgtheater, which he attended regularly, and not only to see the actress Katharina Schratt, with whom he was intimately involved. This addiction could also explain why he was so impressed by Klimt's large watercolour *The Auditorium of the Old Burgtheater* (1888) in which hundreds of spectators are clearly recognizable – a sight that must often have met the Emperor's eyes (Pl. 25).

For his work in the Burgtheater Gustav Klimt received a so-called 'Emperor's Prize' on 26 April 1890:

> His Imperial and Royal Majesty has graciously decided, in recognition of your watercolour entitled *Interior of the Burgtheater*, to award you as of 25 April 1890 the sum of four hundred ducats from the Emperor's privy purse for the promotion of patriotic artistic works and for the encouragement of interest in the annual exhibitions of the Vienna Artists' Guild. It is with great pleasure that I herewith extend my congratulations, and I have the honour to inform you that the privy purse has already been instructed to hand over the sum to you in exchange for a stamped receipt and presentation of this decree.

What was probably the most important meeting between Klimt and the Emperor took place on the occasion of the first exhibition of the Secession, 26 March–15 June 1898 (still on the premises of the Gartenbaugesellschaft on the Parkring). In view of the very conservative taste of the Viennese public at the time, the exhibition was a considerable financial risk for the young artists; but its success was astonishing.

A delegation headed by the eighty-six-year-old watercolourist Rudolf von Alt[9] had obtained an audience with the Emperor and respectfully invited him to attend the exhibition. Rudolf von Alt was already known to the Emperor, since together with his father

Jakob he had painted watercolours for the Emperor's predecessor, Ferdinand I. The Emperor was amazed to see the delegation led by a man older than himself: with disarming modesty Alt replied: 'I am indeed old, Your Majesty, but I feel young enough to start all over again every time.'[10]

Nowadays it is hard to understand what an honour the Emperor's visit was for the young artists. Moreover, the success of the exhibition surpassed all expectations: there were 57,000 visitors, and 218 paintings were sold. The luxury edition *Das Buch vom Kaiser* (*The Book of the Emperor*) features on page 71 a reproduction of a drawing by Rudolf Bacher,[11] an eye-witness.

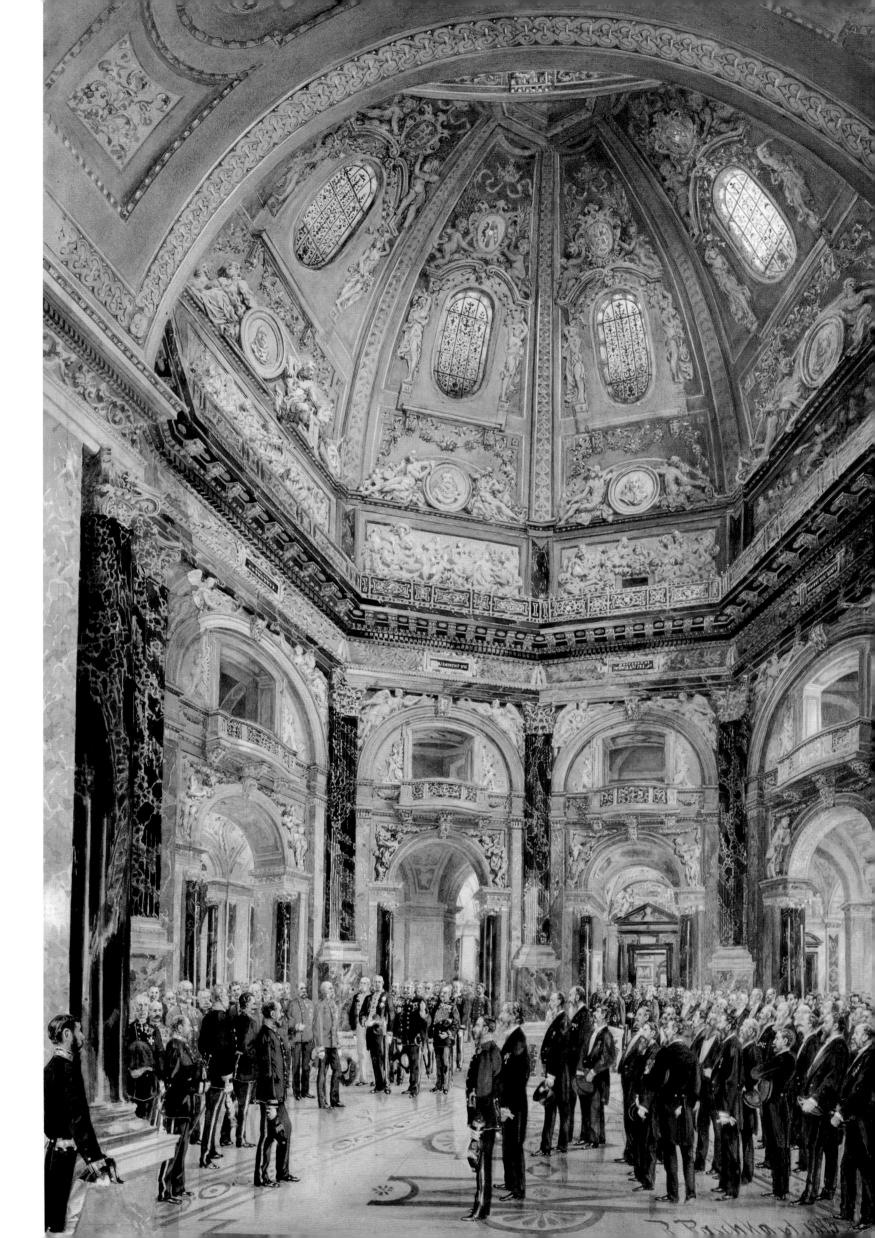

*30* The Emperor in the exhibition of the 'Austrian Artists' union'. *Drawing by Rudolf Bacher for the de luxe edition* Viribus Unitis – the Emperor's Book. *About 1900.*
*Gustav Klimt presents the members of the working committee to the Emperor on the occasion of the Secession's first exhibition in the spring of 1898 (the exhibition was still located in the rooms of the Gartenbaugesellschaft in Vienna's Ist district).*
*The original caption reads (from left to right):*
*'1. Aide-de-camp Major Karl Ritter von Wessely;*
*2. President Gustav Klimt; 3. Professor Rudolf Alt; 4. Josef Engelhart;*
*5. Carl Moll; 6. Franz Hohenberger; 7. Hans Tichy; 8. Architect Josef Olbrich; 9. Carl Müller;*
*10. Eugen Jettel.' This was the Emperor's only visit to a Secession exhibition.*

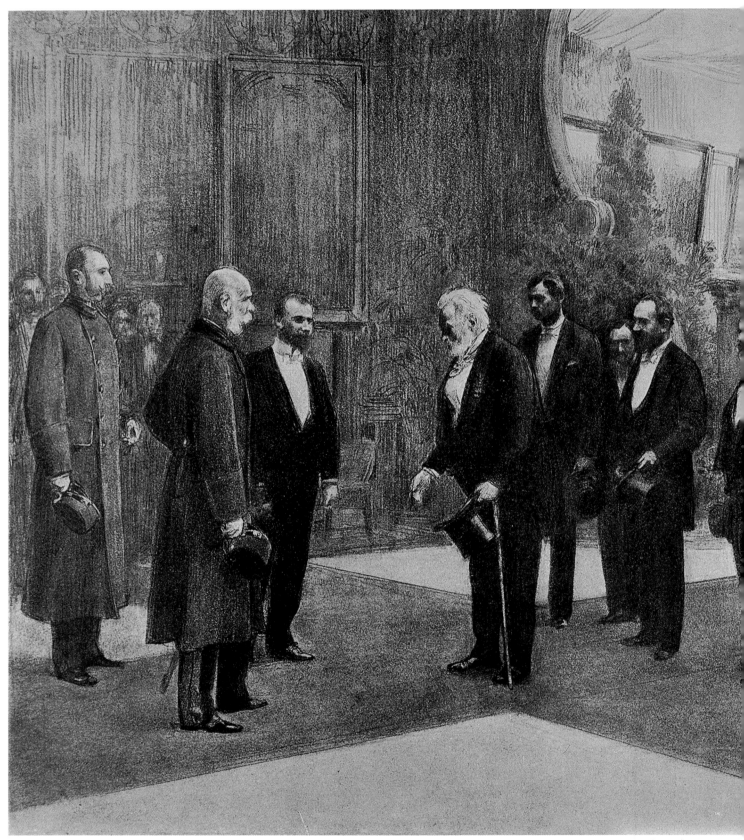

The Emperor is shown in uniform as usual, next to him Gustav Klimt, then the first President of the Secession. In front of the Emperor, hat in hand, stands Rudolf von Alt, and among the men behind him are, from left to right, the painters Josef Engelhart[12] and Carl Moll,[13] and the architect of the Secession, Josef Maria Olbrich.[14]

Gustav Klimt was again honoured by the Emperor almost twenty years later, when he was made an honorary member of the Academy on 26 October 1917; but this was small consolation for Klimt, for the Emperor had three times refused to sign a decree naming Klimt professor at the Academy. The reason for this probably lies in the scandals in which Klimt was involved: since the exhibition of the Beethoven frieze in 1902, but even more since that of his three paintings for the Great Hall at the University, he was the focus of art scandals such as Vienna had never before witnessed – nor since for that matter. From that time onwards the ageing monarch – long a figurehead of a crumbling empire – kept his distance from Klimt. It was his duty to see that law and order reigned. Anyone who was the object of public controversy was unpopular; and this no doubt explains the fact (now forgotten) that the Emperor commissioned in 1900, two years after her murder in Geneva, a life-size portrait of the Empress Elisabeth, not from Klimt but from another, equally modern artist of Austrian descent living in Belgium, Fernand Khnopff.[15]

It must not be forgotten that the Crown Prince Franz Ferdinand[16] was an opponent of modern art and may have used his influence against Klimt's nomination as professor. No statement of his about Klimt has come down to us; but one story relates how in a fit of rage at the sight of paintings by Oskar Kokoschka,[17] he exclaimed: 'He ought to have all his bones broken!'

*31* Left: Early Italian Art (Roman and Venetian Quattrocento) *(D.51, 52) and* Ancient Greece II *(D.56), 1890–91. Oil on stucco base. About 230 × 230 cm. Kunsthistorisches Museum, Vienna.*

Klimt's spandrels and intercolumnar paintings for the staircase of the Kunsthistorisches Museum; the intercolumnar painting Ancient Greece II *(to the right of the plate between the columns), which represents Glykene, the painter Pausanias' beloved, is most interesting here: for the first time Klimt painted 'his' modern type of woman. Even her dress seems to anticipate the new Jugendstil fashion.*

*32* Right: *Study for the intercolumnar painting* Ancient Greece II *(AS 239) (detail). 1890–91. Black crayon, pen and pencil. 45 × 63.4 cm. Kunsthistorisches Museum, Vienna.*

Klimt never succeeded in turning the Emperor's favour to his advantage. He was also snubbed by the aristocracy. Not so his colleague Franz Matsch, who seems to have been the better diplomat of the two. Early in his career he became the favourite of the Burgtheater actress Charlotte Wolter, who was known for her passionate style – the 'Wolter cry' was a byword. After the death of her husband Count O'Sullivan, Matsch moved into her house and set up a studio in the garden. In her salon he met the Viennese elite and became the portrait painter of high society. The Empress Elisabeth also favoured him. In 1908 he was commissioned, on the occasion of the sixtieth year of the Emperor's reign, to paint the large canvas *The Homage of the Princes*, which hangs in Schloss Schönbrunn. Three days before the Emperor's death he was still working on the oil painting *Emperor Franz Joseph in his Study in Schönbrunn* (1916, Historisches Museum der Stadt Wien).

1 In those days it was customary to present to the Emperor, on his first visit to a new building, those who had contributed to its construction.

2 Adolf von Wildbrandt, director of the Burgtheater (1837–1911)

3 The exact sequence was as follows (taken from Fritz Novotny/Johannes Dobai, *Gustav Klimt, catalogue raisonné*, hereafter indicated as D., Salzburg 1967):

Gustav Klimt:
Right-hand staircase:
*Thespis' Cart* (D.38)

*Shakespearian Theatre (The Globe Theatre in London)* (D.39)
*Altar of Dionysus* (D.40)

Left-hand staircase:
*Theatre in Taormina* (D.41)
*Altar of Apollo* (D.42)

Ernst Klimt:
Right-hand staircase:
*Molière's Theatre*
*Buffoon on an Improvized Stage in Rothenburg* (D.43)
This painting was altered in 1892 by Gustav Klimt.

Franz Matsch:
Right-hand staircase:
*Scene from Greek Theatre (Antigone)*
Left-hand staircase:
*Ancient Improvisator* and *Medieval Mystery Stage*

4 Hans Makart, painter (1840–1884)

5 Michael von Munkáczy, Hungarian painter (1844–1909)

6 Albert Ilg, art historian (1863–1929)

7 Gustav Klimt took over the following paintings in the Kunsthistorisches Museum:

Roman and Venetian Quattrocento:
*Baptismal font in early Renaissance style* (not in Novotny/Dobai)
*Idealized saint with tiara and crosier (papal might)* (D.51)
*Venetian Doge* (D.52)

Ancient Greece:
*Hetaira type, in the style of Tanagra figures*
(Glykene, beloved of the painter Pausanias)

Egypt:
*The gods Horus and Thot, female figure with sistrum (paintings in rock-tombs)*
*Painted wooden coffin lid, in front of it a statue of Isis* (D.55)

Early Italian Art:
*Man in fifteenth-century Florentine dress.* Background: frieze in the style of Luca della Robbia (D.53)
*Angel,* Trecento type up to the time of Melozzo da Forli (D.54)

8 Karl von Hasenauer, architect (1833–1894)

9 Rudolf von Alt, painter and watercolourist (1812–1905)

10 It was indeed astonishing that Rudolf von Alt had joined the young and become a member of the Secession. In his remarkable later work he achieved a pointilliste style comparable to contemporary French artists or to Adolf von Menzel.

11 Rudolf Bacher, painter (1862–1945)

12 Josef Engelhart, painter (1864–1941)

13 Carl Moll, landscape, genre and still-life artist, successful organizer of exhibitions (1861–1945; he committed suicide on witnessing the rape of his daughter)

14 Joseph Maria Olbrich, architect (1867–1908)

15 Fernand Khnopff, Belgian painter (1858–1921)

16 Archduke Franz Ferdinand (1863–1914, murdered in Sarajevo)

17 Oskar Kokoschka, painter, graphic artist and author (1886–1980)

40

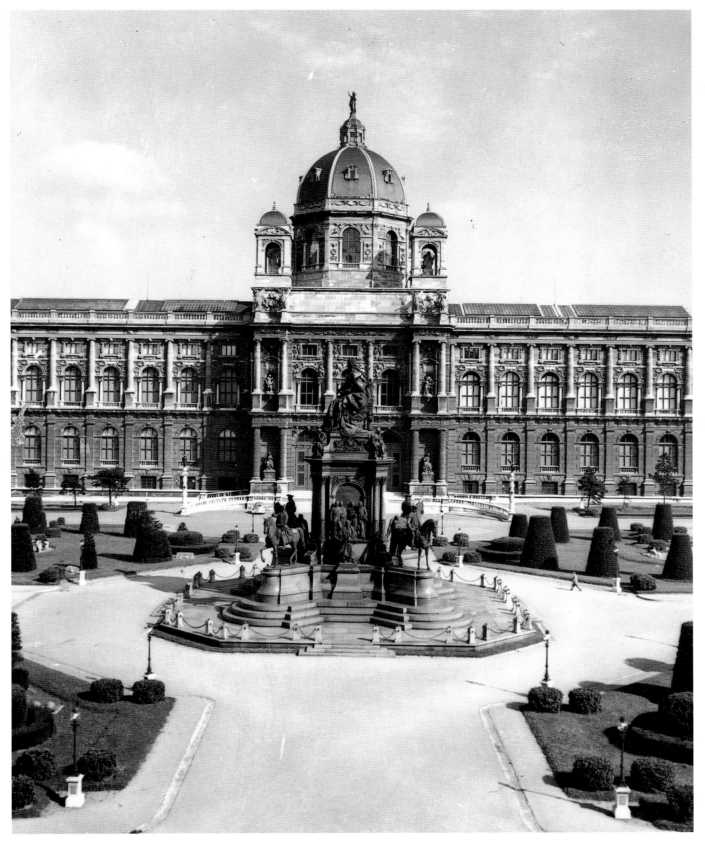

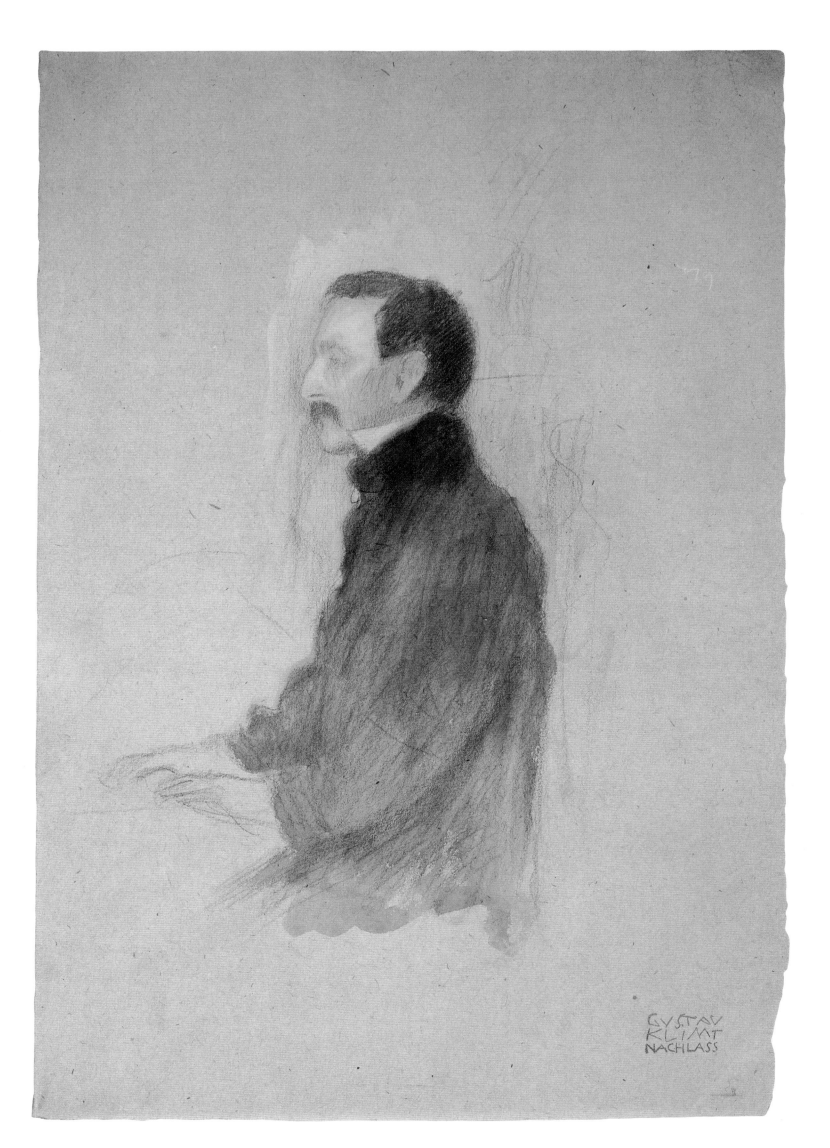

GVSTAV
KLIMT
NACHLASS

# THE DUMBA MUSIC ROOM

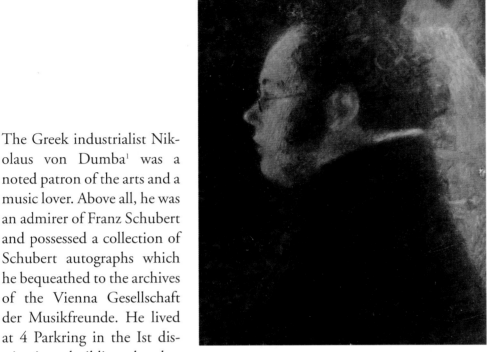

36 Schubert at the Piano II *(D.101), 1899 (detail). Oil on canvas. 150 × 200 cm. Destroyed by fire at Schloss Immendorf in 1945.*

35 Opposite: *Study for the painting* Schubert at the Piano I *(AS 313). 1896. Black crayon and wash, heightened with white. 45 × 31 cm.*

The Greek industrialist Nikolaus von Dumba[1] was a noted patron of the arts and a music lover. Above all, he was an admirer of Franz Schubert and possessed a collection of Schubert autographs which he bequeathed to the archives of the Vienna Gesellschaft der Musikfreunde. He lived at 4 Parkring in the Ist district in a building that has remained unaltered to this day. Unfortunately the same cannot be said of the contents of his apartment, which was sold after his widow's death and the furniture distributed, mostly to relations living abroad.

As a patron of young Austrian artists around 1900, Dumba had decided to entrust the decoration of each of the three main rooms in his first-floor apartment to a different artist; and this applied not only to the walls but also to the furniture.

Hans Makart (Pl. 38, 40) was chosen for the study. Dissatisfied with the Vienna Academy, he had gone to Munich, where he had become a pupil of Karl von Piloty, the best-known German representative of the historicist style.[2] Dumba himself had sent the young man to Venice in 1871 to study there. He was very happy with the resulting large canvasses which were let into the study's panelling. Makart's paintings for Dumba's study are now in a private collection.

The second artist to be employed by Dumba was Franz Matsch, a fellow student of Klimt's at the Kunstgewerbeschule in Vienna from 1876 to 1883. The Kunstgewerbeschule was the first of its kind on the Continent, was associated with the Museum für Kunst und Industrie[3] and served as a training school for the applied arts. Klimt took up his studies there after attending secondary school for four years; his most important teacher there was Ferdinand Julius Laufberger,[4] painter, etcher and lithographer. After Laufberger's death Klimt studied decorative painting with Julius Victor Berger until 1883.[5]

Franz Matsch, who incidentally was ennobled in 1912, worked until 1892 with the Klimt brothers in the so-called Künstlercompagnie, which executed a series of commissions for decorative work in buildings designed by the two Viennese architects Fellner and Hellmer: in Karlsbad, Reichenberg, Fiume and Bucharest, as well as for the Rumanian royal castle in Pelesch and the 'Hermesvilla' in Vienna. These were followed by commissions from the Imperial Court for decorations in the newly built Burgtheater (1886–1888) and the staircase of the Kunsthistorisches Museum (1891).

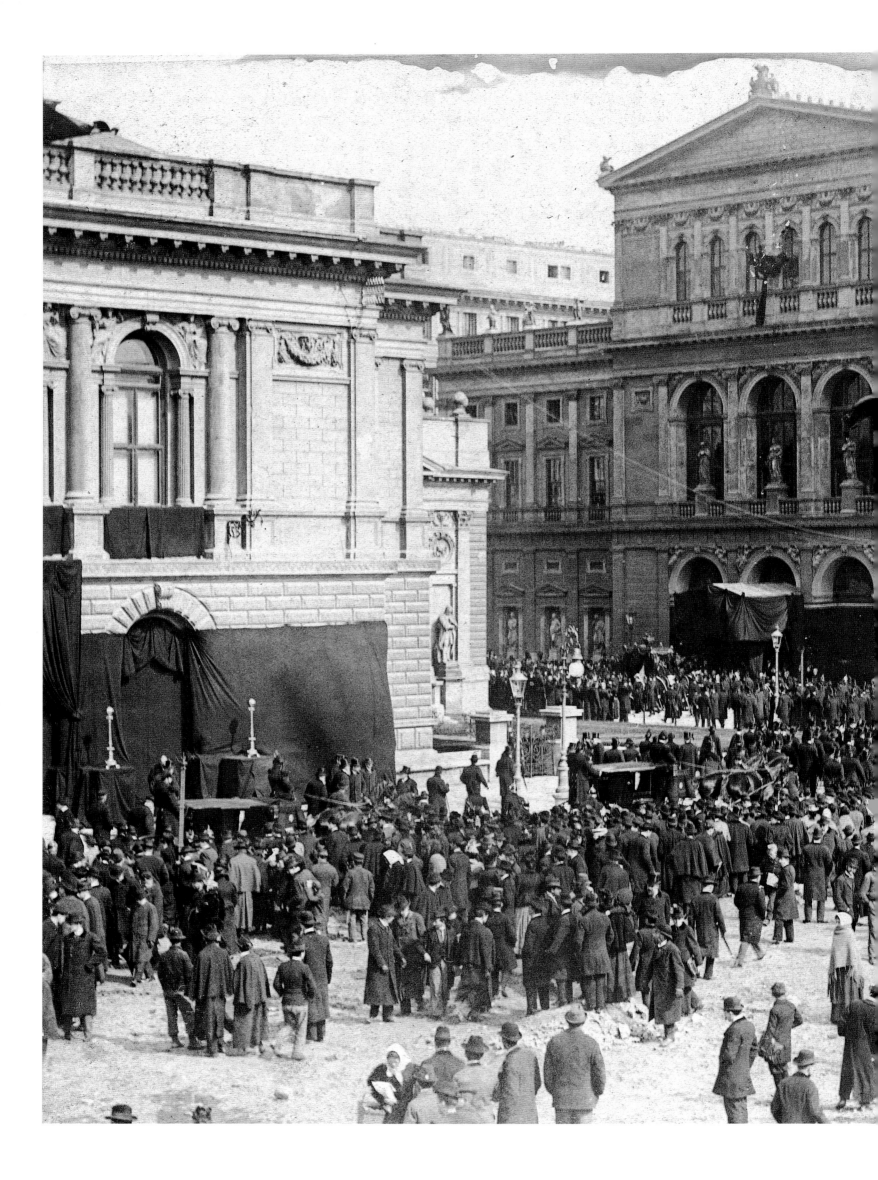

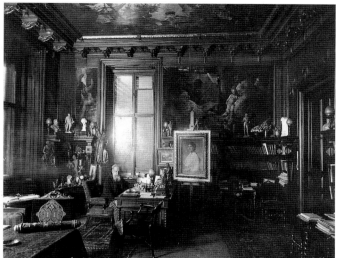

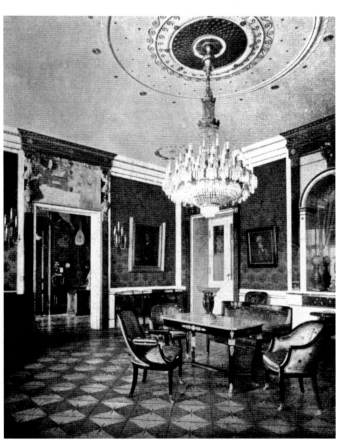

*37* Left: *The funeral procession of the industrialist Nikolaus Dumba passes by the Künstlerhaus and the Musikverein in Vienna. He died in Budapest on 23 March 1900. Photograph, 1900.*

*38* Above: *Nikolaus Dumba in his study, with paintings and furnishings by Hans Makart. Photograph, 1898*

*39* Below: *Dumba's music room, decorated by Gustav Klimt. His painting* Music II *(D.89) had been placed above the door.*

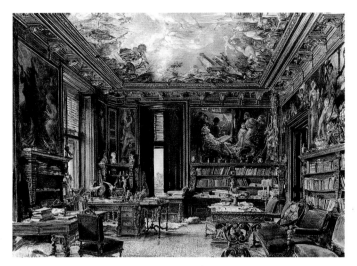

*40* Above: *Nikolas Dumba's study, decorated by Hans Makart.* Rudolf von Alt, 1877. 34.4 × 45.6 cm.

*41* Centre: *Study for the painting* Schubert at the Piano II *(AS 317). 1898–99. Pencil. 9 × 10.3 cm.*

*42* Below: *Design for a wall with door and painting above it in Dumba's music room (AS 3199), 1899. Pencil and wash. 32.4 × 53.6 cm.*

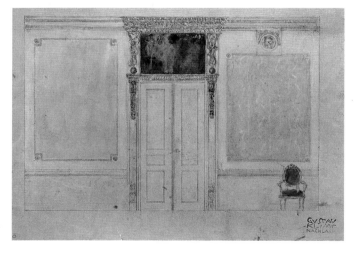

The Künstlercompagnie was dissolved in 1892 after Ernst Klimt's sudden death. As Klimt's father also died in the same year, Klimt suffered a creative crisis which took him a long time to overcome. Dumba's commission for the complete decoration of the music room was therefore particularly important. The result was two overdoor paintings: an allegory on music, *Music II*, 1898 (D.89) and *Schubert at the Piano*, 1899 (D.101). After the sale of the Dumba apartment both paintings were taken over by the Lederer family and later, in May 1945, found their way to Schloss Immendorf, where they were destroyed by fire (see p. 78).

The genesis of a Klimt painting is clearly shown in his *Schubert at the Piano* (Pl. 43): gradually – and presumably at the house-owner's request – the pianist took on the features of Franz Schubert, who was also, incidentally, Klimt's favourite composer. A fine, lightly coloured drawing (Pl. 35) shows that a stranger originally sat for the portrait.[6]

Fortunately, both these paintings of Klimt's for the Dumba music room were, shortly after their completion, excellently reproduced in colour by the Munich art printers Hanfstaengl, so that Klimt's *Schubert* was for a long time his most popular painting, a role now taken over by *The Kiss*.

Contemporary critics were also enthusiastic about the *Schubert*. Peter Altenberg, chief representative of literary impressionism in Vienna, wrote:

> Over my bed hangs a colour reproduction of Gustav Klimt's *Schubert* painting, in which Schubert and three young girls are singing at the piano by candlelight. Underneath, in my hand-writing: 'One of my gods! Men created their gods in order to bring to life their own hidden and unfulfillable dreams!'[7]

And the poet, essayist and critic Hermann Bahr,[8] who styled himself the 'midwife of modern Austrian art' and was a lifelong mediator between the public and the arts, wrote:

> I said lately that in my opinion Klimt's *Schubert* is the finest painting ever done by an Austrian. And there is something else I would like to say: I know of no modern that has struck me as so great and pure as this one . . . What is it? Ah, could I but name it! I only know that I get angry when someone asks if I

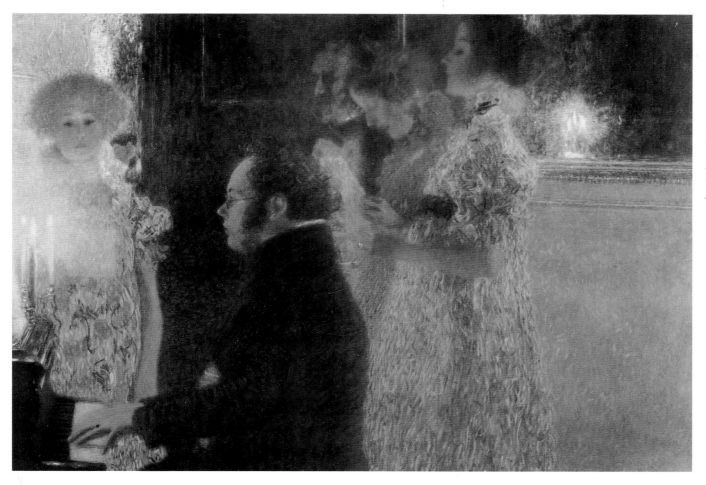

am German. No, I reply, I am not German, I am Austrian. That is no nation, comes the answer. We have become a nation, I say, but we are different from the Germans, we are ourselves. Try defining that! How can one define it? Well, by beholding this Schubert. This tranquillity, this softness, this radiance, this domestic simplicity – therein lies our Austrian nature! Here we have our Austrian creed: that every human being, be he ever so small, has in him a flame that no storm can extinguish. Each of us has his own holy sanctuary, and no destiny can crush it. Whatever the turmoil, we can come to no ill, the flame cannot blow out, no one can deprive us of our inner worth. It is this that I mean by the Viennese feeling for life.[9]

1 Nikolaus von Dumba (1830–1900)

2 Karl Theodor von Piloty, Bavarian historicist painter (1826–1886). According to the painter Moritz von Schwind (1804–1871), who in 1863 painted the *Magic Flute* frescoes in the loggia of the Vienna Court Opera, Piloty painted 'a historical catastrophe' every year. Makart, who matured quickly, outdid Piloty with the public success of his spectacular painting, *Venice Pays Homage to Caterina Cornaro*, 1872/73, which was on show in the Künstlerhaus (now in the Österreichische Galerie,

Vienna). In those days outsize paintings of this kind were often sent on tour, sometimes as far as the USA, and were displayed to admiring audiences.

3 Today in the Österreichisches Museum für angewandte Kunst

4 Ferdinand Julius Wilhelm Laufberger, etcher, lithographer and painter (1829–1881), from 1868 onwards Professor of figure-drawing at the Kunstgewerbeschule, Vienna

5 Victor Julius Berger, painter (1850–1902), from 1887 onwards Professor at the Vienna Academy

6 According to information from Klimt's nephew Rudolf Zimpel, Klimt, himself no pianist, had bought for the purposes of this painting a piano which then remained in his studio. Erich Lederer (1896–1985) told me that the girls in the painting had borrowed dresses from his mother Serena Lederer (Pl. 226), who – according to Josef Hoffmann (architect, art historian, co-founder of the Wiener Werkstätte) – was one of the best-dressed women in Viennese society.

7 Peter Altenberg, *Bilderbögen des kleinen Lebens*, Berlin 1909, p. 73

8 Hermann Bahr, author, critic (1863–1934)

9 Hermann Bahr, *Secession*. Vienna 1900, p. 122 ff

47

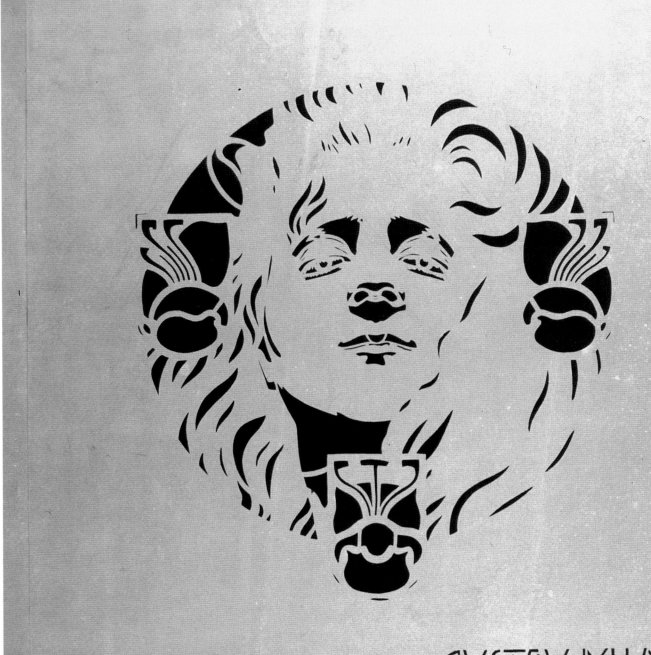

GVSTAV·KLIMT·

48

# THE FOUNDING OF THE SECESSION 1897

*45* Head of Pallas Athene *(AS 710), 1900. Brush and pen with Indian ink. Dimensions and owner unknown. This vignette was used in* Ver Sacrum, *third year, 1900, on the cover of No. 1, for the catalogue cover and poster for Klimt's collective show (eighteenth Secession exhibition, 1903) and also for the Secession's ex libris.*

*44* Opposite: *Kolo Moser. Cover for the graphic in the founder's edition of* Ver Sacrum, *second year, 1899, first series. Stencil. 54.5 × 50 cm. Gustav Klimt's copy.*

The hanging practice of the Vienna Künstlerhaus, whereby paintings were hung so high that nobody could see them, was the last straw for the younger generation of artists. In 1897 they handed in their resignation with the following note:

As the Committee knows, a group of artists, all members of the Association, have been trying for years to obtain recognition for their viewpoint. This viewpoint is: the realization of the need to intensify the contacts between Viennese art and developments in other countries; exhibitions to be organized on a purely artistic, non-commercial basis, thereby awakening a clearer and more modern understanding in a wider public; and lastly, the authorities to be encouraged to give greater support to the arts. This group of artists has not, over the years, met with the right perception or understanding within the Association. This being the case, and in view of the Association's organization and its resulting non-artistic liabilities; also of the apparent impossibility of encouraging the majority of the Association's members to come forward freely and courageously, without which the above viewpoint cannot be realized; in view of all this, and without any personal motives whatsoever, the above-mentioned group of artists has resolved to cease their work in the Association and to take up independent activities. To this end the Union of Austrian Artists was constituted on 3 April 1897 . . .

With the request that this letter, together with the enclosed list of members, be read out at the general meeting of the Association, I remain

Yours sincerely,
GUSTAV KLIMT for the Union of Austrian Artists[1]

Those who left the Association did not, then, immediately call themselves the 'Secession' (the word was coined later[2]), but the 'Union of Austrian Artists'.

In the first issue of *Ver Sacrum*, the periodical edited by young artists from 1898 to 1903 to propagate their ideas, and which was very soon prominent both in the literary and artistic world, there was a contribution by an important and influential writer: the lawyer Max Burckhardt,[3] who had distinguished himself as director of the Burgtheater with productions of contemporary playwrights (Ibsen, Hauptmann, Hofmannsthal, Schnitzler, etc.):

When in ancient Rome the tension arising from economic inequalities, reached boiling-point, it repeatedly happened that part of the population arose and went to the Mons sacer, the Aventine or the Juniculum and threatened, should their wishes not be granted, to stay there and found a second Rome within sight of the city and under the noses of its worthy fathers. This was known as 'secessio plebis'. The city fathers were cunning: they sent a plausible mediator who promised much but held nothing – and the 'secessio plebis' was over . . .

But when their native country was threatened by a great danger, then the whole population vowed to dedicate to the gods as vernal offering (VER SACRUM) all things that come to life in the following spring. And when those born during the Ver Sacrum grew up and were themselves a 'holy spring', they left

49

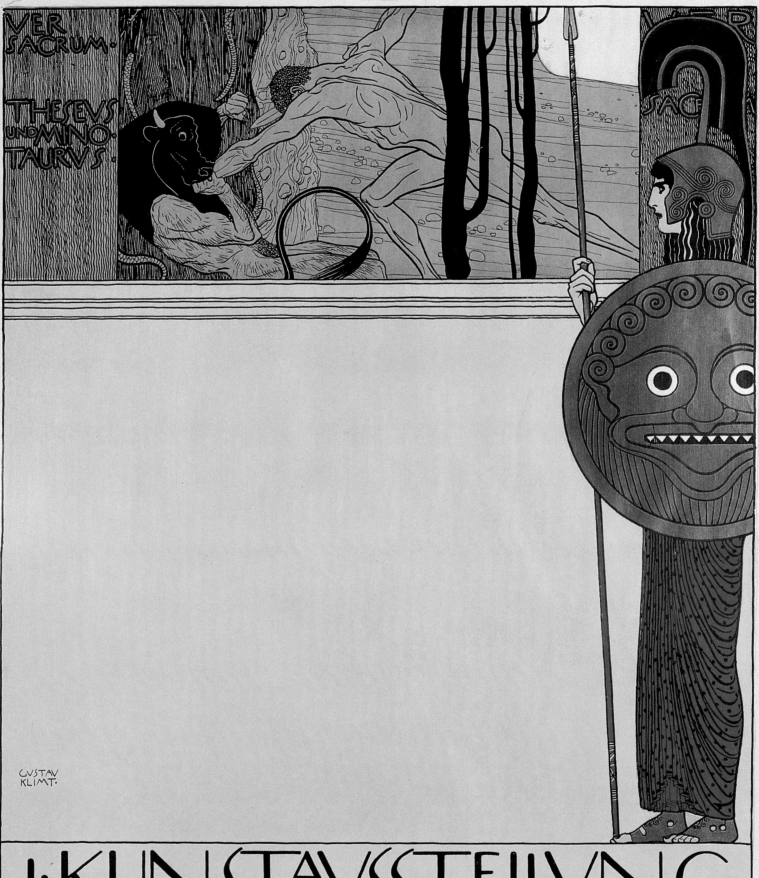

for foreign places, there to found a new community with their own vitality and their own ambitions.

And while the young artists, who have of their own free will broken away in order to found an independent artists' union in Vienna, did so not hoping for material gain, not to threaten with competition, nor to obtain concessions or to be cajoled once again by a modern Menenius Agrippa, they avoided the name 'Secession' in order not to call to mind the causes, aims and issue of the old 'secessio plebis'. It was the threat to art itself that they sensed, and so they chose the name VER SACRUM.[4]

*Ver Sacrum* was the only publication for which Klimt illustrated (Pl. 45, p. 81 ff). Why did the young flock to someone who, although he could boast of two important imperial commissions, had never yet produced a painting that could in any way inspire them? The answer lies in his straightforward personality, his simplicity, his moral steadfastness, his endeavours, but

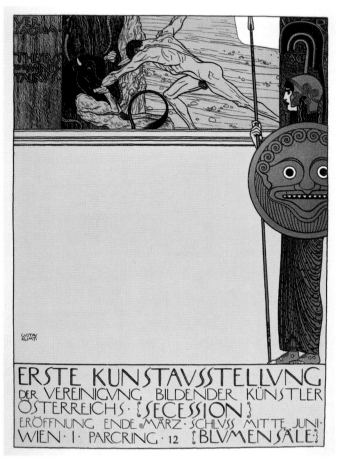

48 Above: *Poster for the first Secession exhibition (uncensored version) 1898. This version was reproduced in pink for the pattern journal* Die Fläche.

47 Below: *Fair drawing of a design (not used) for a poster for the first Secession exhibition (AS 330), 1898. Technique and dimensions unknown.*

46 Opposite: *Poster for the first Secession exhibition (censored version), 1898. Printed by Albert Berger. 64 × 47 cm. Historisches Museum der Stadt Wien.*

*This well-known poster shows Theseus fighting the Minotaur – an allegory of the struggle of the young, modern Secessionists against the might of the academic, conservative view of art. The censor banned the poster and decreed that Theseus' genitals be hidden by a tree-trunk.*

above all the friendship and help he extended to the young.

In his obituary the prominent art historian Hans Tietze[5] touches on this aspect of Klimt's personality:

There were others who took a much more active part than Klimt in the founding of the Secession, but his artistic superiority and the effect of his personality very soon brought him to the top. No one, indeed, represented as he did the spirit and aims of this artistic revolution. He reached out hungrily for all new influences . . . the onslaught of the new led to apparent indecision and searching, and it took years for his personal style to emerge from the crisis . . . But what really made this recluse the leader of the Secession was his unshakeable belief in the sanctity of art: the essence of innovation seemed to him to be not a new technique but a new attitude. He visualized a sort of Nazarene brotherhood in which selfless devotion to art took precedence over all other interests . . . That the spell soon broke and Klimt's dream turned out to be utopian is not surprising, for artists are, they too, earthbound and their unions have to have a solid commercial foundation . . .[6]

51

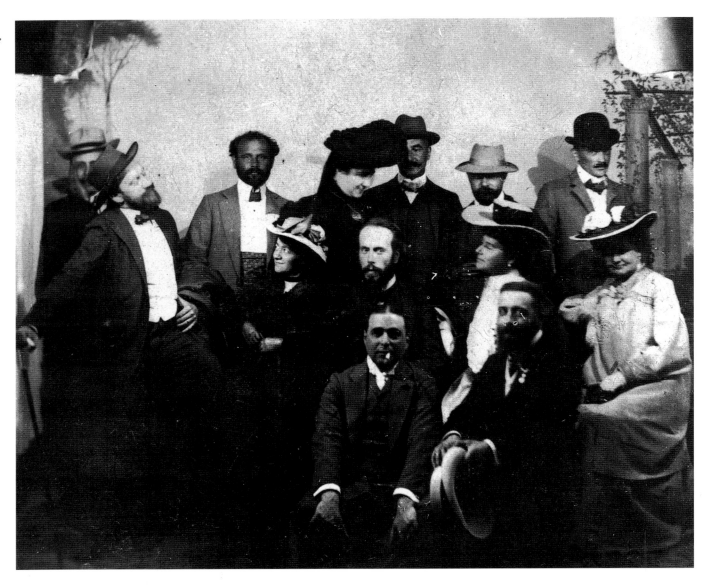

Klimt designed two highly original Secession posters: one, for the first exhibition (Pl. 48), 1898, gave rise to controversy. It shows the Minotaur, a monster with a human body and a bull's head (which had been imprisoned in a labyrinth by the Cretan King Minos). The Minotaur stands for the old guard and is being slain by the victorious young Theseus, who stands for the forces of innovation. The censors objected to Theseus' nakedness, which is amusing since Klimt's model was Antonio Canova's[7] famous Theseus group, which is to be seen, stark naked, on the landing of the Kunsthistorisches Museum, where it has stood ever since the museum was built. The censor insisted on

two tree-trunks being overprinted (Pl. 46). Plate 47 shows Klimt's study for a poster for this exhibition, which, however, was not printed.

Klimt's second poster shows the head of the Greek goddess Pallas Athene, which he had already drawn for *Ver Sacrum*. The poster was used for the eighteenth exhibition in 1903, which was devoted entirely to Klimt.

Prominent Secession artists designed remarkable posters for all the exhibitions, but only one showed an actual painting that was for sale: Ferdinand Hodler's poster for the nineteenth exhibition (Pl. 128), 1904, which brought him his international breakthrough.

With the exception of Joseph Maria Olbrich, who designed the posters for the second and third exhibitions (Pl. 53) showing the Secession building, all the artists, who delivered first-rate work capable of standing comparison with any of their European competitors, nevertheless omitted to do what they were supposed to do, namely, to publicize the subject of the exhibition. The most active of them was Alfred Roller[8] (posters for the fourth, ninth, fourteenth and sixteenth shows); and, after him, with two posters each, Kolo Moser (fifth and thirteenth) and Adolf Böhm (eighth and fifteenth). One poster was contributed by each of the following: Josef Maria Auchenthaller, Ferdinand Andri, Viktor Krämer, Max Kurzweil and Leopold Stolba (seventh, tenth, eleventh, seventeenth and twentieth).[9]

Klimt contributed not only illustrations and posters:

in 1898 he took a hand in designing the exterior of the Secession building itself. Joseph Maria Olbrich's original designs (Pl. 54, 55) seemed to him to be too flamboyant. He wanted large, uncluttered surfaces, presumably with the intention of decorating them with frescoes or large mosaics, a technique which seemed perfectly to suit his style, but which he only succeeded in using once, namely in the Palais Stoclet in Brussels (see p. 151 ff). Two of his designs have come down to us (Pl. 56, 58); and although Olbrich did not accept all his ideas, Klimt does seem to have had a tranquillizing influence.

In a newspaper article entitled 'Reminiscences of Gustav Klimt', Berta Zuckerkandl[10] recalls a pessimistic remark of Klimt's about the chance of ever being able to paint frescoes:

*50 Joseph Maria Olbrich (left), a stranger, Kolo Moser and Gustav Klimt in Fritz Waerndorfer's garden. Photograph, about 1898.*

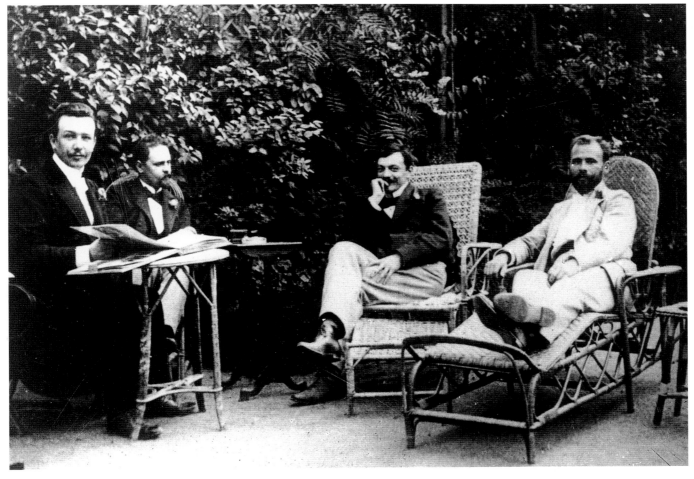

51 Above: *Entrance hall
of the Ist Secession
exhibition, 1898.
Decorative scheme by
Joseph Maria Olbrich.
Publicity postcard from the
Secession.*

52 Below: *Joseph Maria
Olbrich, 'The Secession
building', 1898. Publicity
postcard from the
Secession.*

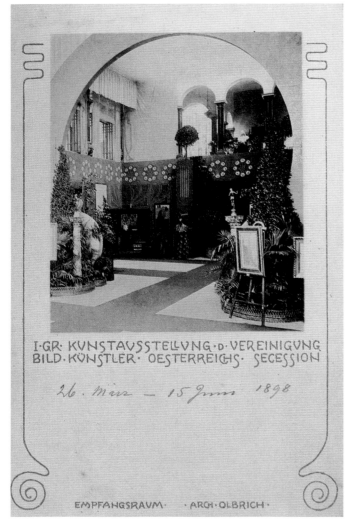

with the new building, but this was soon replaced by a
tall, pompous building with an unusually high roof.
Moreover, plans had been made for the modelling of
the Karlsplatz that would have shown the new house to
advantage, and this presumably caused the choice to
fall on that site; but the plans were eventually dropped.
The present site of the building, its view of the
Karlsplatz blocked by the Verkehrsbüro (built in 1923),
is much less favourable than was at first intended.[12]

Here is Ludwig Hevesi's description of the new
'Secession':

The white house on the river Wien is finished. The young art-
ists have succeeded in erecting in six months a great new build-
ing . . . using large concrete weights, for it stands directly over

'You won't be allowed to build the walls on which I won't be
allowed to paint my frescoes!' Those were his [Klimt's] words,
often spoken to the optimist Otto Wagner when Wagner invit-
ed us to his studio to see his wonderful models of the Technical
Museum, the City Museum on Karlsplatz, or his development
of the Schmelz [a former parade ground in the XVth district,
built on after 1918]. All these things remained dreams, they all
came to nought.[11]

The city authorities had at first put at their disposal an
empty site in the Ist district, where the Wollzeile joins
the Parkring, now occupied by the monument to Dr
Karl Lueger. However, the final choice fell on 12
Friedrichstrasse in the Ist district. The junction of
Linke Wienzeile and Getreidemarkt was then occupied
by an old, low-level house that would not have clashed

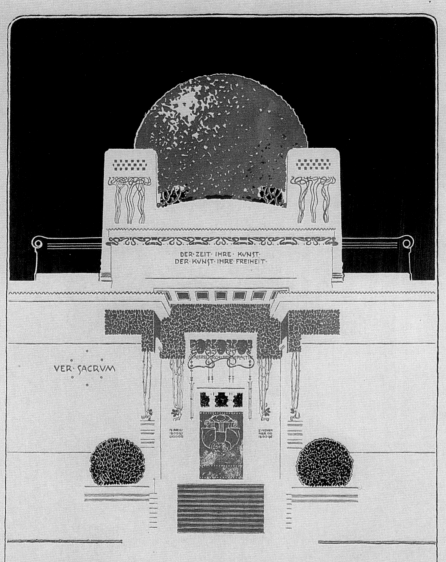

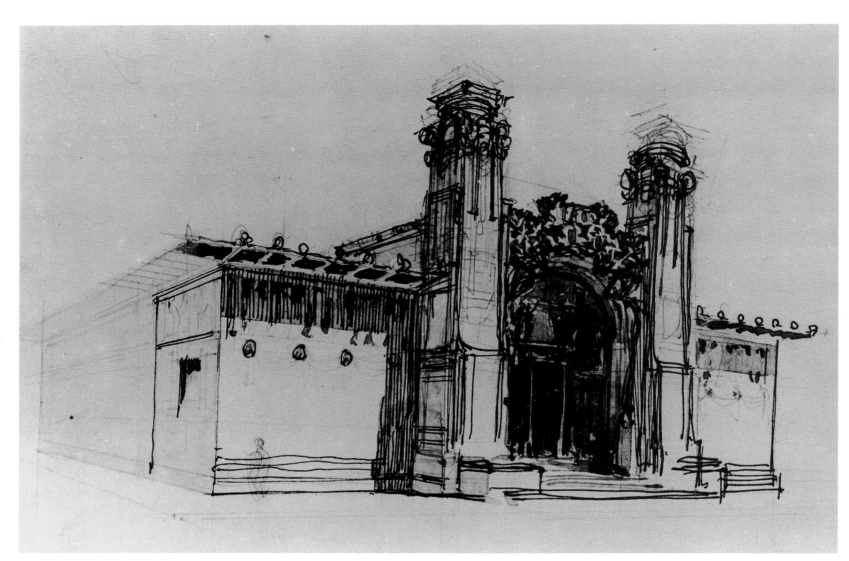

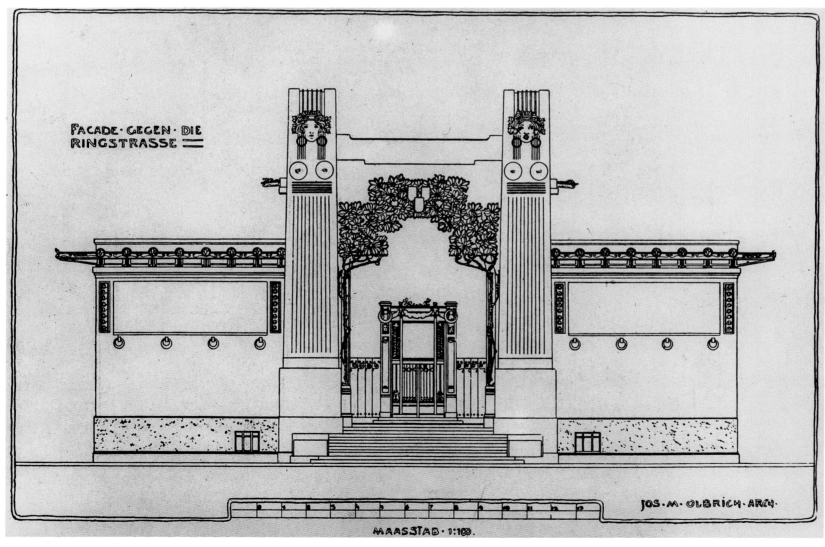

FACADE·GEGEN·DIE
RINGSTRASSE

JOS·M·OLBRICH·ARCH

MAASSTAB·1:100.

56 *Preliminary sketch of the Secession building (AS 321), 1897. Black crayon and wash. 11.2 × 17.7 cm. Historisches Museum der Stadt Wien.*

54 Opposite: *Joseph Maria Olbrich, sketch for the façade of the Secession building, 1897. Pencil and pen in Indian ink. 18.6 × 29.5 cm.*

55 Below: *Joseph Maria Olbrich, design for the Secession building, entitled* Façade facing the Ringstrasse *(the site was originally to be on the Ringstrasse at the junction with the Wollzeile), 1897. Reproduction from* Deutsche Kunst und Dekoration *(German Art and Decoration) (1899).*

the Ottakring stream, its foundations are eight metres deep . . . And for all these months the Viennese passed the strange building daily . . . They shook their heads, laughed, and were scandalized . . . soon there were jokes . . . some called it the Mahdi's tomb, others a cross between a greenhouse and a blast furnace . . . others, again, went as far as to call it an Assyrian public lavatory . . . There was general perplexity, but it gradually dawned on people that it was no joking matter . . . Olbrich's exhibition pavilion costs a total of 60,000 gulden [120,000 crowns, roughly the same as in marks or Swiss francs at the time] because all the artists worked without payment . . . The words over the entrance:
TO EVERY AGE ITS ART AND TO ART ITS FREEDOM (chosen by the artists from a selection I had composed at their request) even the children know them by heart . . . the dome is a bower crowned by a gigantic laurel tree painted in gold-leaf . . . 3000 leaves . . . 700 berries . . . an enchanting sight . . . and through the gaps you can see the sky above and the townscape beyond . . . no visitor will fail to view Vienna's new landmark, for it is unique . . . There will be steps up to the entrance . . . Hermann Bahr's words round the exhibition hall run thus: 'Let the artist show his world, the beauty that was born with him, that never was before and never will be again'.

A novelty are the walls which can be shifted around at will . . . even the great columns that separate the middle room from the back are removable. Thanks to this flexibility it will be possible to have a new groundplan each year over the next ten years. Even the lighting can be varied from overhead to side . . . naturally it will take time for judgments to settle . . .[13]

Klimt was only really active in the Secession during its first and second years, 1897 and 1898. Soon afterwards he was entirely taken up with his work on the University paintings (see pp. 61 ff).

Thanks to the generosity of Ronald Lauder, who was shortly afterwards appointed American Ambassador to Austria, the Secession's cupola was freshly gilded in 1985. On Austrian Television's documentary 'Gustav Klimt and Jugendstil', 1975 (written by the present author and directed by Jean Louis Fournier, Paris), the cupola was lit from inside – an enchanting sight; and at the end of the film the light slowly went out, symbolizing Klimt's death.

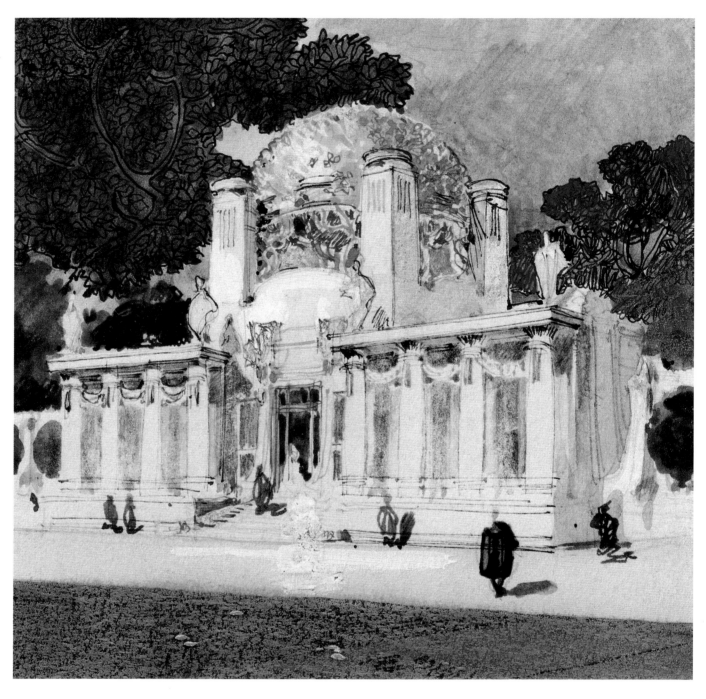

1 From: Walter Maria Neuwrith, 'Die sieben heroischen Jahre der Wiener Moderne'. In: *Alte und Moderne Kunst*, 1964/9, pp. 28–31, with partial reproduction of this letter.

The newly founded Vienna Union originally comprised the following members:

Rudolf Alt, painter, Vienna, Honorary President; Rudolf Bacher, painter, Vienna; Wilhelm Bernatzik, painter, Vienna; Adolf Böhm, painter, Vienna; Alois Delug, painter, Munich; Albin Egger-Lienz, painter, Munich; Josef Engelhart, painter, Vienna; Julian Falat, professor of painting, Cracow; Otto Friedrich, painter, Vienna; Alois Haenisch, painter, Munich; Edmund Hellmer, professor of sculpture, Vienna; Adolf Hölzel, painter, Munich; Albert Hynais, professor of painting, Prague; Eugen Jettel, painter, Paris; Gustav Klimt, painter, Vienna; Benno Knüpfer, painter, Prague; Friedrich König, painter, Vienna; Johann Krämer, painter, Vienna; Max Kurzweil, painter, Vienna; Maximilian Lenz, painter, Vienna: Ludwig Marold, painter, Prague; Julius Mayreder, architect, Vienna; Carl Moll, painter, Vienna; Alfons

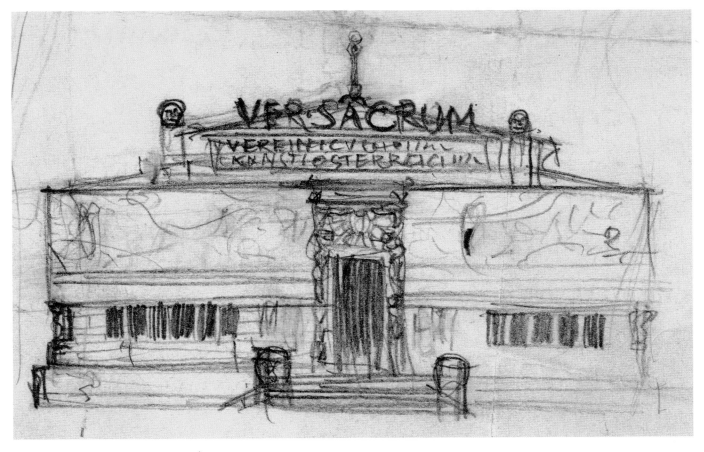

58 Preliminary sketch of the Secession building (AS 322) (detail), 1898. Pencil. 27 × 22.5 cm.

*The sketch is on the verso of a handwritten letter from Alfred Roller to Gustav Klimt. Compared with Olbrich's first sketch, Klimt's attempt is at a less agitated façade structure. He almost certainly visualized frescoes or mosaic work for the large surfaces on either side of the entrance.*

Mucha, painter, Paris; Felician Freiherr von Myrbach, painter, Paris; Josef Myslbeck, professor of sculpture, Prague; Anton Nowak, painter, Vienna; Friedrich Ohmann, architect, Prague; Joseph Olbrich, architect, Vienna; Rudolf von Ottenfeld, painter, Vienna; Kasimir Pochwalski, professor of painting, Vienna; Robert Pötzelberger, professor, Karlsruhe; Maximilian Pirner, professor, Prague; Alfred Roller, painter, Vienna; Hans Schwaiger, painter, Vienna; Ludwig Sigmund, painter, Vienna; Ernst Stöhr, painter, Vienna; Arthur Strasser, sculptor, Vienna; Hans Tichy, painter, Vienna.

The most prominent newcomer at the time was Josef Hoffmann.

In addition, a number of foreign corresponding members had been admitted, among them: Walter Crane, painter, London; Eugène Grasset, painter, Paris; Max Klinger, professor of painting, Leipzig; Max Liebermann, professor, Berlin; Fritz Mackensen, painter, Worpswede; Constantin Meunier, sculptor and painter, Brussels; P. Puvis de Chavannes, painter, Paris; Auguste Rodin, sculptor, Paris; Giovanni Segantini, painter, Soglio di Val Bregaglia; Franz von Stuck, professor of painting, Munich; Fritz von Uhde, professor of painting, Munich.

2 This name had been chosen in 1892 by the Munich publisher Georg Hirth (1841–1916) for the newly founded Munich Artists' Union 'Sezession'. He was the publisher of the weekly periodical *Jugend*, and had the brilliant idea of having the title page of each number designed by an artist. In some cases as many as 150,000 copies were printed. The title pages, printed on good paper, could be bought from the publishers at little cost; art lovers framed them and hung them in their homes. Against Hirth's will, the name 'Jugendstil' came to denote the German art scene around 1900.

3 Max Burckhardt, lawyer, author, director of the Burgtheater (1854–1912)

4 In: *Ver Sacrum*, Vienna 1898/1, p. 1 ff

5 Hans Tietze, art critic (1880–1954)

6 Hans Tietze, 'Vienna's Sacred Spring was Klimt's Work'. An obituary. In: *Kunstchronik*, Leipzig 1 March 1918

7 Antonio Canova, Italian sculptor (1757–1822)

8 Alfred Roller, painter and set designer (1864–1935)

9 See Christian M. Nebehay, *Secession: Kataloge und Plakate, 1898–1905*. Vienna 1986

10 Berta Zuckerkandl, journalist (1864–1945)

11 Berta Zuckerkandl, 'Erinnerungen an Gustav Klimt zu seinem sechzehnten Todestag'. Newspaper article 6 February 1934. See also her book: *Österreich intim*, Frankfurt 1970, pp. 62–66.

12 See Christian M. Nebehay, *Gustav Klimt: Dokumentation*, Vienna 1969, p. 164

13 Ludwig Hevesi, *Acht Jahre Secession*. Vienna 1906, pp. 63–72.

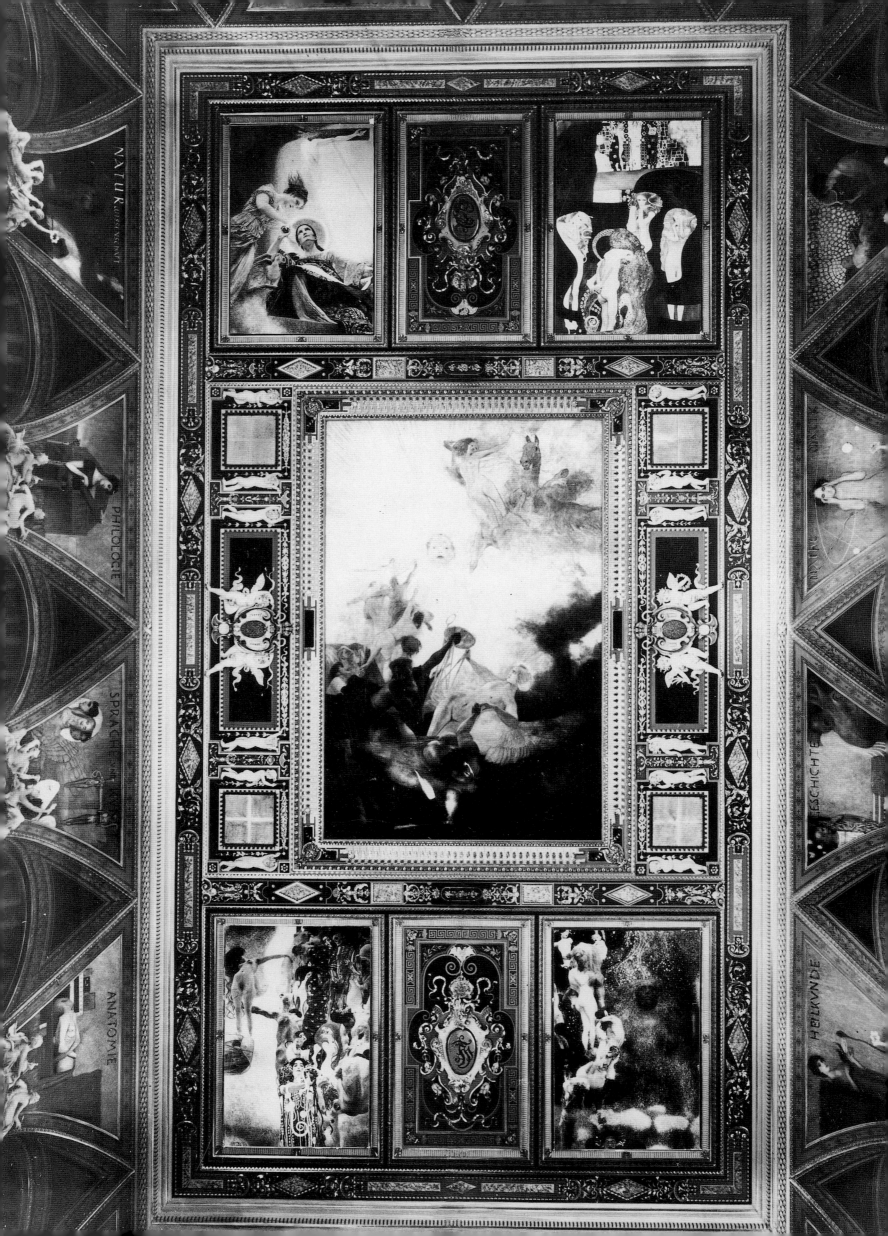

# THE UNIVERSITY PAINTINGS 1894–1907:
## ART SCANDAL AND LITERARY CONTROVERSY

60 *The Ringstrasse, in the foreground Parliament, still surrounded by fences (the building was completed in 1883); in the background, the Town Hall (completed 1883) and on the right, the new University (opened 1884). Photograph, about 1880.*

The three University paintings cost Klimt ten years' hard work. Many hundreds of sketches must have been made for each one in the constant endeavour to achieve the extremely difficult foreshortening of the bodies. His studio at 21 Josefstädterstrasse not being high enough to take the enormous canvasses, he had rented an attic in a neighbouring house at 54 Florianigasse in the VIIIth district, and there he worked, as the seasons allowed.

In her catalogue raisonné of Klimt's drawings, Alice Strobl counts no fewer than 273 sketches for the University paintings. We can, however, assume – and reports from visitors to the studio confirm this – that they were infinitely more numerous. For Klimt they were nothing more than memoranda which he very seldom found worth preserving: heaven knows how many were cast aside (see pp. 196–7).

The University paintings were undoubtedly Klimt's masterpiece. Of those of his works that perished – among them some of his finest paintings and fifty of his sketchbooks – these constitute the greatest loss to posterity.

The 'New Vienna University', built according to the plans of Heinrich von Ferstel[2] and situated at 1 Dr Karl Luegerring – one of the numerous Ringstrasse palaces in the style of the Italian Renaissance – was formally opened on 10 October 1884. The architect had provided the Great Hall with a richly carved gilt ceiling with empty spaces for a centre painting, four corner paintings and ten spandrels. Invitations for tenders for the decorative work were, however, only issued in 1892.[3]

First Franz Matsch, Klimt's colleague, was commissioned; but on 4 December 1893 his sketches were turned down by the Academic Senate of the University, which then, on 4 September 1894, awarded the commission to Klimt and Matsch. The fee was to be 60,000 gulden.

Ill fortune beset the project from the start. The authorities had clearly overlooked the fact that both artists, who had successfully co-operated in their earlier commissions (Burgtheater, Kunsthistorisches Museum), had since developed in different directions: whereas Matsch had developed his style gradually, after 1898, Klimt had made a radical breakthrough to the unique style so admired today.

If the two artists – who had as late as 1898 said they were prepared to alter their sketches – had been given reasonable instructions, the project might have been salvaged. As it was, a basic mistake was made, insofar as Matsch was commissioned to paint the centre-piece and *Theology* (and, later, the ten spandrels), whereas Klimt was to paint *Philosophy, Medicine* and

59 Opposite:
*Reconstruction of the planned sequence of the University paintings: the richly decorated ceiling of the Great Hall of the new University in Vienna (built 1873–84 from plans by Heinrich Ferstel) with reproductions of all the ceiling paintings inserted at the instigation of Alice Strobl.*
Centre: *Franz Matsch,* The Triumph of Light over Darkness *(still extant). All four corner surfaces are now empty.*
Above left: *Franz Matsch,* Theology *(now hangs in the Dean's room in the theological faculty).*
Above right: Jurisprudence, *1903–07 (D.128).*
Below left and below right: Medicine, *1900–07 (D.112) and* Philosophy, *1899–1907 (D.105). Klimt's paintings were destroyed by fire in 1945 in Schloss Immendorf.*

61

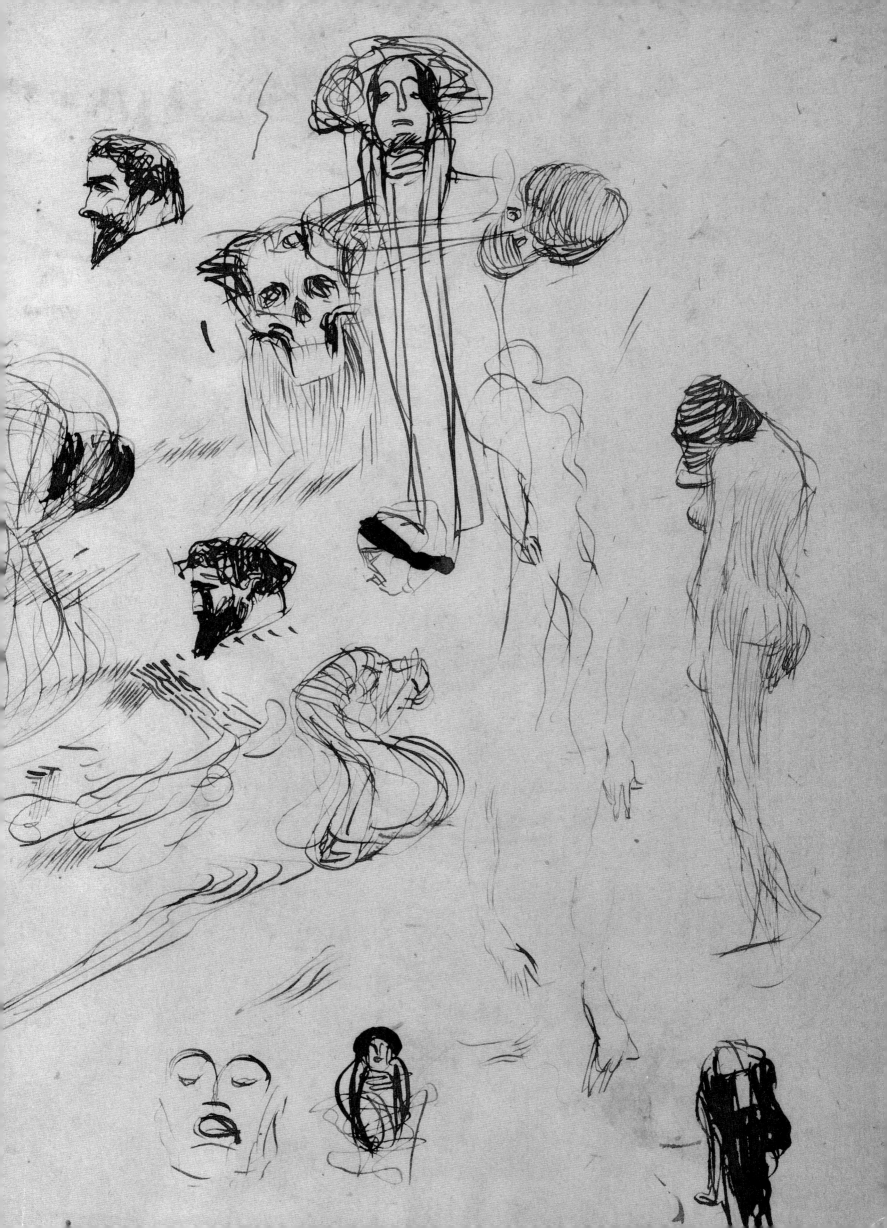

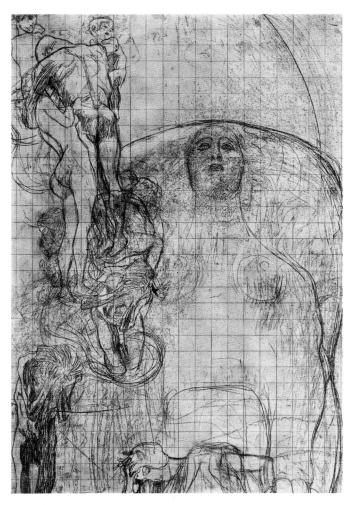

Preceding pages: *61*
*Sheet with studies for the*
*University painting*
Medicine *and sketches for*
*running commissions (AS*
*664), about 1900. Pen*
*and Indian ink. 31 ×*
*44.2 cm. The only existing*
*large sheet with Klimt's*
*rough sketches for*
Medicine, *including*
Hygeia, Pregnancy,
Death, Illness, Desperate
Old Man, *etc., and two*
*self-portraits.*

*62* Above: *Study for the*
*University painting*
Philosophy *(AS 477),*
*1899. Black crayon,*
*pencil. Enlargement grid.*
*89.6 × 63.2 cm.*
*Historisches Museum der*
*Stadt Wien.*

*63* Below: *Sketch for the*
*University painting*
Philosophy *(AS 3342).*
*Composition study from*
*Sonja Knips' sketchbook,*
*p. 63. About 1898. Pencil*
*13.8 × 8.4 cm.*

*64* Opposite: Philosophy
*(D.105), 1899–97. Oil*
*on canvas. 430 × 300 cm.*
*Destroyed by fire in 1945*
*in Schloss Immendorf.*
*The painting is described*
*as follows in the catalogue*
*of the seventh Secession*
*exhibition (March–June*
*1900): 'Left-hand group:*
*Birth, Fertile Life, Death.*
*Right: The Globe, the*
*Enigma of the World.*
*Surging from below:*
*Knowledge.'*

*Jurisprudence.* The four paintings would never have harmonized (Pl. 59). To be fair to Matsch, it must be said that only his large-scale, allegorical figures would have successfully competed with the overly ornamental ceiling. His *Theology* now hangs in the office of the Dean of the Theological Faculty. The corner spaces have remained empty. Klimt's Faculty paintings perished in 1945 (see pp. 78–90).

The exhibition of each of Klimt's University paintings unleashed a scandal which in violence and relentlessness surpassed anything Vienna had ever experienced, chiefly because University professors of all disciplines, worthy citizens all, interfered and united with an aggressive and agitated press in the campaign against Klimt.

Hermann Bahr (see pp. 87 ff), author, critic and one of the chief supporters of the Secession, published in a document entitled *Against Klimt* (Vienna 1903) a selection of attacks on Klimt which outdid each other in excessiveness, malice and stupidity. Nothing throws more light on the situation than a statement by an unnamed but apparently prominent man of science whom protesters tried to win over. He turned them down, saying that he had already signed another protest. Asked why he had done so, he gave the following extraordinary answer: 'Well, you know, I don't know Klimt and I don't know his painting [*Philosophy*]. But I have such an aversion to modern art that I oppose it when and how I can.'[4]

The following appeared in the *Neue Freie Presse* on 28 March 1900:

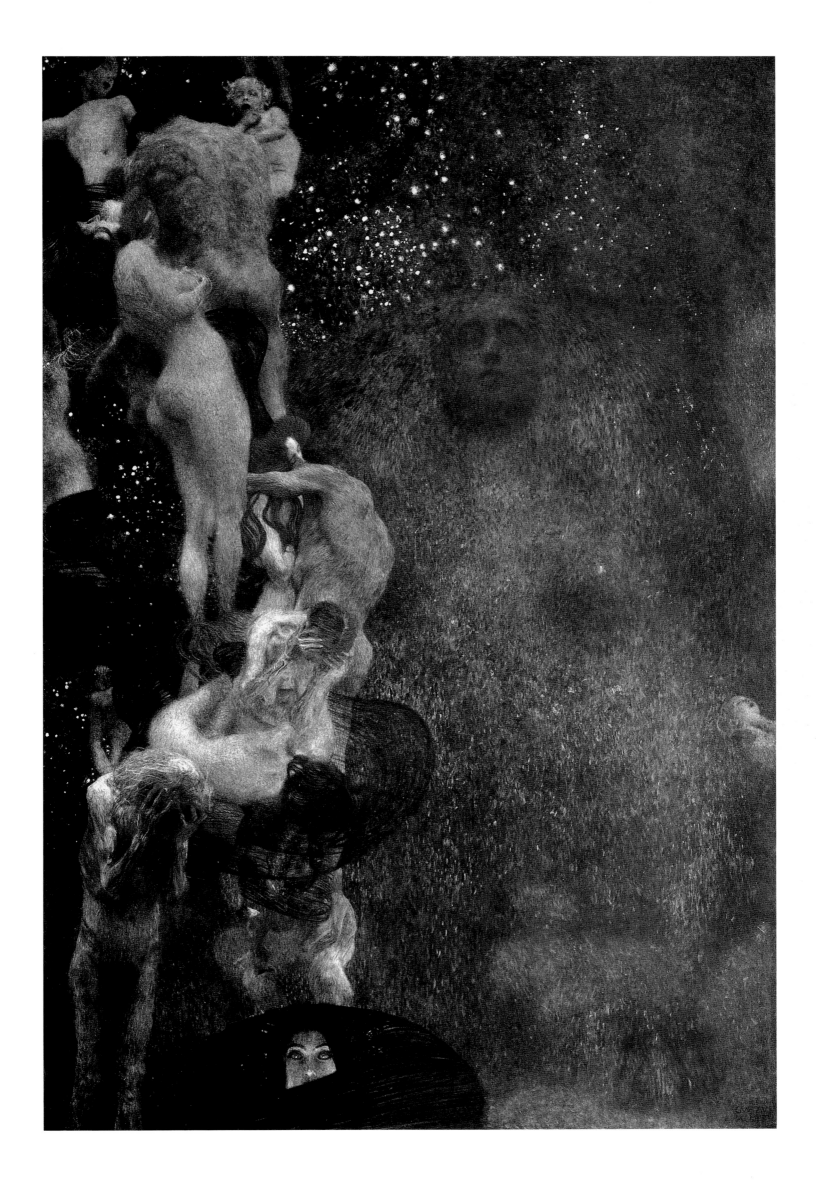

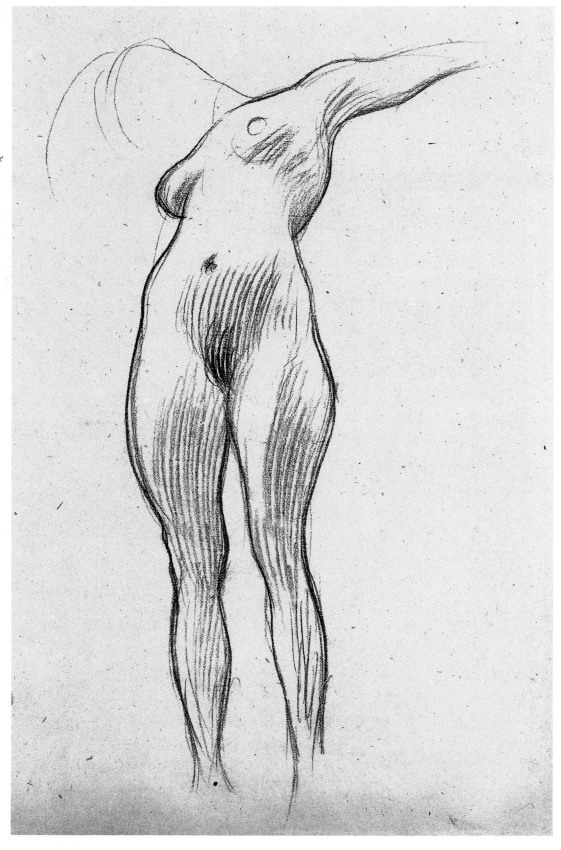

65 *Study for the figurative composition* Floating Woman *from the University painting* Medicine *(AS 621), 1901. Black crayon. 41.5 × 27.3 cm. Graphische Sammlung Albertina, Vienna.*

66 Opposite: *Composition project for the University painting* Medicine *(D.88), 1897–98. Oil on canvas. 72 × 55 cm.*

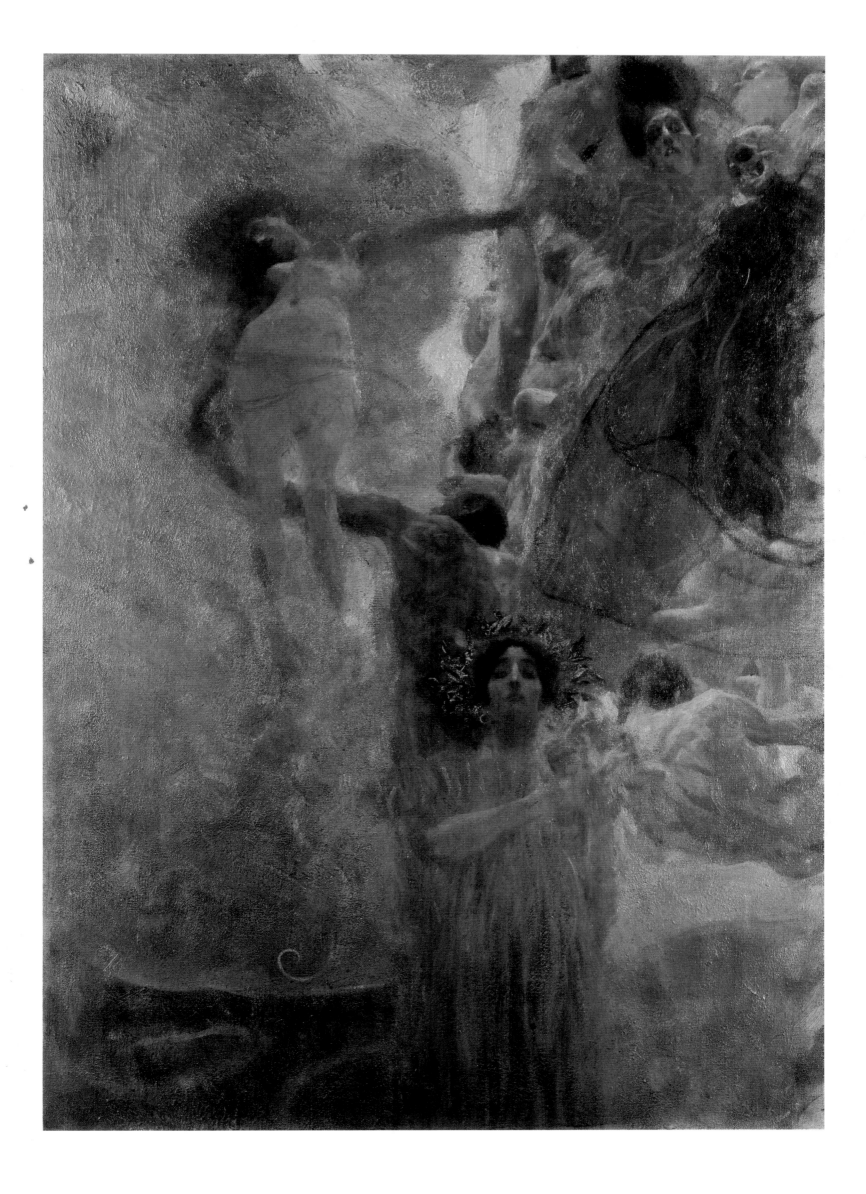

The undersigned are resolved to present to His Excellency the Minister for Education, through the good offices of the Academic Senate, a petition signed by professors of all faculties in which, with regard to Klimt's painting *Philosophy* at present on show in the Secession exhibition:
1 the opinion be voiced that the style of the said painting is incompatible with Ferstel's Renaissance-style building;
2 His Excellency be requested to stop, if possible, the painting being placed in the Great Hall. Should you, after viewing the painting, be in agreement with the sentiments expressed in this petition, we would kindly request you to let us know by returning the enclosed card to us:
[Signed] A. [? Rudolf] Chrobak, F[riedrich] Jodl, Adolph von Lieben, S. [?Wilhelm F.] Exner, H.[einrich] Lammasch, C. [?Karl] Gussenbauer, E.[dmund] Weiss."

And again:

Professor Jodl said to one of our reporters: 'There is nowhere in the University where we could show the painting. We are not opposed to nakedness or to the freedom of art, but we are opposed to ugly art.'

The protest of the professors, all of whom were technically unqualified, aroused the then professor for History of Art, Franz Wickhoff,[5] who had already sent a telegram to the Rector making him responsible for the commotion. Professor Jodl's statement, quoted above, gave him a cue for a lecture which he gave on 9 May to the University's Philosophical Society, entitled: 'What Is Ugly?' These were his closing words:

Seldom has an artist [Gustav Klimt] paid greater homage to science. And now the doors of its temple are to be closed on this great-hearted artist. So it goes: enthusiasm is infectious, but so is malevolence. Once *Philosophy* and *Medicine* stand by side by side, even the sea-green shimmer of the first painting, with its decorative effect, is clear to all, and no one will fail to praise the artist who has endowed us with these wonderful works.[6]

The then President of the Secession, the painter Josef Engelhart, together with Baron Felician von Myrbach,[7] also a painter, and a deputation of other Secession members, called on the then Minister of Education Professor Dr Wilhelm von Hartel[8] and handed him a resolution in which the Secession artists protested against the University professors' action. The minister's reply was surprisingly diplomatic. It was, as things

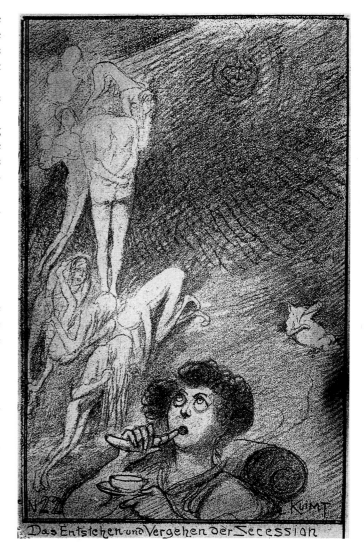

stood, too early to take up a position, he said; one should wait and see what reception the painting got in Vienna. Also, it was to be shown at the world exhibition in Paris, and there it could be judged without prejudice and from a purely artistic point of view.

*Philosophy* was thus described in the seventh Secession exhibition (8 March to 6 June 1900), where it was seen by 35,000 visitors:

No. 22 *Philosophy*. One of the five allegorical paintings for the ceiling of the University's Great Hall (commissioned by the Ministry of Culture and Education). Left-hand group: Birth, Fertile Life, Death. Right: the Globe, the Enigma of the World. Surging from the depths, an illuminated apparition: Knowledge. The painting is on show until the end of March, after which it will be sent to the world exhibition in Paris.[9]

The catalogue was printed in two versions. In the second this page was reset and unnumbered, *Philosophy* already having been sent to Paris.[10]

No colour photographs were made of the three University paintings, except for a detail of *Medicine* (Hygieia, Pl. 70). For inexplicable reasons the paintings were put away too soon during the Second World War and stored, not with the contents of the Kunsthistorisches Museum in the salt mines of Bad Aussee, but in Schloss Immendorf in the northern part of Lower Austria (see pp. 78–9). Why colour photographs were not made before their storage remains a mystery.[11] As a result we must content ourselves – apart from the detail mentioned above – with black-and-white reproductions (Pl. 64, 66).

A text by Ludwig Hevesi provides the only evidence of what colours Klimt used:[12]

Klimt's *Philosophy* is a grandiose vision of almost cosmic inspiration . . . We have before us a fragment of space filled with mysterious fermentation, with movement and a rhythm at which we can only guess. The figures, too, are wrapped in a mystic vagueness which clouds the eye with colour. The artist's job is, as far as possible, to render this vision purely in terms of colour, for it is as colour that he conceives it. The space is filled with mingling colours: blue, violet, green and grey, and these colours are intertwined with a gleaming yellow that sometimes intensifies to gold. One thinks of cosmic dust and swirling atoms, of elemental forces seeking to become tangible. Swarms of sparks fly around, each one a red, blue, green, yellow-orange or flashing golden star. But the chaos is a symphony, and the artist's sensitive soul has mixed its colours. He dreams up a colour harmony, and the eye loses itself, dreaming, in the strange amalgam of those colours. In one spot a green mist has gathered . . . The longer you look at it, the more it takes shape: a stony, impassive face emerges, dark, like an Egyptian basalt sphinx . . . This is an allusion to the world enigma. And from above, past this silent, veiled apparition, floats a luminous stream of life . . . children, fresh young intertwined bodies embracing, joy and sorrow, labour, strife, life's struggle, creation, suffering, and at the end the passing away, the grey old man with his face buried in his hands, a feeble husk sinking into the depths. But from below a great, living head emerges, with wide-open eyes and red-gold hair, crowned with laurel leaves and girdled with veils: it has a finger to its lips, it holds its peace, and looks and meditates. It is bathed in a fiery light, it glows and flowers in its own splendour, it heralds a creative power equal to the chaos above. The apparition . . . is Knowledge or Philosophy . . .

Klimt found himself at the centre of a literary controversy. In 1899 Karl Kraus[13] had founded his periodical *Die Fackel* for which he had been the sole contributor from 1911 onwards. He fought inequality, for the purity of language, against the then leading newspaper *Neue Freie Presse* and against ethical and cultural decline. He normally kept away from art, but when the Klimt affair came up he aimed his poisoned darts not so much at Klimt himself as at two literati who were anathema to him: Hermann Bahr and Ludwig Hevesi – the latter he dubbed an 'art driveller' or 'the Secession's confusion-counsellor'. Being a purist, he poured scorn on Hevesi's wordy style, forgetting how important he was as the chronicler of the Secession (Pl. 96).

The Viennese author and theatre critic Hans Weigel discussed Karl Kraus's polemics against Klimt in his book *Karl Kraus oder die Macht der Ohnmacht* (*Karl Kraus or the might of impotence*), Vienna 1968. In his opinion a mistaken, unfair judgment was never to be found in *Die Fackel* except in its attacks on Gustav Klimt in its early issues: Karl Kraus had not succeeded sufficiently in setting Klimt apart from the Secession group and its apostle Bahr.

But here is Kraus himself, in *Die Fackel* No. 41, May 1910:

'From today onwards Gustav Klimt is a made man', announced the art driveller of a Viennese paper . . . I don't need to mention Klimt's art as it has lately manifested itself. Nor need I say that the patron – in this case the University – whose house is to be decorated with one of his paintings must surely have the right to refuse a painting . . . The success of Herr Klimt and the Secession in Paris lies in the fact that the Parisians have dubbed this strange art *le goût juif* . . .

Kraus had already attacked Klimt in *Die Fackel* No. 36, March 1900:

But who's interested in how Klimt visualizes Philosophy? An unphilosophical artist may paint Philosophy; but he must allegorize her as the philosophical minds of the times see her.

*Four pages from* Ver
Sacrum, *4th year, 1901,
No. 6, in which
movement studies for
Klimt's University
painting* Medicine *are
shown (the painting was
exhibited for the first time
on 15 March 1901 in the
tenth Secession exhibition).
The journal thus helps to
date Klimt's drawings of
that time.*

**68** Pages VIII and IX:
*Studies for the figurative
compositions* Hygeia *(AS
560) and* Couple *(AS
604) for the University
painting* Medicine, *1901.*

**69** Pages XII and XIII:
*Studies for figurative
compositions (AS 602, AS
565) for the University
painting* Medicine, *1901.
Klimt personally designed
the numbers of the sixteen
pages devoted to his
movement studies.*

**70** *Opposite:*

Medicine *(D.112),
1900–07. Oil on canvas.
430 × 300 cm. Detail
with* Hygeia. *Destroyed by
fire in 1945 in Schloss
Immendorf.*

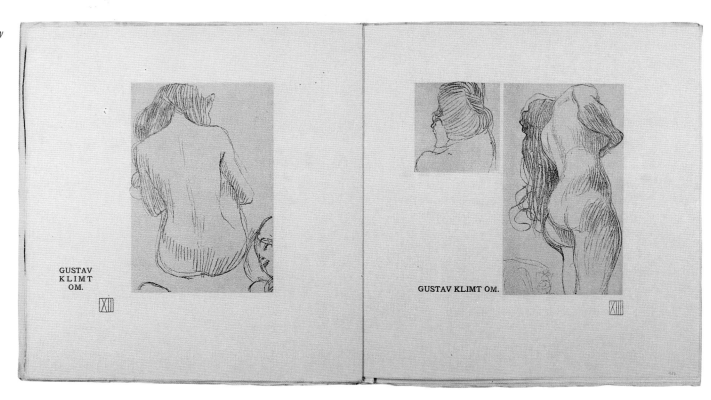

70

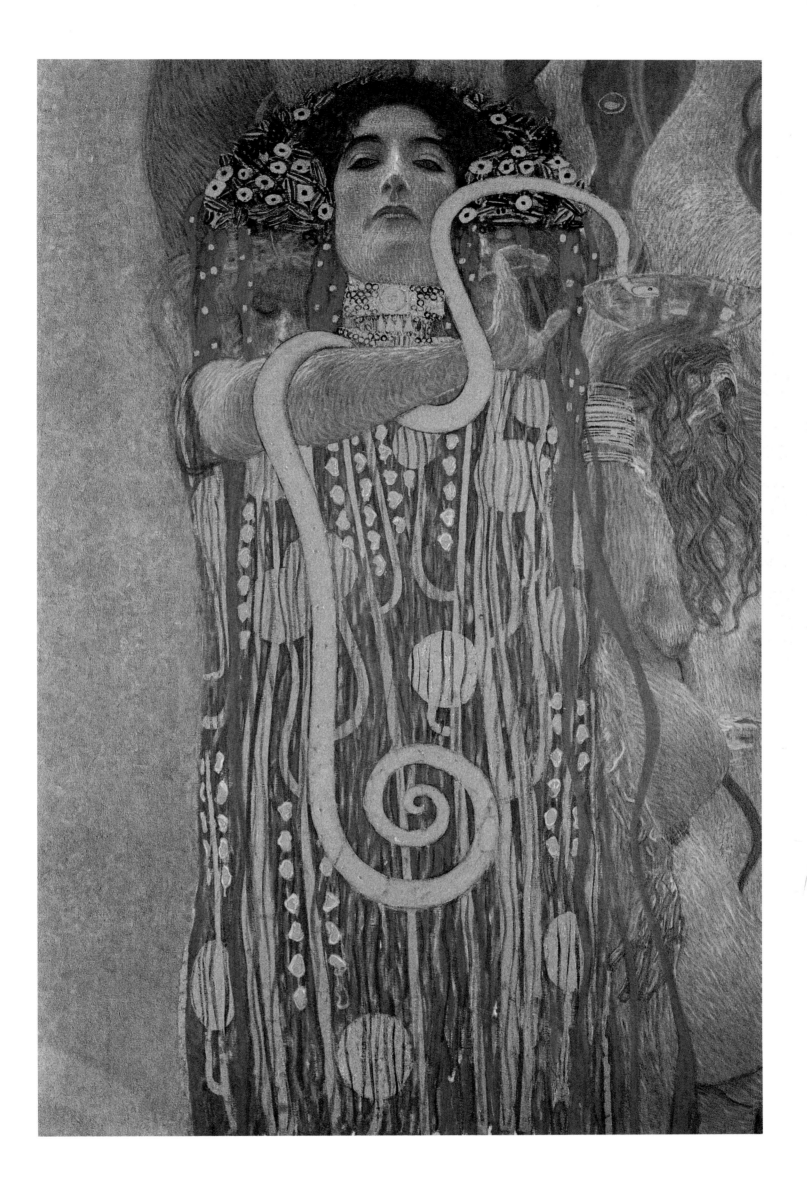

*71 Above: Josef Hoffmann. Design for the Klimt room (on the left, the University painting* Philosophy*) for the Secession's intended participation in the St Louis World Exhibition which, however, did not come about. 1904. Reproduction from the* Ver Sacrum *special number 'The Vienna Secession and the St Louis exhibition', dated February 1904.*

*72 Below: The main room in the Secession's tenth exhibition, designed by Kolo Moser (March–May 1901), with Klimt's* Medicine, *three landscapes and, left, the portrait* R. R. *(Rose von Rostheim).*

Whereas the reviews of *Philosophy* had been tolerably lenient, where *Medicine* was concerned they broke all bounds. It was of course, considering the moral standards of the time, more than risky of Klimt to paint not only a nude woman floating in the air on the left, but also a pregnant woman on the right![15]

The Viennese humorist Eduard Pötzl wrote about *Medicine* at the time:

> For my own part I would prefer to bypass Klimt's personality, if only because I feel sympathy for his quiet, suffering nature, and because I consider him to be deluded rather than guilty. The guilty ones among us are the attackers and defenders . . . We amateurs were quick to applaud Richard Wagner, Brahms, Hugo Wolf, Böcklin . . . Gerhart Hauptmann . . . etc. But we oppose Richard Strauss, Arno Holz, Rodin, Jan Toorop and company, because we dislike both imitations and convulsive efforts to be different. Let no one tell us that a man is a genius because he was rejected.

Klimt's second University painting was *Medicine*, which matched *Philosophy* both in layout and, presumably, also in colour. It was shown at the tenth exhibition and was seen by a crowd as large and as curious as had visited *Philosophy*. Kolo Moser[14] had been entrusted with the arrangement of the exhibition rooms, a task he carried out splendidly, being certainly far ahead of his time in this respect (Pl. 72).

An anonymous contribution to the *Wiener Tageszeitung* of 21 March 1901 runs:

> These two symbolic paintings are in bad taste and do not harmonize with their surroundings . . . The figures in them might perhaps be suitable for a museum of anatomy, but certainly not for public display in the University . . . the coarseness of conception and lack of aesthetics being deeply offensive to the general public.

On 24 March 1901 Hermann Bahr gave a reading in the 'Concordia' (an authors' society formerly located in the Herrengasse in the Ist district) in which he defended Klimt against the obviously co-ordinated attacks and, above all, took exception to the text of a parliamentary question which began with the erroneous statement: 'It appears that the Ministry of Education intends to buy this painting for the University'. (In fact, as we have seen, the painting had been commissioned long ago). In his address he warned against the danger of sabotaging by arbitrary attacks Austria's visible successes in painting, in arts and crafts and above all in literature and the theatre. He closed with the words:

> What would happen if our artists were to say, one day, that here all is futile, that they are only wasting their efforts, that the conditions for art and culture are lacking? What could happen?

. . . I remind you again how things were ten years ago, in the bad years from 1880 to 1890, when we were cut off from artistic events in Europe. In those days, when I was in Paris and spoke of Vienna, they would say: 'Là-bas? C'est en Roumanie? N'est-ce pas?' We were an Asiatic province. And in Berlin they thought the only thing we were any good at was singing couplets. All that has changed. Our plays are being staged all over Germany . . . The painters did even better, perhaps because they had more talent or were more united among themselves; they are known all over Europe, and our designers have evolved a style of their own which is known as the Austrian Style. For all this we have to thank a handful of men, twelve or fifteen at the most. Not one of them needs to stay here; not one of them is bound to this country for material reasons . . . If they nevertheless do stay, the reason is a strong sense of duty and a high, most distinguished form of patriotism. But as soon as they realized that it was becoming impossible for them to practise their art for lack of support from the cultivated public, then there would no longer be any point in having a sense of duty. Then they would be justified in going away and seeking another home. And then? Then, after five years, they will again say: Làbas? C'est en Roumanie? n'est-ce pas? Then we shall once more be an Asiatic province . . . I hope I shall not be proved right.[16]

Karl Kraus, incidentally, once again summarized the situation in *Die Fackel* in early April 1901 (No. 73, pp. 1–13 and 18–26).

The eighteenth Secession exhibition was devoted to a collective show of Klimt's work (Pl. 73). The catalogue comprises no fewer than forty-eight paintings, among them the third University painting, *Jurisprudence*, which was shown together with *Philosophy* and *Medicine*. As we have already seen, the two last-named paintings were conceived, as it were, as counterparts. As *Jurisprudence* would have been placed on the same level as Franz Matsch's *Theology*, Klimt had no need to take the other two works into consideration when painting it. This – and not any noticeable change of style, presumably due to a visit to Ravenna in the spring of 1903 – explains why *Jurisprudence* differs radically from the other two University paintings.

Hevesi gives a lively account of his impressions of Klimt's studio and *Jurisprudence*:[17]

I saw *Jurisprudence* for the first time during the dog days: in the master's larger studio, way out in the Josefstadt, on the top

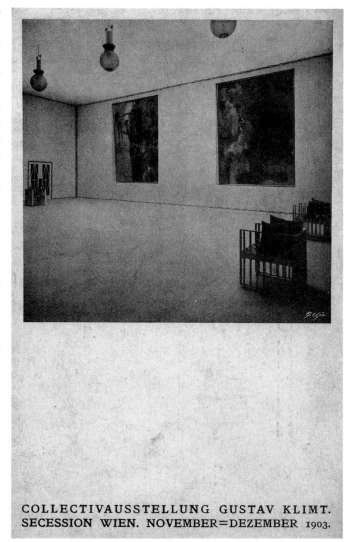

COLLECTIVAUSSTELLUNG GUSTAV KLIMT. SECESSION WIEN. NOVEMBER=DEZEMBER 1903.

73 *The main room in the Secession's eighteenth exhibition, designed by Kolo Moser (November–December 1903), with Klimt's University paintings* Medicine *and* Philosophy. *Publicity postcard from the Secession.*

floor of Schmid's furniture factory. [Thanks to the discovery of a letter from Klimt in the Manuscript Department of the Austrian National Library, A. Miller-Aichholz Collection, this information of Hevesi's seems to be wrong – unless Klimt did in fact use various studios for this work.] An iron attic door, with the letters 'G.K.' written on it in chalk, and the words 'Knock loudly'. I use both fists, but the master is very lively and opens the door at once. It is afternoon, and 35 degrees centigrade. He is wearing his usual dark working smock and nothing underneath. He spends all his time in front of the great canvas, climbing up and down the ladder, walking about, looking, meditating, creating out of a void, taking chances . . . How often has he drawn the poor sinner, the defendant in *Jurisprudence*? This emaciated, naked old man with bowed head and bent back . . . there he stands, from his profile utterly lost, irretrievably condemned . . . On the canvas he was still a shadow, tormented by three wraiths. These three twentieth-

73

century lemures, modelled for Klimt by Toorop's daughters but undeniably bearing his features . . . and that pale red hair, those strange comet-tails around their heads, those galactic tresses, misty and sparkling with gold, and golden snakes with glowing fangs . . . golden twinges of conscience!

But no, the conscience is the mighty octopus with his tentacles winding round the poor sinner. A giant octopus grappling with the man . . .

I saw *Jurisprudence* again two days ago. It was Friday 13 November . . . and it wasn't until three o'clock in the afternoon that I found Klimt in the Secession. He was still painting and had given up hope of finishing. I looked at the painting in this churchlike dusk, through which the gold sparkled in a peculiarly alluring way. The colours were still all discernible . . . but a veil of evening light lay over them and the gold shone even more. And then . . . something dawned on me.

I had returned from Sicily four days earlier. I could still feel the intoxication of the mosaics . . . the gold-grounded world of the Middle Ages, glittering and glimmering, and over

APAGE SATANAS.

it all the gilded smile of the mystic rose . . . All this dawned on me as I stood looking at Klimt's painting. His gold enlightened me . . . A newly won style, after all the artistic orgies of the last decades. A more solemn, more religious form and colouring . . .

Karl Kraus answered with his most powerful polemic style in *Die Fackel* of 21 November 1903:

Gustav Klimt, who has already twice glossed over the pallor of his thinking with brilliant colours, wanted to paint 'jurisprudence' and has symbolized criminal law. As if in a caricature, a criminal and a threatening, octopus-like monster stand at the bar. Tipsy students who are fined ten crowns for calling a policeman [Polizist] 'octopus' [Polyp], must envy Herr Klimt for getting away with a painted insult to a policeman; and, perceiving the bold use of colour, enjoy the artist's joke as he uses black, red and gold – a combination strictly frowned upon by the authorities – for *Jurisprudence*, commissioned by the Ministry of Education.

. . . for Herr Klimt jurisprudence means crime and punishment, justice means catch and wring their necks, and to those who 'have nothing to do with the courts' he presents a terrifying picture of the criminal. Even those whose horizon is limited to the gossip in the gutter press think further than this . . .

Klimt's work has now been hanging at the Secession for five years, and in one single room we can now see how Herr Klimt visualizes Philosophy, Medicine and Jurisprudence. Those of us who are modern will react in different ways: according to character and mood some will mock, others be moved to pity at the sight of this man, drunk with colour, reeling through our modern lives.

The despicable ones are those who have curried favour with him as companions and supporters so that they may be rewarded for the propaganda they make by cashing the ninety or thirty farthings for selling Klimt booklets . . .[18]

By 1904 Klimt had had enough of the antagonism towards his work and himself. He wrote the following letter:[19]

To the Imperial and Royal Ministry for the Arts and Education.

Over ten years ago, when I was commissioned to paint the Great Hall of the University, I embarked on this important task with enthusiasm. My sincere efforts over the years have, as you know, earned me a profusion of insults which, given their origins, did not at first diminish my zeal. With time, however, this changed. His Excellency Minister Dr Hartel has given me to understand that my work has now also become an embarrassment to those who first commissioned it. If my work, which has taken so much of my time, is to be completed, then I must find satisfaction in it again, and that satisfaction is totally lacking as long as I must consider it as a state commission in the present circumstances. I am therefore unable to complete the work. I have already, with the approval of the Ministry, abandoned the spandrels. I now forego the whole commission and wish to return to you, with thanks, the advances I have received over the years. I would be grateful if you would let me know where the money is to be paid.

Yours faithfully, Klimt.

The Viennese journalist Berta Zuckerkandl, a valiant supporter of the Secessionist cause, records a revealing conversation with the furious Klimt in her book *Zeitkunst: Wien 1901–1907*:[20]

The main reasons, Gustav Klimt said to me, for my withdrawal from the Ministry's commission for the University paintings do not concern any resentment of the various attacks. All that

77 *Study for* Justitia *in the University painting* Jurisprudence *(AS 934), about 1903. Pencil. 44.5 × 31.1 cm.*

78 *Opposite:* Jurisprudence *(D.128), 1903–07. Oil on canvas. 430 × 300 cm. Destroyed by fire in Schloss Immendorf in 1945.*

responsible for all my subsequent work; and slowly the Minister seems to have convinced himself that he does indeed bear the responsibility. The result is that at many exhibitions my work comes in for extraordinarily close inspection. For instance, at my collective show I was obliged to withdraw a painting that was 'frightening' [the painting *Hope*]. I complied because I did not want to cause the Union embarrassment; but I would have defended my painting personally. In Düsseldorf, where our Austrian exhibition was an official one, I was asked by the Ministry of Education to remove *Goldfishes* [1901/02, D.124, no doubt Klimt's retort to the many rude attacks, Pl. 76], because the German crown prince, who was to open the exhibition, might be shocked. This didn't happen, but you see how things are. The same nervousness caused the exhibit designed by the Secession for St Louis to be rejected. No, I have always and everywhere been a dreadful embarrassment for the Minister, and by stepping back as I am now doing I am freeing him from the curious patronage which he had extended . . . I refuse all state assistance, I give up everything . . .

On 27 April 1905 the Ministry agreed to return the three paintings to Klimt. With the help of his patron August Lederer[21] he was able to reimburse the fee of 30,000 crowns which he had received (more likely 60,000 crowns, which would have been the equivalent today of 30,000 gulden). August Lederer subsequently acquired *Philosophy*, which Josef Hoffmann built into the room he had designed for Lederer in his apartment in the Bartensteingasse (Ist district, near the town hall).

In 1911 Kolo Moser, who had become very wealthy through his marriage to Editha Mautner-Markhof, acquired *Medicine* and *Jurisprudence*. When Moser died in 1918, Erich Lederer[22] was able to buy both paintings from the inheritors. He sold *Medicine* at a good price to the Österreichische Galerie and was thus able to retain *Jurisprudence*, but the painting was never hung and remained rolled up in a room of the Lederer apartment until 1938, when it was requisitioned by the German authorities.

All three University paintings were shown for the last time in 1943 in the 'Friedrichstrasse Exhibition Pavilion', as the Secession was then known, on the occasion of Klimt's eightieth birthday. Erich Lederer had emigrated to Geneva. The Lederer family was forcibly dispossessed and *Jurisprudence* ended up in the Österreichische Galerie after all.

had little effect on me and would not have affected my enthusiasm for the work. I am quite immune to attacks. But I begin to be touchy when I feel that my employer is not pleased with my work; and that is exactly what happened with the University paintings . . . The Ministry gave me innumerable hints that I had become an embarrassment to them. Now there is nothing worse for an artist than to have to work and accept payment from an employer who is not heart and soul behind him. Such a situation is impossible for me, and I had long been looking for an opening to free myself from a predicament that I consider to be absolutely humiliating for a genuine artist. I had the same feeling eight years ago, when my sketches were presented to the art commission: I was asked to paint *Philosophy* in darker tones; *Jurisprudence* was to be 'less hectic'; and in *Medicine*, either a man should replace the naked woman, or the lady should be given clothes.

I wanted to withdraw immediately, but thanks to Baron Weckbecker of the Education Ministry, who drew up a very reasonable contract with a clause giving the artist full freedom, I agreed to get to work. Ever since this unfortunate 'state commission' people have got used to making Minister von Hartel

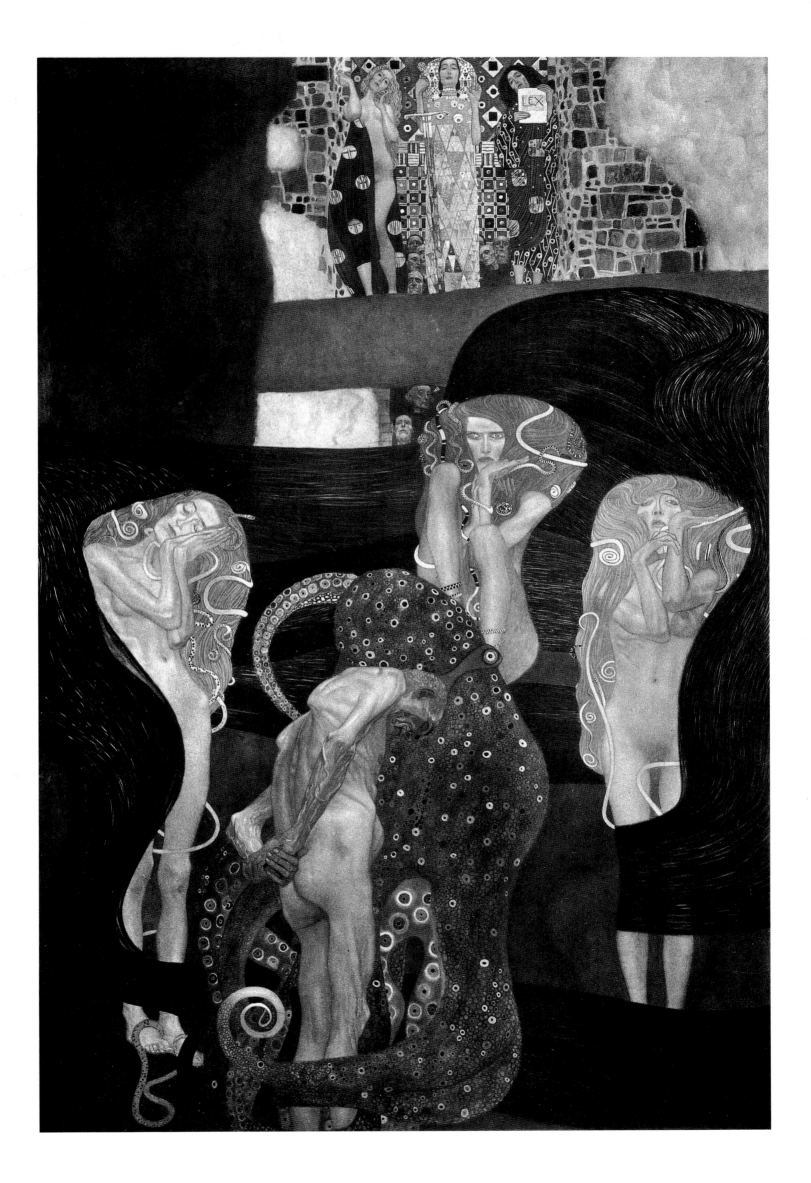

It seems that the three University paintings, along with other of Klimt's works originally part of the Lederer collection, were taken immediately after the memorial exhibition to Schloss Immendorf in the wine region near the Czech frontier, north-east of Schöngrabern, where they were destroyed by fire in May 1945. The owners of the castle, the Freudenthal family, were at the time faced with the choice between taking in war refugees or works of art, and they chose the latter.

I have lately attempted, with the kind assistance of Baron Johannes Freudenthal, to make closer enquiries. The Baron was only ten years old when the old fortified castle, which had been restored in neo-Gothic style at the turn of the century, fell victim to the flames; but he can relate family memories. Of the Klimt paintings, he remembers one, the famous *Golden Apple Tree*, 1903 (D.133). What he says does not explain everything, but he is able to make one or two important corrections. The castle had to be completely demolished, as the necessary iron beams were not available in the years following 1945. The foundations are still to be seen, hidden behind trees.

The first correction was of the version that SS troops had set fire to the castle for fear of being seen from the towers and fired on while retreating. The castle did not, however, occupy such a commanding position.

Secondly, it seems fairly certain that the German troops retired to the West without giving battle. No more fighting took place here. The Russians apparently advanced at noon and took up quarters in the castle, where they were resting when fire broke out, first in one tower before spreading to the other three. The Russians thereupon left the castle, promising help which did not actually materialize. Thanks to the owners' efforts, the fire was contained and then put out.

A few days later, around noon, the fire began again in the basement, simultaneously reaching all four corners of the castle. This time it could no longer be contained.

The Baron was able to relate something new to me. In the 1950s he met a well-dressed couple who were looking around with interest. They introduced themselves as Dr and Mrs Müller from Bad Tölz in Bavaria. Dr Müller had been the last German commander in Immendorf, and he confirmed that the castle had been intact when his troops left. The mystery therefore remains, as to who could have set fire to it.

Until then it had always been assumed that the paintings were destroyed on 11 May 1945. Baron Freudenthal, however, pointed out that the German troops had left on the last day of the war, that is on the day Fieldmarshal W. Keitel signed the unconditional surrender of the German army in the Soviet headquarters in Berlin on 9 May at 0016 hours. Allowing for the necessary delay, this must have been the day in question.

Some years ago I had another conversation with an elderly lady, presumably Baron Freudenthal's mother. She confirmed the outbreak of fire in the towers and also, later, in the four corners of the basement. Once everything was over and the owners could at last re-enter the rooms, an unforgettable sight met their eyes: the great canvasses were blackened, but with some imagination and effort one could still discern the outlines of the figures. Then a draught blew onto these sad remains, causing them to flutter slowly to the floor in a kind of rain of ashes. She said the sight was heart-breaking.

Among those destroyed were thirteen paintings by Gustav Klimt, some of them his best, all formerly the property of the Lederer family (D.86, 87, 89, 101, 131, 133, 174, 186, 200, 201, 202, 215, 219). This was Austria's worst art loss in the Second World War. There seems to have been a curse on Klimt's work: here, his most important and most beautiful paintings, and there – in Emilie Flöge's apartment – the sketchbooks, all destroyed by fire. Both losses occurred after hostilities had ceased.

1 Gustav Klimt had the following studios during his life:
Before 1883: in the Kunstgewerbeschule, by permission of the director.
1883–1892: 4th floor of 8 Sandwirtgasse, VIth district, Vienna.
1892–1914: 21 Josefstädterstrasse, VIIIth district, Vienna, in the garden pavilion of a house dating from 1709. Demolished in 1914.

1898–1906(?): 4th floor (attic) 54 Florianigasse, VIIIth district, Vienna. 1914–1918: 11 Feldmühlgasse XIIIth district, Vienna.

2 Heinrich Freiherr von Ferstel, architect (1828–1883)

3 The following is taken from Alice Strobl's excellent research carried out in the Viennese archives. Published in: *Albertina Studies*, Vienna 1964/4, 2nd year, pp. 144 and 156 ff (Alice Strobl is the editor of the catalogue raisonné of Klimt's drawings).

4 *Illustrirtes Wiener Extrablatt*, 28.3.1900

5 Franz Wickhoff, art historian (1853–1909)

6 *Fremdenblatt*, 15.5.1900

7 Felician von Myrbach, painter (1853–1940)

8 Wilhelm von Hartel, university professor (1839–1907)

9 According to Karl Kraus (*Die Fackel*, 1900/36) this description is by Ludwig Hevesi.

10 The exhibition of this painting brought Klimt no success, apart from a few friendly remarks by Parisian critics. Both *Philosophy* and the portrait of Sonja Knips (Pl. 221) were submerged by the great number of exhibits. The same was true in Germany, where Klimt took part in no fewer than fourteen important exhibitions, but without success. The time for international recognition had not yet come.

11 At the time there were 'Agfa Colour Films' for the Leica and other 35mm cameras.

12 Ludwig Hevesi, *Acht Jahre Secession*. Vienna 1906, pp. 233–234

13 Karl Kraus, author (1874–1936)

14 Kolo(man) Moser, designer, painter (1868–1918)

15 Of the three University paintings, only the central figure of *Medicine*, Hygeia, was ever reproduced in heliogravure. It was printed in the Austrian State Press for the supplementary volume, published in 1931, of *Das Werk Gustav Klimts*, Vienna 1908–1918, and entitled *Gustav Klimt, eine Nachlese*. The present writer remembers that, when visiting museums between the two world wars, he repeatedly observed retouchers from two Viennese printers (Jaffé and Staatsdruckerei) comparing colour proofs for hours with Brueghel's originals. They must have had a phenomenal sense of colour to visualize how the blueprint they were checking would look when printed with the others. There were up to sixteen colour proofs for each of Klimt's paintings in both volumes.

16 Hermann Bahr, *Rede über Klimt*, Vienna 1901, pp. 12–13

17 Ludwig Hevesi, op. cit., originally published on 15 November 1903

18 The article ended with a response to Hermann Bahr's *Gegen Klimt* and Felix Salten's pamphlet 'Gustav Klimt' (Vienna 1903). After that, Kraus no longer wrote about Klimt.

19 First published in: Alice Strobl, 'Zu den Fakultätsbildern von Gustav Klimt anläßlich der Neuerwerbung einer Einzelstudie zur Philosophie durch die Graphische Sammlung Albertina'. In: *Albertina Studies*. 1964/4. 2nd year, p. 162

20 Published 1908. See pp. 163–166

21 August Lederer, Klimt's patron

22 Erich Lederer (1896–1985), the son of Klimt's patrons August and Serena Lederer

*79 Sketches for initials,*
Alphabet *(AS 347), 1898.*
*Pencil. 20.9 × 17 cm. The*
*names of the painters*
*Engelhart and Moll occur*
*several times in the notes.*

80

# GUSTAV KLIMT AS ILLUSTRATOR:
## THE JOURNAL *VER SACRUM*

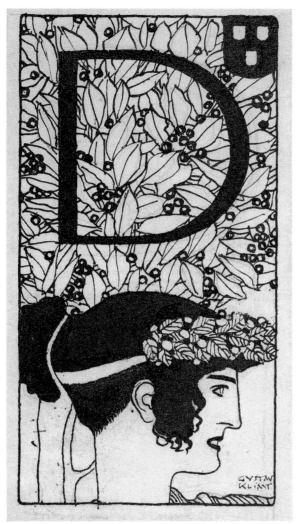

The Artists' Union published the monthly journal *Ver Sacrum* from 1898 to 1903: it seemed, apart from listing forthcoming exhibitions, to be the best means of propagating their ideas.

The first number contains the following declaration by the editors:

*Ver Sacrum* is the official organ of the Austrian Artists' Union. In this richly illustrated art journal, the first attempt ever is to be made to establish Austria as an independent producer of art. *Ver Sacrum* is an appeal to the people to invest their artistic judgment in the stimulation, promotion and propagation of artistic life and artistic independence. The illustrations are contributed by members of the Union; the texts by prominent literary experts. A year's subscription to *Ver Sacrum* costs . . . 10 m[ar]ks . . . there will also be a luxury edition which . . . will be printed in numbered issues, not for sale in the trade, containing supplements of signed prints, which will cost 167 marks for a year's subscription.

Gustav Klimt illustrated exclusively for *Ver Sacrum*, chiefly for the first year's issues in 1898, then in odd numbers of the third and fourth years (1900 and 1901). The vignettes reproduced on the front- and endpapers of this book were designed by Klimt for the plates of the large volume of reproductions entitled

*Das Werk Gustav Klimts*, with introductory texts by Hermann Bahr and Peter Altenberg, which appeared in instalments under his supervision from 1908 onwards and in an edition of 300 copies in 1918.

The following is a list of Klimt's original designs for illustrations which have survived:

1st year, 1898:
No. 1, p. 4: *Duo quum faciunt idem/non est idem* (Strobl 278). Pastels, the initials raised in gold. 34 × 29.5 cm. Theatre Museum, Vienna, formerly Hermann Bahr's collection.

No. 2, p. 1: *Witch* (Strobl 331). Red and blue crayon, 16.2 × 16 cm. The colours in *Ver Sacrum* are not accurately reproduced, also the word, 'Hexe' has been touched up with Indian ink and now reads 'Heixe' (Strobl supplementary volume p. 60 [colour reproduction]). Theatre Museum, Vienna, formerly Hermann Bahr's collection.

No. 3, jacket: Sacrificial tripod (Strobl 352). Finished drawing, pen and ink corrected in white. 41.5 × 9.8 cm. Albertina, Inv. No. 37133. In our opinion the writing reproduced on the left of the jacket was also designed by Klimt.
p. 12: *Nuda Veritas* (Strobl 350). Finished drawing, black crayon, pencil, pen, brush and ink. 41.3 × 10.4 cm. City of Vienna Historical Museum, Inv. No. 101718.
p. 23: Finished drawing for initial G (Strobl 346). Pen, brush and ink, 12 × 5 cm. Albertina, Inv. No. 35882.

*80 Fair drawing for the initial D (AS 342), 1898. Pen and brush in Indian ink. 19.5 × 9.8 cm. Reproduced in* Ver Sacrum, *1st year, 1898, No. 3, p. 23.*

*81* Above: Ver Sacrum, *1st year, 1898, in the Secession's original cloth binding.*

*82* Below: Ver Sacrum, *5th and last year, 1903, in the Secession's original cloth binding.*

*83* Right: *Folder, leather and cloth binding, belonging to Gustav Klimt, with the gold vignette of Pallas Athene which he designed for the Secession.*

84 Above: *January calendar page for* Ver Sacrum, *4th year, 1901, calendar issue, p. 2.*

85 Below left: *Dedication page to mark Rudolf von Alt's eighty-eighth birthday.* Ver Sacrum, *3rd year, 1900, facing p. 317.*

86 Below right: *Use of an illustration from the pattern book* Allegories, New Series *as a frame for his curriculum vitae.* Ver Sacrum, *1st year, 1898, No. 3, p. 1.*

3rd year, 1900 (from now on numbered through):
p. 319: Dedication for eighty-eighth birthday of Rudolf von Alt (Strobl 714). Pen and ink. Measurements and owner unknown. Underneath the illustration the words: 'Treue wahre dir selbst, es bleiben treu dir die Zeiten [Be true to yourself and the times will be true to you]'. Reproduction (printed in gold) in *Ver Sacrum*, 1900, p. 317.

4th year, 1901:
p. 2: Finished drawing for *Saturnus* (Strobl 719). Pen and ink. 41.5 × 50.6 cm. Klimt's instructions at the foot of the page: 'If I am not mistaken, these pages should be reproduced in two colours – black and gold – I think – if this is correct, then the women and the snake in black, but Saturnus, the god of time, in gold. G.K.' The page was reproduced in black and gold in the 1901 *Ver Sacrum* calendar.

The following were not used in *Ver Sacrum*:
Sketches for initials, alphabet (Strobl 347). Pencil. 20.9 × 17 cm.

On the left, the names of the artists Moll and Engelhart written several times.
Girls dancing at the edge of a wood, in the foreground a caricatured statue of Hermes (Strobl 364). Pencil, pen and ink, watercolour, heightened in white. 17 × 11 cm.
Girl's head in profile to the left. Below: *Ver Sacrum* (Strobl 345). Pen and brush and ink. 11.3 × 9 cm.

When the journal stopped being published, the editors announced that the artists had contributed 471 drawings, 55 original lithographs and 216 woodcuts. They also pointed out that all the woodcuts in the sixth issue (and probably also those of the other issues) had been printed with stereotype plates. The artists were willing to let collectors have proofs from the original clichés.

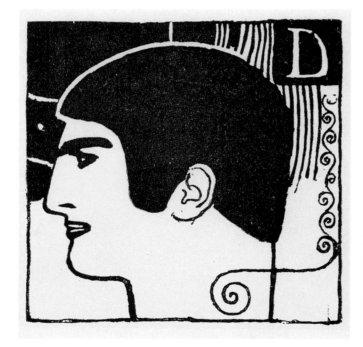

84

*89 Designs for signets for the heliogravure book* Das Werk Gustav Klimts *(The Work of Gustav Klimt) which appeared in five instalments from 1908 to 1914 (AS 2158–2185), 1913. Pencil. Dimensions unknown. The designs were for inclusion in the fourth and fifth instalments.*

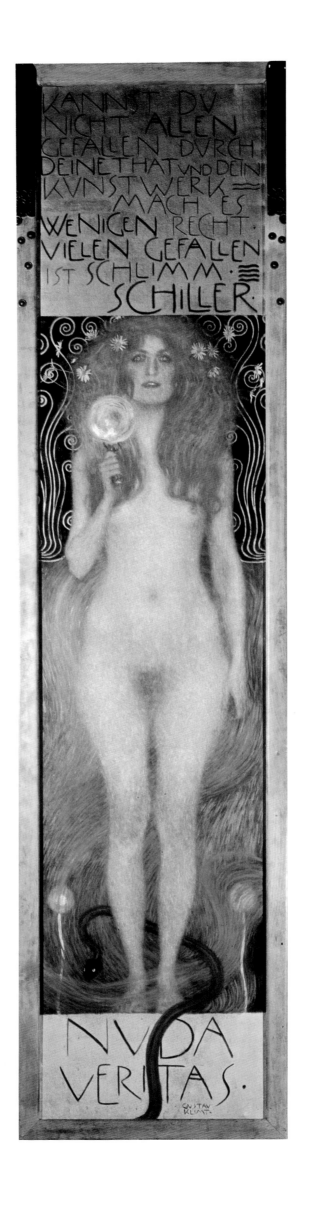

# GUSTAV KLIMT AND HERMANN BAHR

*91 Sketch for the painting* Nuda Veritas *(AS 3393).
Composition study from Sonja Knips' sketchbook, p. 60. 1899.
Pencil. 13.8 × 8.4 cm.*

When the Secession was founded, one of those who collaborated was to become a close friend of Klimt's: Hermann Bahr. He was

one of the most prominent dramatists of his time, with an extraordinary knowledge of human nature; a brilliant stylist, essayist and critic. His writings, especially the autobiographical ones, are among the most interesting documents of the intellectual and cultural history of Austria at that time.[1]

Hermann Bahr was an enthusiastic and faithful supporter of Gustav Klimt and an indispendable advisor in the editing of *Ver Sacrum*; and it was probably he who established the relationships with German authors and poets whose contributions set the journal's high literary standard from the very start.

In their first letter to Bahr, already by that time a highly respected figure, the young artists tried hard to strike the right note:

Sir! In the name of the Austrian Artists' Union, and mindful of your kind promise to our representatives that you would contribute an article to the Union's new journal *Ver Sacrum*; further, since the Union wishes the first number to be particularly distinguished, it is extremely anxious to include your promised article; I herewith take the liberty of begging you to write this article. Delegates of the Union will, with your permission, fetch it in a few days' time.

With the assurance of our highest esteem, I remain, Sir, your obedient servant,

Gustav Klimt, President of the Austrian Artists' Union[2]

Hermann Bahr always supported and encouraged the young Secession artists, as can be seen from an enthusiastic letter to his father dated 5 October 1898:

So I am very pleased: for when I chased the young artists out of the Künstlerhaus, all Vienna called me a fool; and when this exhibition was announced my enemies hoped that I had put my foot in it nicely. And now this success![3]

In a postscript he describes his efforts – extremely unusual for the times – to take working class people on Sunday morning guided tours through the first Secession exhibition (in 1898, still in the Gartenbau building on the Parkring) in order to arouse their interest in modern art. We do not know, however, whether he had any success.[4]

Bahr wrote the following words to go round a glass window designed by Kolo Moser above the entrance hall of the Secession (the window has not survived), which testify to his attachment to the Secession and to his efforts on its behalf:

*90* Opposite: Nuda Veritas *(D.102), 1899. Oil on canvas. 252 × 56.2 cm. Österreichisches Theatermuseum, Vienna.*

*92 Above: The villa at 22 Winzergasse in Vienna's XIIIth district, built by Joseph Maria Olbrich for Hermann Bahr. Photograph, about 1905.*

*93 Below: Hermann Bahr's study. Olbrich built* Nuda Veritas *into the wood panelling. Photograph, about 1905.*

LET THE ARTIST SHOW HIS WORLD,

THE BEAUTY THAT WAS BORN WITH HIM,

THAT NEVER WAS BEFORE

AND NEVER WILL BE AGAIN

This is a worthy supplement to the words over the building's entrance, often quoted and originally thought up by Ludwig Hevesi:

TO EVERY AGE ITS ART, TO ART ITS FREEDOM

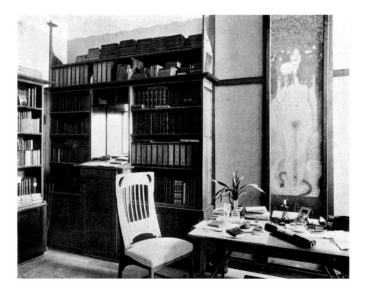

These words were, incidentally, twice removed: the first time after the departure of the Klimt group in 1905, the second after the German occupation in 1938.

The best that was ever written about the newly founded Secession came from the pen of Hermann Bahr, in an article requested by the artists:

Dear friends! You have a right to be proud. You have worked miracles in our country. Such an exhibition has never been seen – an exhibition in which there is not a single bad painting! . . .

I'll tell you what worries me: I'm afraid you may rest on your laurels too soon. For God's sake don't. Don't sit back, don't let them pacify you. Don't think that everything's over. Don't rest . . .

You must achieve something that has so far not existed: unmistakably Austrian art! You all know what I mean. When you walk through our quiet old streets or when you see the sun shining on the railings of the Volksgarten, where the lilac is blooming and little girls are playing with their skipping ropes, or when you hear the strains of a waltz coming from some inner courtyard, then a strange feeling comes over you and no one can say why his heart is so full. He can only smile: that is Vienna! And this Vienna is what you must paint . . .

And one thing more: painting isn't enough. We won't have an Austrian art until it becomes part and parcel of our daily lives. See! As I write these lines I look over my table and out of the window on to the Liechtenstein garden below: there stands, grave and elegant, the palace, and beyond it the Kahlenberg is already green; the beauty of this view is unequalled the world over. And it fills me with joy. But then I look down on my table, and it irritates me: you could find it in any Berlin household. I would like to have a table that harmonizes with my Liechtenstein garden and with my Kahlenberg, a table that is as Viennese as the garden and the mountain, and not only my table but also my lamp and my chair. Do you see what I mean? I would like to be surrounded by the products of Austrian art, an art whose outlines and colours tell me what blissful hours in the Viennese spring tell me . . . Let our people be swathed in Austrian beauty! . . . You have achieved much, but greater things are yet to come. Now is the hour. Do not hesitate! Go![5]

One of the most prominent publicists to support Gustav Klimt's work from the start was the journalist and author Ludwig Hevesi (Pl. 96). Born the son of a doctor in 1842, he studied medicine and classical philology. From 1866 onwards he had been on the staff of two leading German-language papers, the *Pester Lloyd* and the *Wiener Fremdenblatt*. Starting as a

humorous travel and young person's writer, he changed to art criticism and became an exemplary champion of modern art. His reviews – an inexhaustible source of information on the years of the Viennese Art Spring – were published in book form just before he committed suicide in 1910.[6]

In 1898 Klimt painted two canvasses: *Pallas Athene*, in a metal frame which he designed and his brother Georg made (Historical Museum, Vienna, Pl. 97), and *Nuda Veritas* (Pl. 90). The latter was preceded by a drawing in *Ver Sacrum* (1898, No. 3).[7]

Hermann Bahr bought *Nuda Veritas* from Klimt for the sum of 4,000 crowns.[8] He had a small house built by Joseph Maria Olbrich at 22 Winzergasse in Ober St Veit, a part of the XIIIth district (Pl. 92), which still exists, albeit not in its original form. Olbrich's somewhat rustic interiors (Pl. 93) have, however, been lost. Klimt's painting was let into the wood panelling in Bahr's study. Bahr's widow Anna Bahr-Mildenburg, a well-known opera singer, left it to the National Library's theatre collection (now housed in the Theatre

Museum, Palais Lobkowitz, Ist district). The painting now hangs in the annex of the Theatre Museum, 3 Hanuschgasse, which houses the memorial rooms for Hermann Bahr and Anna Bahr-Mildenburg.

Stylistically, *Nuda Veritas* and *Pallas Athene* are products of the same period in Klimt's work. Both were shown at the second Secession exhibition in 1898, the first in Olbrich's newly built pavilion, and they began the first Klimt scandals, as documented in the following reviews. It was *Pallas Athene* which aroused the most indignation:

> But right next door hangs *Pallas Athene*, the public's bête noire. And what a beauty she is! . . . A bust, with helmet and coat of mail. The helmet is golden and from it hangs a flat metal nose-piece. That's too much for the Viennese, it puts their noses out of joint. No matter that the nose-piece is a part of a Greek helmet and that the antique gold stripes are a striking contrast to the pale complexion – that doesn't impress them. But the chain-mail, Athene's scaly aegis, that arouses their fury. A thousand eagle eyes have detected that the Medusa mask that acts as a clasp on the aegis, on the mythological scale-cape, is what made all Vienna break into derisive laughter when it appeared

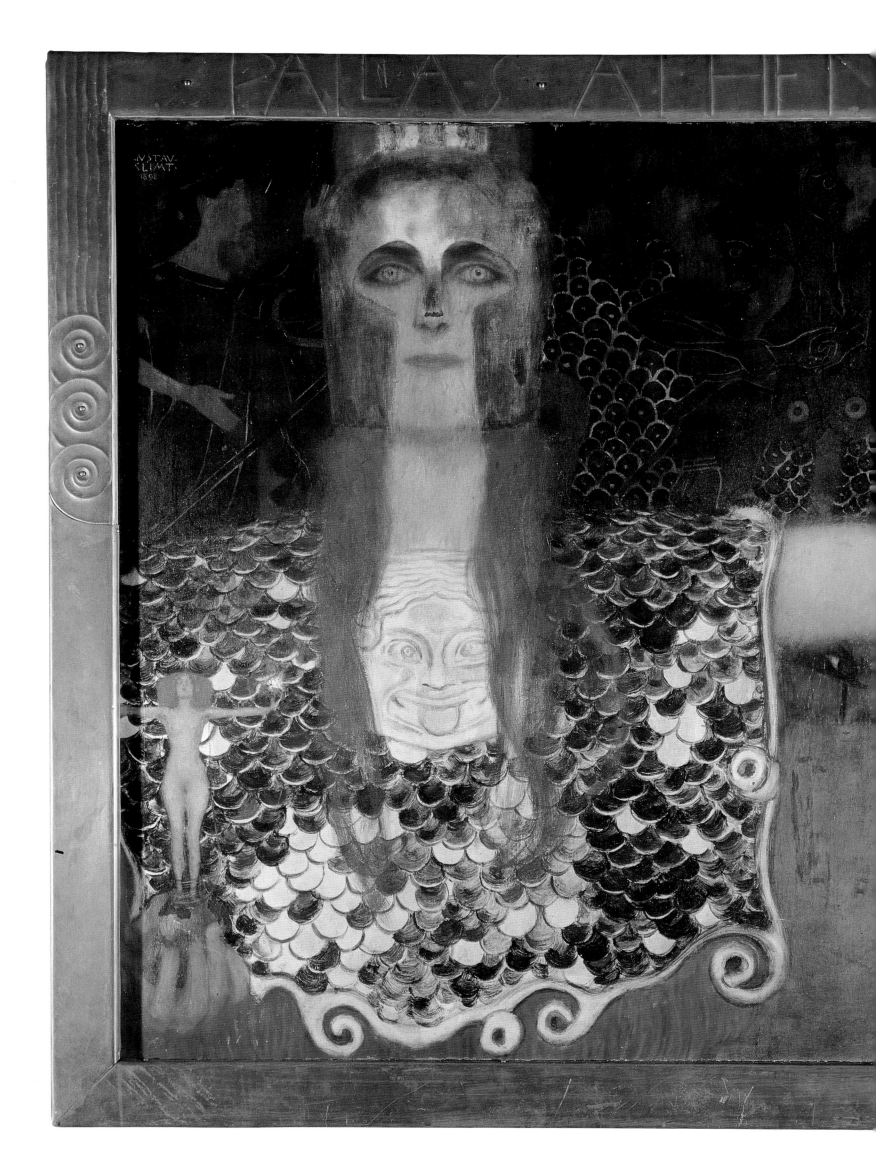

97 Left: Pallas Athene *(D.93),*
*1898. Oil on canvas, 75 × 75*
*cm. Historisches Museum der*
*Stadt Wien.*
*Embossed metal frame designed*
*by Georg Klimt. The painting*
*was ridiculed by most of the*
*press at the second Secession*
*exhibition in 1898, on account*
*of Pallas Athene's nose-piece*
*which was, however, a true copy*
*from the antique. No attention*
*was paid to the beautiful nude*
*standing on the globe.*

*The Secessionists' self-mockery:*
98 Above: *Friedrich König,*
*caricature depicting Josef*
*Hoffmann battling with Klimt's*
*monsters (see Pl. 86), with*
*Pallas Athene in the*
*background. Reproduced in* Ver
Sacrum, *4th year, 1901, p. 51.*

99 Below: *Bertold Löffler,*
*cover for* Quer Sacrum, *a*
*pastiche of* Ver Sacrum *Vienna*
*1899. An artist is seated on*
*Pallas Athene's globe.*

on the Secession's poster in the spring. This grimace . . . is the
exact reproduction of the oldest Medusa faces in antiquity . . .
but the good people of Vienna took it as a childish product of
Secessionist dottiness put there for sensation's sake.[9]

Ludwig Hevesi writes further:

> They [the public] take their revenge on his *Naked Truth.* A
> female figure, truly naked, standing before a purple back-
> ground. Her . . . hair falls symmetrically to right and left and
> there is something hieratic in her face and in the rigid posture.
> A Secessionist Isis, so to speak. And then the shining crystal ball
> held in her half-raised right hand. The strange, pale blue con-
> tours on the purple background suggest, in ornamental form,
> the falling of the veil. And the two upright flowers on either
> side of the figure are two dandelions (Leontodon taraxacum).[10]

Strangely enough, the critics of the time forgot to men-
tion the delightfully painted, red-headed nude held in

Pallas Athene's hand. We find her again, larger in size, in *Nuda Veritas*.

Hermann Bahr was also the editor of *Gegen Klimt* (*Against Klimt*), Vienna 1903, in which he reproduces a selection of the vitriolic reviews which greeted the exhibition of each of the three University paintings (see p. 61 ff).

Hermann Bahr's reputation and influence were doubtless also responsible for the fact that many contemporary poets and authors, especially those living abroad, could be persuaded to contribute articles to *Ver Sacrum*: among them Peter Altenberg, Otto Julius Bierbaum, Richard Dehmel, Knut Hamsun, Detlev von Liliencron, Maurice Maeterlinck, Ferdinand Saar, Richard Schaukal and many others. Thanks to their contributions, which appeared mostly in the early numbers, and to the attractiveness of the illustrations, *Ver Sacrum* was probably the best Jugendstil journal in the German language.

Bahr also edited the second published collection of reproductions of Klimt's drawings. In 1922 a small folder appeared with fifty plates, among them three reproductions of drawings belonging to Bahr, the originals of which, missing for decades, were found by Alice Strobl. In his foreword to the folder Hermann Bahr (Pl. 94) wrote as follows on Klimt's drawings:[11]

In my house three of his drawings hang opposite the *Nuda Veritas*. One is a study for one of the girls in the Dumba Schubert painting: at once one recognizes Makart's pupil . . . The second drawing, which was destined for the first *Ver Sacrum* number at the beginning of the Secession, is of a red witch with hair by Burne-Jones or Rossetti, eyes by Toorop and

a mouth by Khnopff, only that Rossetti, Toorop and Khnopff must just have returned from an excursion to the realms of bliss, so radiantly do they still come through. The third drawing is from his mature period, when he had solved the last mystery: the art of leaving out all superfluousness. There his hand had become a divining-rod which glided quietly along the semblances of this world until, where the essence lay buried, it twitched: his drawings from this period are shorthand notes of these quests for the secret behind all appearances. His eye almost burnt itself out with the flame of visual impact, but it was his hand that reached down to the roots: somewhere between the two lies common, everyday meaning, but it escaped his notice.

1 Austrian Dictionary of Biography. Graz – Cologne 1957, p. 44. Hermann Bahr, 1863–1934.

2 Theatre Collection of the Austrian National Library, A 19667 BaM.

3 Hermann Bahr, correspondence with his father. In: *Jugend in Wien*. Catalogue, German Literature Archives in the National Schiller Museum. Marbach 1974, p. 278

4 op. cit., p. 279

5 *Ver Sacrum*, 1st year, 1898, May–June number, p. 5

6 Ludwig Hevesi, *Acht Jahre Secession*, Vienna 1906, and *Altkunst–Neukunst 1894–1908*, Vienna 1909. Both books contain reprints of his published essays and criticisms in the above-named journals.

7 This bears a text by Leopold Schefer (1784–1862), whereas the painting shows one by Friedrich Schiller.

8 See 'Four letters from Klimt to Hermann Bahr' in: *Gustav Klimt: Dokumentation*, Christian M. Nebehay, Vienna 1969, p. 204. In particular, see footnotes 7b–7e in Chapter 16.

9 Ludwig Hevesi, *Acht Jahre Secession*, Vienna 1906, pp. 81–72. Arthur Roessler, in his book *In memoriam Gustav Klimt* (Vienna 1926), also describes the public's reaction to *Pallas Athene* (p. 10 ff).

10 op. cit., p. 148. See also: Arthur Roessler, *In Memoriam Gustav Klimt*, Vienna 1926, p. 10

11 Hermann Bahr, foreword to: *Gustav Klimt, 50 Zeichnungen*, Vienna–Leipzig 1922.

On the occasion of the exhibition of Max Klinger's *Beethoven* statue in Vienna in 1902, Klimt painted his Beethoven frieze which, given the destruction of his three University paintings, must be considered as his masterpiece.

Max Klinger was a serious and admirably versatile artist. He aimed at perfection in everything he undertook, whether graphic art (he was one of the best graphic artists of his time in Germany), oil

*100 Portrait of Max Klinger. Photograph by Nicola Perscheid, about 1900.*

painting or sculpture. His father, a well-to-do soap maker who had wanted to be a painter, passed on his talent to his son: and not only for painting but also for music, which played an important role in Klinger's life – he was an accomplished pianist.[1]

Klinger's graphics were printed in series (mostly in small editions) by various publishers and established his reputation in Germany. Some of his output, however, no longer appeals to modern generations; in the same way, his remarkable paintings are now considered to be dated. His achievements as a sculptor, however – to which we will return later – are indisputable.

Klinger was an aggressive person, whose behaviour often caused surprise. First of all, in 1888, he refused to participate in an artists' address to the Emperor Wilhelm II, whose bad taste in matters artistic was legendary. Then, in 1898, he was prepared to provide

security out of his own pocket for the amount of 30,000 marks on behalf of the artist Thomas Theodor Heine,[2] who was imprisoned in Leipzig for contributing a biting caricature entitled 'Emperor Wilhelm II's visit to Jerusalem' to the journal *Simplicissimus*. These were two plucky political actions, but Klinger showed even more generosity in 1906 when he founded the Villa Romana Prize. He bought a villa in Florence, with a park extending to 15,000 square metres, and gave well-known artists the opportunity of spending a few months there as recipients of his prize. The first one to be invited was Gustav Klimt, but he waived his right in favour of his Secession colleague Maximilian Kurzweil.[3] Other beneficiaries were the graphic artist Käthe Kollwitz[4] and the well-known sculptor Georg Kolbe.[5]

Klinger's masterpiece is undoubtedly his *Beethoven*. Impressed by the findings of the German archaeologists Paul Hartwig, Botho Graef and Paul Wolters, who, while digging on the Acropolis in Athens, had found remains of coloured stone sculptures, he began to use colour in his own work. *Beethoven* was also created in a mixture of various precious marbles, ivory, alabaster and bronze. Ludwig Hevesi saw the statue as 'the work of a sculptor who is also a painter'.[6] Klinger

93

had, incidentally, travelled to Vienna[7] and had not only studied Beethoven's death mask in the Historisches Museum but also carefully measured it, according to the unpublished memoirs of the Viennese etcher Ludwig Michalek.[8]

*Beethoven* was first shown a few days after its completion (which had been delayed by a whole year) to a small circle of friends in the artist's studio in Leipzig. After the Vienna exhibition it went to Düsseldorf and then to Berlin. Finally, the Viennese having postponed a decision for too long, it was acquired by the city of Leipzig for the then exorbitant price of 240,000 marks and installed in the annex of the Leipzig Art Museum, to the cost of which Klinger had contributed.

After the Second World War the statue was temporarily housed on the second floor of the former Reichsgericht (Supreme Court) in Leipzig; today it is

in the entrance hall of the newly built Gewandhaus (Concert Hall) on the Augustusplatz.

As regards the price, it is interesting to note that Klinger, who was accustomed to finding his marble in the best European quarries and in general used only the best quality materials, estimated the cost price at 150,000 marks, in which he probably did not include his own working time. The most expensive items were presumably the casting material and the bronze plating of the throne.[9]

Klinger's *Beethoven* has a total height of 3.10 metres. The upper body and feet are made of Greek marble which Klinger had personally fetched from Syra, as he did the alabaster from Laas (for the clothing) and the marble from the Pyrenees (for the rock base and eagle). The part that cost the most work was the bronze throne.

For a detailed account of the extraordinarily difficult casting of the statue we are indebted to Klinger's friend Elsa Asenijeff,[10] the mother of his only daughter Désirée who was born in Paris. Elsa Asenijeff's book *Max Klingers Beethoven: Eine kunst-technische Studie* (*Max Klinger's Beethoven: A practical artistic study*) (Leipzig 1902), gives valuable information about the 'cire perdue' technique of casting bronze.[11] Klinger had spent over a year modelling the wax and had conceived a whole programme of delicate figures most of which are not visible to the viewer because they appear on the sides and back of the throne. In all Europe there was only one man, P. Bingen of Paris, who was willing to risk casting a statue of this size. But even he could not give a guarantee, for once the mould has been carefully heated, success or failure is a matter of a few seconds: if things go wrong, all the work is wasted, for the wax has melted. An advantage of this technique lies in the fact that no chasing is necessary afterwards. The substance was an alloy of copper, pewter and brass and weighed about 1,000 kilos.

While Asenijeff gives us a graphic description of the complicated casting technique, the artist himself gives us a personal account of the creation of this masterpiece of European sculpture at the turn of the century:

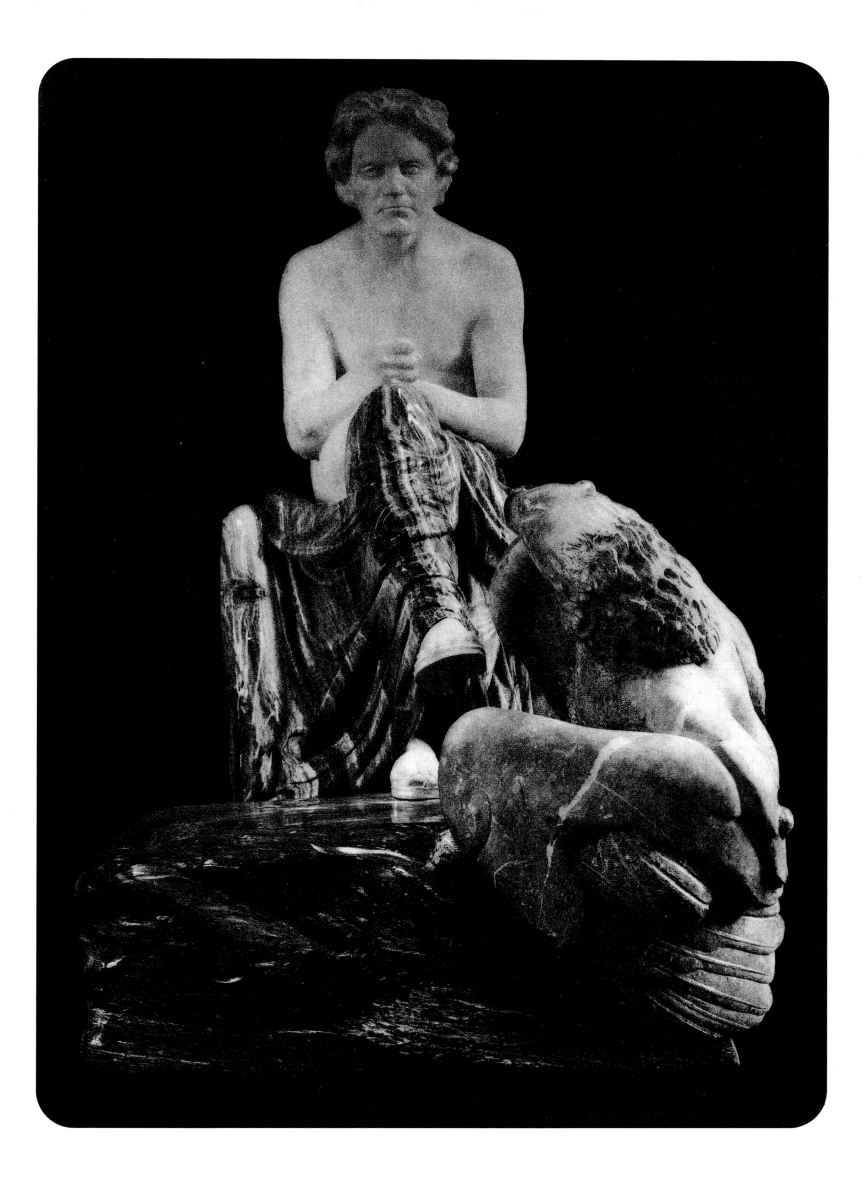

*Beethoven* was shown in Paris in 1885 in exactly its present form, except that the proportions and the material were different, and the coloured model was refused by the big Berlin art exhibition in 1887 or 1888. Rodin's *Victor Hugo* and *The Thinker* did not exist at the time.[12] The idea came to me one evening in Paris when I was seated at the piano, the figure and the colours amazingly clear: posture, fist, the red robe, the eagle, the throne, the folds . . .[13]

We learn from this letter that Klinger worked for no less than seventeen years at the statue.

His reference to Rodin is interesting. In another letter, addressed to his patron Hummel in Trieste and dated 31 December 1904, he again mentions Rodin:

> There is a fine Rodin exhibition here just now, many original pieces in bronze and marble, among them *The Thinker* in bronze. My *Beethoven* looks dreadfully insignificant in comparison.[14]

What a remarkably self-critical statement! It shows that in 1904 Klinger was quite aware of Rodin's superior standing. He also owned drawings by Rodin, who nevertheless walked past his statue in the Beethoven exhibition in Vienna (1902) without making any comment.

The 1885 model mentioned by Klinger is presumably the one that stood for whole decades, dusty and forgotten, in the courtyard of the Beethoven House in Bonn. Displayed in 1986 at the 'Myth of Beethoven' exhibition in Bonn, it was shown to be surprisingly ugly.

Although the Vienna Secession's plan to acquire Klinger's *Beethoven* for Vienna did not materialize, their fourteenth exhibition (15 April to 15 June 1902) nevertheless deserves appreciation: for never, and certainly not around the turn of the century, has a work of art been so acclaimed as was Klinger's *Beethoven*.

1 Max Klinger, German painter, graphic artist and sculptor (1857–1920). He was on friendly terms with Johannes Brahms, whose acquaintance he had made in 1880, and to whom he dedicated his best graphic series: *The Brahms Symphony*, published in 1894, a cycle of forty-one etchings and lithographs. See: Hans Wolfgang Singer, *Max Klingers Radierungen, Stiche und Steindrucke*, Berlin 1909. Nos. 183–229 (Opus XII).

He was also a friend of the composer Max Reger (1873–1916), who had come to Leipzig in 1907 to be Music Director at the University there.

2 Thomas Theodor Heine, German draughtsman and painter (1867–1948). Up to 1933 he contributed caricatures to *Simplicissimus*, which he had helped to found in 1896.

3 Maximilian Kurzweil, painter (1867–1916)

4 Käthe Kollwitz, German graphic artist (1867–1945)

5 Georg Kolbe, German sculptor (1877–1947)

6 Ludwig Hevesi, *Acht Jahre Secession*, Vienna 1906, p. 388

7 In 1895 Klinger was offered a post as professor at the Vienna Academy, but he turned it down because he could not obtain a guarantee that he would be allowed to spend five consecutive months on his own work.

9 Klinger also used the same marble for a half-sized version of the *Beethoven* torso. It stands in the Museum of Fine Arts in Boston, USA, and was to be seen – unfortunately not very well placed – in the 1985 Vienna exhibition *Traum und Wirklichkeit* – see catalogue No. 16/3. (It was the pianist Paul Wittgenstein who donated this edition to Boston.)

10 Elsa Asenijeff (1868–1941) was known to her contemporaries as an 'eccentric Austrian'. After her divorce from a Bulgarian consular employee named Nestoroff, she went to study in Leipzig in 1879. Her relationship with Klinger, who portrayed her twice, lasted fifteen years. He left her after she began to show signs of mental derangement. She spent the rest of her life in institutions and lunatic asylums.

11 In bronze casting, the 'cire perdue' process consists of modelling in wax over a clay kernel, the wax melting away in the course of casting.

12 Rodin's *The Thinker*, originally modelled for *Gates of Hell*, has been cast in bronze since 1880. The memorial to Victor Hugo was, however, not unveiled until 1909.

13 Max Klinger. Exhibition catalogue, Leipzig Museum of Fine Arts, Leipzig 1970, p. 55.

14 op. cit., p. 56

# THE FOURTEENTH SECESSION EXHIBITION
# AND GUSTAV KLIMT'S BEETHOVEN FRIEZE  1902

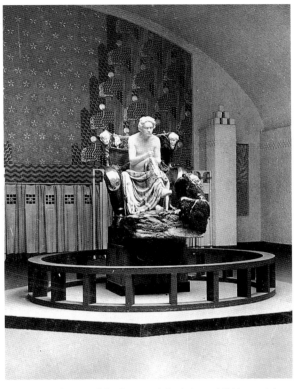

*103  Central room of the fourteenth Secession exhibition, with Max Klinger's* Beethoven *statue. The painting* Night *descending by Alfred Roller in the background was also on the poster and covers of* Ver Sacrum.

For the fourteenth exhibition all the prominent Secession artists (Pl. 107) created – without remuneration and with only very slight prospects of selling – a variety of works that all had to do with Beethoven. Thanks to its specially created woodcuts, the catalogue of the fourteenth exhibition was artistically the most remarkable until 1905. In it we read that numerous artists, led by Alfred Roller, volunteered to decorate the rooms. The works they created have mostly been lost. Miraculously, Klimt's Beethoven frieze survived: we shall return to it later.

Ludwig Hevesi writes about the preparations for the fourteenth exhibition:

I meet an art lover on the Opernring. Of course he's just come from the Secession, where he pulled every imaginable string to get a look into the Holy of Holies. In vain. It's hermetically sealed. Finally he offered to buy the Beethoven, but they wouldn't believe him, so that was no use either. All the same he stayed a while in the building. He heard the loud clamour of trumpets filling Josef Hoffmann's new Beethoven temple. On the platform in the left aisle Director [Gustav] Mahler was standing and rehearsing *fortissimo* a theme from the Ninth Symphony that he had arranged for trumpets . . .[1]

The fact that Gustav Mahler,[2] who was particularly shy,

sensitive and retiring, agreed to transpose and rehearse a theme from the Ninth for trumpets and perform it at the opening of the Beethoven exhibition was probably due to his having frequented the hospitable house of the painter Carl Moll, whose stepdaughter Anna Schindler he married. It was there, too, that Klimt and Mahler met, although there are no clues as to the nature of their relationship. Klimt's Beethoven frieze must – after the destruction of his University paintings in 1945 (see pp. 78–79) – be considered as his masterpiece. After years of restoration it has now been built into a newly constructed basement of the Secession building, which corresponds exactly to the dimensions of the ground-floor room above, for which it was painted.[3] In 1902, after the exhibition was over, the frieze was saved from destruction by the fortuitous appearance of the collector Carl Reininghaus,[4] who spontaneously decided to acquire it.

There has been much speculation about whose help Klimt – whose own imagination was not particularly lively – can have sought respecting the theme of his frieze. It might help therefore to look at the catalogue of the fourteenth exhibition which, in our opinion, offers the most reliable indications. The text of this

104 Above: *Study for the figurative composition* The sufferings of feeble mankind *in the Beethoven frieze (AS 762), 1902. Black crayon. 44.6 × 31.7cm. Graphische Sammlung Albertina, Vienna.*

105 Below: *Study for the figurative composition* The sufferings of feeble mankind *in the Beethoven frieze (AS 760), 1902. Black crayon. 44.6 × 31.7 cm.*

overlook the fact, however, that Stöhr was not only a poet but also – and above all – a musician: proofs of both talents are to be found in *Ver Sacrum.* It is our opinion that he advised Klimt and edited and designed the catalogue, which contains the following description of Klimt's Beethoven Frieze, no doubt from his pen:

> Beethoven frieze. Wall paintings in the left room. The paintings cover, in the manner of a frieze, the upper halves of three walls of this room . . . Material: casein colour, applied stucco, gilding . . . Height approx. 2.5, length 30 metres. Surfaces of rough casting have been decorated with due regard for the arrangement of the walls. The three frescoes are conceived as a continuous sequence.

catalogue is also important, and Ernst Stöhr's foreword is instructive:

> In the summer of last year the Union decided to interrupt the usual series of art exhibitions with a new sort of event . . . the main idea that was to lend our undertaking inspiration and cohesion was our hope that we might find a focus for our exhibition in the form of a particularly outstanding work of art. Klinger's Beethoven memorial was nearing completion. The hope of creating a worthy framework for Klinger's earnest and grandiose homage to Beethoven was enough to generate the enthusiasm which, in spite of the knowledge that the whole thing was to last only a few days, spurred us to work. So it was that this exhibition came into being. Its transitory nature should not be held against it.
> Ernst Stöhr

Ernst Stöhr[5] was a painter, graphic artist, poet, musician and co-founder of the Secession. He painted historical subjects, portraits, landscapes and interiors, but is today almost forgotten. 'He fluctuated between naturalism and literary-poetic fantasy.'[6] We should not

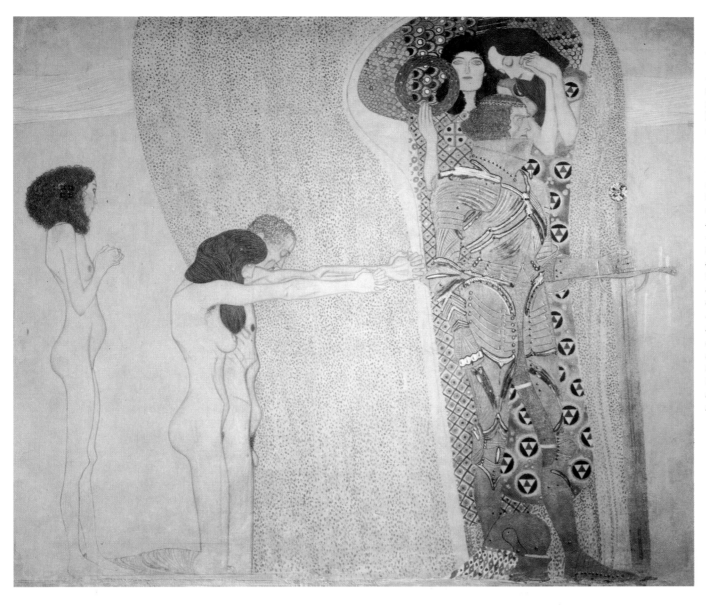

106 *Beethoven frieze (D.127), 1902. Casein on stucco. 2.2 × 34 m. Detail with the figurative compositions* The sufferings of feeble mankind *and* The longing for happiness. *Secession, Vienna.*

107 *Following page: Group photograph of the Secessionists in the main room of the fourteenth exhibition. Left to right: Anton Stark, Gustav Klimt (sitting in a chair made by Ferdinand Andri), Kolo Moser (seated in front of Klimt), Maximilian Lenz (lying down). Standing: Adolf Böhm, Wilhelm List, Maximilian Kurzweil, Leopold Stolba, Rudolf Bacher. Seated in front of them: Ernst Stöhr, Emil Orlik, Carl Moll. Photograph by Moriz Nähr, 1902.*

Left-hand wall:
The Longing for Happiness. The Suffering of Weak Mankind. Their Entreaties to the Armoured Man to take up their Fight for Happiness.
[For the figure in armour Klimt had copied one of the finest ceremonial armours from the Kunsthistorisches Museum.]
End wall: The Forces of Evil. The giant Typhoeus, against whom even the gods could not prevail; his daughters, the three Gorgons. Disease, Madness, Death. Desire and Unchastity, Licentiousness, Nagging Grief. The Longings and Desires of Mankind fly overhead.

At this point Klimt earned misunderstanding and criticism. In the eyes of many critics, the nakedness and ugliness of the female figures (Pl. 108) violated the laws of propriety. Attention should be drawn to the 'Longings and Desires of Mankind' – they look like elongated angels (Pl. 113, 114) – that float over the paintings on all three walls and act as a kind of linkage.

Right-hand wall:
The longing for happiness finds appeasement in Poetry. The arts guide us to the ideal realm where alone we can find joy, pure happiness and pure love. Choir of the angels of paradise. 'Freude schöner Götterfunken. Dieser Kuss der ganzen Welt' ['Joy, heaven-descended flame. This kiss of the whole world' – Schiller's text from Beethoven's Ninth symphony]

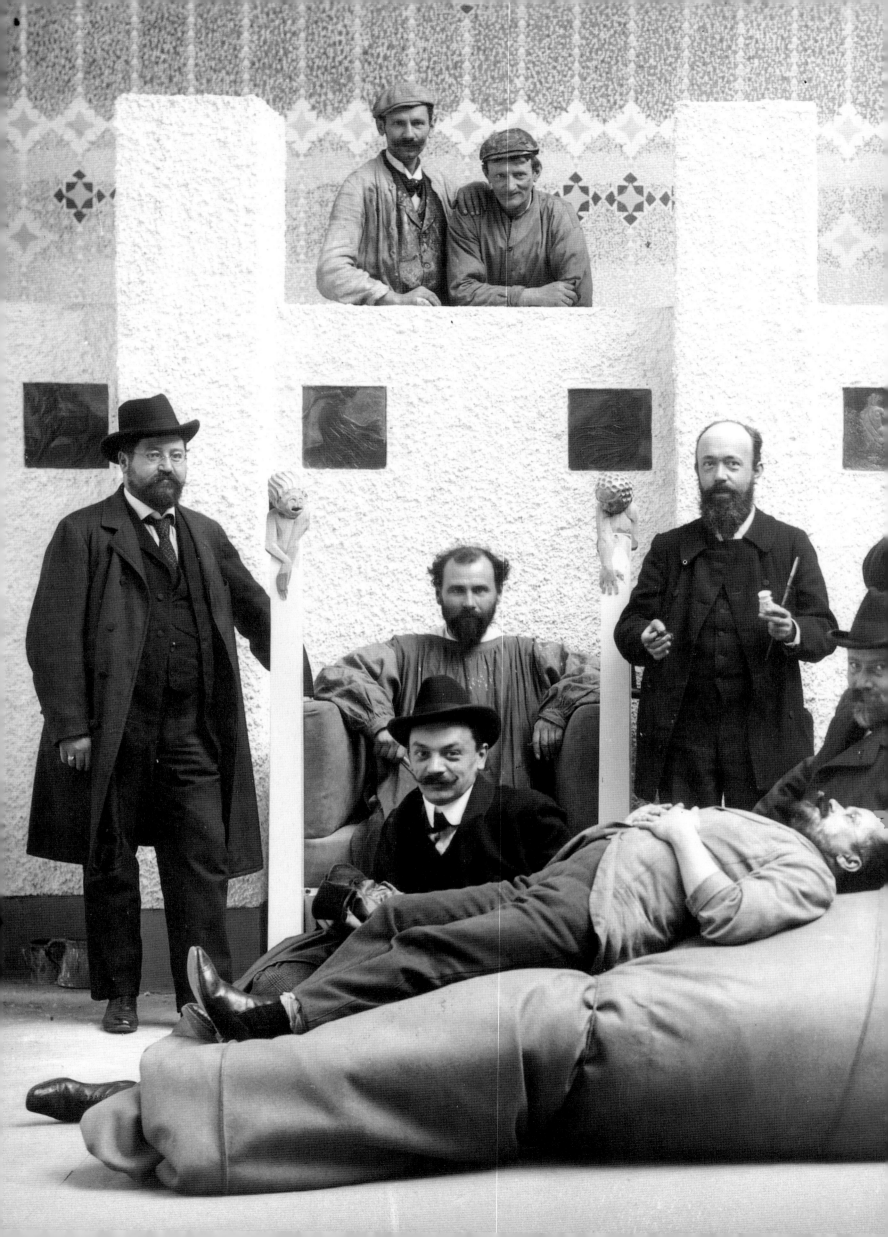

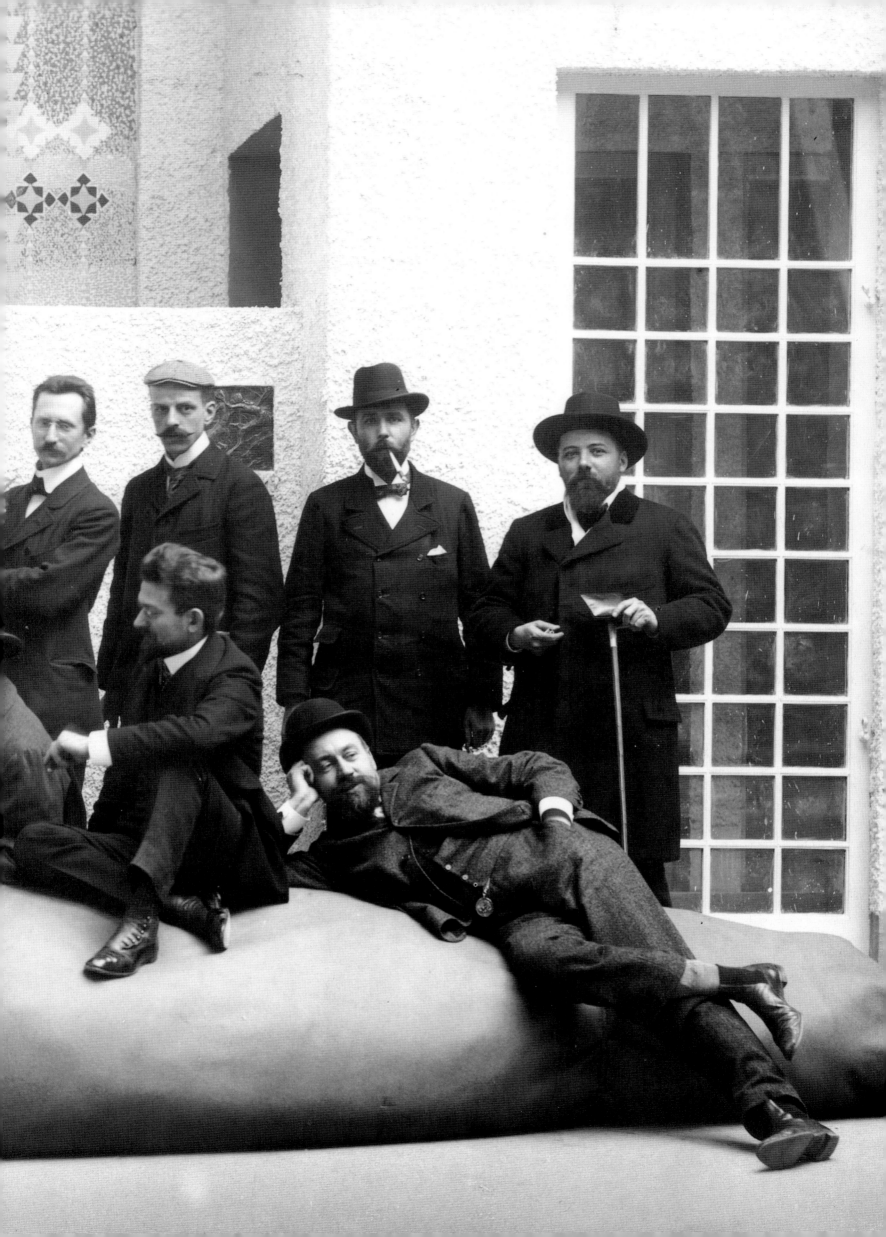

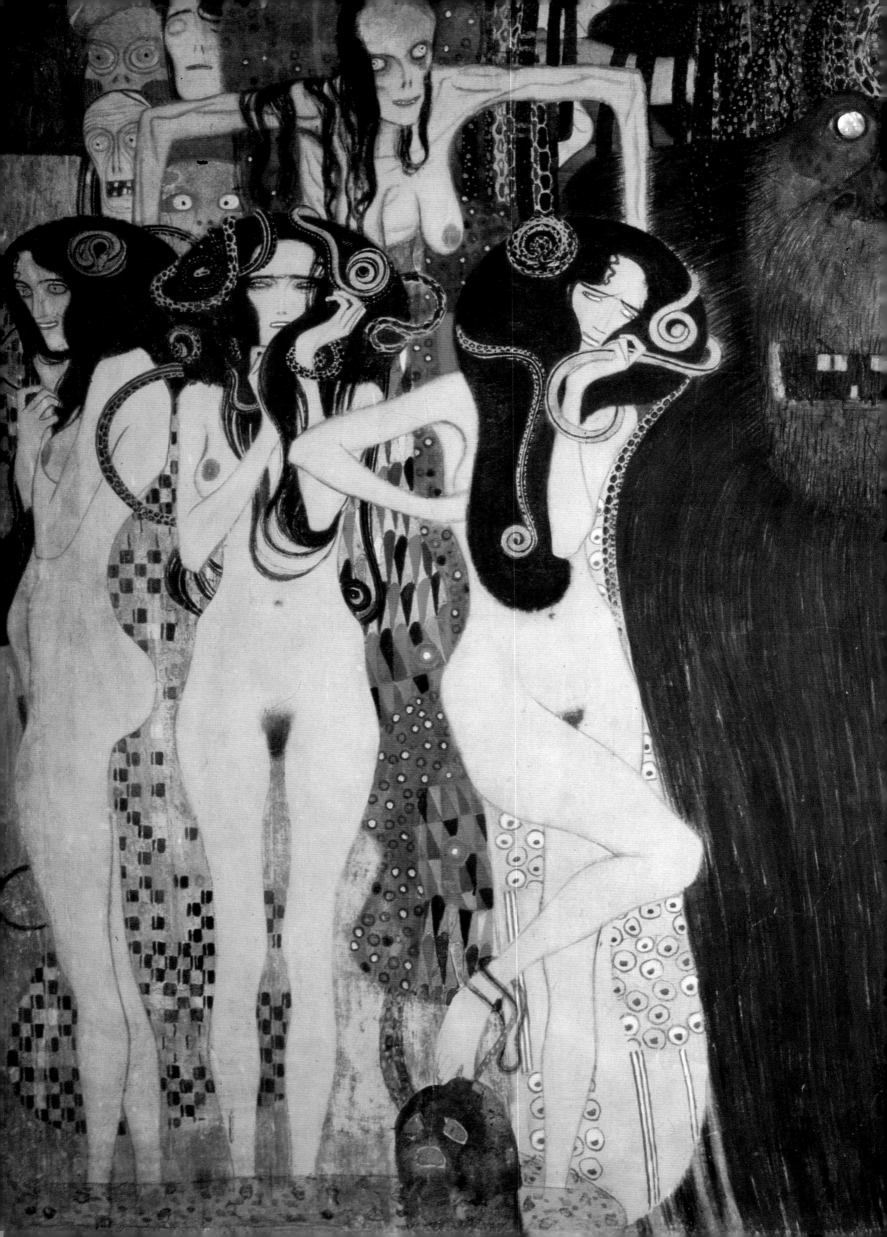

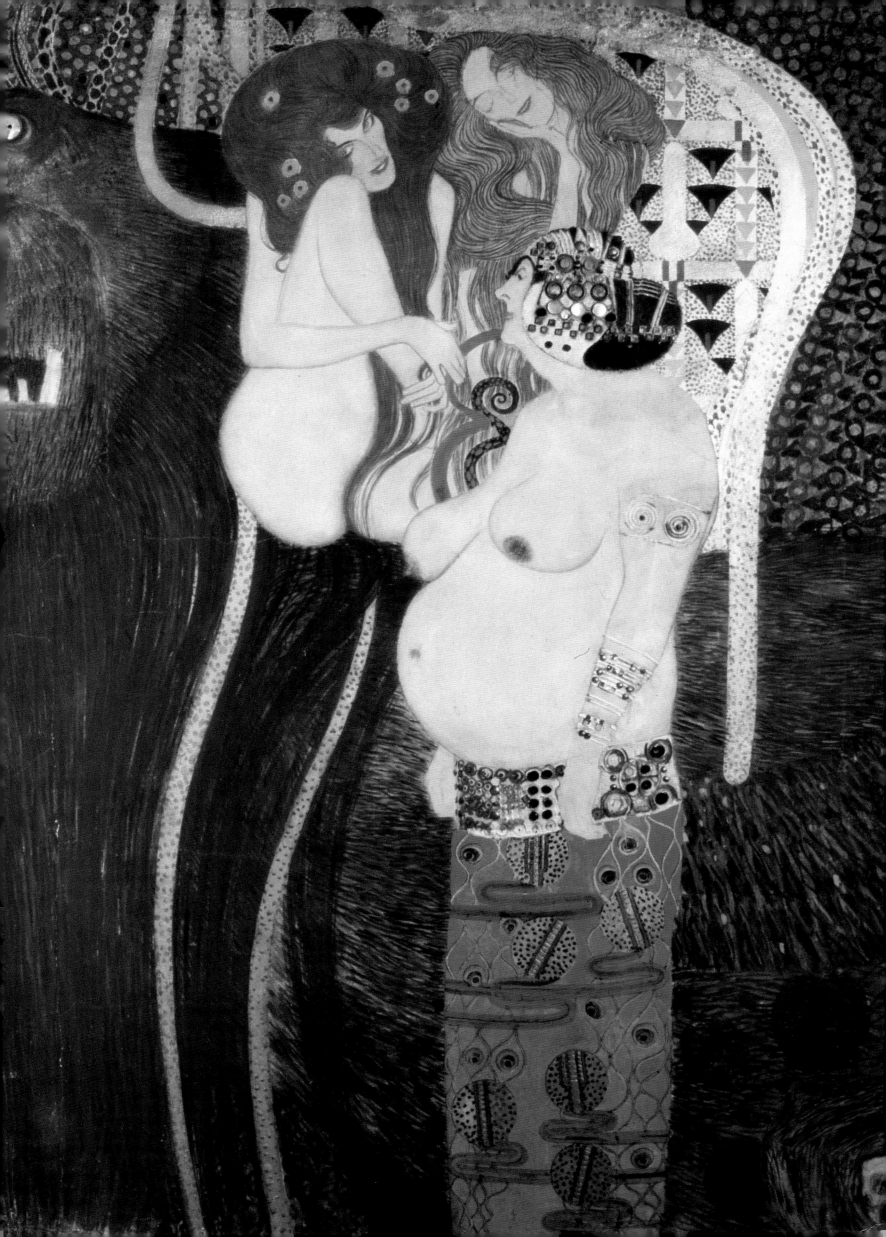

*Poetry* is undoubtedly the high point of the frieze (Pl. 113). When the heavy panels were taken down it was seen that, in spite of great care in handling, the figures had developed vertical cracks. When Erich Lederer, the son of Klimt's patron, told the artist about this, he answered calmly: 'Ah yes, Poetry! She's always the first to fray!'

Egon Schiele earned a commission when, in 1917, he negotiated the transfer of the frieze from Carl Reininghaus to the Lederer family, although the latter could not immediately set it up. Erich Lederer then sold it to the Austrian State in 1973.

Klimt later repeated the theme of the couple embracing ('Dieser Kuss der ganzen Welt' – 'this kiss of the whole world') on two occasions: for *Fulfilment* in the Stoclet frieze, 1905–1911 (Pl. 189); and in his famous painting *The Kiss*, 1907/08 (Pl. 191). Klimt's obvious 'borrowing' from Ferdinand Hodler's painting *The Chosen* for his Angels of Paradise is discussed in a later chapter (see p. 117).

In the supplement to her catalogue of Klimt's drawings, Alice Strobl notes that she found 161 of his studies for the Beethoven frieze. Of these, 148 were handed over to the Lederer family when they brought the frieze; they bore the artists's full signature and, in addition, the letter R (for Reininghaus). Eleven of the 148 were donated by Elisabeth Lederer to the Albertina after the close of the exhibition 'Dream and Reality' in the autumn of 1985 (Pl. 104, 114).

It is worth remembering that over the last eighty years anyone who wanted to see the frescoes had to content themselves with inadequate black-and-white photographs. The separate panels of the frieze are enormously heavy and they could only be transported with the help of a crane and the Vienna Opera's big scenery truck. Erich Lederer used to give vivid descriptions of these difficult removals during and immediately after the Second World War. When the frieze had at last been provisionally set up in the restoration workshop of the Office for Monuments and Arts in the Arsenal, IIIrd district, we saw, with relief, that the edges of the panels had only crumbled to a limited extent.

The big surprise was the incredible brilliance of the colours.

The fourteenth Secession exhibition provoked the critics of the day as few others did. The art historian Arpad Weixlgärtner[7] was very positive:

The 1902 autumn exhibition, built round Klinger's *Beethoven*, showed the great . . . painted frieze . . . This exhibition is without precedent in the history of art exhibitions: a group of serious, independent artists have joined up to honour, with works executed to a fixed plan, the achievement of a foreign colleague, and to frame that achievement in a worthy manner. In this exhibition we make the acquaintance of a painting by Klimt which as has already been said, may be considered

as a turning point in his development, because it establishes him as a master of a purely decorative style. As in Egyptian frescoes he works almost without modelling, just with coloured surfaces and outlines. The colours have achieved an incredible intensity: no one who has seen *Poetry* will forget how they culminate in a jubilant climax of chrome yellow. (Incidentally, it is now in a private collection and is stored in a ground floor depot where, as a result of vibration from the electric tramway, it is beginning to crumble at its lower edge) . . .[8]

The author Felix Salten[9] reports:

It had been hoped that Klinger's *Beethoven* could be acquired for Vienna . . . for weeks there was heated argument, debate and

*111 Above: Beethoven frieze (D.127), 1902. Casein on stucco. 2.2 × 34 m. Detail with the figurative composition* Nagging grief. *Secession, Vienna.*

*112 Below: Study for the figurative composition* Nagging grief *from the Beethoven frieze (AS 3457), 1902. Black crayon. 44.3 × 30.9 cm.*

intrigue in the ministries, in the town hall, in the salons, in the editorial offices, in the clubs and in the coffee houses. Some did all they could to push the deal through . . . others said this *Beethoven* was the most despicable betrayal of art. And they won the day. A great pity . . .

Vienna hesitated too long, so that the Secession's efforts in vain and it was Klinger's home city, Leipzig, which acquired *Beethoven* in 1902.

There were many anecdotes about the fourteenth exhibition. Here is one, told by Felix Salten:

That was two days before the opening of the Klinger-Beethoven exhibition. The various rooms were still resounding with the noise of the last and last-but-one preparations. But a few visitors were already wandering in: journalists, art lovers, rubbernecks. This is the social hour of the exhibition . . . Klimt was still painting on his scaffolding in a corner of the left-hand room which would later see so many outbursts of fury and enthusiasm, where so many quarrelled and so many catcalled at his frescoes.

Suddenly an exclamation came from the centre of the room: 'Hideous!' An aristocrat, a patron and collector, whom the Secession had let in today together with other close friends, had lost his temper at the sight of the Klimt frescoes. He shouted the word in a high, shrill, sharp voice . . . he threw it up the walls like a stone. 'Hideous!'

Everyone recoiled and their helpless, astonished and furious glances followed the man as he went out.

Klimt, too, had heard the shout. He turned round, stepped to the edge of the scaffolding and looked down, very far down, at the fleeing count . . . Klimt looked marvellous in this instant. His eyes were still shining with the glow of his work; a flush had darkened his brown cheeks, his hair and beard were a little ruffled and untidy. His gaze followed his laconic critic as if he were ashamed of him and at the same time made fun of him. Then he exchanged another short, amused glance with his colleagues, and a second later he turned back to the wall and was working with his brush, once more locked in his own private atmosphere, as if there had never been a count who shouted 'Hideous'.

For me, this amusing scene demonstrated Klimt's whole relationship with the public . . . Klimt paints. People come and shout. Klimt hears the shouts, looks down on the gawpers, turns away and goes on working. At best he uses the interruption to light another cigar. This amusing scene was also an illustration of the Viennese way of looking at art. It's over in a flash. One look, one opinion, one word. Works of high inspiration, artistic stimulation, artists' aims and achievements are all wiped away as with a rag wiping the dust from a table-top. 'Hideous!' All over . . .[10]

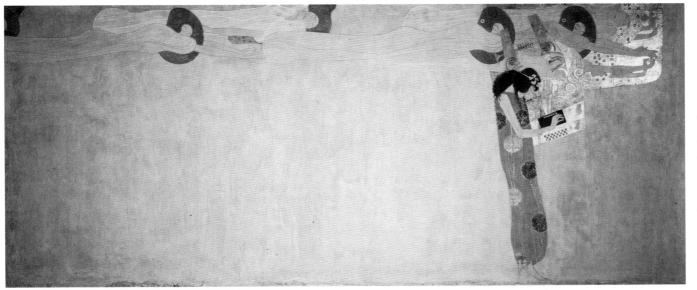

113 Above: *Beethoven frieze (D.127), 1902. Casein on stucco. 2.2 × 34 m. Detail with the figurative composition* Poetry. *Secession, Vienna.*

114 Centre: *Study for the figurative composition* The longing for happiness (the longings of mankind fly above and beyond) *from the Beethoven frieze (AS 750), 1902. Black crayon. 31.8 × 45.6 cm.*

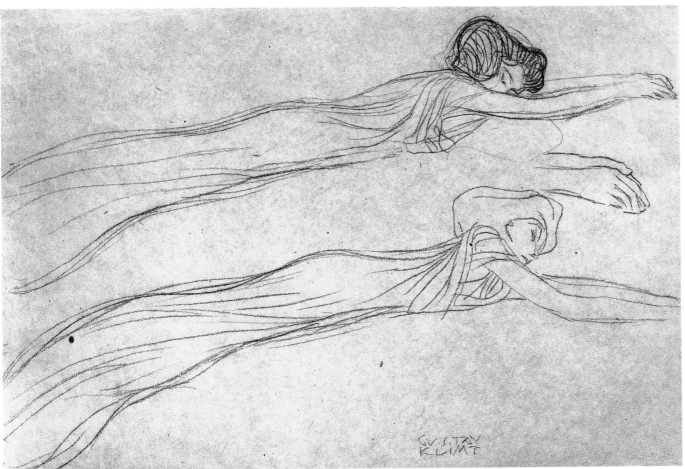

115 Below: *Beethoven frieze (D.127), 1902. Casein on stucco. 2.2 × 34 m. Detail with the figurative composition* Freude, schöner Götterfunken *(Joy, heaven-descended flame) and* Diesen Kuss der ganzen Welt *(This kiss of the whole world). Secession, Vienna.*

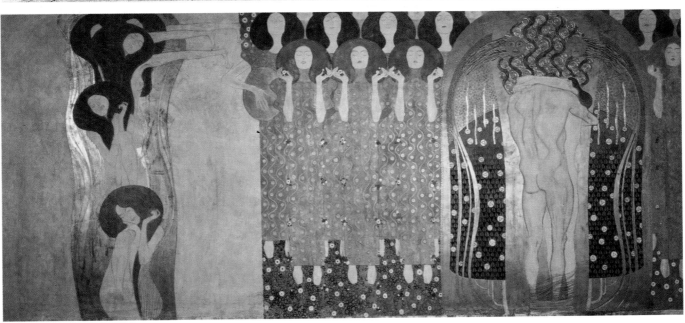

The protestor was Count Karl Lanckoronski, an influential man in Austro-Hungarian art circles and owner of an important collection of old master paintings.

The press reactions to the fourteenth exhibition were on the whole very negative. Here are three typical examples:[11]

Vienna, 20 April 1902. They are the ugliest women I have ever seen, and I can only think that Klimt painted them to infuriate us. (*Reichswehr Tageszeitung*)

Frankfurt, 20 April 1902. Klimt has once more produced a work of art that calls for a doctor and two keepers. His frescoes would fit well into a Krafft-Ebing institute [prominent psychiatrist] . . . The representations of Unchastity on the back wall are the last word in obscenity. And that is Klimt's road to Beethoven! (Dr Robert Hirschfeld, no source)

Vienna, 22 April 1902, This is beyond a joke . . . Are there no men in Vienna to protest against such assaults? . . . Vienna defeated the Turks in 1683 and will find ways and means of repulsing this new barbarity too. (S.G., no source)

1 Ludwig Hevesi, *Acht Jahre Secession*, Vienna 1906, p. 383 ff. This article appeared for the first time in *Pester Lloyd* on 13 April 1902.

2 Gustav Mahler (1860–1911) was first a conductor, then director of the Vienna Opera. During his directorship (1897–1907) he achieved exemplary work: not only in the musical sphere, where he built up the best ensemble the house had ever had and produced legendary performances; but also by employing Alfred Roller, who revolutionized the stage scenery and did away with the outmoded fitments.

3 It is a little confusing for the visitor that the right-hand wall is interrupted without it being explained that this also corresponds to the original arrangement. There is no indication that Klimt purposely interrupted his painting out of consideration for Max Klinger's *Beethoven* which had been set up in the neighbouring centre room. The visitor was required to follow a set route: when he reached the Klimt room he saw for the first time, through the gap in the partition, Klinger's statue.

4 Carl Reininghaus (1857–1929), an industrialist from Graz and one of the most prominent collectors of modern art in Vienna.

5 Ernst Stöhr (1865–1917)

6 Thieme-Becker, *Künstlerlexikon*, Vol. 32, p. 88

7 Arpad Weixlgärtner, art historian (1872–1961)

8 Arpad Weixlgärtner, *Gustav Klimt*. In: *Die graphischen Künste*. Vienna 1912, p. 55

9 Felix Salten (actually Siegmund Salzmann), author (1869–1945). His most successful book, *Bambi*, was filmed by Walt Disney.

10 Felix Salten, *Geister der Zeit. Erlebnisse*. Vienna 1924, p. 33 ff.

11 Excerpts from *Gegen Klimt*. Foreword and editor Hermann Bahr. Vienna 1903.

# AUGUSTE RODIN'S VISIT TO VIENNA 1902

*116 Auguste Rodin at the age of sixty-two. Photograph by Edward Steichen, 1902.*

In 1901 the Vienna Secession arranged its ninth exhibition. It was small (only 102 exhibits) but exclusive and devoted to three artists.

First was the painter Giovanni Segantini,[1] who was considered to be Austrian by reason of his birth in Arco, then a part of the Austro-Hungarian empire. Fifty-six of his paintings were shown in 1901 and, in the following year, a luxury edition, *Giovanni Segantini: Sein Leben und Werk* (*Giovanni Segantini: Life and Works*) was published by the Ministry of Culture and Education. One of his most important paintings, *Evil Mothers*, was acquired by the state for the Moderne Galerie (now Österreichische Galerie, Belvedere); it shows the lifeless body of a woman hanging in a leafless tree, with a baby at her breast.

The second was Max Klinger, whose *Beethoven* was to have a unique reception a year later. Fourteen oil paintings were shown which he finished in the years 1884–1885 for the Villa Albers in Steglitz and which had for many years been missing after the villa had been broken down; also his statue *Squatting Woman* which he made in 1900–1901 from a block of antique marble excavated in the Via Nazionale in Rome.[2]

The third was Auguste Rodin. The arrangement of this exhibition had been entrusted to Alfred Roller (Pl. 121) who had done exemplary work – as had Kolo Moser – for the modernization of exhibitions. One fact has sunk into oblivion, namely that in 1901 no fewer than fourteen of Auguste Rodin's works were on show. They are listed in the small octavo catalogue designed by Josef Hoffmann:

No. 39 *The Burghers of Calais*, plaster
No. 40 *Balzac*, plaster (only the head was shown)
No. 41 *A Small Pillar. Heros and the Goddess of Victory*
No. 42 *L'Age d'Airain*, Pl. 119, plaster
No. 43 *Eva*, plaster (unfinished owing to the model's pregnancy. A bronze cast stands by Rodin's tomb in Meudon near Paris)
No. 44 *Joseph*, plaster
No. 45 *A Pillar. St. John*
No. 46 *Faun and Nature*, plaster
No. 47 *Moon and Earth*, marble
No. 48 *Weeping Girl*, bronze
No. 49 *La Vieille Heulmière*, bronze
No. 50 *Defence*, bronze
No. 51 *Valkyrie*, bronze
No. 52 *Nymph Kneeling*, bronze

When the Secession was founded (as the Austrian Artists' Union) Rodin was elected a corresponding member. He was already on show at their first exhibition in 1898. The catalogue (Pl. 120) contains the following numbers:

No. 63 *Faun and Nymph*, bronze
No. 64 Fragment of the model for the *Victor Hugo Monument*

*117 The 'Sacher Garten' in the Vienna Prater, where the Secession honoured Auguste Rodin in 1902. Photograph, about 1910.*

110

No. 65 Fragment of the model for the *Victor Hugo Monument*
No. 66 Fragment of the model for the *Victor Hugo Monument*
No. 67 *Sin*, plaster
No. 68 Fragment of the model for the *Victor Hugo Monument*
No. 69 *Study*, plaster
No. 70 *The Friends*, marble
No. 71 *Female Torso*, plaster
No. 72 *The Great Pan*, plaster
No. 73 *Woman Bending Down*, plaster
No. 74 *Adonis's Youth*, plaster
No. 75 *Dalou*, bronze
No. 76 *Study*, plaster
No. 77 *Woman with Child*, plaster

Rodin took part in the fourth exhibition in 1899 (No. 15), the seventh in 1900 (No. 53) and finally the sixteenth (Nos. 126, 127), but never attracted much attention.

There is no explanation for the fact that Rodin's exhibits were so little noticed or why he found no buyers, whereas Max Klinger's sculpture *Woman Squatting*, shown in 1902, was bought on the opening day by the collector Karl Wittgenstein. Perhaps it was a mistake to

first shown in the Paris Salon because Rodin was accused of having used a 'moulage' (moulding) casting technique (from the living model). It availed him nothing that he at first placed photographs of his model (a sailor) next to the sculpture and, when this had no effect, had the model himself pose. It was no doubt on the basis of this incident that Berta Zuckerkandl quoted Rodin's words (reproduced below) about the injustice he had suffered. Through this exhibition, however, the Secession did at least help two other artists to international renown: Georg Minne[3] and Ferdinand Hodler.[4]

In 1902 the artists' union 'Manes' in Prague gave an important exhibition of Rodin's work that put the Viennese show completely in the shade. They also invited him to visit Prague. By an odd coincidence he returned to Vienna just in time to see Klinger's *Beethoven* in the Secession. It is hardly surprising that

show the majority of Rodin's works as plaster casts. It is also a mystery as to why his wonderful *Burghers of Calais* did not get the attention it deserved.

By and large, the choice of the Rodin works was carefully made. Special mention must be made of *L'Age d'Airain* (Pl. 119), which caused a scandal when it was

– as we see in the report below – he wasted no words on the statue and made only a few polite comments on Klimt's frieze. Rodin and Klinger were, artistically speaking, too far apart: Klinger, as we have seen, knew that Rodin was a much greater artist than himself; and his remarkable insight corresponds to the present-day evaluation of the two artists – respect for Klinger's work within the context of his time, and admiration for Rodin's immortal creations.

Berta Zuckerkandl, one of the pillars of the Vienna Secession, wrote a newspaper article – which was later reprinted in her remarkable book *Ich erlebte fünfzig Jahre Weltgeschichte* (*I witnessed fifty years of world history*), Stockholm 1939 – in which she describes Rodin's visit. Thanks to her sister Sophie's marriage to the politician Georges Clemenceau's brother, Paris had become her second home, and so she had been asked to look after Rodin in Vienna. She writes:

113

When Rodin came to Vienna in 1902, I took him to see Klimt. Rodin, whose drawings are among the most grandiose résumés of body and movement, recognized a peer. Turning to me, he said: 'These masterly drawings remind me of Baudelaire's saying: "Le dessin de création est le privilège du génie."'

Zuckerkandl[5] and I invited Rodin to tea in the Prater. It was a wonderful July day. The whole Secession had gathered there, Klimt in radiant mood, next to him Rodin who could not stop admiring the smart Viennese horse-drawn cabs. I had had the table set in the open. Near Klimt sat two beautiful women, who also made a deep impression on Rodin. Klimt had created from Viennese women an ideal female type: modern, with a boyish figure. They had a mysterious fascination; although the word 'vamp' was still unknown he drew women with the fascination of a Greta Garbo or a Marlene Dietrich long before they actually existed. Rodin and Klimt were now surrounded by such women, and Alfred Grünfeld[6] had sat down at the piano in the big room with its doors opened on to the garden. Klimt went up to him:

'Could you play us some Schubert?'

And Grünfeld, a cigar between his lips, dreamed up Schubert. Rodin leaned over to Klimt:

'I've never experienced anything like this. Your Beethoven frieze, so tragic and so peaceful; your exhibition, temple-like and unforgettable, these women, this music! And in and around you all this gay, childlike joy. What is it?'

I interpreted Rodin's words.[7] Klimt bowed his head, handsome as St. Peter, and spoke one word:

'Austria!'[8]

This chronicle, which ends with Klimt's acknowledgment to his country, was elegantly complemented by the Secession chronicler Ludwig Hevesi (originally in *Pester Lloyd* on 8 June 1902):

That was an interesting idyll yesterday afternoon in the Sacher Garden (Pl. 117, 118) . . .
We had been invited to a Viennese tea-party, by a Viennese lady who is very prominent in our modern art scene . . . The hero of the hour was . . . Auguste Rodin . . . A magician, but without a magician's airs. Quite bourgeois, in an old suit, no trace of a trouser crease . . . He sat as guest of honour at the top table, between the hostess, who toasted him in French, and the Minister of Education Ritter von Hartel, who engaged him in animated conversation. Round about sat elegant ladies in fresh spring attire, among them celebrities of fashion and art. A sight for an artist's eyes. A few modern artists with their wives, all young. Klimt with his air of irritability: actually we should have a Siberia where such enfants terribles could be sent . . . I didn't ask Rodin his opinion of the Klinger Beethoven, no one asked him. Nor of all the other things on show in the Secession. He neither praised nor criticized . . . He had another, quite different, experience of Beethoven: the young people took him to 'Venedig in Wien',[9] to Grädener's[10] concert, where he heard the *Eroica*. It thrilled him . . . he complained that he couldn't stand concerts in Paris because the programmes were such a mixture . . . [11]

Unfortunately Rodin's visit did not result in one of his masterpieces being acquired; so Vienna possesses, apart from Gustav Mahler's head in the foyer of the State Opera, only a plaster bust of the French publicist and politician Henri Rochefort[12] in the Museum of Applied Arts. The bust was shown at the fourth Secession exhibition from March to May 1899; today a bronze cast of it exists.

1 Giovanni Segantini, Swiss painter (1858–1899). He died suddenly at the age of 41 from a burst appendix.

2 Christian M. Nebehay Gallery, catalogue No. 43, Vienna 1975. The figure is now to be seen in the Kunsthistorisches Museum, Vienna.

3 George Minne, Belgain sculptor (1866–1941). His figures round a well, created in 1906, influenced both Kokoschka and Schiele.

4 Ferdinand Hodler, Swiss painter (1853–1918)

5 Emil Zuckerkandl, anatomist, husband of Berta Zuckerkandl (1849–1910)

6 Alfred Grünfeld, pianist and composer (1852–1924)

7 Klimt had a smattering of French; he had only had a year of it at school.

8 Berta Zuckerkandl, *Ich erlebte fünfzig Jahre Weltgeschichte*. Stockholm 1939, pp. 174–179

9 Large amusement premises in the Vienna Prater.

10 Hermann Grädener, violinist, conductor and composer (1844–1929). Conducted the Vienna Academy Choir from 1892 to 1896, later important orchestral concerts.

11 Ludwig Hevesi, *Acht Jahre Secession*. Vienna 1906, pp. 394–397

12 Henri Rochefort (1830–1913)

# GUSTAV KLIMT AND FERDINAND HODLER 1904

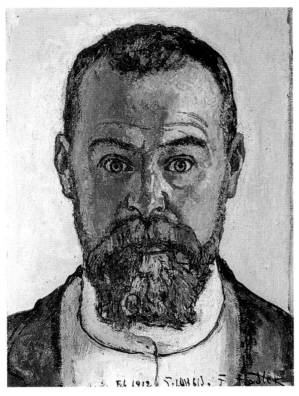

*122 Ferdinand Hodler, Self-portrait, 1912. Oil on canvas. 38.5 × 29.5 cm. Kunstmuseum, Basle.*

Ferdinand Hodler was, like Klimt, the son of poor parents. He had a very difficult childhood: the eldest of six children, he was seven years old when his father Johann, a joiner, died in Berne of tuberculosis; and a little later all his brothers and sisters died of the same disease. His mother Margarethe married the decorator Gottlieb Schüpbach in 1861. Schüpbach came from a respected and wealthy family and already had three children; at the time of his marriage he employed twenty workmen, but then he began to keep bad company and finally lost all his money. Margarethe Schüpbach died at the age of thirty-nine after having borne her second husband three more children. She was given a pauper's burial, which left a lasting impression on the fourteen-year-old Ferdinand.

The rest of his life was overshadowed by illness and death: in 1915, his mistress Valentine Godé-Darel, with whom he had been living since 1908, developed cancer, from which she finally died. So it is not surprising that death played a part in his paintings (see for example *Night*, Pl. 123), although not to the same extent as those of Edvard Munch or Egon Schiele.

Hodler had the good fortune to be taken up and trained by a successful painter from Geneva, Barthélémy Menn,[1] who had studied under Ingres in Paris and later had connections with the Impressionists, in particular with Manet and Corot. Hodler owed his subsequent success to his encounter with this man and to his apprenticeship with him.

Ferdinand Hodler's progress towards the status of leading Swiss painter of his time was no easier for him than it was for Klimt. Both were involved in art scandals, and both went doggedly on their way. In Hodler's case the stumbling-block was his painting mentioned above, *Night*, which was to be shown in the Geneva City Art Exhibition and had been unhesitatingly approved by the jury. Before the opening day, however, came the usual tour of the exhibition by the city fathers, namely the mayor and his councillors, and they declared the painting to be indecent and immoral and insisted on its being taken down. Calvin's Geneva had always been known to be prudish: presumably the city fathers – novices like the Viennese professors who protested against Klimt's three University paintings – objected to the nakedness in the painting. At the time Hodler was still unknown and had no social standing. The city fathers were also probably unaware that he had executed the painting during a psychological crisis. At that time he was involved with two women. In the left foreground lies, naked, Augustine Dupin, with whom he

115

had an intimate relationship; and on the right, also naked but with her back towards the beholder, Bertha Stucki, who was for a short time his wife. Hodler himself features twice in the painting. Once he wakes, with distorted features, from a nightmare, and Death squats before him, wrapped in black; and again, in the upper corner of the painting, he lies naked and quietly sleeping (Pl. 123).

The ban by the city fathers was of course the talk of the town. Hodler rented premises directly opposite the Musée Rath and there he showed his painting for a modest entrance fee. It was welcomed by the younger generation of art lovers in Geneva, who pulled strings and arranged for the painting to be shown shortly afterwards in the Salon du Champs-de-Mars in Paris. The critic Edouard Rod (see below) reports that a verse by the French poet Charles François Panard had been placed on the frame: 'Plus d'un qui s'est couché tranquillement le soir, ne s'éveillera le lendemain' (Many who lie down peacefully at night will not wake in the morning). This text, meant to make the painting's meaning clearer, was later removed.

In his 1891 review entitled 'Les Salons' published in the prominent art journal *Gazette des Beaux-Arts* (series III, 16), Rod defended Hodler against the charge of immorality levelled at him in Geneva:

The painting is aggressive and provocative, but I cannot understand how it could shock even the most puritan of moralists. Parts of it, for instance the back of the naked woman in the foreground, are masterly; and almost all the pencil work is of an exactitude and confident power that prove that Hodler is a cultivated and reputable artist.[2]

Friendly critics in Paris helped to establish Hodler's international reputation. This was a beginning; but the real breakthrough came at the Vienna exhibition in 1904. Hodler had been elected a member of the Vienna Secession in 1900 and had been invited to exhibit. What he first sent was hardly calculated to arouse the interest of the Viennese: single studies for his large canvas, painted for the county museum in Zürich, *The Retreat of the Swiss at Marignano*, 1897. The next year he sent two more suitable paintings: *The Chosen One*, 1893–94 (Kunstmuseum Bern, Pl. 125) and *Spring*, 1901 (Museum Folkwang, Essen).

The first of these paintings is especially important in our context. In the first place it is interesting that Hodler, while in Vienna, painted a copy of it (probably for the collector Reininghaus); but, more importantly, the painting undoubtedly served as a model for the last part of Gustav Klimt's Beethoven frieze (1902), namely the *Choir of the Angels of Paradise* (Pl. 126). Hodler had left wider gaps between his angels where Klimt painted his in a tightly formed row;

116

but there is a marked similarity in their posture, in the way they hold their hands, and above all in the feet floating above ground.

Hodler, in a 1904 interview with the Viennese journalist Else Spiegel, bore Klimt no grudge for his 'loan':

What I value most in painting is form. Everything else must serve form, and the most important of these servants is colour. I like clarity in my paintings and therefore I like parallelism . . . When I started painting I went in for Impressionism, but gradually, through much study and years of observation, I came to my present style: clear forms, simple presentation, repetition of subjects. My favourite artists are Dürer and the early Italian painters. Of the modern ones, I greatly admire Klimt. I particularly like his frescoes [the Beethoven frieze]: there all is quiet and fluid, and he too likes repetitions with which he achieves his wonderful decorative effects. His is a personality that goes its own very individual way, and at the same time is Viennese in its grace and delicacy. Of the three University paintings I know only *Philosophy*, I like it less than the frescoes and the portraits, but then I see it not as a critic but as an artist, and the colour harmony and the presentation seem to me to be wonderful. Klinger I like less: he always wants to say too much.[3]

Hodler's definitive breakthrough to international recognition came at the nineteenth Secession exhibition (22 January to 6 March 1904).[4] This exhibition (Pl. 127), in its compression and fullness, in the arrangement of the rooms by Kolo Moser with furni-

ture by Josef Hoffmann, was the last high point of the Secession exhibitions before the Klimt group left the Secession in 1905.

The poet Peter Altenberg writes:

XIXth Secession exhibition, Vienna. Ferdinand Hodler from Geneva: you show us nature and men with cold vigour, with the poetry of wisdom and cool maturity! You are full of depth and simplicity! . . . Ferdinand Hodler goes his way unswervingly, obeying blindly and without hesitation the dictates of his organization, safely led by the enormous power that is in him, a strong, simple wanderer on the heights! Looking around him, but from on high![5]

No fewer than twelve of the thirty exhibits were sold in that exhibition. The chief buyer was the prominent

*124* Above: *Autograph postcard from Ferdinand Hodler to Carl Moll dated 11.10.1907. The translated (French) text reads: There are four of us, here is what we have consumed. Long live Vienna, Long live the Secession, Long live Carl Moll and Koloman Moser and the famous Klimt. Long live all those whom I got to know in Vienna and long live especially the lovely Viennese girls. F. Hodler.'*

*125* Below left: *Ferdinand Hodler,* The Chosen One, *1893–94, Tempera and oil on canvas. 219 × 296 cm. Kunstmuseum Berne. Klimt adopted Hodler's idea of floating angels, to which Hodler did not object.*

*126* Below right: *Beethoven frieze (D.127), 1902. Casein on stucco. 2.2 × 34 m. Detail with the figurative composition* Freude, schöner Götterfunk en *(Joy, heaven-descended flame) and* Diesen Kuss der ganzen Welt *(This kiss of the whole world). Secession, Vienna.*

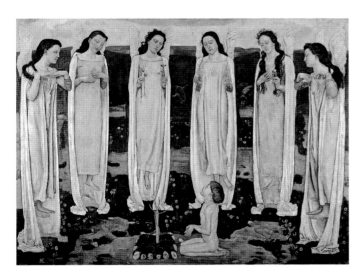

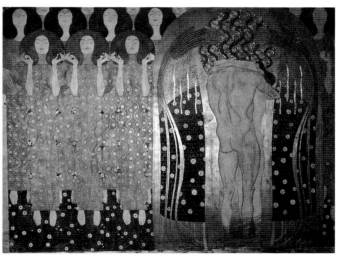

industrialist and collector of modern art from Graz, Carl Reininghaus.

Hodler had spent seven weeks in Vienna that winter. He was full of enthusiasm: 'No institution in the world does so much for art as the Secession!'[6]

Hodler had also designed the poster for the nineteenth Secession exhibition (Pl. 128). He used the lower half of his painting *The Dream*, 1897–1903: a nude boy lying in a field. He also designed the lettering for this poster. Of all the Secession posters designed by artists, Hodler's stands out because it is the only one that uses one of the exhibits. All the other early Secession posters are, artistically speaking, remarkable and modernistic, and are now highly valued collectors' objects. They aroused interest mainly because of their unusual formats, but they did not achieve their object, which was to publicize the exhibits.

While Klimt was presumably influenced by a painting of Hodler's, there is also the possibility that Hodler borrowed from Klimt – at any rate thematically. In his painting *Truth II*, 1903 (Kunsthaus Zürich), Hodler used as a model for his central figure Bertha Jacques, whom he had married in 1898. She accompanied him to Vienna, acted as his secretary and looked after her successful husband. It is possible that Hodler was inspired by Klimt's *Nuda Veritas*, 1899 (Austrian Theatre Museum, Vienna, Pl. 90). Even if he had never seen the original painting, he must certainly have seen Klimt's drawing reproduced in the first volume of the Secession *Ver Sacrum*, which came out in large editions. The drawing must be considered as the first concept for the painting of the same name.

As regards Hodler's contacts in Vienna, he was particularly good friends with Carl Moll[7] who had put

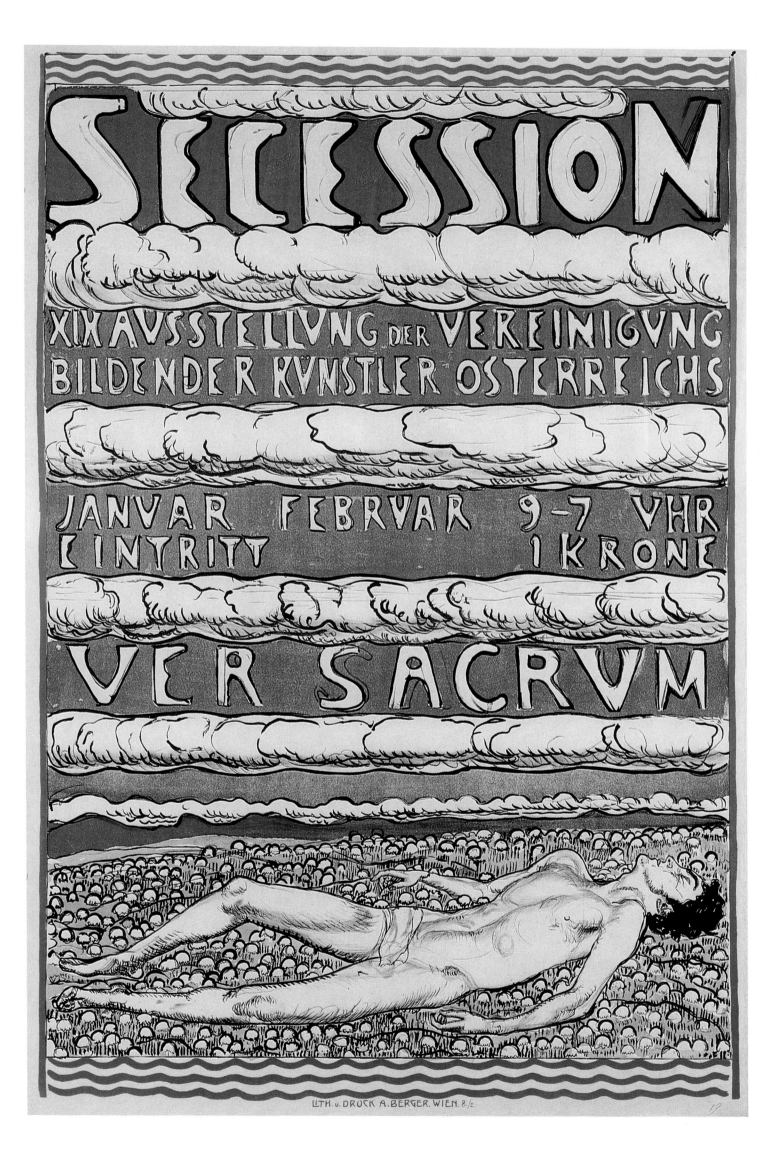

129 Above: *Felician von Myrbach, Ferdinand Hodler (centre) and Josef Hoffmann outside the Café Museum in Vienna. Photograph, 1904.*

130 Below: *Hall of the villa built by Josef Hoffmann for Hugo Henneberg on the Hohe Warte in Vienna. Klimt's* Portrait of Marie Henneberg *(D.123) hangs over the fireplace. Photograph, about 1903.*

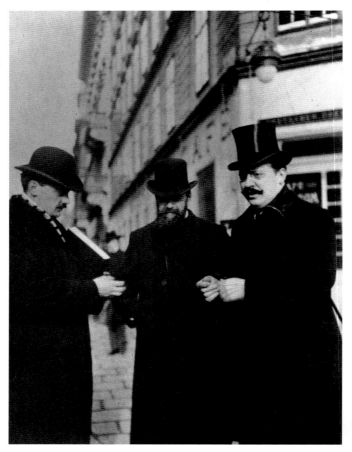

Swiss painter Cuno Amiet,[8] a close friend of Hodler's since 1898, and Edvard Munch,[9] who sent an equally extensive selection of his paintings. Unfortunately neither found favour with the Viennese public. Amiet, who towards the end of his life was awarded an honorary degree, wrote the following vivid account of the nineteenth Secession exhibition:

Now we passed from the half-lit entrance hall into the light, into the tall, bright Hodler room. There they were, all the majestic masterpieces, long admired and venerated by us, there they were, united and completely new: *Tell, Night, The Weary Ones, The Disappointed Souls, Eurhythmics, The Chosen One, Truth, The Day, Youth Admired by Women, Emotion, Sensibility, Spring, A View of Eternity, The Sacred Hour* – all along the four walls, each separated from the next by a small, slim, green tree. And it was one mighty flood of lines, forms and clear, light colours: and these works of a great master, created one after another, merged into a supremely powerful Hodler.

Hodler had come, he stood in the room and looked, and marvelled. Never before had he seen his paintings all together

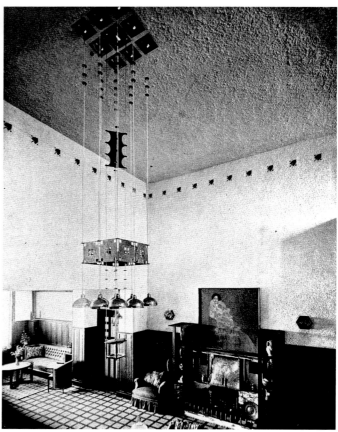

him up in a neighbouring house on the Hohe Warte in the XIXth district, built by Josef Hoffmann at the same time as his own. This house (Pl. 130) belonged to Dr. Hugo Henneberg, who owned a large collection of Japanese woodcuts and was himself an amateur woodcut artist and photographer.

More important still was Hodler's relationship with Kolo Moser. Moser was one of Vienna's most gifted craftsmen; he was responsible for the exemplary settings of the Secession's best exhibitions. After marrying Editha Mautner-Markhof in 1905 he devoted all his energies to painting, a field in which he achieved a remarkably high standard. Some of his paintings were so similar to landscapes by Ferdinand Hodler, after whom he modelled himself closely, that after the First World War they were bought up by forgers who resold them with Hodler's signature.

Two other artists showed their work at the Secession's nineteenth exhibition with Hodler: the

as here. His eyes shone, his nostrils quivered, his mouth was wide open. This fifty-one-year-old man was moved, he was happy. Here it was, the success he had longed for. Here was victory.[10]

Hodler demonstrated his friendship with his Viennese colleagues by acquiring Klimt's painting *Judith* (Pl. 132). This is the only one of Klimt's paintings that was sold to Switzerland during his lifetime; in 1954 it was bought back and now hangs in the Belvedere. Apart from the sale in 1912 to the Moderne Galerie in Dresden of the landscape *Buchenwald I* (about 1902), it was Italy that bought the most Klimt paintings: *Judith II* and *Salome* (Pl. 135), 1909, acquired in 1910 by the Galleria d'Arte Moderna in Venice; and *The Three Ages* (Pl. 155), 1905, acquired in 1912 by the Galleria Nazionale d'Arte Moderna in Rome.

In 1914 Hodler moved to a new apartment at 29 Quai du Mont Blanc, Geneva. He had it furnished by Josef Hoffmann and the Wiener Werkstätte. In the 1950s the furniture (Pl. 131) was auctioned together with the remaining possessions of Hodler's widow Bertha.

The author of this book tried in vain, at the time, to persuade the Historical Museum of the City of Vienna to buy the furnishings. The then director of the museum, Dr Franz Glück, had succeeded in having a new museum built on the Karlsplatz to which he transferred the rich inventory from the dark, inadequate rooms of the new town hall.[11] The furniture was split up in the auction: some of it now stands, a little lost, in the Hodler room of the Musée d'Art et d'Histoire in Geneva; other pieces are in the Kunstgewerbemuseum in Zürich. That auction would surely have been the last chance of acquiring an important creation of Josef Hoffmann's for Vienna.

1 Barthélémy Menn, Swiss painter (1815–1893), is reckoned to be the chief founder of modern Swiss painting.

2 Quoted from: Sharon L. Hirsch, *Ferdinand Hodler*. Munich 1981, p.75. Other passages have also been quoted from this book.

3 Hans Ankwicz-Kleehoven, 'Ferdinand Hodler und Wien'. In: 'Hodler und Wien', New Year number of the Zürich Artists' Society 1950, p. 18.

4 See also: Cuno Amiet, 'Die Ausstellung der Secession in Wien, Januar–Februar 1904'. In: 'Hodler und Wien'. New Year number of the Zürich Artists' Society 1950, pp. 22–28.

5 Peter Altenberg, *Märchen des Lebens*, Berlin 1911, p. 20.

6 See note 4 above.

7 Carl Moll was a pupil and friend of the painter Jacob Emil Schindler, whose widow he married, and the stepfather of Alma Schindler-Mahler. He was one of the most important personalities of the Vienna art scene.

8 Cuno Amiet, Swiss painter, graphic artist, and arts and crafts designer (1868–1961)

9 Edvard Munch, Norwegian painter, etcher and wood-block cutter (1863–1944)

10 Peter Altenberg, *Märchen des Lebens*, Berlin 1911, p. 24.

11 This new building was much too hastily commissioned for the eightieth birthday of General Theodor Körner who was in the first place mayor of Vienna and then President of the Republic; it turned out to be far too small. The director, Dr Franz Glück, to whom I suggested he salvage the Hoffmann furniture for Vienna, was reserved. He did not want, as he told me, 'to make a Musée Carnavalet (Paris) of his museum'.

*131 Chair by Josef Hoffmann for Ferdinand Hodler's apartment in Geneva. 1913–14. Oak, stained black with white grain, covered in a Wiener Werkstätte material, 'Swallowtail', designed by Dagobert Peche.*

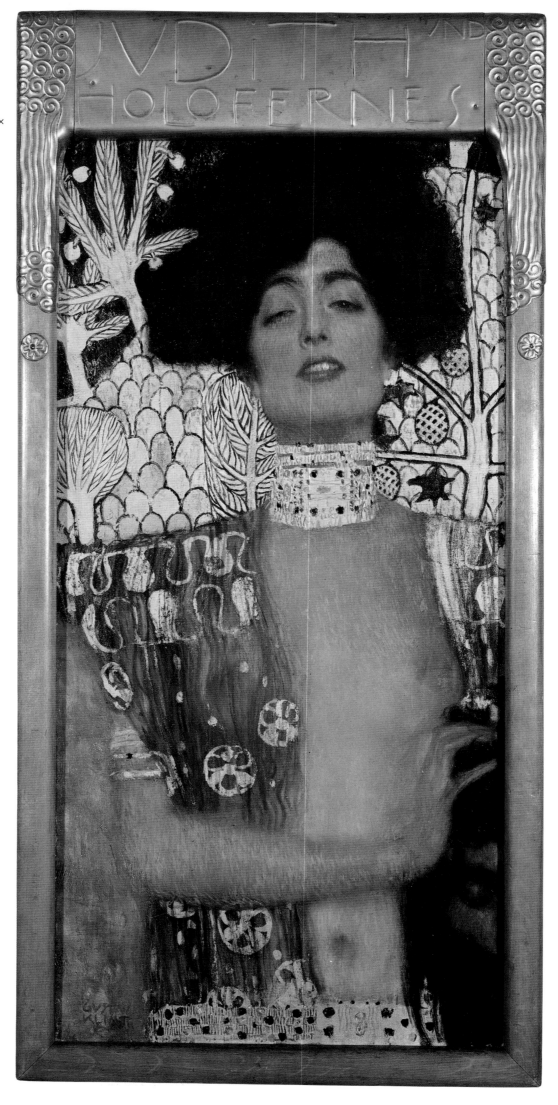

*132* Judith I *(D.113)*,
*1901. Oil on canvas. 84 ×*
*42 cm. Österreichische*
*Galerie, Vienna.*

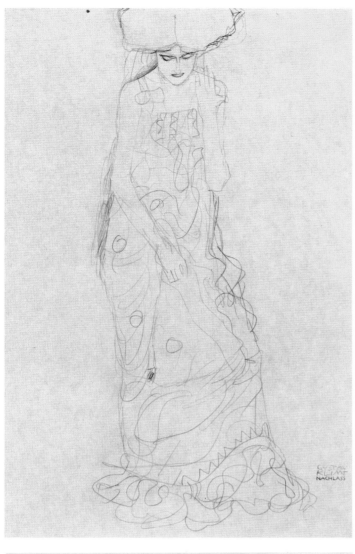

*133* Above left: *Study for the painting* Judith II, *also* Salome *(AS 1702), 1909. Pencil. 56 × 37 cm.*

*134* Below left: *Study for the painting* Judith II, *also* Salome *(AS 1695), 1909. Technique and dimensions unknown.*

*135* Right: Judith II, *also* Salome *(D.160), 1909. Oil on canvas. 178 × 46 cm. Galleria d'Arte Moderna, Venice.*

# GUSTAV KLIMT AND PETER ALTENBERG

'Gustav Klimt,/ Josef Hoff-mann,/ I love you!/ Peter Altenberg.' (Pl. 137)[1]

This book would not be complete without an attempt to revive the memory of a Klimt enthusiast who has sunk into almost complete oblivion: Peter Altenberg. Of all the writers of the time, it was he who found the most striking words for his idol. Peter Altenberg's most important letter to Klimt reads as follows:[2]

*137 Peter Altenberg. Autograph dedication ('Gustav Klimt, / Josef Hoffmann, / I love you! / Peter Altenberg.') on a sheet of the poet's notepaper, bearing a photograph of himself.*

*136 Opposite: The room in the Graben Hotel in the 1st district where Peter Altenberg lived for years. The walls were hung with portraits, illustrations and, above all, photographs of his loves. Photograph, about 1914. Historisches Museum der Stadt Wien.*

life in his own particular style, interspersed with punctuation, exclamation marks and extra spacing. He recorded the world as he saw it with his large, astonished and understanding eyes. He could make a heart-stirring story out of a trifle. He could go into ecstasies before a flower or a beautiful picture, or the charm of a blossoming young girl, just as he could sink into deep despair and melancholy when one of his adored ladies snubbed him.

Gustav Klimt, as a discerning painter you are also a modern philosopher, an entirely modern poet! When you paint you suddenly turn, almost magically, into the most modern of men, which perhaps you are not at all in the routine of days and hours. Your cottage gardens with hundreds of thousands of flowers and one giant sunflower are the ideal combination of realism with romanticism: theoretically, the practical solution to the problem. Your dark ponds, your forest pools, your reed-ed lakes are melancholy, modern poems and songs. Over-tender souls could be moved to tears by your beech woods, so lonely, soft and dim are they! . . . But if anyone were to ask me point-blank: 'Peter, if you were a rich man – you are, thank Heaven, easy to delight – which of these ideal paintings would you take out of this folder and hang in your room in a broad moulded mahogany frame?' I would answer without hesitation: 'The one giant, solitary and yet magnificent apple tree!'
Peter Altenberg, 12./9.1917[3]

Peter Altenberg was an unusual apparition: a genuine poet, who wrote deeply felt, ecstatic sketches of everyday

He never married. His warm heart was open particularly to the heavy-laden: the tired waitresses in smoke-filled bars; the prostitutes freezing on the streets, and others who greeted him when he entered one of his favourite coffee shops and with whom he sat for hours. Or the chambermaids and staff of the Graben Hotel (still extant) in the Dorotheergasse in the city centre, where he lived for years in a small room on the top floor (Pl. 136). The racy language of these outcasts never had a better chronicler.

He never achieved real success, although he was widely read. He was a true Bohemian: one who slept all day and ruined his health by coming home in the early hours and only getting to sleep with the help of overdoses of alcohol and, worse still, tranquillizers. At dusk he would turn up in the streets of the city centre,

1896. It went through eleven editions before he died.

Altenberg came from a respectable family of Viennese merchants. His 'pathological brain', as he himself put it, made him unfit for a normal calling. He failed in everything: first as a medical student, then as a bookdealer. It was only in his thirties that he began to earn money by writing. His real name was Richard Engländer, and he chose his pseudonym in a highly romantic way: he took on a new name in memory of an unfulfilled early attachment.

The object of his passion was Bertha Lecher[4] (Pl. 141), daughter of Zacharias Konrad Lecher, editor-in-chief of the *Neue Freie Presse*, then Austria's leading daily newspaper. Lecher's wife Luise was a theatre and literature fan, and it was presumably she who invited the young poet to her house at Altenberg on the right bank of the Danube near Vienna. One of her sons had been at school with Altenberg in the Akademisches Gymnasium. Together with his two brothers, who were probably tough students and no doubt made secret fun of this ingenuous poet, he tyrannized Bertha

with measured gait and a knobbly walking-stick tucked under his arm – an apparition of supreme individual elegance. He liked to wear suits made of expensive, loosely woven checked material, the jackets of which hung straight from his shoulders. His large, childlike eyes shone from under a wide-brimmed hat that shaded his features. Instead of spectacles he wore a simple pince-nez which hung on a wide ribbon. His silk shirts were made by the best shirtmaker in Vienna, his clothing by the best tailors. He wore gaily coloured socks and openwork leather sandals. Not only was he a hypochondriac but also a health crank who vainly tried to convert others to his way of life.

Unknown to him, Karl Kraus and Arthur Schnitzler had sent those of his witticisms that had appeared in the daily press, together with other unpublished material, to S. Fischer in Berlin, then the leading German publishers. Thus it was that this shy poet was thirty-seven years old when his first and most successful book *Wie ich es sehe* (*As I see it*) was published in

Bertha {„Peter" gerufen} Lecher, 13 Jahre alt, 1880, in Altenber. a. d. Donau.

and her three sisters. As the brothers had no 'fag', the sisters had to do the more thankless household chores for them for very little pocket money, and were given men's names. So it was that Bertha was called Peter. Altenberg chose that name and the name of the village as his pseudonym.

Altenberg writes that as long as his brother[5] was alive, he managed to live on a monthly income of 240 crowns (no doubt his share of his father's firm) without incurring debts. As soon as his brother went bankrupt, however, he began to have financial trouble, and became a 'cadger', letting others pay for him in coffee-houses and restaurants and being not over-scrupulous about refunding loans which he often solicited in imploring letters. Another well-known coffee-house man of letters, the journalist Anton Kuh, who always sported a monocle, describes the general amazement when, after Altenberg's death in 1919, a savings book was found with a deposit of 120,000 crowns – a respectable sum in those days.[6]

To this day no biography of Altenberg has been published, nor a definitive complete edition of his writings and correspondence. The best source is *Das Peter Altenberg Buch* (Vienna 1922), edited by one of his friends with whom he spent whole nights sitting in coffee-houses and bars, the cultural publicist, theatre critic and cabaret actor Egon Friedell.[7] In his foreword he writes:

> Seldom has a simple chronicler of brief inspirations and abrupt impressions been so immoderately loved, admired, even worshipped; and seldom has so pure and profound, genuine and kind-hearted a human being been so thoughtlessly misjudged, misunderstood and ridiculed . . .

The book contains obituaries dedicated to him by prominent contemporary authors such as Heinrich and Thomas Mann, Alfred Kerr, Hermann Bahr, Hugo von Hofmannsthal, Felix Salten, Herbert Eulenberg, Georg Kaiser, Alfred Polgar, Adolf Loos and others, which testify to the respect in which he was held.

Dr Genia Schwarzwald, founder and headmistress of the famous Schwarzwald school, wrote the following ironical contribution entitled 'An Honourable Funeral':

> It was a beautiful, dignified funeral. Official Vienna was absent to a man . . . The women, who feel they cannot live without his panegyrics, wept. The men felt that not only the last, but also the best Viennese speciality had gone. Now they had really lost the World War . . .

The book closes with a selection of Altenberg anecdotes with which Egon Friedell used to bring the house down.

Perhaps, at this point, I may contribute an anecdote from my own reminiscences. My father used to tell us that one day he returned to Vienna from one of his numerous trips to Leipzig (where he worked for twenty-six years), and in the evening he went into a bar for a nightcap. There he saw Altenberg sitting with Friedell, had the waiter bring Friedell to his table, introduced himself and said:

> I recently read a sentence by Peter Altenberg in which he writes that it would be wonderful to be offered a bottle of Veuve Clicquot 'without the wretched donor insisting on coming to sit at my table.' So I have taken the liberty to have the waiter bring you a bottle of this excellent champagne, and wish both of you a pleasant evening. Goodbye!

1 Christian M. Nebehay Gallery, catalogue No. 6, Vienna 1963, p. 6.

2 We have found a few other texts that throw some light on the relationship between Klimt and Altenberg:

a) A declaration of love:
'Dear, beloved Klimt, had I seen nothing else of yours than your two cottage gardens, your portrait of the young Wittgenstein girl, and your painting *The Three Ages*, I would still vow lifelong admiration . . . Everything springs from a source of immeasurable strength, which then becomes sublime in the most delicate art . . . The occasional minor brushes between us were always caused by my nervousness, never by you!
9./3.1909                                      Yours, Peter Altenberg.'
(Christian M. Nebehay Gallery, catalogue No. 6)

b) As art critic, on the painting *The Three Ages*, 1905:
'No. 1 in the catalogue: *The Three Ages*. The old woman weeps over her physical collapse. She has lost her nimbus, so what use are her profound soul and her perception? The young mother is tired, she has given her baby all her strength in every sense of the word, she is tired, tired. The child is also tired, it sleeps in its mother's arms. Everything is in this painting, the tragedy and romance of a woman's life, nirvana and the gaze into the void.
'Are you a real, honest friend of nature? Then drink in these paintings with your eyes: cottage garden, beech wood, roses, sunflower, poppies!

*141* Opposite: *'Bertha (alias "Peter") Lecher, 13 years old, 1880, in Altenberg on the Danube.'* Photograph, with inscription on the mount in Peter Altenberg's own hand and bearing a lock of the sitter's hair, 1880.

The landscape is treated as you treat a woman: it has been raised to its own romantic pinnacle, it comes into its own, it is transfigured and made visible to the sceptics' joyless eyes! Gustav Klimt, a strange mixture of primitive strength and historical romanticism. Let the trophy be yours!' (*Bilderbögen des kleinen Lebens'*. Berlin, 1909, p. 115 ff)

c) 'Fame. [The only known Klimt anecdote]
This summer a large group of us artists were in a champagne pavilion in Venedig in Wien [Venice in Vienna, a famous amusement park in the Vienna Prater]. Three sweet girls came and sat with us. Someone in our party said to them: "Girls, do you know what company you're keeping today? This gentleman here is the famous artist Gustav Klimt!"

"Oh?" said the girls nonchalantly. Then a fourth girl joined them and said: "Do you know who that is? I know exactly who it is . . ." "What's that got to do with us, who he is?" "But that's the gentleman who paid for twelve bottles of Heidsieck this winter in the Casino de Paris!" "What, that's him? Now I recognize him! Good health, Sir . . .'"
(*Bilderbögen des kleinen Lebens*. Berlin, 1909, p. 97)

3 Facsimile of an Altenberg letter in *Das Werk Gustav Klimts*, Vienna 1918.

4 Dietmar Grieser, *Schauplätze österreichischer Dichtung*. Münich–Vienna 1974, p. 61 ff.

5 Altenberg dedicated his book (published posthumously) to him:
'I dedicate this book to my brother Georg. Hard pressed by life, working, striving, he nevertheless had the deepest and most tender understanding for him who, dreaming, meditating, beholding, was perfidious enough to elude the harsh law of the day!' (*Was der Tag mirzuträgt*, Berlin 1921, p. 9).

6 Anton Kuh (1890–1941), *Von Goethe abwärts*, Vienna 1921.

7 Egon Friedell (alias Friedmann), critic, actor and freelance writer (mainly cultural history). (1878–1938, committed suicide)

*142* Poppy Field
*(D.149), 1907. Oil on
canvas. 110 × 110 cm.
Österreichische Galerie,
Vienna.*

# GUSTAV KLIMT AND JOSEF HOFFMANN

*144 Portrait of Josef Hoffmann. Photograph, about 1918.*

Josef Hoffmann[1] was not only an excellent architect but also a brilliant craftsman. Unfortunately much of his best work from around 1900 was lost. Charles Rennie Mackintosh's[2] oeuvre was almost completely destroyed in Glasgow, only a few of his creations having survived; but the outcome in Hoffmann's case – difficult though it may be to grasp – was equally sad, if not sadder.

The best Jugendstil artists needed customers who followed them blindly. They inflicted on their customers – forcefully, one is tempted to say – what seemed to them to be well made and beautiful, and watched over their creations with Argus eyes lest even the smallest detail be altered. Hoffmann, for instance, never set foot again in the Kaffee Kremser on the Kärntnerring in the Ist district – a coffee-house he frequented for years, where he took his afternoon coffee in the company of his friends – because the luckless proprietress had decided to alter something for practical reasons. The bone of contention was a potted palm which Hoffmann had placed to the left of the cashier so that the waiters who came out of the kitchen tripped over it. The proprietress therefore moved it to the right of the cashier, and when she refused Hoffmann's request that she put it back, there was a row and Hoffmann never returned to the café.

This small incident perhaps explains why subsequent generations lost their patience and began to do away with objects that had been the pride and joy of their owners. It is a fact that in some cases the interior decorators simply went too far and their unyielding refusal to fulfil reasonable wishes resulted in their creations being destroyed. One should also remember that the change from the historical style to Jugendstil was radical and the next generation, not being able to sift the chaff from the wheat, dismantled through sheer ignorance objects they should have better left intact. It is a sad fact that in the whole of Austria no single dwelling exists, no Hoffmann interior furnished by him with unrivalled perfection, and that our museums can show nothing that would bear witness to the brilliance and beauty of his creations.

Hoffmann – if we are to grade him as an interior architect – was a perfectionist. The rooms he furnished were unique in their harmony: the colour of the walls, the grain of the wood, the chandeliers, the furniture, the objets d'art were not only chosen with loving care but also made in the best possible taste. His masterpiece, the Palais Stoclet in Brussels (see p. 151 ff) is a mecca – without being a museum, since it is still inhabited and lovingly cared for by the descendants of

*143 Opposite: Chair by Josef Hoffmann for Gustav Klimt's studio at 21 Josefstädterstrasse in the VIIIth district, made by the Wiener Werkstätte. 1905. Oak, stained black with white grain.*

*145 Josef Hoffmann, Poster for the Wiener Werkstätte, about 1908. 90 × 62 cm. One of a series of indoor posters with hand-stencilled background patterns.*

*146 Opposite: Josef Hoffmann, A silver chain with a heart-shaped pendant featuring a mirror in which two opals are embedded behind perpendicular silver bars, about 1905.*

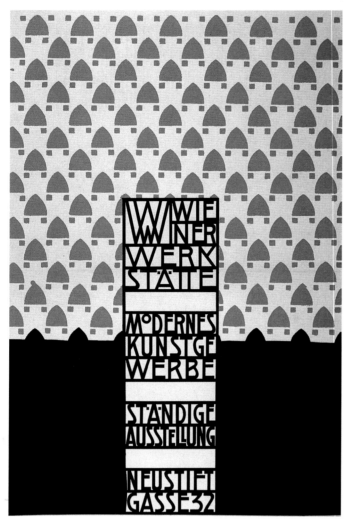

Josef Hoffmann had attended the Technical Academy at Brünn. He spent a year in the army building office, and from 1892 to 1895 he studied at the Academy of Fine Arts in Vienna, first under Karl von Hasenauer,[6] architect and chief surveyor, and then under Otto Wagner,[7] brilliant founder of the Wagner School which produced many eminent and pioneering architects, Hoffmann and Joseph Maria Olbrich, the architect of the Secession building, being among his best pupils.

From 1897 onwards Arthur von Scala,[8] an exceptionally open-minded person, was director of the Austrian Museum of Art and Industry. The museum had been founded in 1863, the first of its kind on the Continent, by Rudolf von Eitelberger with the aim of setting a standard for the up and coming arts and crafts industry in the Austro-Hungarian Empire. Scala was full of admiration for the contemporary English style of life, especially for the Arts and Crafts movement. He broke with the traditional historicist style and reformed the regional handicrafts. Owing to the fact that he engaged first-rate artists, he paved the way for Jugendstil in Vienna; but his continued imitation of English models eventually brought him into conflict with the aims of the Secession and the Wiener Werkstätte, who both attempted – with some success – to create a new, identifiably Austrian language of form.

Scala must, however, be given credit for having sent Felician van Myrbach (director of the neighbouring Academy of Arts and Crafts from 1899 to 1905) together with Josef Hoffmann to Glasgow. Hoffmann had become professor at the Academy in 1899 and had taught there for some years. His meeting with Charles Rennie Mackintosh, whose design was to have a strong influence on him, led to a close friendship which deepened when the Mackintoshes visited Vienna in 1902.

The Wiener Werkstätte began work in 1903 and soon grew to be an enterprise that earned the admiration of the whole world: idealistic, yet not commercially run. In no time its craftsmen, who were talented and had learned their trade in the days of the historicist

the original owner. Unfortunately it is very difficult nowadays to obtain permission to view the house.

In 1982 a book of fundamental importance[3] was published on Hoffmann as architect, which gives excellent information on the basic facts; we can therefore concentrate on the Palais Stoclet, especially as it was here that the co-operation with Gustav Klimt proved to be most fruitful. So far no basic book has been published about Hoffmann as artisan. A large book has appeared[4] on the Wiener Werkstätte, which Hoffmann founded in 1903 together with Kolo Moser,[5] who was equally talented, and Fritz Waerndorfer who financed the project (see p. 140). But the book cannot be termed a catalogue raisonné.

style, but were now inspired by first-rate designers, produced work of extraordinary quality. Hoffmann re-animated the crafts in every field, whether jewelry, furniture, silverware, textiles, fashion, glass, etc. There was even an attempt to publish artistic postcards, some of which were designed by Oskar Kokoschka and Egon Schiele. Josef Hoffmann had, in other words, the great gift of looking out for new young talents and employing them to the best of his ability.

But, as we have already seen, from the very beginning and all through the years the enterprise lacked a solid commercial basis. We shall see (p. 140 ff) that Fritz Waerndorfer and Otto Primavesi lost their fortunes there. In the end, in spite of repeated optimistic efforts to start up again, the Wiener Werkstätte had to close its doors in 1932.

To come back to the Hoffmann–Klimt relationship: Hoffmann was one of the founders of the Secession in 1897. He had been detailed to set up the first exhibition, which was still housed in the Gartenbaugesellschaft building on the Parkring. The results of his efforts were sensational and largely contributed to the success of that first exhibition. His style at the time was still earthbound, ornamental and somewhat dated; Olbrich, who set up the second exhibition (the first to be housed in his new pavilion) followed on the same lines.

The eighth exhibition took place on Hoffmann's initiative and confronted the young Austrian artisans with the best from abroad. Hoffmann was entrusted with the arrangement of five rooms, Kolo Moser with two, and the Mackintoshes presumably with room X (Pl. 161). The tenth exhibition showed Klimt's second University painting, *Medicine* (Pl. 72); and one can but admire the way in which Kolo Moser established the new Viennese exhibition style, which served as a model and was later taken over by Hoffmann.

One of the high points in the collaboration between Hoffmann and Klimt – the latter always in the background but nevertheless, thanks to his personality, the leader of the Secession as long as the Klimt group was still in the house (until 1905) – was the fourteenth exhibition (see p. 97 ff).

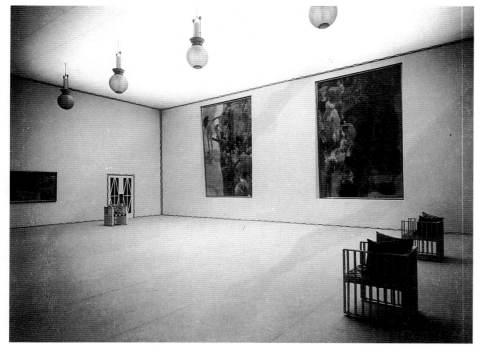

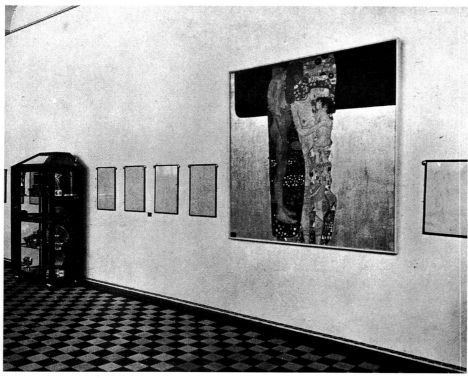

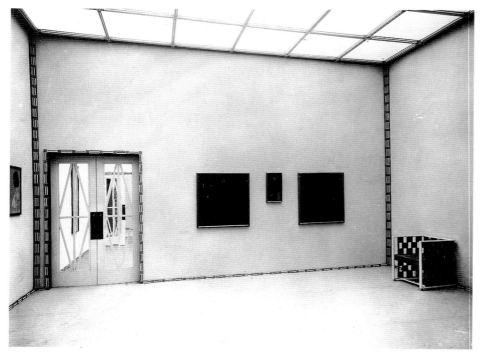

For the eighteenth exhibition (the Klimt collective show) Moser and Hoffmann acted as interior architects (Pl. 147, 149, 150). All three University paintings were shown there for the first time.

The last high point was the nineteenth exhibition (see p. 115) which housed, for the first time, a collective show of Ferdinand Hodler's paintings (Pl. 127) and brought this artist recognition beyond Switzerland. Here again the Moser-Hoffmann duo took the arrangements in hand. Soon afterwards Moser married a well-to-do lady and was able from then on to devote himself to painting.

The climax of the Hoffmann–Klimt co-operation was reached in the two Kunstschau exhibitions in 1908 and 1909 (see p. 168). The first of these was devoted to modern Austrian artists, the second confronted them with European artists. On the site that was later to accommodate the Vienna Konzerthaus (built in 1913), Hoffmann found room to set up improvized pavilions with fifty-four rooms. The two Kunstschau exhibitions were the last manifestations of the Klimt group after it had left the Secession.

Hoffmann also erected the Austrian pavilion at the International Exhibition of Art in Rome (Pl. 148). Klimt's painting *The Three Ages* (Pl. 155) won a gold medal and was acquired by the Galleria Nazionale d'Arte Moderna. (In 1910, incidentally, the Galleria d'Arte Moderna in Venice acquired Klimt's *Judith II* which he had painted in 1909.) It is to Italy's credit that it was the only country outside the Austro-Hungarian Empire to recognize Klimt's importance.

Klimt was himself a client of the Wiener Werkstätte: he ordered jewelry from them which he gave Emilie Flöge (Pl. 146). In 1906 his mother celebrated her seventieth birthday, and the Wiener Werkstätte gave her a large and comfortable armchair, clearly designed by Hoffmann, with a small gilt card bearing the words: 'For Gustav Klimt's mother, from the WW'; photographs exist of the card and of Klimt's mother happily seated in the armchair.[9] There also exist objects designed by Hoffmann: a throne-like chair with arms (Pl. 143); Klimt's seal with his initials, made of silver

Opposite:
*147* Above:  *Main room of the eighteenth Secession exhibition (Klimt collective), arranged by Kolo Moser, 1903. Photograph. On the left wall* Music II *(D.89), on the right the two University paintings* Medicine *(D.112) and* Philosophy *(D.105).*

*148* Centre:  *The Klimt room in the Austrian pavilion arranged by Josef Hoffmann for the International Art Exhibition, Rome 1911. Photograph. On the wall,* The Three Ages *(D.141), which was bought in 1912 by the Galleria Nazionale d'Arte Moderna in Rome: and five Klimt drawings in Hoffmann frames which were stained black.*

*149* Below:  *Main room of the Secession's eighteenth exhibition (Klimt collective), arranged by Kolo Moser. Photograph, 1903.*

This page:
*150* Above:  *The hallway of the eighteenth Secession exhibition, arranged by Josef Hoffmann, with a glimpse of Gustav Klimt's* Pallas Athene *(D.93). Photograph, 1903.*

*151* Below left:  *Josef Hoffmann, seal for Gustav Klimt; made by the Wiener Werkstätte, about 1910. Silver with semiprecious stones.*

*152* Below right:  *Josef Hoffmann, box made by the Wiener Werkstätte. Gilt brass inscribed: 'For your fiftieth birthday. Wiener Werkstätte. Vienna, 14.VII.1912.'*

137

153 Below: *Catalogue of the Austrian pavilion at the International Art Exhibition in Rome 1911. Cover by Rudolf Junk.*

154 Above: *Study for the painting* The Three Ages *(AS 1306), 1904. Pencil. 54.9 × 35 cm. Institute of Arts, Detroit.*

155 Opposite: The Three Ages *(D.141), 1905. Oil on canvas. 180 × 180 cm. Galleria Nationale d'Arte Moderna, Rome.*

and set with semi-precious stones (Pl. 151); Klimt's tiepin and his cufflinks in a leather case; and a small bowl with a lid (Pl. 152), in chased brasswork, with the inscription: 'For your 50th birthday. The Wiener Werkstätte. Vienna, 14.VII.1912.'

Hoffmann himself designed frames for the Klimt drawings that were shown at various exhibitions. These frames were handsome, but they were stained black, which no one would think of doing nowadays. On closer inspection they can be seen on the photographs of the exhibitions.

1 Josef Hoffmann, architect and craftsman (1870–1956)

2 Charles Rennie Mackintosh, Scottish craftsman (1868–1928)

3 Eduard F. Sekler, *Josef Hoffmann. Das architektonische Werk*, Monograph and Catalogue, Salzburg 1982

4 Werner J. Schweiger, *Wiener Werkstätte. Kunst und Handwerk 1903–1932*. Vienna 1982

5 Kolo(man) Moser, craftsman, painter (1868–1918)

6 Karl von Hasenauer, architect (1833–1894)

7 Otto Wagner, architect (1841–1918)

8 Arthur von Scala, museum expert and economist (1845–1909)

9 Christian M. Nebehay, *Gustav Klimt: Dokumentation*, Vienna 1969, p. 14

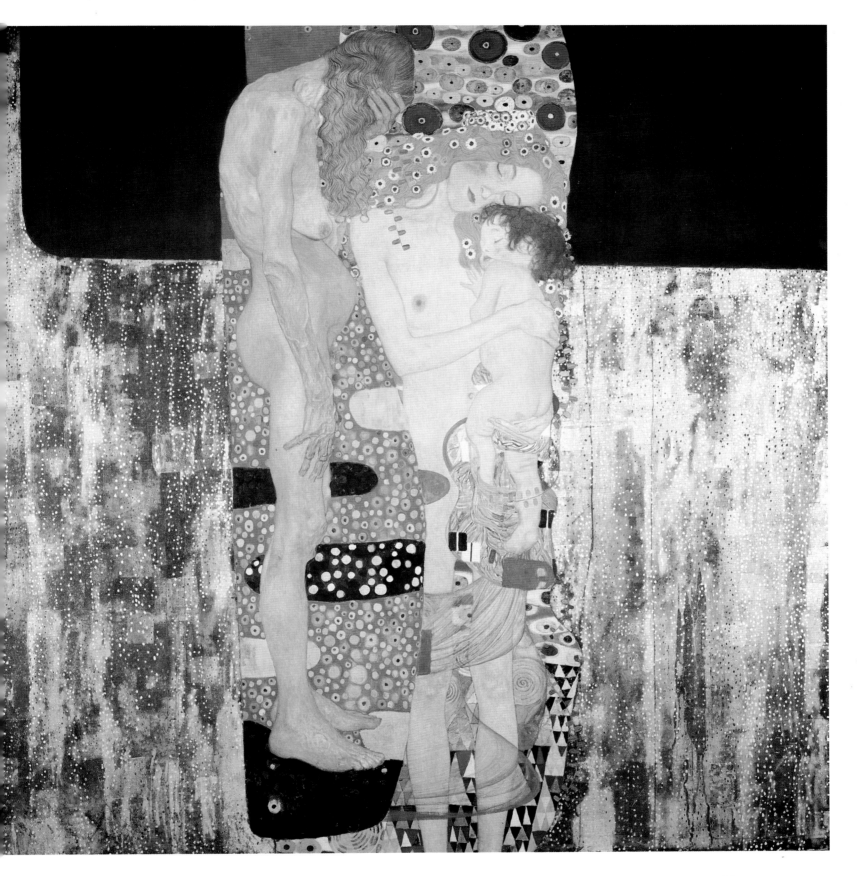

# GUSTAV KLIMT, FRITZ WAERNDORFER
## AND THE PRIMAVESI FAMILY

*156 Fritz and Lili Waerndorfer. Photograph, about 1895.*

Very little was known about Fritz Waerndorfer until recently, and too little attention has been paid to him considering the important role he played in the Viennese art scene around 1900. It is thanks to a British art historian that we now know more.[1] The British interest in Fritz Waerndorfer probably has to do with his music room, furnished by Mackintosh.

Fritz Waerndorfer was of Jewish descent. His family owned the large cotton-spinning mill Waerndorfer-Benedict-Mautner in Nachod, Bohemia. Further purchases of mills in Günseldorf, Lower Austria, increased the firm's capacity to the considerable number of 63,000 spindles.

The young Fritz Waerndorfer – he used this spelling although the family's name was in fact Wärndorfer – attended the Akademisches Gymnasium in Vienna. Restless as he was, he was taken out of the school in the 1890s and sent to England for a prolonged stay to study his family's trade. But he spent his time visiting the London museums and art dealers, for modern English design fascinated him. He was apparently – as was Hermann Bahr – a freemason, and over many years he kept up a correspondence with Bahr which has come down to us. It was also Bahr who established contact between him and the Klimt group.

Waerndorfer gave a big dinner party for Klimt in 1901, and it was probably he who had Klimt's studio in the Josefstadt fitted out with furnishings by Josef Hoffmann while Klimt was away on the Attersee. More important, though, is the fact that in 1906 he took Klimt with him as his guest on a trip to London, where Wiener Werkstätte objects were on show at Earls Court. Klimt's entrance ticket was found among his papers after his death (Pl. 350). Together with Josef Hoffmann and Kolo Moser, Waerndorfer was one of the founders of the Wiener Werkstätte. He was their first financier and lost so much money this way that his infuriated family banished him to the United States after his bankruptcy in 1914, and there he stayed for the rest of his life.

Waerndorfer was an extremely interesting personality and an important figure in the art scene. For the Wiener Werkstätte it was particularly useful to have at its head a liberal man who, just by ordering a complete dining room from Josef Hoffmann, could create employment. It should not be forgotten that life was anything but easy for this young enterprise, run as it was on artistic rather than on commercial principles.

Waerndorfer is above all interesting as a collector. But before we come to speak of his purchases of Klimt

140

paintings, it is worth mentioning that he owned no fewer than 150 autograph letters of the British draughtsman and book illustrator Aubrey Beardsley,[2] among them the famous letter written on his deathbed to his publisher Leonard Smithers, in which he implores him to destroy all the obscene drawings that might be found in his estate – in order, he wrote, to save his soul.

Another artist whose works Waerndorfer collected was the Belgian sculptor George Minne,[3] whose masterpiece was *Kneeling Boys* – figures around a fountain, still plaster, not yet cast in bronze (Pl. 163) – shown at the eighth Secession exhibition in the autumn of 1900; these figures were to influence Oskar Kokoschka as well as Egon Schiele. As with Hodler, Minne was an artist who achieved international recognition through the Secession:

> it is the home city of the intransigent George Minne, whose austere sculpture has been bought up by his native land . . . Who . . . in Belgium thought it worthwhile to execute these lean, suffering, martyred figures in marble? It was in Vienna that he got his first commission for a marble statue. In the Vienna Secession they built a special temple-like rotunda for his works, with the round fountain in the centre, surrounded by kneeling boys. When Herr Wärndorfer visited the artist in his home village in Belgium (Laethem St. Martin), he saw this fountain with its eight boys in the middle of the family's living-room, for Minne did not even have a studio: a humble villager and rustic modeller, chiselling away in those oppressively narrow confines. Since then Minne is sculpting monuments in his own land . . .[4]

Few people know that Waerndorfer was also one of Klimt's chief customers. He owned the following Klimt oils:

*Pallas Athene* (D.93), 1898 (Pl. 97)
*Orchard at Dusk* (D.106), 1899
*Pond in the Castle Park at Kammer* (D.108), 1899
*Farmhouse with Birch trees* (D.110), 1900

Waerndorfer's chief acquisition was Klimt's *Hope I,* 1903 (Pl. 160), which hung in a cabinet designed by Kolo Moser and was only shown to special friends.

Ludwig Hevesi writes of this painting:

*157* Above: *Ver Sacrum third year, 1900, in a special binding presumably created by Josef Hoffmann for Fritz and Lili Waerndorfer, 1901. White leather stamped in gold.*

*158* Below: *Part of a silver dinner service for Fritz and Lili Waerndorfer, designed by Josef Hoffmann and executed by the Wiener Werkstätte, 1904.*

Following pages:
*159* Left: *Study for the painting* Hope I *(AS 953), 1903–04. Blue crayon. 45 × 31 cm.*

*160* Right: Hope I *(D.129), 1903. Oil on canvas. 181 × 67 cm. National Gallery of Canada, Ottawa.*

That evening we sat together for a long time and looked at the austere works of art collected by Herr Wärndorfer. One large painting is screened off from intruders by two hermetically closed folding doors: this is the famous – or should we say infamous? – *Hope* by Klimt, namely of that young woman in the last stages of pregnancy whom Klimt dared to paint *au naturel.* One of his masterpieces. A deeply moving creation . . . It could not be shown in the Klimt exhibition two years ago because the powers that be turned it down. Now it lives, highly secluded, in the Wärndorfer home.[5]

Fritz Waerndorfer's most precious possession was his music room, designed and furnished by Mackintosh with paintings by his wife, Margaret Macdonald-Mackintosh (Pl. 162). From what we know it must have been a jewel of art created around 1900, which, sadly, disappeared without trace after the Waerndorfer household had dispersed in 1914. A drawing by Margaret Macdonald (pencil and wash), found in the Hunter Museum in Glasgow, is the only indication of what had been lost.

The neighbouring salon is the famous Mackintosh room that was once the great topic of conversation in the Secession. A group of avant garde art lovers had invited Mr and Mrs Mackintosh to come to Vienna as their guests. The couple came and stayed six weeks, and the result was the Mackintosh room in the Wärndorfer home: an artistic curiosity of the first order, but also an abode of spiritual enjoyment . . . To start with, an elegant room for Maeterlinck's *Six Princesses.* The arresting parts of the ornamentation are the eyes and the tears: stylized eyes and tears in Frances MacNair's woodwork, in the glazing, in the delicate embroideries. The upper walls are still awaiting their illustrations of the Six Princesses.[6] Will they be woven or embroidered? This room is an organism in itself. The furniture fits in like the natural organs of a living creature.[7]

Mackintosh was just as much a victim as Klimt of the senseless destruction of masterpieces that prevailed at the time. In an article that appeared in the *Burlington Magazine* (July 1983, p. 402), Peter Vergo reports on a newspaper article, published in 1916, about the intended sale of the house that had been vacated by Waerndorfer's divorced wife Lili. The Museum of Applied Arts let it be known that, regrettably, it did not have the necessary funds to acquire either Hoffmann's

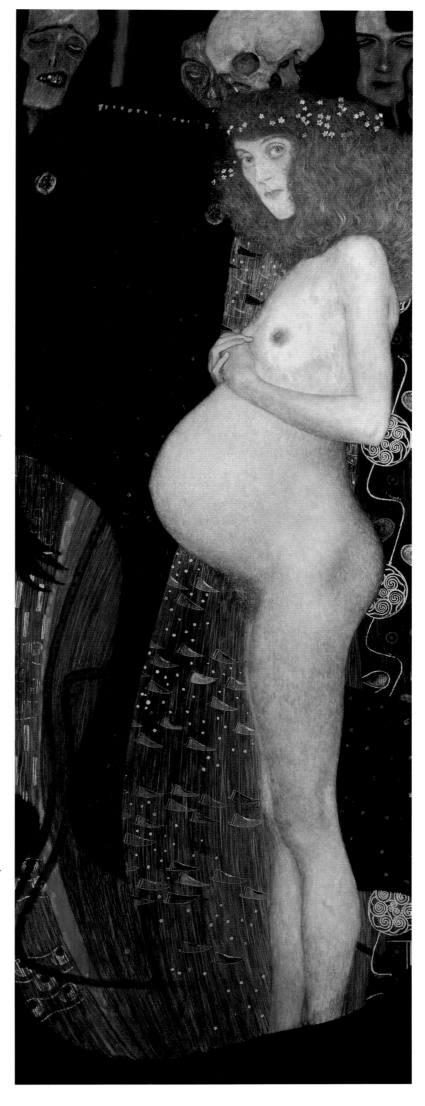

161 Above left: *Charles Rennie Mackintosh and Margaret Macdonald Mackintosh. View of Room X in the eighth Secession exhibition, designed by them. Fritz Waerndorfer then commissioned the couple to design the legendary music room in his apartment at 45 Carl Ludwig-Strasse in the XVIIIth district. Reproduction from* Ver Sacrum, *4th year, 1901, p. 399.*

162 Below left: *Charles Rennie Mackintosh, part of the music room in Fritz Waerndorfer's apartment in the XVIIIth district. Photograph, 1903.*

163 Above right: *George Minne,* Fountain; *Five youths kneeling on the edge of a fountain. Designed in 1898 and shown at the eighth Secession exhibition in November–December in Vienna, where it was acquired by Fritz Waerndorfer. Plaster model. Height of figures 80 cm. Reproduction from* Ver Sacrum, *4th year, 1901, p. 30.*

164 Below right: *Kolo Moser, Ex libris for Fritz Waerndorfer, 1903.*

dining room or Mackintosh's music room. The author closes with the words:

> One can readily imagine that the new owners of the house in

the Carl-Ludwigstrasse found the decor hideous and simply removed it. If this was really the case, then the destruction of the Waerndorfer furnishings . . . must be considered as the most regrettable case of vandalism of our century.

Like Fritz Waerndorfer, Otto Primavesi – his successor in the Wiener Werkstätte – became an important collector of Klimt paintings. In 1914 the Primavesi family had acquired shares of the Wiener Werkstätte, and the main shareholder was the industrialist Otto Primavesi. From 1915 to 1925 he was manager of the Wiener

144

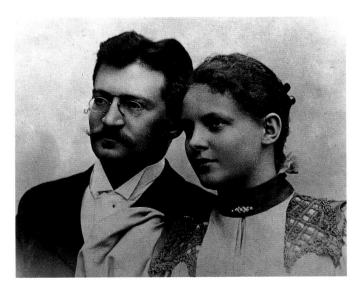

Werkstätte, but he also failed to solve the enterprise's financial problems.

In 1912 Primavesi had made the acquaintance of Josef Hoffmann and commissioned him to convert his

bank in Olmütz. At the same time he had him build a country house in Winkelsdorf (Pl. 166) in the Mährisch-Schönberg region of the Altvater mountains, which he moved into in 1914. Berta Zuckerkandl wrote about it in 1916 in the journal *German Art and Decoration*.[8]

The Primavesis were good customers of the sculptor Anton Hanak;[9] they bought a number of his works. It was presumably through Hanak that they met Hoffmann and, later, Gustav Klimt.

The Primavesi family owned the following paintings by Klimt:

*Farmhouse with Roses* (D.99), about 1898
The working drawings for the Stoclet frieze (D.152), 1905–09 (Pl. 185)
*Portrait of Mäda Primavesi* (D.179), 1913 (Pl. 170)
*Portrait of Eugenia Primavesi* (D.187), 1913–14
*Litzlberg Cellar* (D.193), Attersee, 1915–16 (Pl. 173)
*Garden with Mountain Top* (D.216), 1917

*165* Above left: *Otto and Eugenia (Mäda) Primavesi. Photograph, about 1900.*

*166* Below left: *Notepaper by Josef Hoffmann for the house that he built and furnished for the Primavesis in Winkelsdorf. The letterhead shows a view of the interior. 1914.*

*167* Below right: *Gustav Klimt at one of the Primavesis' artists' parties, wearing a housecoat made from a Wiener Werkstätte material, 'Wood Idyll', designed by Carl Otto Czeschka. Photograph, 1916. Österreichisches Museum für angewandte Kunst, Vienna.*

Following pages:
*168* Left: *Study for the painting* Portrait of Mäda Primavesi *(AS 2119), 1912–13. Pencil. 55.8 × 36.6 cm. Historisches Museum der Stadt Wien.*

*169* Below: *Sketch for the painting* Portrait of Mäda Primavesi *(AS 2139), 1913. Technique and dimensions unknown.*

*170* Right: Portrait of Mäda Primavesi *(D.179), 1913. Oil on canvas. 150 × 110 cm. The Metropolitan Museum of Art, New York.*

The country house in Winkelsdorf, which unfortunately burnt down completely in 1922, served as a refuge for many artists during the First World War when food became very short. In spite of the war, artists' feasts repeatedly took place there (Pl. 167) and were also attended by Gustav Klimt.

1 Peter Vergo, professor at Essex University, is a first-rate specialist on this period – see, for example, his article 'Fritz Waerndorfer as Collector' in: *Alte und moderne Kunst.* Vienna 1981/77, p. 33 ff. Fritz Waerndorfer's dates: 1868–1931.

2 Aubrey Beardsley, British draughtsman and book illustrator (1872–1898)

3 George Minne, Belgian sculptor (1866–1941)

4 Ludwig Hevesi, *Altkunst–Neukunst*, Vienna 1909, p. 223

5 *ibid.*, p. 223

6 They arrived after Hevesi's article had appeared.

7 As note 4, pp. 222–223

8 *Deutsche Kunst und Dekoration*, 1916/38, pp. 199–221. See plates on pp. 198–224.

9 Anton Hanak, sculptor (1875–1934)

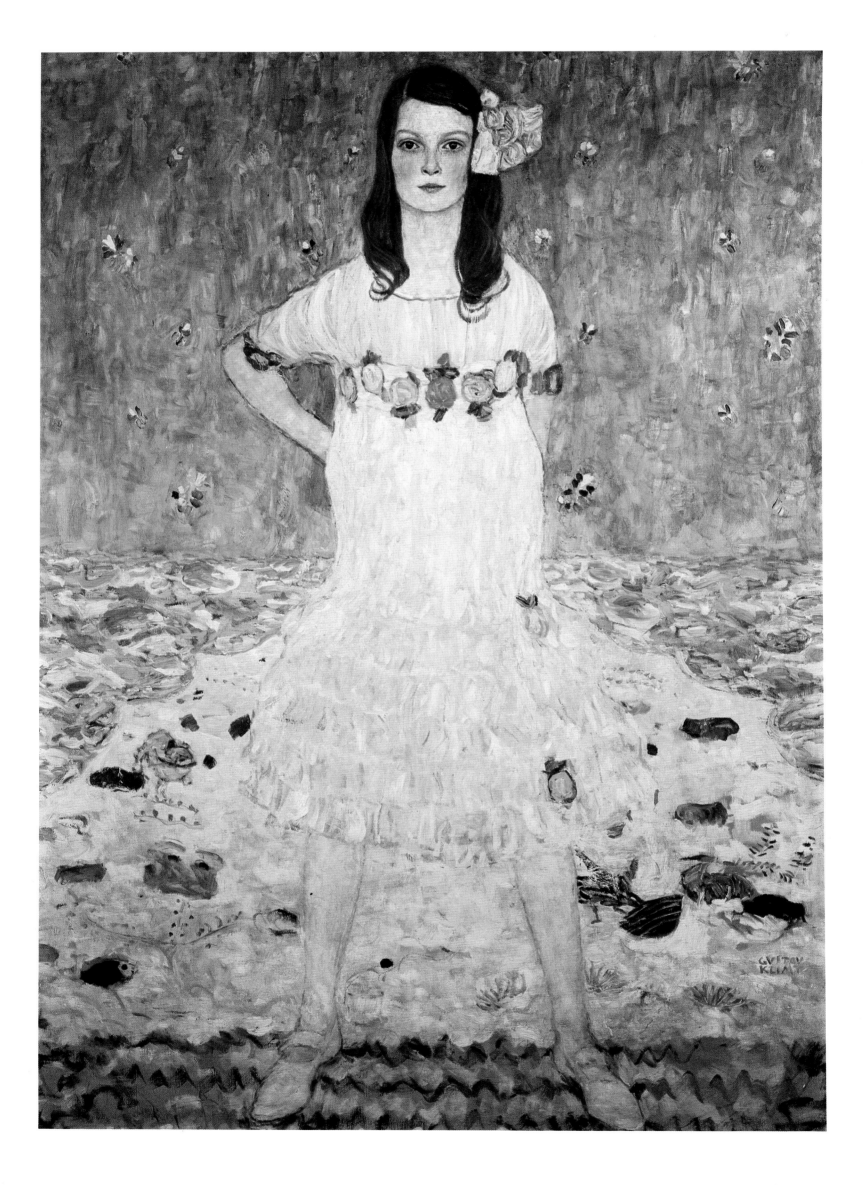

*171* Above: *Studies for the painting* Portrait of Eugenia Primavesi *(AS 2157), 1912–13. Pencil. 56 × 37.5 cm. Detail.*

*172* Below: *Eugenia Primavesi in her house in Winkelsdorf. Photograph, about 1916. Klimt archives, Graphische Sammlung Albertina, Vienna.*

*173* Opposite: Portrait of Eugenia Primavesi *(D.187), 1913–14. Oil on canvas. 140 × 84 cm. Toyota City Museum, Toyota, Japan.*

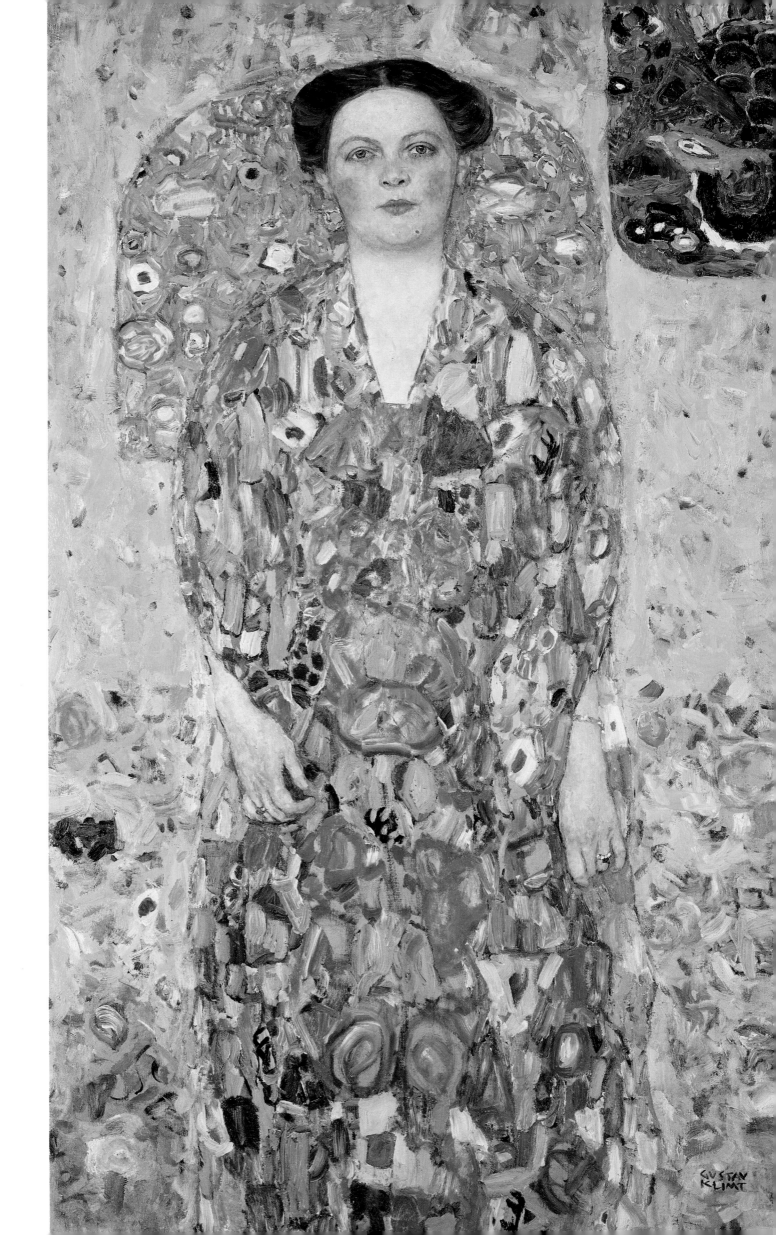

# THE STOCLET FRIEZE

*175 Josef Hoffmann's Palais Stoclet in Brussels under construction. Photograph, about 1907–08.*

*174* Opposite: *Finished small-scale project for* Expectation, *also known as* The Dancer, *for the working project of the Stoclet frieze (AS 3579), about 1908. Pencil, watercolour and gouache on gold-bronze tracing paper. 22 × 75.3 cm. Detail. Österreichisches Museum für angewandte Kunst, Vienna.*

Josef Hoffmann built the Palais Stoclet at 281 Avenue Tervueren, Brussels, from 1905 to 1911. At the time of its erection the house stood slightly set back from the broad street leading out of the city and commanded an extended view over fields to a wood, which probably accounted for the look-out tower (Pl. 177), topped by a gilt dome of flowers and flanked by four somewhat static, athletic male figures by the sculptor Franz Metzner.[1]

A further detail that catches the eye is the facing of the walls in white Turilli marble framed in gilt and black metal. The flower-dome is mildly reminiscent of Joseph Maria Olbrich's myriad gilt leaves on the cupola of the Vienna Secession building;[2] in the same way as the Pallas Athene over the porch, the work of the Viennese sculptor and potter Michael Powolny,[3] recalls Gustav Klimt's painting of the same name. At the eastern end of the building the figure of a pot-bellied man with an elephant's head can be seen: the Indian god Ganesha, remover of obstacles and protector of learning. The exterior of the house thus affords a foretaste of what awaits the visitor inside.

It is a dream house, not so much on account of its exterior – in spite of its commanding setting on the hill – as its interiors. It is Hoffmann's chef d'oeuvre: it is here that his dreams came true. The house, which is to this day still the property of the Stoclet family, may strike some visitors merely as a remarkable building; but in the building's interiors the viewer can experience the wonderful harmony of Hoffmann's 'Gesamtkunstwerk' (artistic synthesis): room after room, wall after wall, object after object, everything has been thought out to the last detail with love and skill by this artist of genius.

Thanks to the congenial teamwork of Hoffmann and Klimt, which had already proved itself on the occasion of the fourteenth Vienna Secession exhibition in 1902 (Max Klinger's *Beethoven* and Klimt's Beethoven frieze), the most renowned dining room of its time constituted an absolute high point of Austrian artisanship in the splendid days of Vienna's own 'Ver Sacrum' at the turn of the century.

Incredibly, not one of Hoffmann's numerous interiors has survived in Vienna in its original form. The reason for this is probably that these interiors were conceived to satisfy the special requirements of clients, and the next generation felt confined in them. All the more recognition is due to the fact that in the Palais

*176 Gustav Klimt, Josef Hoffmann and Fritz Waerndorfer on the building site of the Palais Stoclet. Photograph, 1906. Österreichisches Museum für angewandte Kunst, Vienna.*

Stoclet the third generation is still tending its inheritance, although, sadly, the house is now practically closed to visitors. It is also worth mentioning that the copper roof has also been replaced, having been removed by the German occupation forces during the First World War when copper was scarce.

Baron Adolphe Stoclet moved in the world of Belgian banking and high finance. He was known to be a dedicated art collector with a preference for primitive art. His wife Susanne was the daughter of the influential Parisian art critic and dealer Arthur Stevens, a brother of Alfred Stevens,[4] whose reputation as a portrait painter of Parisian society had spread beyond France. When newly married, the Stoclets had spent a few years in Vienna and were much struck by Viennese Jugendstil. Walking one morning to the 'Hohe Warte' (then a popular inn in the XIXth district), the couple came upon the colony of villas by Hoffmann. Their interest aroused, they went into the garden of one of the villas and were cordially greeted by its owner, who

was none other than the artist Carl Moll.[5] Moll introduced them on that very day to Josef Hoffmann, with whom they immediately struck up a friendship based on sympathy and understanding, the prerequisites to fruitful collaboration. At first there was talk of building a villa on an unoccupied site behind Moll's villa, where Hoffmann's Villa Ast, known between the two world wars as Villa Mahler-Werfel, now stands. In 1904, however, Baron Stoclet's father died and he was recalled to Brussels. There, with a large fortune at his disposal, he commissioned Josef Hoffmann to build the Palais Stoclet.

Eduard Sekler writes in his Hoffmann monograph,

The house was a highly personal setting for a way of life based on deep respect for beauty and for the transfiguring power of art, devised by a man who was also a realist, capable of running an important bank and at the same time of enjoying a bathroom reminiscent, in its dimensions and luxury, of the thermal springs in Rome. Pride of possession, in this house, is tempered by the reticence of a highly cultivated individualist for whom aesthetic perfection takes on an almost metaphysical connotation. This no doubt also explains the hieratic character of some parts of the building, which so impressed contemporary visitors that they compared them to Egypt and Byzantium.'[6]

The cost of the house has remained a secret to this day. The owner gave Hoffmann 'carte blanche', and Hoffmann let himself go. His client insisted on the very best, and the result was a house that was intelligently and skilfully conceived, with rooms furnished on a scale of luxury unusual for the times.

Carl Moll wrote in the *Neues Wiener Tagblatt* on 24 January 1943:

In my friendship with Gustav Klimt it was Klimt who gave and I who received, whereas between Gustav Klimt and Josef Hoffmann a balance was held by virtue of their artistic collaboration. Klimt's influence was perceptible in the Wiener Werkstätte, and, vice versa, the Wiener Werkstätte influenced him in his middle period. Their teamwork found its highest expression in Klimt's frescoes for the exhibition of Klinger's *Beethoven* and in that monument to an epoch of Viennese culture, the frieze for the dining room of the Palais Stoclet in Brussels. Klimt died in 1918 at the zenith of his artistic achievement. The Wiener Werkstätte, admired abroad, had to close down in Vienna for lack of patronage.[7]

177 Above: *The Palais Stoclet seen from the garden. Photograph, about 1910.*

178 Below: *The dining room in the Palais Stoclet. The frieze with the figural composition* Fulfilment, *also known as* Embrace, *on the long side wall of the room, where the entrance door can also be seen. On the sideboard is a centrepiece in the form of the Palais. Photograph, about 1911.*

A detailed description of the interiors would exceed the scope of this book. The following important items should, however, be mentioned: the great hall, which once housed the main objects of the Stoclet art collection; the music and theatre room with walls clad in Portovenere marble framed in gilt copper, a built-in organ, red curtains and red armchair covers; not forgetting the bathroom on the first floor, of unusual size, with walls clad in greenish Statuario marble, insets of black marble and a floor of blue Belge marble.

These interiors met the wishes of the proprietors, who were agreed that, with the exception of a statue by the Belgian sculptor George Minne,[8] only Austrian work should be shown. The magazine *Le Flambeau*, in an obituary published in 1949 and entitled 'Adieu à Monsieur Adolphe Stoclet', described the Stoclet couple coming down the stairs to meet their guests: 'The lady of the house in a gold lamé creation by Poiret [the fashionable Parisian dress designer of the day] – heron's

154

feathers in her hair, at her side Adolphe Stoclet with his symmetrical Assurbanipal beard . . . The flowers on the table, all of the same colour, and Mr Stoclet's tie exactly matched the lady's attire. There was nothing commonplace, provisional or mediocre about the house.'

Georges A. Salles,[9] in his foreword to *The Adolphe Stoclet Collection*, had the same recollections of Adolphe Stoclet: 'His black beard, shot with silver, his manner – charming but with a very slight touch of the pompous – and his distinguished bearing lent him a remarkable affinity to the style of the objects in his collection, with which he seemed to have a natural contact. Indeed, the marble panelling in the great hall harmonized just as well with him as it did with the carvings to which it formed a background: Buddhist gods, Egyptian kings, a head of Darius, a Khmer torso, a golden bear or a green dragon. He was entirely at home in these monumental surroundings.'

The big rectangular dining room (Pl. 178, 179) is panelled in white speckled Paonazzo marble. The dressers are of dark Portovenere marble and Macassar wood; the long, highly polished table is surrounded by twenty chairs covered in black leather with gilt borders; at one end of the room are two showcases containing silver table decorations designed by Josef Hoffmann. In spite of repeated requests permission has unfortunately never been given to photograph the fully set table. The centrepiece is a small replica of the Palais (Pl. 178). The floor is chequered and a large gilt-ornamented carpet is spread under the table. Klimt's Stoclet frieze covers both the side walls up to the ceiling.

For the decoration, Klimt devised a tree of life (Pl. 178) with ornamental branches filling the entire space, identical on both walls except for the two large figures: on one side *Expectation*, originally named *The Dancer*; on the other; *Fulfilment*, originally named *Embrace*. Flowers, butterflies and falcons lend life to the scene, and a flower frieze runs the whole length of the lower half.

Eduard Sekler[10] describes the decorations thus:

The third mosaic panel with the abstract design faces the window, and may thus be conceived as a symbolic window on to a world that is the antithesis of the real world manifest in the garden outside the dining room windows . . . As in an Egyptian mastaba with its fake door, one had the feeling of being in a zone of transition between two worlds. Should the meaning of the abstract design ever be fathomed, then we shall know what Klimt, here in the innermost recess of the room, wanted to divulge to the guests seated around the table; on the side walls he clearly wanted to show them a garden of art and love which – watched over by the divine Horus falcons – would, unlike the garden outside, never fade.

The abstract design on the end wall kept its secret for a long time.[11] Surprisingly, in 1989 a completely new answer was found for which we are indebted to Alice Strobl. In the fourth volume of her work *Gustav Klimt. Die Zeichnungen 1878–1918* (Salzburg 1980), she reproduces one of his postcards to Emilie Flöge, showing the dining room in the Palais Stoclet and dated 18 May 1914[12] (Pl. 180). The card is the property of the manuscript collection of the Austrian National Library and the text runs, on both sides:

Brussels. The Stoclet house is really very, very beautiful: photographs give you no real impression of it. The garden, too, exceeds all expectations, also the newest layout. Right now there aren't many flowers, the tulips etc. are over, the roses – there will be many – and all the other flowers are not yet in bloom.

And when I walk through this room – then memories of Kammerl [in the vicinity of the Attersee] crowd in on me, the wall in Kammerl, the work, the joys and the worries of those days, I think of them with longing – and of much else too. This photograph also gives a bad impression of the original. My poor knight looks quite black and green – the pattern of his tunic is too much embossed, but the change in the metal comes out quite well. There are some things I should have done otherwise – and much that the Werkstätte should also have done otherwise. The wall could take much more gold. Fondest greetings Gus.

The text, if carefully read, makes it clear that in this case too – as in the Beethoven frieze – Klimt depicted a knight, with one important difference, namely that in the Beethoven frieze he faithfully copied a suit of armour from the Kunsthistorisches Museum in

155

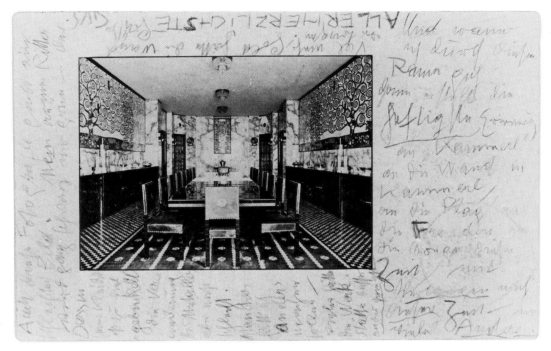

Vienna, whereas here, surprisingly, he gave his imagination free rein. It is easier to understand what he writes if one bears in mind that Emilie Flöge helped with the working drawings for the Stoclet frieze:

> In the summer of 1905 the unfinished sketches for the Stoclet frieze stood around in the house they shared on the Attersee. The weather being so summery, Klimt felt not the least urge to work at them, although the Wiener Werkstätte were pressing for completion. So Emilie Flöge got up one day at 5am and started filling in the empty spaces with gold. Sometime later Klimt came out of his room and, surprised, asked her what she was doing, but then he nodded approvingly and left her with the words: 'That's good. Carry on. You're better at it than I am anyway.'[13]

On closer examination of this so-called abstract part of the frieze, the viewer slowly becomes aware of a white, gothic-style helmet. Using his imagination, he may discern, below the helmet, the outlines of a very angular male figure, clad in a colourful garment which, in our opinion, has nothing to do with armour. For this section of the Stoclet frieze Klimt made a life-size working drawing (Pl. 181). Surprisingly, he completed the final version of this section of the frieze neither in Vienna nor in Brussels in 1911, but three

years later on a more recent visit to Brussels – hence the remarks in his postcard to Emilie Flöge. It was his idea to give the knight a coloured garment; and it was this notion – not an altogether happy one – that occasioned the hitherto mistaken interpretation of the section. Alice Strobl writes:

> The knight in armour in the Beethoven frieze had also been variously interpreted. According to Alma Mahler he represented Gustav Mahler, the champion of modern music and interpreter of Ludwig van Beethoven's music, but perhaps also Gustav Klimt himself; whereas I saw in the *Golden Knight* (Novotny-Dobai No. 132) a higher concept, a symbol of the creative genius battling against his environment. Concrete happenings very often gave Klimt occasion to generalize; on the other hand a change had taken place since 1903, and the days of the great struggle were over. In 1908 Klimt and his group were at the height of their achievement: Klimt was the uncrowned king and even recognized as such by those who would have liked to take his place, such as Oskar Kokoschka, who in a letter to Klimt's mother after his death wrote, referring to the 1908 Kunstschau:
>
> 'I wept over poor Klimt, who was the only Austrian artist with charm and talent. Now I am his successor, as I begged of him once in the Kunstschau, and I do not yet feel mature enough to lead this chaotic pack.'
>
> Klimt must have thought of the knight in armour, as he did in the case of the Beethoven frieze, as the symbol of the

156

exaltation of life through art or through the artist, the latter being at the same time the creator of an earthly paradise, represented by the two trees of life with their accompanying figures Expectation and Fulfilment, not forgetting the falcons as symbols of mortality.[14]

Klimt's first sketches for the Stoclet frieze have been on show of late in the Museum of Applied Arts in Vienna, together with the restored large-scale working drawings (Pl. 181, 185, 189). Their whereabouts had been unknown until Alice Strobl reproduced them in the fourth volume of her publication mentioned above.

Alice Strobl listed Klimt's working drawings for the Stoclet frieze in her second volume. Here is her transcription of Klimt's notes on the 195 × 94 cm working drawing depicting the left-hand extremity of the tree of life, together with Gustav Klimt's oval signature:

FIRST PART FROM THE LEFT. 1ST PART
This flower not to be used [arrow pointing to bluebell]. Flower to be used [arrow pointing to and over flower with eye pattern] – right flower – leaf mosaic – do not use this flower – use spiral for diminishing flower stem. Where mosaic is used the marble must be hollowed out deeper than where other materials are used (tree blossom, flowers and leaves on the ground)

Beaten metal (greenish) gold – flowers to be used – enamel to be mounted in silvery frames – beaten metal – blossom material – green mosaic – flowers in material (enamel)

Green mosaic – beaten metal quite heavily embossed

The spirals should puncture the outside edge in order to become broader and not narrower – do not use material (enamel) – material – leaves in beaten metal (a little embossed and the crystal glass blossoms polished)

Enamel – mosaic (green) – material (enamel) – mosaic leaves of beaten metal (greenish and slightly embossed) – material (enamel or glass) – mosaic

Mosaic of tree leaves do not use very pale green

The tree to be in mosaic, also the spirals and leaves – but the tree blossoms are intended to be of material (enamel, maybe coloured glass) – beaten metal (greenish gold – Gustav Klimt).[15]

We will dispense with a further list of Klimt's instructions and merely quote the ones pertaining to the 196 × 90 cm working drawing on the end wall:

*181 Working project for the Stoclet frieze: composition for the end wall, designated by Klimt as 'the Knight' (D.152 H, AS 1810). Tempera watercolour, gold, silver-bronze, crayons, pencil, white, gold leaf, silver leaf, on brown paper. 196 × 90 cm. Österreichisches Museum für angewandte Kunst, Vienna.*

157

The larger white surface should be in white enamel, the small white shapes in the upper middle field should also be in mother-of-pearl 899 cm.

The majority of the white shapes in this and the opposite field should be rendered in mother-of-pearl. All coloured surfaces to be rendered with enamel technique. The shiny metal surfaces to be polished.

STOCLET DINING ROOM END WALL M1:1TOP.16

Berta Zuckerkandl, in her article on the Klimt frieze published in the *Wiener Allgemeine Zeitung* on 23 October 1911,[17] tells us of his many years of devoted work:

Only in this way, by following Klimt's detailed instructions, could that wonderful creation take shape that was, all in all, a product of intense collaboration between Klimt and the artists of the Wiener Werkstätte. And what nobody knew until now is that Klimt, after the blueprint had been transferred to the marble surface and the drawing incised onto it, went over the outlines once more with material in order to stamp them with the 'feel' of his hand.

The tripartite frieze consists of fifteen marble plates measuring two metres high by one metre broad, seven plates to each side wall. The marble work was carried out by the firm of Oreste A. Bastreri. The frieze took shape in the mosaic workshop of Leopold Forstner,[18] whose noted talent for style and decorativeness urged him to experiment with new mosaic techniques. He was responsible for the shading of the gold tones and for the rhythm of light and shade, both of which achieve effects quite different from those of coloured drawings. Forstner took unending trouble with his experiments, which included eleven gold trials (among them an entirely new, crusty gold mosaic) until a really 'Klimt-like' effect was achieved. The enamel work, for instance the rose-bush's two hundred leaves, was carried out by Fräulein von Starck according to Klimt's instructions in various shades of green; the ceramic details, e.g. the swarm of bright butterflies and the falcons, were the work of Löffler.[19]

The materials alone cost over 100,000 crowns, and the actual assembly lasted one and a half years. In agreement with the Wiener Werkstätte Klimt decided not to exhibit the frieze in public. He declared, in so many words, that he would not have his creation, which had cost so many years' work groping and struggling and for which the artisans and artists had given of their best with so much quiet and devoted persistence, exposed

184 *Study for the figural composition* Expectation, *also known as* The Dancer *(AS 1667), about 1907–8. Pencil. 55.9 × 37.1 cm. Historisches Museum der Stadt Wien.*

185 Opposite: *Working project for the figural composition* Expectation *also known as* The Dancer *for the Stoclet frieze (D.152 B, AS 1813), 1908–10. Tempera, watercolour, gold, silver-bronze, crayons, pencil, white, gold leaf, silver leaf, on brown paper. 195 × 120 cm. Österreichisches Museum für angewandte Kunst, Vienna.*

Following pages:
186 Left: *Study for the figural composition* Fulfilment *also known as* Embrace *from the Stoclet frieze (AS 1737), about 1904–5. Pencil. 56.5 × 37.2 cm. Historisches Museum der Stadt Wien.*

187 Right: *Detail from the unfinished small-scale project for the figural composition* Fulfilment, *also known as* Embrace *for the working copy of the Stoclet frieze (AS 3579 b), about 1908. Watercolour and gouache, gold-bronze and pencil on tracing paper. 22 × 75.3 cm. Österreichisches Museum für angewandte Kunst, Vienna.*

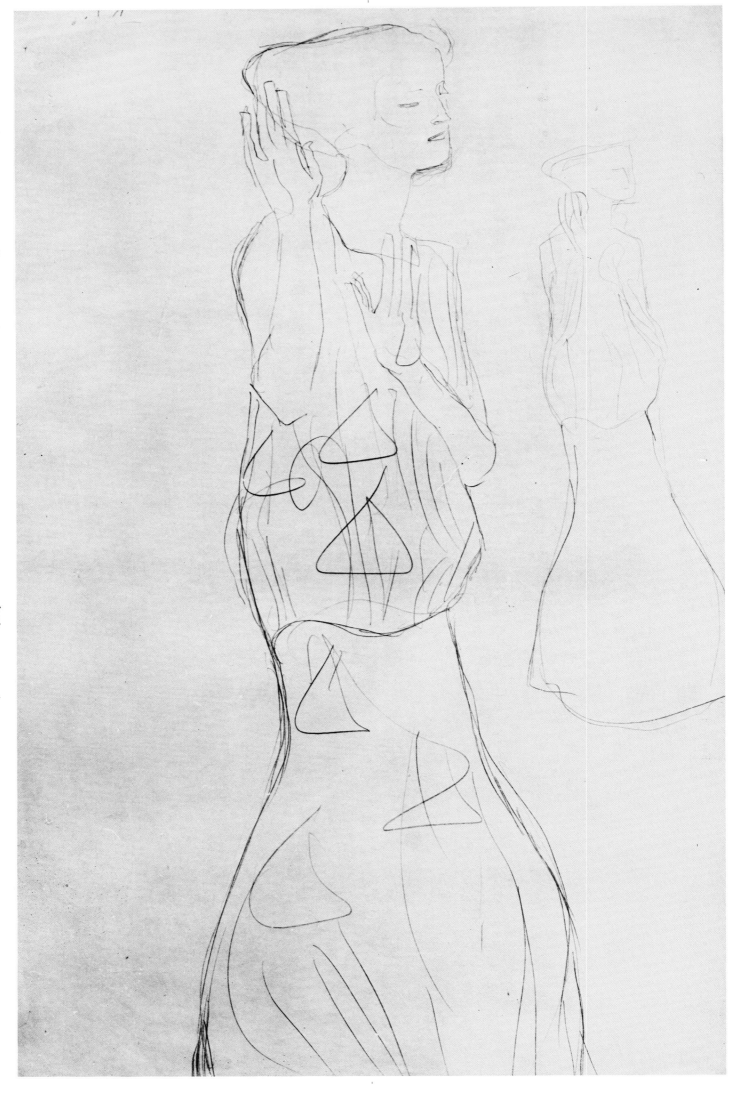

to scorn and disparagement: a reference to his collective show at the Galeria Miethke in December 1910, which earned the reproach of pornography . . . Friends and a wide circle of art connoisseurs did, however, have the opportunity to view the frieze in Leopold Forstner's mosaic workshop, among them the author Arthur Schnitzler.[20]

The working drawings were the property of the Viennese industrialist Otto Primavesi, one of the financiers of the Wiener Werkstätte. Gustav Nebehay exhibited them in 1920 in his art gallery in the Hotel Bristol. Dagobert Peche,[21] architect, painter and artisan, created a poster for the exhibition (Pl. 274). The working drawings then found their way to the Museum of Applied Arts.

The frieze came in for much attention in the contemporary press:

As has been remarked elsewhere, this phase in the artist's development came to a natural if temporary close in that he was able to work with his own hands at least one mineral element of the bright and glittering materials he had striven, as a painter, to bring to luminous effect . . . This work, executed in the Wiener Werkstätte, is surely the most striking outcome of Klimt's relationship to his friends Kolo Moser and Josef Hoffmann . . . How disquieting, how shaming for the Viennese art scene, that the commission came from abroad and that the work has not even been shown to the Viennese public . . .[22]

The plan to exhibit the Stoclet frieze in Vienna never materialized. Klimt had had enough of the criticisms levelled at him on exhibition of each of his University paintings.

Berta Zuckerkandl writes:

When the moment came to exhibit the mosaic frescoes in public before transporting them to Brussels, Klimt surprised his friends by refusing to show them.

'No! I refuse to have my work, which is probably the ultimate stage of my ornamental development, which has cost so many years' work groping and struggling and for which the artisans and artists have given of their best with so much quiet and devoted persistence, exposed to the scorn and disparagement of Beckmesser & Co. [Beckmesser: a bothersome heckler in Wagner's opera Die Meistersinger]. My friends can see the frieze in my studio. Away from Vienna! . . .'[23]

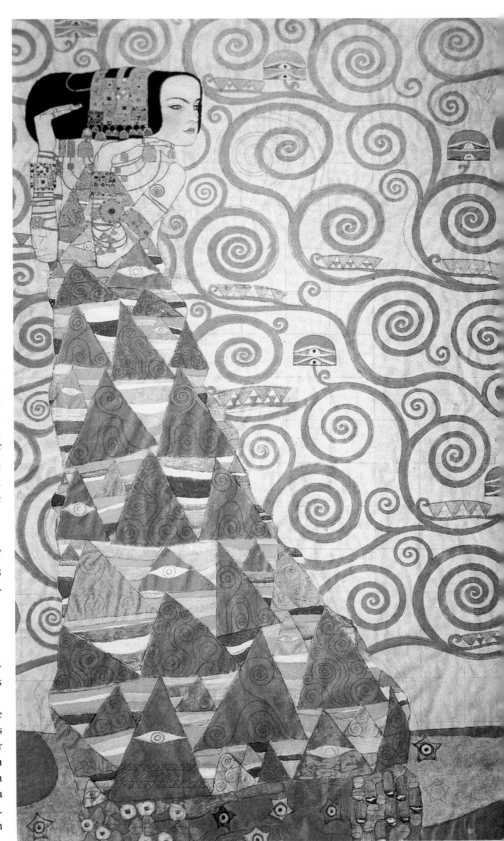

161

The art historian Max Eisler[24] wrote in 1920:

> In the context of Klimt's production [the Stoclet mosaics] constitute a definite departure from monumental freedom and grandeur, a falling back on handicraft with its dependence on materials; for the Viennese handicrafts, on the other hand, it is a great enrichment, for here is an artist who, familiar with both the intentions of the architect and mosaic technique, is working for the combined arts. Thanks to his characteristic sensibility a timeless work of art has been created . . . The Stoclet frieze is, properly speaking, an exercise in materials: the artist, not content with having made the working drawings, intervenes continually and effectively in their execution, scattering them with handwritten instructions. He files and hammers, he embosses and cuts, he melts and glazes and does not give up until he has the colour, the shine and the tone he wanted . . .

It must be said that mosaic is the ideal medium for the realization of Klimt's ideas, and it is regrettable that he only used it for the Stoclet frieze. All the more remarkable is his project, dated 4 May 1897, for the building of the Vienna Secession (Pl. 58), the front elevation of which presents large surfaces for decorative purposes which he may possibly have found suitable for mosaics.

The art historian Hans Tietze wrote:[25]

> The dining room of the Palais Stoclet in Brussels, for which Klimt designed mosaic decoration, provides what is probably the clearest answer to his problems: it is here that handicrafts take the undisputed lead and that Klimt's collaboration with the architect [Josef Hoffmann] and the Wiener Werkstätte bears most fruit.

1 Franz Metzner (1870–1919) was professor at the Kunstgewerbeschule in Vienna from 1903 to 1906. His principal work was the figures decorating the monument to the Battle of Leipzig, whereby 'he had a tendency to violence which often led him to exaggeration and empty pathos . . .' (Thieme-Becker, Vol. 24, p. 449).

2 Joseph Maria Olbrich, architect (1867–1908)

3 Michael Powolny (1871–1954) produced much sculpture and ceramic work for the Wiener Werkstätte.

4 Alfred Stevens (1823–1906) was named 'maître de la vie amoureuse' and painted stylish portraits of elegant Parisian women during the reign of Napoleon III.

5 Carl Moll, painter (1861–1945)

6 Eduard F. Sekler, *Josef Hoffmann. Das architektonische werk.* Salzburg 1982, p. 98

7 Carl Moll, 'Memories of Gustav Klimt'. In: *Neues Wiener Tagblatt*, 24.1.1943. See also Christian M. Nebahay, *Gustav Klimt: Dokumentation*. Vienna 1969, p. 389.

8 George Minne, Belgian sculptor (1866–1941)

9 Georges A. Salles, *The Adolphe Stoclet Collection.* Brussels 1956, p. 15

10 See Eduard F. Sekler, op. cit., p. 98. Much information has been gleaned from this book.

11 I too wrote in my *Gustav Klimt: Dokumentation*, Vienna 1969, p. 382: 'For the end wall Klimt created a remarkable, abstract-decorative composition . . . This part of the Stoclet frieze might be examined to advantage with regard to its possible influence on the artistic trends of our time.'

12 See also Wolfgang Georg Fischer, *Gustav Klimt und Emilie Flöge. Genie und Talent, Freundschaft und Besessenheit*, Vienna 1987. Collected correspondence, p. 184, No. 324

13 Christian M. Nebehay, *Gustav Klimt: Dokumentation*, Vienna 1969, p. 274

14 Alice Strobl, *Gustav Klimt. Die Zeichnungen 1878–1918*, Salzburg 1980, Supplement to Vol. 4, p. 152

15 *Ibid.*, p. 152

16 *Ibid.*, p. 152

17 Published in the *Wiener Allgemeine Zeitung* on 23 October 1911

18 Leopold Forstner, artisan, proprietor of the Wiener Mosaikwerkstätte (1878–1936)

19 Bertold Löffler, graphic artist, potter and artisan. Together with Michael Powolny he founded the 'Wiener Keramik' in 1906 and taught at the Kunstgewerbeschule in Vienna from 1907 to 1935.

20 Arthur Schnitzler, author (1862–1931)

21 Dagobert Peche, architect, painter and artisan (1887–1923)

22 Arpad Weixlgärtner, 'Gustav Klimt'. In: *The graphic arts.* Vienna 1912, p. 56

23 Berta Zuckerkandl, 'Erinnerungen an Gustav Klimt.' *Wiener Tageszeitung*, 6.2.1934.

24 Max Eisler, *Gustav Klimt*, Vienna 1920, p. 36 ff. Max Eisler's dates: 1881–1937

25 Hans Tietze, *Gustav Klimt. Neue Österreichische Biographie*, Vienna 1926, p. 87.

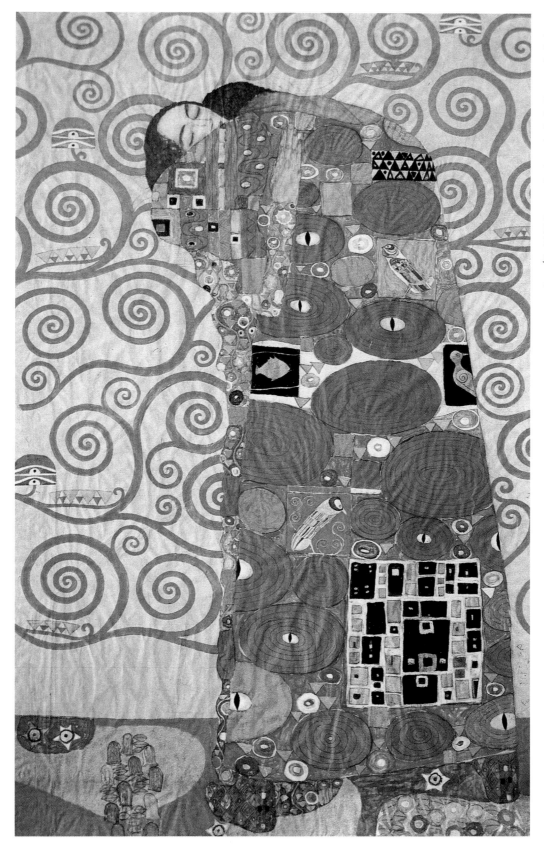

*190 Study for the painting*
The Kiss *(AS 1793),*
*197–08. Pencil. 29.6 ×*
*28.2 cm.*

*191 Opposite: The Kiss*
*(D.154), 1907–08. Oil*
*on canvas. 180 × 180 cm.*
*Österreichische Galerie,*
*Vienna.*

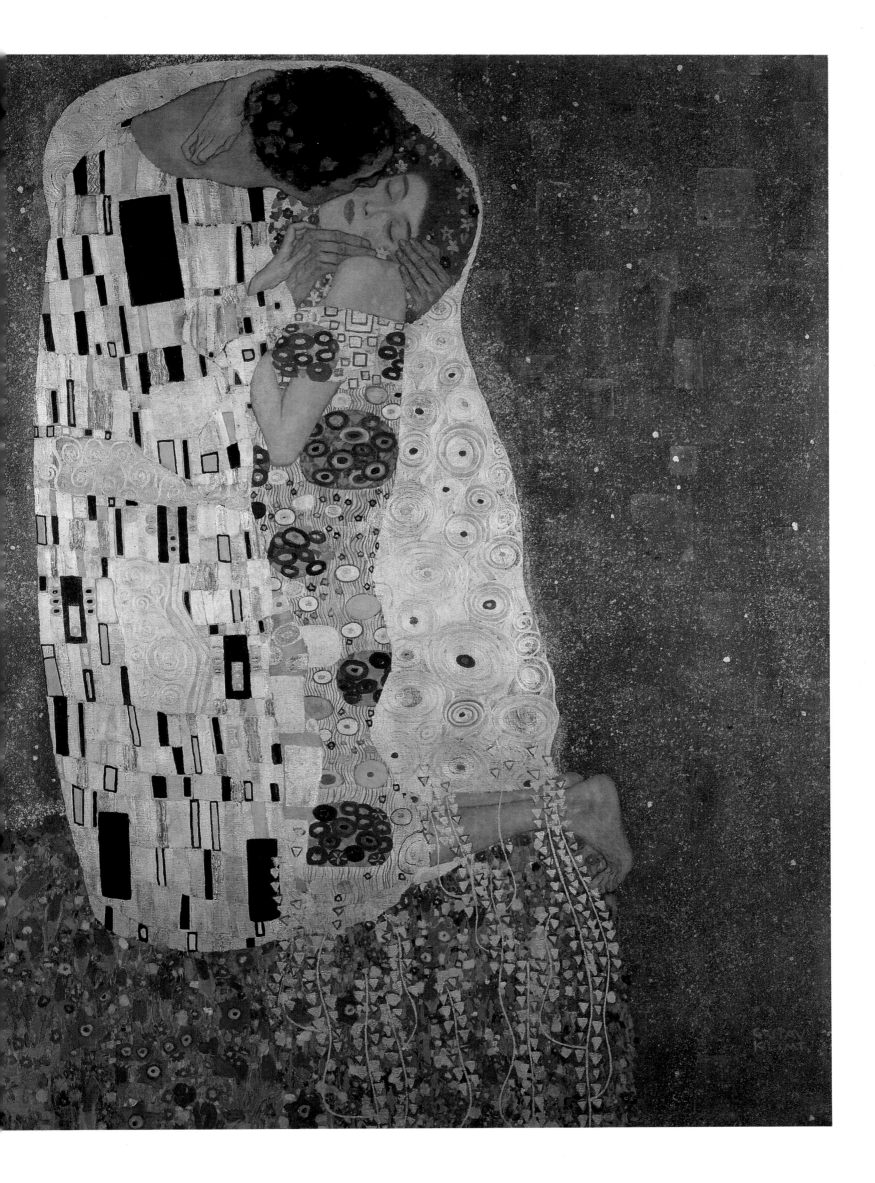

# THE WITHDRAWAL OF THE KLIMT GROUP FROM THE SECESSION AND THE KUNSTSCHAU EXHIBITIONS IN 1908 AND 1909

*192 Poster for the Kunstschau Wien 1908. Printed by Albert Berger. 70 × 70 cm. Historisches Museum der Stadt Wien.*

In the spring of 1905, after a difference of opinion regarding Carl Moll's activities in the then leading gallery H. O. Miethke, the 'Klimt group' had left the Secession. This group, which comprised, apart from Klimt, architects such as Josef Hoffmann and Otto Wagner and artisans such as Kolo Moser, was opposed by the so-called Painter group, led by Josef Engelhart,[1] who protested against Moll's exhibition activities at Miethke's which, they said (not without reason) were damaging to the Secession. When it came to a ballot, the opponents – having roped in one of their members then staying in Berlin – won by one vote.

Again the real talents gathered around Klimt: the rest were mediocre. The eight wonderful years of the Vienna Art Spring were over: after the 'Ver Sacrum' came no mild summer, no fruitful autumn, no contemplative winter.

Of those who stayed on, not one achieved recognition or fame. Josef Engelhart, the new president, was a gifted painter of the Viennese milieu. He wrote about the quarrel in his memoirs;[2] he is, regrettably, the only artist who gave a lively account of those highly interesting times. As he spoke various languages, he had been entrusted in 1898 with the task of inviting well-known foreign artists to take part in the first Secession exhibition.

Then Moll made the mistake of taking on the job of adviser to the Miethke gallery, the foremost dealers in modern art at that time . . . As he now stood between two competing enterprises, there were bound to be problems. I was at the time president of the Secession, and as such I suggested to Moll that he choose between us and Miethke . . . There was a short tussle, after which twenty-four members of the Moll party resigned. From then on part of the press treated us as the 'Rump Secession'.[3]

The Klimt group were certainly confident that they would be able to erect a new exhibition pavilion, but this was not the case. Ludwig Hevesi hints at plans for premises in the Graben in the Ist district, but the élan and the enthusiasm that had inspired them in 1898 were gone. The Klimt group had no home.

Carl Moll, who started it all, wrote:

> The dominating presence of Klimt and the Wiener Werkstätte artists naturally led to their ascendency in the Secession. The result was jealousy and continued friction . . . Once again experience showed that too many creative personalities working together tend to suppress the purely artistic element and concentrate on commercial aspects.[4]

Officially the Klimt group informed the Minister of Education of their motives in a printed open letter.[5]

Quite unexpectedly, the Klimt group were in luck. There were plans for the erection of the Konzerthaus by the theatre architects Fellner & Helmer on the site

next to the Vienna Skating Rink; and the building was indeed inaugurated in 1913. Meanwhile the site was put at the disposal of the Klimt group for the two years 1908 and 1909, and here they were able to show their two last exhibitions (the Kunstschau). Josef Hoffmann, who was a brilliant improvisator, at once erected pavilions (Pl. 194), terraces, courtyards and gardens, a theatre and a coffee-house. There was a total of fifty-four rooms available for exhibitions.

Ludwig Hevesi wrote:

So the Klimt group's exhibition opens on Monday afternoon. The five men who are now the backbone of Viennese art have once again squeezed water from stone. They have improvised beyond all expectations . . . There is an inscription over the door:
'TO EVERY AGE ITS ART, TO ART ITS FREEDOM'.
. . . This honourable device has been resurrected and has found its rightful place.[6]

But the first visitor to the building site every morning is Gustav Klimt himself . . . And there is Hoffmann, the man who knows no fear, who is at work day and night, who solves all problems simultaneously . . . And then Gustav Klimt, sitting in the middle of it all . . . homely but determined, exuding strength, born to be the focus . . . He always talks sense and always comes down firmly on one side. His intonation, his pace, his gestures lend courage. That is why the young can in all circumstances turn to him and have unbounded trust . . . The waverers have only to look at Kolo Moser to recover their certitude: when Hoffmann is calm and Klimt invulnerable, Moser is roguish; and under his smooth surface there is a ripple of humour . . . And Carl Moll, he is the perpetuum mobile . . . as long as he is in motion there is no stopping.[7]

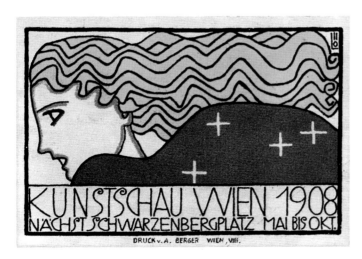

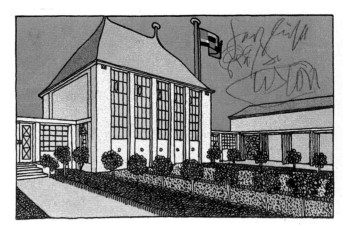

193 Below: *Berthold Löffler, publicity stamp for the Kunstschau Wien 1908.*

194 Above: *The Kunstschau building. Wiener Werkstätte postcard (No. 2 by Emil Hoppe). With autograph greetings from Gustav Klimt to Emilie Flöge, dated 7 July 1908.*

The two Kunstschau exhibitions must be seen as a single entity. The first, in 1908, was devoted to young Austrian artists and was hitherto the most extensive of its kind, showing not only paintings, graphics, sculptures and arts and crafts, but also all sorts of other forms such as posters, theatre sets, playing cards, religious art, monumental masonry, etc. The second, in 1909, showed foreign artists such as Cuno Amiet, Pierre Bonnard, Maurice Denis, Paul Gauguin, Henri Matisse, Vincent van Gogh, Edvard Munch, Félix Vallotton and the best arts and crafts from England and Germany.

Gustav Klimt, usually so reticent, made a remarkable inaugural speech which appeared as the foreword to the 'Kunstschau 1908' catalogue:

For the last four years we have not had the opportunity to show you our work in an exhibition. Not that we consider an exhibition to be the ideal method of establishing contact between an artist and his public: we would be much happier with large-scale public commissions. But as long as the authorities go on thinking in terms of commerce and politics, exhibitions are our only way, and we must be grateful to all public and private sponsors who have helped us take this path and show you that we have not been idle – on the contrary, perhaps just because we were freed from worries about exhibitions, we have worked all the more assiduously and intensely on the development of our ideas.

We are neither an association, nor a union, nor a league, but have come together informally especially for this exhibition, in the firm conviction that no field of human life is too unimportant and insignificant to warrant artistic activity; that, to quote William Morris, even the most trifling object, if it be well

169

executed, helps increase the beauty of this world; and that the progress of culture lies solely in the increasing saturation of our lives with the pursuit of art. This exhibition does not, therefore, claim to present the end-products of artistic careers: it is, rather, a review of Austrian art, an accurate report on culture in our realm.

And we interpret the concept 'artist' as widely as we do the notion of 'work of art': not only the creator is an artist, but also the enjoyer – one who has feeling and sympathy for a work. To us, an artistic community means the ideal partnership between all those who create and all those who enjoy. And that that partnership really exists and is strong and potent by reason of its youth and energy and its genuine sentiments is proved by the fact that this house could be built and that this exhibition can now be opened.

Our opponents are therefore wasting their time when they attack this modern movement and call it moribund, for they are attacking growth and rebirth – in other words, life itself. Now that this exhibition is opened, we who have worked together at it for weeks will scatter, and each one will go his own way. But perhaps, with time, we shall come together again in new groups with other aims. In any case we rely on each other, and I thank all those who were with us this time for their diligence, their cheerful devotion and their faithfulness. I also thank all our patrons and promoters who made it possible to carry our plans through. Ladies and gentlemen, you are invited to tour the exhibition and I hereby have pleasure in inaugurating the 'Kunstschau Wien 1908'.

Both exhibitions, incidentally, ended in deficit; nor did they bring any recognition for Oskar Kokoschka in 1908 or Egon Schiele in 1909. Contrary to expectations the public did not protest against their exhibits but merely shrugged its shoulders and ignored them.

Klimt held his last collective show (Pl. 195). The catalogue lists the following works:

No. 1 *The Three Ages* (D.141), 1905 (Pl. 155). Galleria Nazionale d'Arte Moderna, Rome. Acquired 1912.

No. 2 *The Kiss* (D.154), 1907/08 (Pl. 191). Österreichische Galerie, Vienna. Acquired 1908.

No. 3 *Portrait of Fritza Riedler* (D.143), 1906 (Pl. 4). Österreichische Galerie, Vienna. Acquired 1937.

No. 4 *Portrait of Adele Bloch-Bauer I* (D.150), 1907 (Pl. 267). Österreichische Galerie, Vienna. Donated 1936.

No. 5 *Portrait of Margaret Stonborough-Wittgenstein* (D.142), 1905 (Pl. 246). Neue Pinakothek, Münich. Acquired 1960.

No. 6 *Water Snakes*, also *Friends I* (D.139), 1904–07 (Pl. 197). Österreichische Galerie, Vienna. Acquired 1950.

No. 7 *Sisters*, also *Friends III* (D.157), 1907–08.

No. 8 *Portrait of a Lady in Red and Black* (D.158), 1907–08.

No. 9 *Beech Wood II* (D.137), about 1903. Österreichische Galerie, Vienna. Acquired 1948.

No. 10 *Cottage Garden* (D.144), 1905–06. Narodni Galerie, Prague. Acquired 1910.

No. 11 *Roses under Trees* (D.147), 1905. Missing.

No. 12 *Cottage Garden with Sunflowers* (D.145), about 1905–06. Österreichische Galerie, Vienna. Acquired 1939.

No. 13 *Poppy Field* (D.149), 1907. Österreichische Galerie, Vienna. Acquired 1957.

No. 14 *Apple Tree.* Not identifiable.

No. 15 *Danae* (D.151), about 1907–09 (Pl. 200).

No. 16 *Water Snakes*, also *Friends II* (D.140), 1904–07 (Pl. 198).

Klimt also exhibited in the second Kunstschau:

No. 1 probably *Lady with Hat and Boa* (D.161), Österreichische Galerie, Vienna. Acquired 1950.

No. 2 *Judith II*, also *Salome* (D.160), 1909 (Pl. 135). Galleria d'Arte Moderna, Venice. Acquired 1910.

No. 3 *Schloss Kammer on the Attersee I* (D.159), about 1908. Narodni Galerie, Prague. Acquired 1910.

No. 4 *Hope II* (D.155), 1907–08. The Museum of Modern Art, New York.

No. 5 *Cottage Garden* (perhaps identical to D.144).

No. 6 *Hope I* (D.129), 1908 (Pl. 160). National Gallery of Canada, Ottawa.

No. 7 *Old Woman* (D.162), 1909. Missing.

171

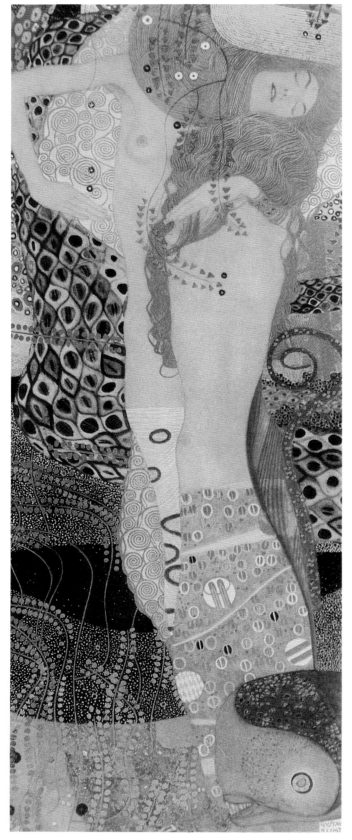

*197* Water Snakes I, *also known as* Friends I *(D.139), about 1904–07. Mixed technique on parchment. 50 × 20 cm. Detail. Österreichische Galerie, Vienna.

The Klimt group's withdrawal from the Secession occurred at a moment when a certain glut became apparent on the modern art market. For Klimt, the years of struggle were past and he was at the height of his powers. His painting *The Kiss*, 1909, brought him widespread fame. But his way, which he followed unerringly, was clear; and his friends had likewise matured. Things had become quieter.

1 Josef Engelhart, painter (1864–1941)

2 Josef Engelhart, *Ein Wiener Maler erzählt*. Vienna 1943, p. 123–124.

3 *Ibid*. p. 123 ff.

4 Carl Moll, 'Erinnerungen an Gustav Klimt'. *Neues Wiener Tagblatt*. 24.1.1943.

5 Fritz Novotny-Johannes Dobai, *Gustav Klimt*. Salzburg 1967, p. 389.

6 Ludwig Hevesi, *Altkunst–Neukunst*. Vienna 1909, p. 311 ff. This wording, conceived by Hevesi, was originally to be seen over the entrance to the Secession.

7 Op. cit., p. 309 ff.

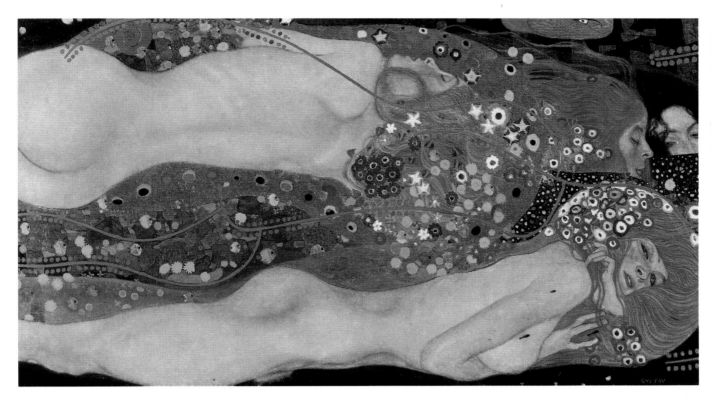

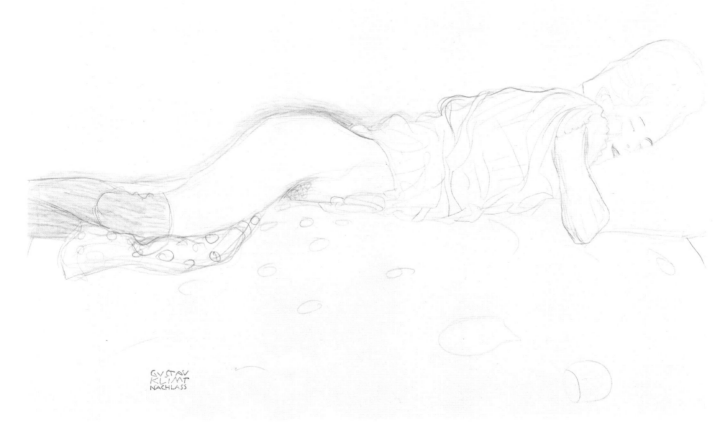

*198* Above: Water
Snakes II, *also known as*
Friends II *(D.140), 1904,
altered in 1907. Oil on
canvas. 80 × 145 cm.*

*199* Below: *Study for the
painting* Water Snakes II,
*also known as* Friends II
*(AS 1466), 1907. Blue
and red crayon.
37 × 55.2 cm.*

GVSTAV
KLIMT
NACHLASS

173

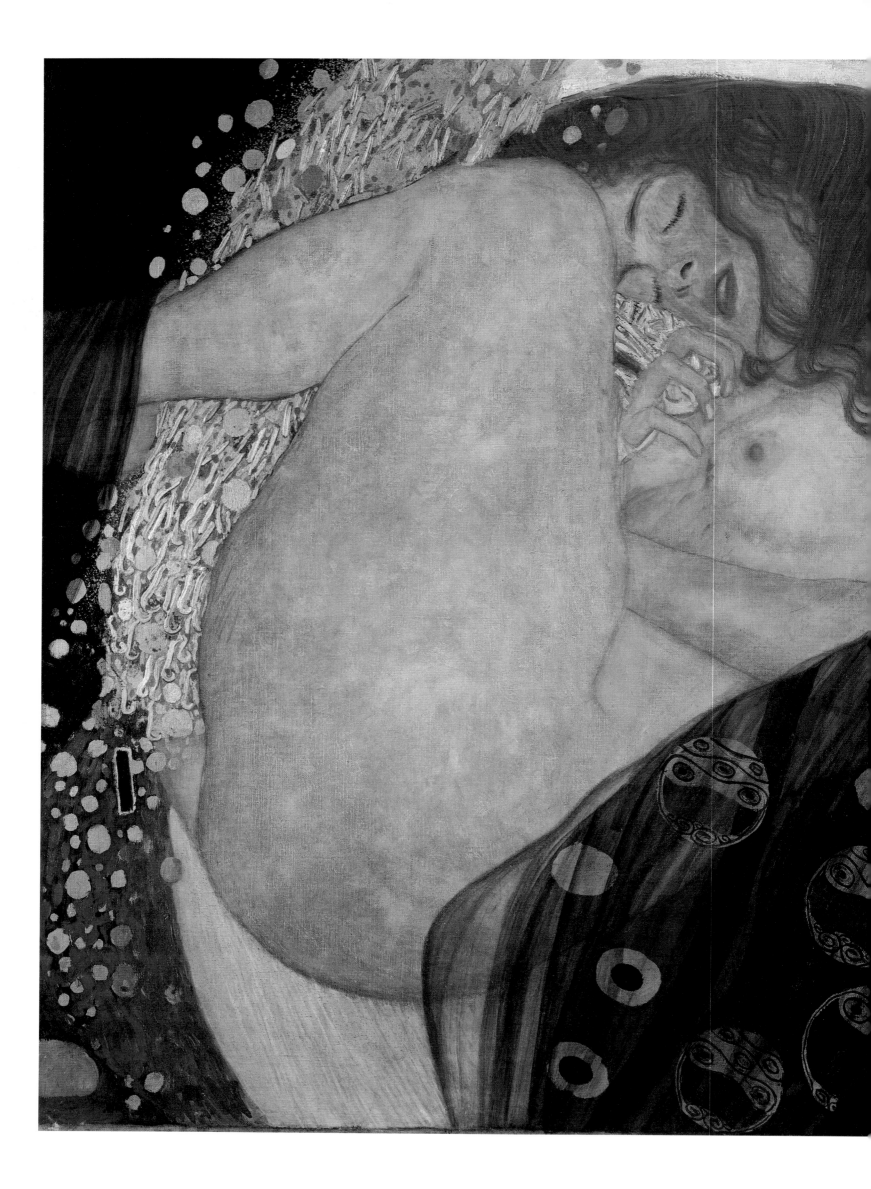

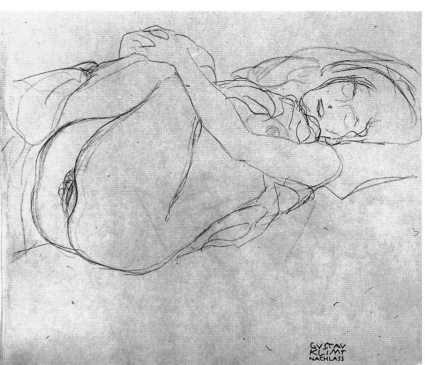

*200* Left:  Danae
*(D.151), about 1907–08.
Oil on canvas.
77 × 83 cm.*

*201* Above right:  *Study
for the painting* Danae
*(AS 1626), about 1907.
Blue crayon 56 × 37 cm.
Detail.*

*202* Below right:  *Study
for the painting* Danae
*(AS 3513 a), 1907. Red
Crayon. 43.2 × 29.3 cm.
Detail.*

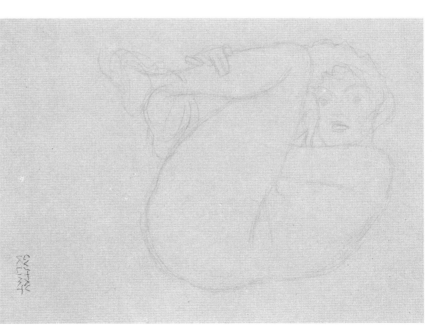

175

# GUSTAV KLIMT AS THE SPONSOR OF
# YOUNG TALENT

*203 Oskar Kokoschka,* The maiden Li and I. *Eighth colour lithograph from* The Dreaming Youths, *1907–08, published by the Wiener Werkstätte in 1908. 24 × 22 cm.*

The two Kunstschau exhibitions were milestones for two young artists, each of whom stirred up the hitherto easy-going Viennese art scene. Oskar Kokoschka[1] and Egon Schiele[2] found themselves facing a public as yet unaware that these works were introducing a new art movement in Austria, namely Expressionism.

The presence of the two at the Kunstschau would have been unthinkable without the generosity of Gustav Klimt, who was spokesman for his friends. The Vienna public, however, remained unappreciative and there is no question of either Kokoschka or Schiele having gained appreciation or new friends, let alone new clients. It is interesting to note that the same public that railed against Klimt now walked past these incomprehensible works and merely shook their heads.

Klimt had, for a start, obtained permission for Kokoschka to exhibit his work without presenting it to the jury, and he was given the use of a small room. Unfortunately none of his exhibits have survived, unlike Schiele's four large portraits, which signalled his breakthrough in 1909.

A small room contained decorative paintings of a strange kind. Ludwig Hevesi had christened it the 'Wild Gallery'; and within the Klimt group itself were uttered warnings not to provoke the critics and the public with such 'wildness'. But Klimt, mild but firm as ever, had replied:

'We are duty bound to give great talent the chance to express itself. Oskar Kokoschka is the most talented artist of the young generation. And even were we to run the risk of having our Kunstschau demolished, then we would be ruined. But we would have done our duty.'

The 1908 Kunstschau was, indeed, very nearly ruined. The critics not only demolished Kokoschka – they could not know that by 1927 he would be the most highly paid German artist – but took his exhibits to be a schoolboy joke by the Klimt group. It was thanks to them that the most spirited and interesting review of Austrian culture turned out to be a financial disaster. How often we sat, Hevesi, Richard Muther [influential German art historian] and I in the small Kunstschau café and discussed how we could counter the malicious, destructive and poisonous attacks against the Kunstschau. 'It's no use now', Hevesi would say, 'but in 20 years' time we shall have been right.'[3]

There is another saying of Klimt's about Kokoschka, with which he answered Ludwig Hevesi's critical remark that 'Kokoschka is certainly very talented, but he lacks the most important thing: taste. He hadn't got a Kreuzer-worth of taste!' 'But a Gulden-worth of talent!' cried Klimt. 'Taste is good enough for a tippler or a cook. But art has nothing to do with taste.'[4]

Else Lasker-Schüler[5] also recorded her impressions in Herwarth Walden's[6] Berlin journal *Der Sturm*:

We step from the big into the small room and see a pack of bears clumsily prancing about, female figures as from an old

German procession, *Meth fliesst unter ihren Fellhäuten* [mead flowing from under their furs]. My companion retreats to the big room . . . For Kokoschka's princesses are hothouse plants, you can count their little stamens . . . What makes me suddenly think of Klimt? He is a botanist, while Kokoschka is a planter. Klimt plucks, but Kokoschka digs things out by their roots – Klimt unfolds people, while a whole farm of creatures thrive on Kokoschka's colours . . . Both Kokoschka and Klimt see and sow the animal in men and harvest it according to their colours.[7]

It is not known how Klimt came to know of Kokoschka – probably through Kokoschka's activity in the Wiener Werkstätte; he even used Kokoschka's gaily coloured Wiener Werkstätte postcards for his correspondence with Emilie Flöge (Pl. 206). Kokoschka, who was at that time still studying at the Vienna Kunstgewerbeschule, must in our opinion have been influenced by the colour reproduction of Wilhelm Laage's[8] six-colour woodcut *Fairy Tale* (Pl. 207), which was shown in 1901 in *Ver Sacrum*, 4th year, issue No. 16. In 1908 Kokoschka dedicated to Klimt his book

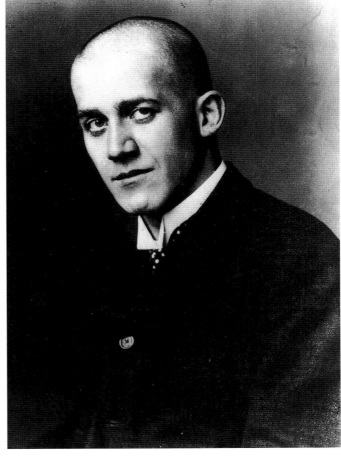

204 Below: *Dedication to Gustav Klimt in Oskar Kokoschka's book* The Dreaming Youths, *1907–08, published by the Wiener Werkstätte in 1908. Letterpress.*

205 Above: *Oskar Kokoschka. Photograph, 1909.*

*Die traümenden Knaben* (*Dreaming Boys*) (Pl. 203, 204, 208) which he illustrated in similar brightly coloured, fairy tale style. It was intended to be a children's book, but he wrote a text for it that was practically incomprehensible and arose from his love for a Norwegian girl called Li. This book is one of the most beautiful produced at the time. Shortly afterwards Kokoschka left for Berlin, having had enough of Vienna.

Kokoschka wrote as follows on Klimt:

> I admired Klimt, and when I was twenty he bought some of my drawings. My drawings were similar to his, strictly linear and without shading . . . I actually only saw and spoke to Klimt once, I never went to his studio.[9]

Only a little will be said here about Egon Schiele, who was also given a small gallery at the second Kunstschau in 1909. Four years younger than Kokoschka, Schiele had also designed postcards for the Wiener Werkstätte,

striving indefatigably to achieve his own personal style of draughtsmanship, form and colour. Artistically speaking, Schiele had for some years no longer been in debt to Klimt, but he had a great affection for his predecessor, more for the man than for the artist; and Klimt returned that affection with paternal sympathy, for he was aware of the similarities – even physical ones – between them, and this touched the old bachelor in him.

Klimt's esteem for Schiele – even early on, when the younger man was still struggling for recognition – can be judged from the following incidents. Klimt one day visited Schiele in his studio in the Grünbergstrasse near Schönbrunn. The great man stood for a long while, totally immersed and in complete silence, in front of his young colleague's big canvasses. To Schiele it was an eternity. At last the master turned to the younger artist, shook hands with him warmly, and said: 'I envy you the expression on the faces in your paintings!'

Schiele blushed to the roots of his hair, his eyes shone, he swallowed, smiled and, embarrassed, made no reply. Years later, when Schiele – still full of admiration and of even more affection – expressed a wish to own one or, if possible, several of Klimt's drawings, he suggested an exchange, assuming in his innocence that he would give Klimt several of his drawings in exchange for one of Klimt's. Klimt's answer was: 'What do you want to exchange drawings with me for? You draw better than I . . .', but he nevertheless agreed to an exchange, and furthermore he bought several of Schiele's drawings, which gave Schiele as much pleasure as did the exchange.[10]

In this way Klimt had done his best to promote two up-and-coming young artists. Kokoschka's career found success outside Vienna. It is hard to understand

some of which show signs of his later style; but in 1908 and 1909 he was still unassuming, poor and alone, and had not found his way to Klimt, whom he so much admired, much less dared to show him his work. Klimt's remark about Kokoschka being 'the most talented artist of the young generation' might otherwise not have been so categorical.

Arthur Roessler writes in 'Memory of Egon Schiele':

As a draughtsman Schiele was heir to Klimt, and he never denied his debt to the master; but he soon shook off his influence and even outdistanced him, refunding with interest what he had borrowed off him (Klimt's last works confirm this) and

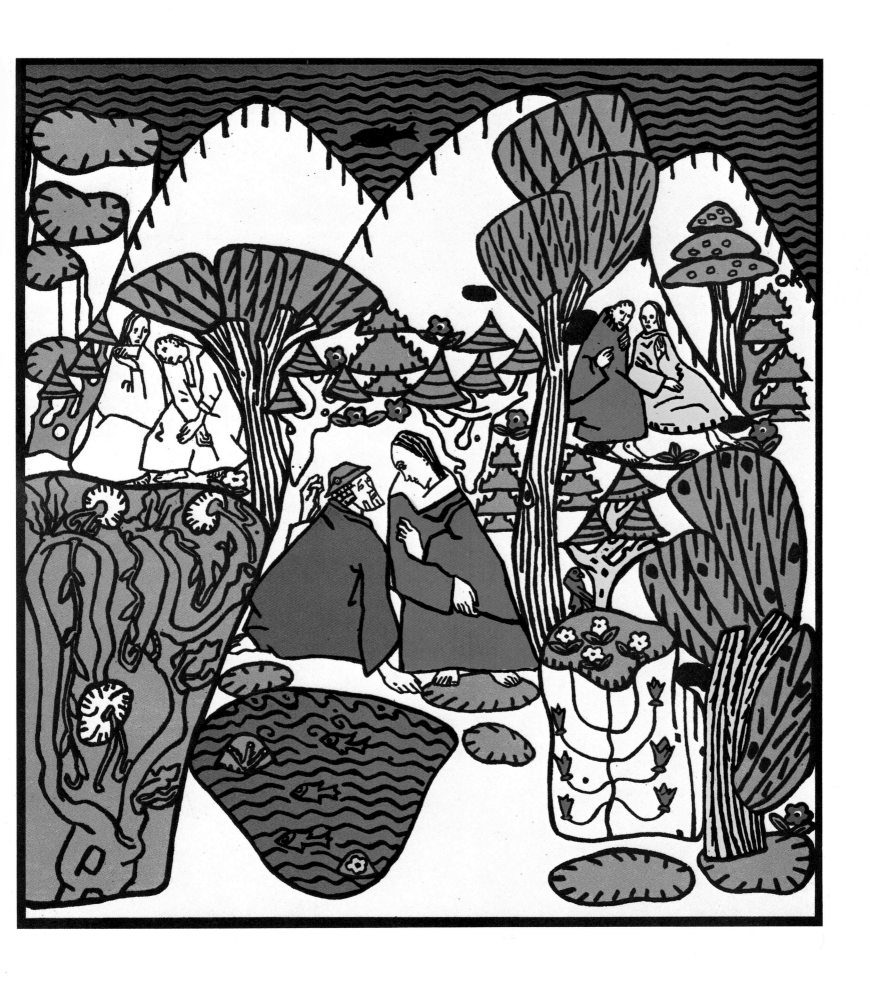

*209, 210* Above and below: *Two double spreads from a pamphlet parodying the Kunstschau 1909, in particular Oskar Kokoschka's* The Dreaming Youths, *Vienna 1909.*

why Kokoschka, right up to the end of his long life, not only refused to recognize Schiele but was also hostile towards him: apparently he took it ill that on account of Schiele's presence at the 1909 Kunstschau he, Kokoschka, was no longer the 'enfant terrible' of the Vienna art scene. To his last day he would never tolerate a rival.

1 Oskar Kokoschka, painter, graphic artist, poet (1886–1980)

2 Egon Schiele, painter and draughtsman (1890–1918)

3 Berta Zuckerkandl, 'Als die Klimtgruppe sich selbstständig machte'. In: *Neues Wiener Journal*, 10.4.1927

4 Arthur Roessler, *Der Malkasten: Künstleranekdoten*, Vienna 1924, p. 65

5 Else Lasker-Schüler, expressionistic poet (1869–1945)

6 Herwarth Walden (alias Georg Lewin), musician, art critic and author (1878–1941). Editor of the expressionistic journal *Der Sturm*. Collector.

7 Else Lasker-Schüler, in: *Der Sturm*, 21.7.1910, p. 166

8 Wilhelm Laage, German graphic artist (1868–1930)

9 Oskar Kokoschka, in *Weltkunst*, 26th year, No. 202, October 1966, p. 1026

10 Arthur Roessler, 'Erinnerung an Egon Schiele'. In: Fritz Karpfen *Das Egon Schiele Buch*. Vienna 1921, pp. 85–86

# GUSTAV KLIMT AND EGON SCHIELE

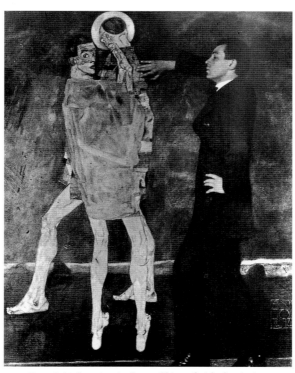

*211 Egon Schiele posing in front of his unfinished painting* Meeting, *1913, which he entered for the Reininghaus competition but which has not been preserved. Photograph by Anton Trcka (Antios), 1914.*

For various reasons it can be assumed that Gustav Klimt and Egon Schiele first met in 1909. The first Schiele drawing depicting him together with Klimt dates from that year: it is an unfinished study for a Wiener Werkstätte postcard. It was probably Josef Hoffmann, who was always attracting young talent to the Wiener Werkstätte, who introduced the two men (Pl. 144).

By 1909 Schiele had not yet established his distinctive personal style. The breakthrough came practically overnight: in the second Kunstschau in 1909 Schiele took his place as a demonstrable expressionist next to Kokoschka,[1] whom Klimt had praised before the inauguration of the first Kunstschau (see p. 176) as the finest talent of the younger generation. During his whole life Schiele admired Klimt, who was his senior by twenty-eight years. The drawing of the two men can therefore be considered as a homage to the great, laconic master who seemed to him to be a sort of father figure.

Klimt's first mention of Schiele comes in a letter of Schiele's to the art critic Arthur Roessler[1] dated 5 November 1910.[2] The meaning of this short passage is, however, a little obscure: 'Klimt said nice things.' (N.133)[3]

The next letter is also a little difficult to understand, chiefly because Schiele mentions the Künstlerhaus, from which the Klimt group had withdrawn when the Secession was founded in 1897.

Why shouldn't there be a big international exhibition in the Künstlerhaus? I talked to Klimt about it. For instance, each artist to have his own hall or his own room. Rodin . . . Van Gogh . . . Gauguin . . . Minne . . . What a boost for Vienna! Catastrophe! . . . (N.144)

On 4 January 1911 Schiele again writes to Roessler – who reproduces the encounter with trimmings – about his first visit to Klimt's studio, then at 21 Josefstädterstrasse in the VIIIth district: 'I have two fine Klimt drawings, I was at his place in the afternoon. He showed me everything.' (N.170).

Klimt probably exchanged two of his drawings with some by Schiele, which was more than a compliment for the young artist. On 31 January 1911 Schiele writes proudly to the art collector Dr Reichel about an appreciative remark made by Klimt during a return visit to his studio about one of his paintings:

I know no one in Vienna who is better informed about art than you. So I have chosen this painting from the new series and am sending it to you . . . This is the painting about which G. Klimt said he would be happy to see such faces . . . (N.176)

181

On 18 April 1911 he writes to Arthur Roessler that Klimt has bought two drawings from him. They cannot have been the only ones, for in the first sales catalogue of Schiele drawings issued by Gustav Nebehay's gallery in Vienna in 1909, mention is made that some items came from the estates of Klimt and Kolo Moser.

> I sold a drawing to Dr Reichel lately for 10 crowns. Of course there was nothing left after two days, so Klimt bought another drawing from me on top of our exchange . . . (N.204)

In 1912 Schiele came back to the scheme of his Wiener Werkstätte postcard and painted, in altered form, his *The Hermits* (Pl. 213). He and Klimt are shown in penitential robes; there is no immediate explanation for this, but at that time there were a number of self-portraits of Schiele in monk's attire. Schiele was not one to comment in detail on his paintings, but there is a long letter dated 27 February 1912 to the art collector Carl Reininghaus, whom he clearly hoped to persuade to buy the painting, which however did not happen.

> Dear Carl Reininghaus, I gladly admit that you are right: one doesn't see at once exactly how the two are standing . . . But I want to say something about the thought behind the painting, which justifies much, perhaps everything, not only for me but also for the beholder. It is not a grey sky but a sad world in which the two men move, one in which they grew up alone, in which they rose organically from the ground; . . . I could not paint the picture from one day to the next, it came from my experiences over the years since my father's death; it is a vision rather than a painting after drawings. Perhaps this makes the whole thing easier to understand, I don't know, I simply had to paint it, whether it's good or bad, but if you knew how I see the world and how people have treated me up to now, I mean how deceitful they've been; so I have to go and paint such pictures that only have value for me. It took shape in my innermost being. I see that you want me to be quite sincere, and so I am, because I wouldn't alter anything in the painting. Best wishes, Egon Schiele. (N.320)[4]

On 18 May 1912 Schiele once again wrote to Arthur Roessler, who was away at the time: shortly after his release after the 'Neulengbach affair', which has lately been newly documented.[5] The judge presiding over the case burned one of Schiele's erotic drawings over a candle in court.

I am still quite shattered. One of my drawings, the one that hangs in my house, was burned in court. Klimt wants to do something about it, he says: this sort of thing could happen to one of us today and to another tomorrow, and then we couldn't paint anything at all etc. etc. (N.353)

Klimt's first effort to help his young friend was to try to get him a state subsidy.[6] But what was even more important, and surprisingly generous on Klimt's part, was that he recommended Schiele to his patrons, August and Serena Lederer, who invited Schiele to their house in Raab (Györ, Hungary) for Christmas and New Year 1912–1913. They became regular customers of his, and their young son Erich became a close friend. Interestingly, he tells Arthur Roessler in a letter addressed to him on 24 December 1912 that Serena Lederer took lessons from Klimt for fourteen years – a fact that has nowhere else been recorded: 'Mrs L[ederer] was a pupil of Klimt's for fourteen years and is quite good, but of course not individual or creative . . .' (N.429)

In January and February 1914 the Pisko Gallery, at the junction of Schwarzenbergplatz and Lothringerstrasse in Vienna's Ist district, housed an exhibition of the paintings entered for the Reininghaus competition. Klimt and Josef Hoffmann were among the jury in this competition, in which generous prizes were offered and prominent French artists also took part. It was generally expected that Schiele would get first prize; but Serena Lederer seems to have pleaded too insistently in his favour. Hoffmann was furious. The jury gave first and second prizes to Anton Faistauer[7] and Paris Gütersloh.[8]

183

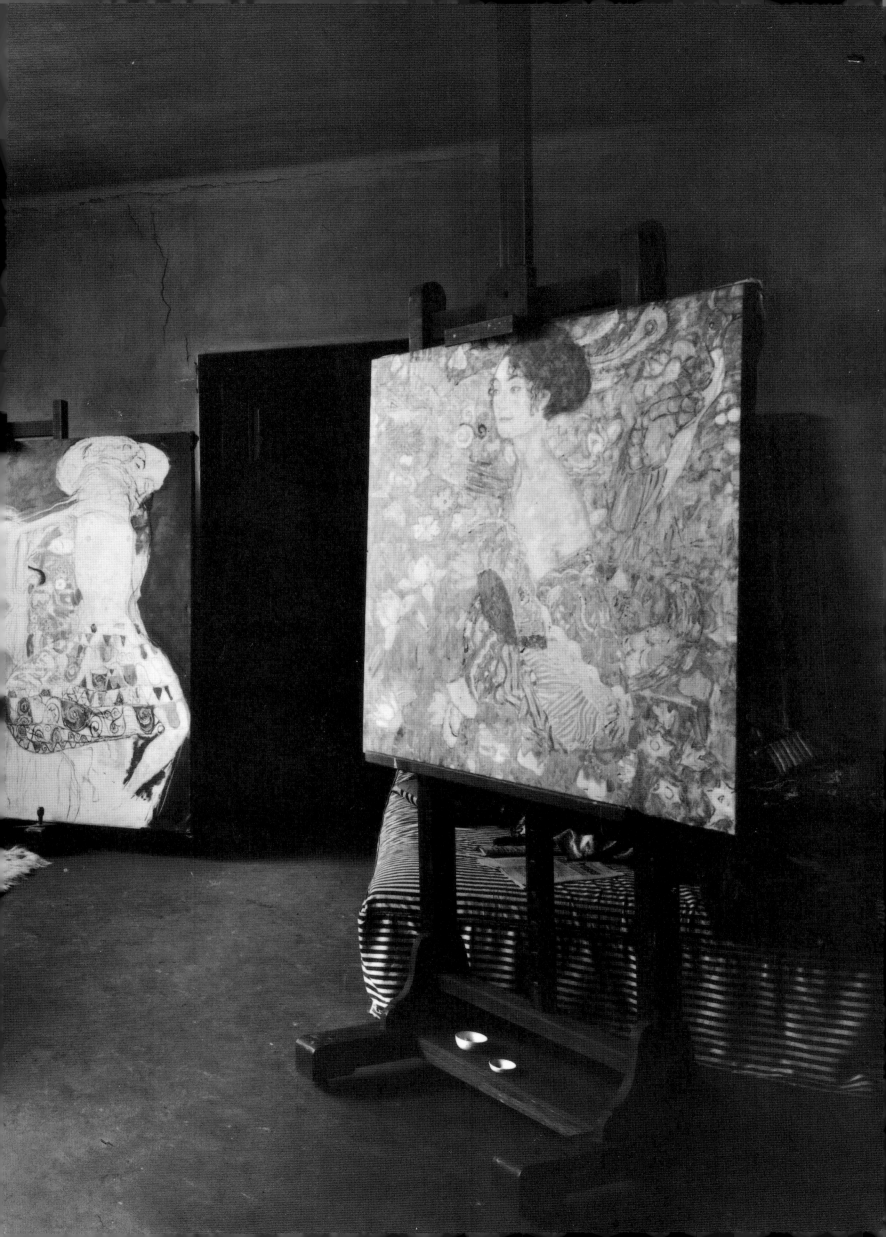

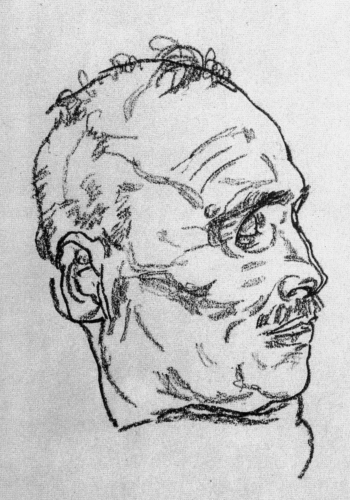

*215 Egon Schiele*, The dead Gustav Klimt, in profile facing right, *1918. Black crayon. 47.1 × 30 cm. One of the three drawings made by Egon Schiele in the mortuary of Vienna's General Hospital. Klimt's beard had been shaved off.*

GUSTAV KLIMT

Against his friends' advice, Schiele had entered an unfinished painting, *The Meeting*, 1913 (Pl. 211) and would have gone away empty-handed had not Reininghaus bought the painting, which has since been lost.

In 1915 Schiele executed a drawing with wash showing Klimt standing with fingers spread, this time not in a monk's habit but in his blue working smock (Pl. 11). Klimt certainly never sat for Schiele, and all Schiele's Klimt portraits – except for the drawings in the mortuary of the Vienna hospital (Pl. 215) – were drawn from memory. The same is true of the portrait in the New York sketchbook which its editor, Dr Otto Kallir, dates between 1913 and 1915.[9] This drawing is marked 'Gustav Klimt' in an unknown hand.

On 11 January 1918, while getting dressed in the morning, Klimt had a stroke which paralyzed him down one side. Schiele wrote on 19 January 1918 to his close friend, later his brother-in-law, the painter Anton Peschka:[10]

> I heard yesterday that Klimt has had a stroke and is very ill . . . (N.1351)

On 30 January 1918 he writes again to Peschka:

> Klimt is unfortunately not better, I feel so sorry for him, especially as they burgled his studio on the second day after his stroke. That is the world's gratitude, and they waited to give him big commissions until he was disabled . . . (N.1366)

Gustav Klimt died as a result of this stroke at 6am on 6 February 1918. At first he was put into Professor Gerhard Riehl's dermatology department in the General Hospital, as he had developed bed sores. The immediate cause of death was pneumonia. In the clinic he had lain on a water-bed and his beard had been shaved off, which explains why his features are almost unrecognizable in the drawings Schiele made of him in the mortuary on 7 February 1918 (Pl. 215, there are three in all) and on his death-mask.

On 15 February 1918 Schiele, who had poetic talent, published an obituary in the journal *Der Anbruch* (1st year, No. 3):

GUSTAV KLIMT
AN ARTIST OF UNBELIEVABLE PERFECTION
A HUMAN BEING OF RARE PROFUNDITY
HIS WORKS ARE SACRED

Schiele had originally suggested that Klimt's studio (Pl. 214) be preserved for posterity as Klimt had left it. But when he realized that this plan could hardly be realized in the fourth year of the First World War, he asked the painter Felix Albrecht Harta[11] to approach his mother-in-law who was the landlady of Klimt's last studio at 11 Feldmühlgasse in the XIIIth district, with a view to letting Schiele be a tenant there. Harta had at first promised that he would assist him in his plans (N.1713), but then he had to inform him that Emilie Flöge had been granted tenancy until February 1919 and that she would not be subjected to pressure to leave. Schiele's untimely death on 31 October 1918 settled the matter.

1 Arthur Roessler, art journalist, critic, promoter of Egon Schiele (1877–1955)

2 We list below all the known written sources regarding the meetings between the two. These are correspondence and documents filed in the Egon Schiele Archive, Max Wagner Foundation in the Albertina, Vienna.

3 This and all subsequent N numbers refer to: Christian M. Nebehay, *Egon Schiele: Leben, Briefe, Gedichte*, Salzburg 1979.

4 *Ibid.*

5 Op. cit. See also: *Egon Schiele im Gefängnis*. With commentaries by Christian M. Nebehay and Peter Müller. Graz 1990.

6 Friedrich Dornhöffer (1865–1934), mentioned in the letter dated November 1912 (N.409) and addressed to Schiele's landlord, the architect Moritz Otto Kuntschik, was an art historian, director general of the Bavarian State Gallery in Munich since 1902, and since 1909 director of the newly founded State Gallery (now Österreichische Galerie) in Vienna.

7 Anton Faistauer, painter (1887–1930)

8 Albert Paris Gütersloh (alias Albert Conrad Kiehtreiber), painter and author (1887–1973)

9 *A sketchbook of Egon Schiele's*. Commentary by Otto Kallir, New York 1967. Klimt's portrait on p. 93 is titled by an unknown hand.

10 Anton Peschka, painter, Schiele's brother-in-law (1885–1940)

11 Felix Albrecht Harta, painter (1884–1974)

# GUSTAV KLIMT AND SONJA KNIPS

*216 Sonja Knips in a Wiener Werkstätte dress. Photograph, about 1911.*

The portrait of Sonja Knips[1] (D.91), 1898 (Pl. 220) is Klimt's first important portrait and marks the breakthrough to his own style. The years of groping and searching were over, and from now on until his death he was the central figure of Austrian art in his time.

The portrait, whose beaten metal frame for the portrait was made by his brother Georg, could not be finished in time for the first Secession exhibition, held from 26 March to 15 June 1898, so it was shown at the second exhibition from November to December 1898.

It has already been mentioned that Klimt, when the young gathered round him, had not yet painted a really important picture; so that it was his qualities as a human being and not as an artist that put him at the forefront of the young Austrian art movement. This portrait was shown at the 1900 Paris World Exhibition (Austrian section, group 2, Secession room No. 7) next to Klimt's *Philosophy*.

Of the many female portraits which Klimt painted until his death, none shows more pleasant features than this one: there seems to be no doubt that he took enormous pains to convey his model's charm. By comparison, the portrait of Margaret Stonborough-Wittgenstein (Pl. 246) or one of the two portraits of Adele Bloch-Bauer (Pl. 267, 268) show the distance between him and these haughty society ladies.

The model is seated in an armchair. She wears a dress with a high neckline and ruching. Her left hand holds the arm of the chair, her right hand a small red notebook: a sketchbook that Klimt gave her.[2] Alice Strobl reports an eyewitness's impressions when visiting Klimt in his Josefstadt studio. The floor was 'strewn with thin red notebooks in which he jotted his artistic ideas down in shorthand, as it were.' Klimt was apparently as disorderly with his notebooks as he was with his sketches which lay about in heaps on the studio floor (see next chapter, p. 196–197 ff).

In those days this kind of notebook was available in the shops in a plain black cloth binding, so that Frau Knips had one bound in red leather specially for him and gave it to him; whereupon he returned it to her full of sketches (Pl. 63, 91, 218). It was part of her estate and still exists (Pl. 220): in it, loosely inserted, is a cutout from a photograph of Klimt (Pl. 217, in original size: Pl. 339). Would it be wrong to assume that this small detail could point to a closer relationship between painter and sitter? A married society woman would have never dared keep anything that was more than a souvenir. Johannes Dobai reports that the lady told him that the figures hidden in the foliage behind her had no symbolic meaning; and as for the notebook in her hand, that was chosen for the colour effect. All but three of the notebooks went to Emilie Flöge; there

must have been over fifty of them. They perished when her apartment burnt down in 1945. If Emil Pirchan[3] had not reproduced some of the sketches from the notebooks in his very readable and well illustrated book on Klimt, we would know nothing of them.

Sonja Knips was the daughter of a Lieutenant-Fieldmarshal Baron Max Potier des Echelles, and had married the industrialist Anton Knips, head of the firm of C. T. Petzold & Co., an ironworks in Neudeck, Bohemia, in 1896. In 1903, the year the Wiener Werkstätte was founded, she had her apartment decorated by Josef Hoffmann and extended by him in 1909. Hoffmann built a country house for the couple in Seeboden on the Millstättersee in Carinthia (pulled down after 1945). He also built them a large, elegant villa in 1924–25 at 22 Nusswaldgasse in the XIXth district, the charming interior of which remained untouched until Frau Knips's death, when it was destroyed through ignorance just at the time when

217 Below: *Gustav Klimt. Photograph, about 1898. Enlargement of the small photograph found inside the sketchbook.*

218 Above: *Two sketches for the painting* Will-o'-the-wisps *(AS 3403). Composition study from Sonja Knips's sketchbook, p. 135. 1898–1900. Pencil. 13.8 × 8.4 cm.*

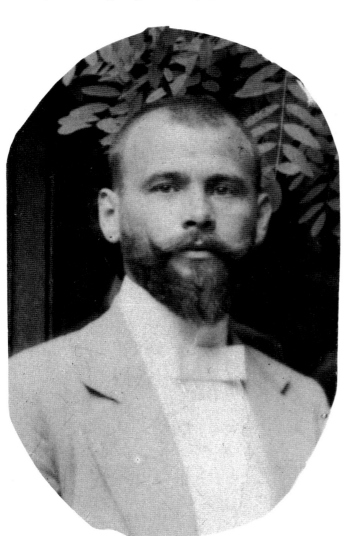

Hoffmann's art was beginning to be appreciated again. The portrait by Klimt hung in the middle of the living-room; it could be seen from the entrance hall through a glass partition. After Frau Knips's death it was donated to the Österreichische Galerie.

Ludwig Hevesi, who by 1898 had not yet grasped Klimt's importance, contented himself – contrary to his later detailed reports on each new painting – with only a few lines regarding the Sonja Knips portrait:

> Gustav Klimt's seated lady in the pink dress, and especially his remarkably coloured Pallas Athene are of top quality . . . The large portrait of the lady seated in pink is greatly admired. It has a special charm both as regards draughtsmanship and colouring.

189

219 Above: *Study for the painting* Portrait of Sonja Knips *(AS 420), 1898. Black crayon. 32 × 45.2 cm. Graphische Sammlung Albertina, Vienna.

219 Above: *Study for the painting* Portrait of Sonja Knips *(AS 420), 1898. Black crayon. 32 × 45.2 cm. Graphische Sammlung Albertina, Vienna.*

220 Below: *Klimt's sketchbook, property of Sonja Knips. 1897–1900. Red leather. 14.2 × 9 cm. In Klimt's portrait, the sitter is holding the sketchbook in her hand.*

221 Opposite: *Portrait of Sonja Knips (D.91), 1898. Oil on canvas. 145 × 145 cm. Österreichische Galerie, Vienna.*

He goes on:

> Notice the rippling pink of the seated lady . . . Henri Martin [pointillist, painted mainly frescoes] does similar work. But Klimt sticks to no one line: he always takes new liberties, especially for his female portraits, where each has a different colour scheme and is painted with a differently disposed hand.[4]

When the portrait was exhibited in Paris in 1900, it was greatly admired by French artists, but also by Arsène Alexandre, the editor of the *Figaro*,[5] who published a colour reproduction of it in the *Figaro Illustré, Les Sections Etrangères à l'Exposition de 1900*. But the Paris public was unimpressed by Klimt's paintings: he remained a stranger to them to the end of his life.

Alice Strobl, incidentally, also refers to an article in the *Wiener Allgemeine Zeitung* of 15 November 1903 and to the book *The World Exhibition in Paris 1900*, edited by Julius Meier-Graefe[6] and others in the same year, and which contained a report on the portrait.

1 Sonja Knips (1873–1959)

2 The sketchbook from Sonja Knips's estate was edited by the author of this book in 1987. It is one of Klimt's three sketchbooks that have come down to us. Alice Strobl was able to date it more precisely in her catalogue raisonné of Klimt drawings: the sketches were made some time after September 1897 and before 1899 (possibly 1900). There is no study for the portrait of Sonja Knips.

3 Emil Pirchan, architect, painter, set designer (1884–1957)

4 Ludwig Hevesi, *Acht Jahre Secession*, Vienna 1906, pp. 73 and 81. These lines were originally published in *Pester Lloyd* on 13 November and 19 November 1898.

5 See Alice Strobl, *Gustav Klimt. Die Zeichnungen*, Salzburg 1980, Vol. 1, p. 131.

6 Julius Meier-Graefe, influential art journalist (1867–1935), co-founder of the journal *Pan*. He later, along with most German art historians, took no notice of Klimt's work. Klimt sent his paintings to fourteen important German art exhibitions, without success.

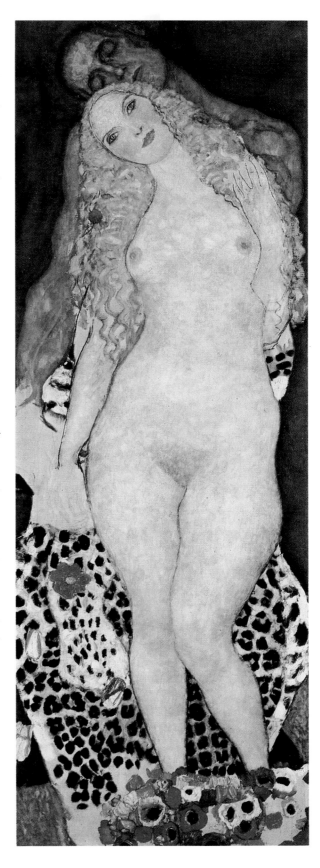

223 Adam and Eve (D.220), 1917–18 (unfinished). Oil on canvas. 173 × 1360 cm. Österreichische Galerie, Vienna.

222 Opposite: *Study for the painting* Adam and Eve *(AS 2918), 1917–18. Pencil. 56.9 × 37.5 cm.*

# GUSTAV KLIMT AND THE LEDERER FAMILY

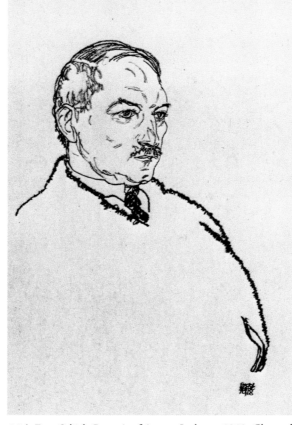

The year 1899 saw the appearance of another important female portrait, that of Serena Lederer (Pl. 226). It differed from the Sonja Knips portrait, not only in its narrow perpendicular format, but also in its technique which is reminiscent of Whistler.[1] Before he went to London Klimt had known Whistler's paintings only from black-and-white reproductions in British art journals, for Whistler showed none of his important work in Vienna. We can assume that

*224 Egon Schiele,* Portrait of August Lederer, *1918. Charcoal. Dimensions unknown.*

the charm of the Sonja Knips portrait so impressed the Lederers that they gave him the commission and paid him well.

Vienna was not very well disposed towards modern art, and the Lederers were also traditional in their collecting habits. They lived at 9 Bartensteingasse, near the new town hall, in Vienna's smartest residential area, and their apartment was full of remarkable art treasures. There were beautiful works of applied art, and on the walls were hung valuable paintings by Italian artists of the Renaissance and eighteenth century. Everything was of the best quality. After 1899 some of Klimt's finest paintings also hung there; and after 1905 his *Philosophy* was built into one of the rooms by Josef Hoffmann. His *Jurisprudence,* which had been

acquired in 1918 after Kolo Moser's death, was not put into place: it was rolled up and kept in the apartment.

Apart from their Vienna home the Lederers had a second house in Győr (Raab in Hungary, between Vienna and Budapest). Their villa was built on to the buildings of the big distillery which August Lederer (Pl. 224) had taken over from the state monopoly. Thanks to his efficiency, the business, which had previously shown a deficit, flourished and became profitable. Eduard Josef Wimmer-Wisgrill,[2] at that time employed in the fashion department of the newly founded Wiener Werkstätte, had been commissioned by the Lederers to convert their house; the result was a fine and comfortable interior. All of the art collection remained, however, in the Vienna apartment. Unfortunately no photographs exist of the two homes.

Serena Lederer was a great beauty in her youth and possessed all her life the manner of a grande dame. She was from the Pulitzer family. The Pulitzer Prize, known to this day all over the world, is awarded once a year by the University of Columbia in New York for outstanding journalistic work. Its founder, Joseph Pulitzer, came from Hungary and emigrated to the United

194

States where he made his reputation as a newspaper editor and amassed a considerable fortune.

We may assume that it is thanks to Frau Serena Lederer that this, the largest and most important collection of Klimt paintings, took shape. The Lederers also owned the largest number of drawings by Klimt. Towards the end of the First World War a fac-simile edition of twenty-five drawings from the Lederer collection was published:[3] these were those which the Lederers had bought from Klimt himself.

*225* Below: *Study for the painting* Portrait of Serena Lederer *(AS 451), 1899. Pencil. 45.2 × 31.8 cm. Graphische Sammlung Albertina, Vienna.*

*226* Right: Portrait of Serena Lederer *(D.103), 1899. Oil on canvas. 188 × 83 cm. The Metropolitan Museum, New York.*

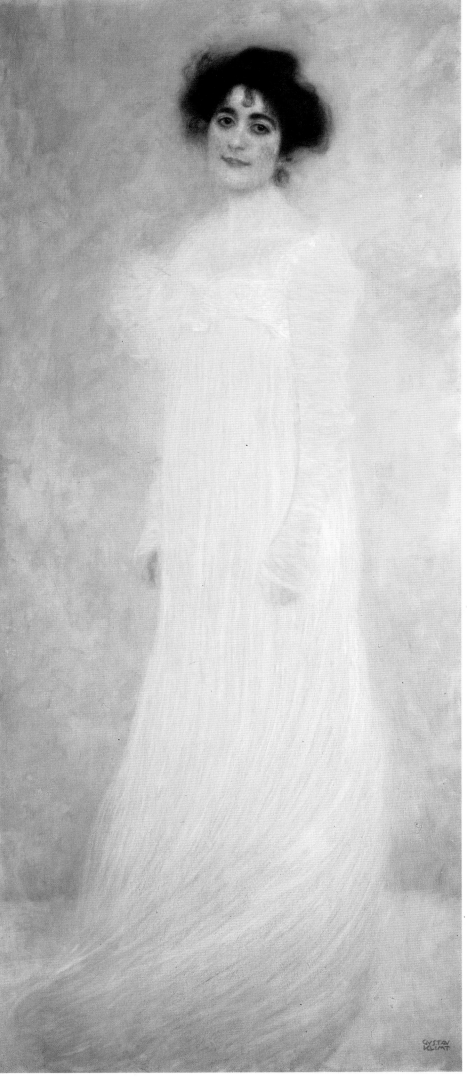

*227* Above left: Leda
*(D.202), 1917. Oil on
canvas. 99 × 99 cm.
Destroyed by fire in Schloss
Immendorf in 1945.*

*229* Below left:
*Composition sketch for the
painting* Leda *(AS 2847).
Sketchbook 1917, p. 105.
Pencil. 16.2 × 10 cm.
Detail.*

*228* Above right:
Gastein *(D.219), 1917.
Oil on canvas. 70 ×
70 cm. Destroyed by fire
in Schloss Immendorf
in 1945.*

*230* Below right:
*Preliminary sketch for the
painting* Gastein *(AS
3140). Sketchbook 1917,
p. 81. Pencil. 16.2 × 10 cm.
This is one of Klimt's rare
landscape sketches.*

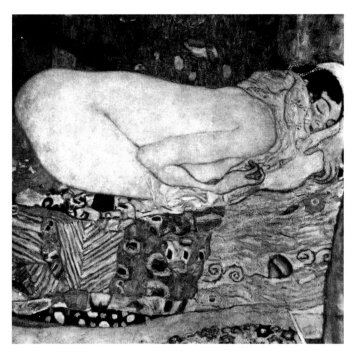

Of the three University paintings, Klimt's studies for them, and the piles of drawings in Klimt's studio, Arthur Roessler writes:

I myself saw stacks of studies taller than a man, among them dozens of the same subject: a hand, a shoulder, a torso, a few

legs, a standing or reclining figure, the contrapunctal embrace and intertwining of two bodies, or even a gesture; the same repeated over and over again, but always seen and rendered afresh. Klimt considered these myriad proofs of diligent and penetrative work from nature merely as a means to an end, and he destroyed thousands of them once they had served their purpose or did not achieve the greatest expression with

196

the greatest economy of technique. Once when I was sitting in Klimt's studio and rummaging through a pile of hundreds of such sketches, with all around me eight or ten yowling and purring cats who chased each other about and sent the paper flying, I asked him why he put up with this – it ruined hundreds of his best drawings. He grinned and answered:

'Well, if they crumple one or other of the sketches, that doesn't matter; but they'll piddle on the rest, and you know, that's the best fixative!'[4]

A large number of the Klimt drawings from the Lederer collection came from a purchase Frau Lederer had made in 1919 in my father Gustav Nebehay's gallery in the old Hotel Bristol. He had organized an exhibition in June of that year and had published the first catalogue of Klimt drawings from his estate: *The Drawings: Book II*. The catalogue comprised 200 selected drawings. Hardly had the invitations to view the exhibition and the catalogues been posted than the gallery door was opened and in swept – there is no other way of putting it – Frau Serena Lederer. She took a short look round and then said: 'What does the whole thing cost, Herr Nebehay?' My father thought he had not heard aright, but she continued: 'Did I not make myself clear? I said the whole thing and I meant it. So what does it cost?' My father hastily counted up the prices from his list and named her a sum. 'Done!' came the answer, 'send the lot to me at Bartensteingasse. Good morning!' and out she swept again, leaving my father speechless. I should add that that was the Lederer family's last major acquisition, for the fall of the Austro-Hungarian monarchy resulted in a severe reduction of their huge fortune.

The Lederer collection of Klimt paintings was dogged by bad luck. When Austria was annexed by Germany in 1938 the collection was confiscated: only the family portraits could be saved and taken over the frontier. The following Klimt paintings, together with the University paintings (of which *Philosophy* and *Jurisprudence* belonged to the Lederers) perished in 1945 in the fire at Schloss Immendorf in Lower Austria (see pp. 78–79), where they had been stored:

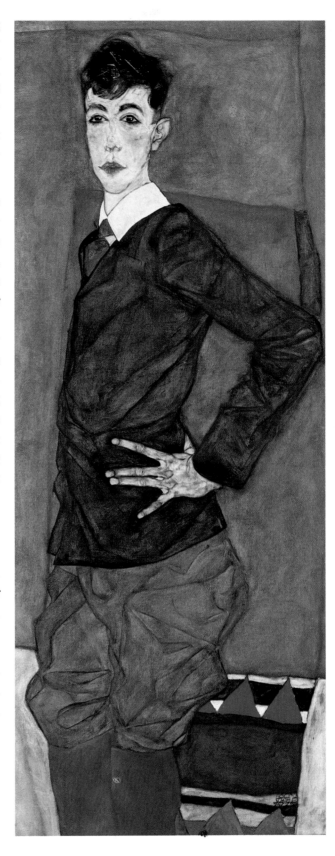

*231 Egon Schiele*, Portrait of Erich Lederer, *1912–13. Oil on canvas. 139 × 55 cm. Kunstmuseum, Basle.*

This is perhaps the moment to remember their son, Erich Lederer:[5] highly gifted, he grew up in the cultured atmosphere of the parental home and grew to be an art connoisseur par excellence. He became a leading expert in the field of Italian Renaissance bronzes, of which his parents owned a considerable collection. He had a special predilection for Egon Schiele, whom he had met at the age of sixteen in Györ at New Year 1912–1913. Schiele painted a portrait of him at the time (Pl. 231) which now hangs in the Kunstmuseum in Basel, to whom it was donated in memory of the sitter. Erich Lederer persuaded his somewhat conservative parents to help Egon Schiele by buying his drawings on a large scale; he told me that they had owned as many Schiele drawings as there are days in a year.

Serena Lederer, as we read in a letter dated Györ, 24 December 1912 from Egon Schiele to Arthur Roessler,[6] had been a pupil of Klimt's for fourteen years; Erich Lederer decided to do likewise with Egon Schiele at the beginning of their friendship. Schiele, by the way, did not treat his pupil particularly gently, as can be seen from his letter dated 3 October 1914:[7]

> Dear Erich, you have far too little respect for art. You are old enough to be able to differentiate between real art and kitsch. Either you become an artist or a businessman – you must know which you prefer. But if you want to be an artist, then you must work unceasingly and at full pressure, so that after a few years you achieve such skill and ability as will enable you to convey in paints your mental life, your philosophy and your impressions . . . When you work, you must work with me in the studio and not in the drawing room. I know why this won't work, and I know that you don't know why . . .

*234 Study for the painting* The Friends *(AS 2833), 1916–17. Pencil, blue and red crayon. 51 × 33 cm.*

*235* Above: *Garden Path with Hens (D.215), 1916. Oil on canvas. 110 × 110 cm. Destroyed by fire in 1945 in Schloss Immendorf.*

*236* Below: *Sketch with flowers (AS 3122). Sketchbook 1917, p. 95. Pencil. 16.2 × 10 cm.*

1 James A. M. Whistler, British portrait and landscape artist (1834–1903)

2 Eduard Wimmer-Wisgrill, architect, fashion designer, worked in the Wiener Werkstätte (1882–1962)

3 *Gustav Klimt. 25 Handzeichnungen*, Vienna 1919

4 Arthur Roessler (1877–1955) was an art journalist, critic and promoter of Egon Schiele. The quotation comes from his book: *In memoriam Gustav Klimt*, Vienna 1920, p. 21.

5 Erich Lederer (Vienna 1896–1985). See Christian M. Nebehay, *Gustav Klimt, Egon Schiele und die Familie Lederer*, Bern 1987.

6 Vienna City Library, Inventory No. 180.671, first published in: Arthur Roessler, *Briefe und Prosa von Egon Schiele* No. 75.

7 Christian M. Nebehay, op. cit. p. 86 ff.

It must be said, in all honesty, that this young and very precocious boy, who was sharply watched over by his mother, was very keen to visit Schiele as often as possible in his studio in order to meet his models!

Erich Lederer, who emigrated to Geneva in 1938 with his young wife – they took with them little more than the clothes they were wearing – succeeded in rescuing his Klimt and Schiele drawings from the grip of the authorities. In the days of his greatest financial need he sold some of them at cut-price rates in order to keep his head above water. But he managed to keep all the drawings he really valued, and he never gave up believing that one day the world would realize what remarkable artists they were. It was granted to him, towards the end of his life, to see the prices of both artists match those of their contemporaries.

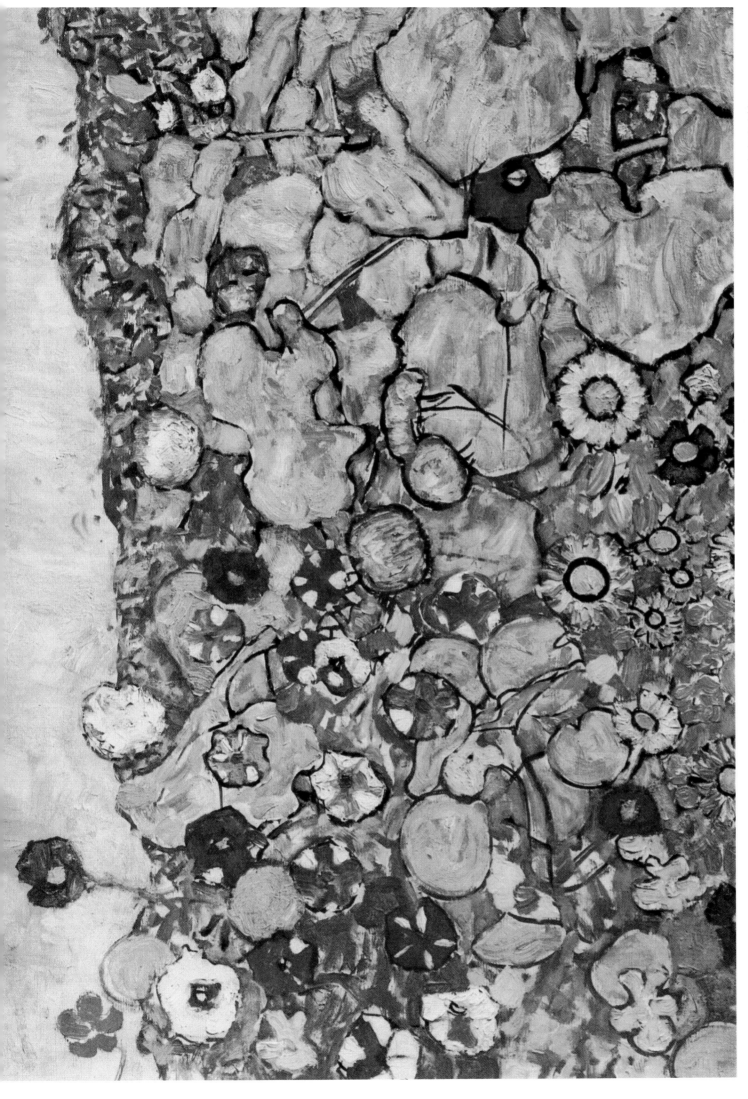

238 *Study for the painting* Portrait of Baroness Elisabeth Bachofen-Echt *(AS 2499), 1916. Pencil. 56.8 × 37.3 cm.*

239 Below: *Study for the painting* Portrait of Baroness Elisabeth Bachofen-Echt *(AS 2503), 1916. Pencil. 56.9 × 37.2 cm.*

240 Opposite: Portrait of Baroness Elisabeth Bachofen-Echt *(D.188), about 1914. Oil on canvas. 180 × 128 cm. Kunstmuseum, Basle.*

Elisabeth Lederer, daughter of August and Serena Lederer, married a member of the Viennese Bachofen-Echt beer dynasty. Her parents commissioned the portrait.

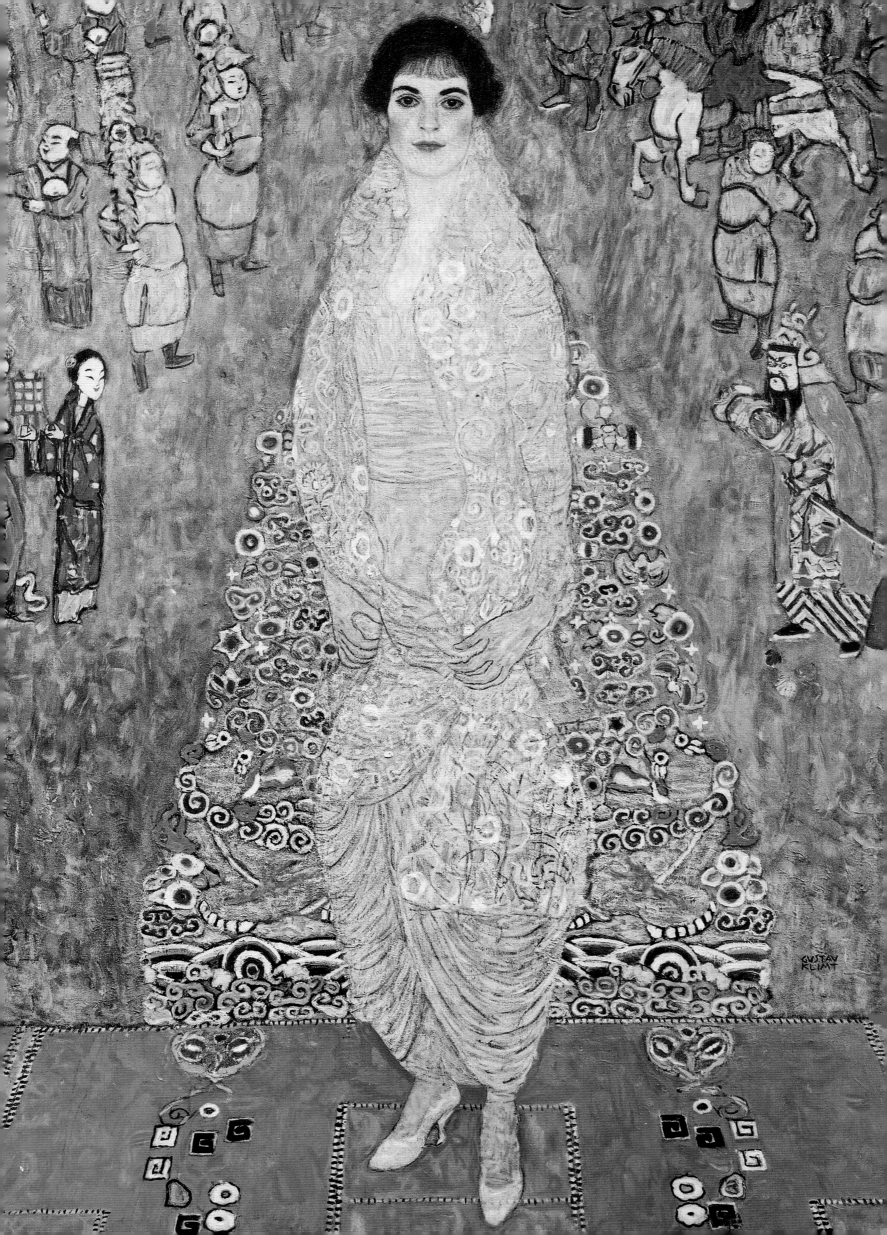

*241* Portrait of a Lady, *also known as* Portrait of Ria Munk III *(D.209), 1917–18 (unfinished). Oil on canvas. 180 × 90 cm. Neue Galerie der Stadt Linz – Wolfgang-Gurlitt-Museum.*

*242* Opposite: *Study for the painting* Portrait of Ria Munk III *(AS 2623), 1917–18. Pencil, red and blue crayon, heightened with white. 50 × 32 cm. This portrait from the Neue Galerie der Stadt Linz was identified by Alice Strobl as one of three posthumous portraits of Ria Munk, daughter of Alexander and Aranca Munk. Aranca, a sister of Serena Lederer, had commissioned the portraits by Klimt after her daughter's suicide in 1911.*

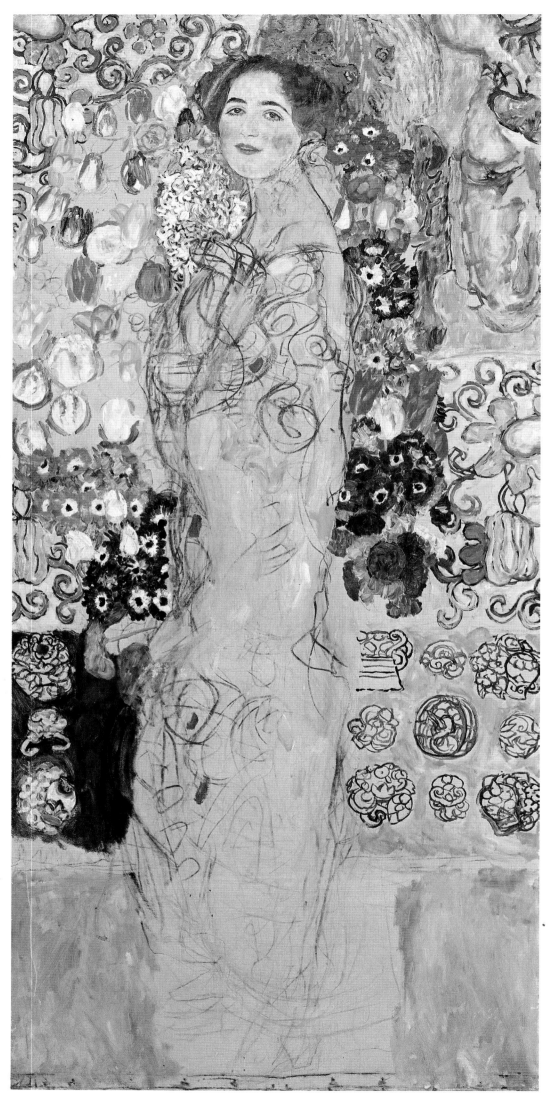

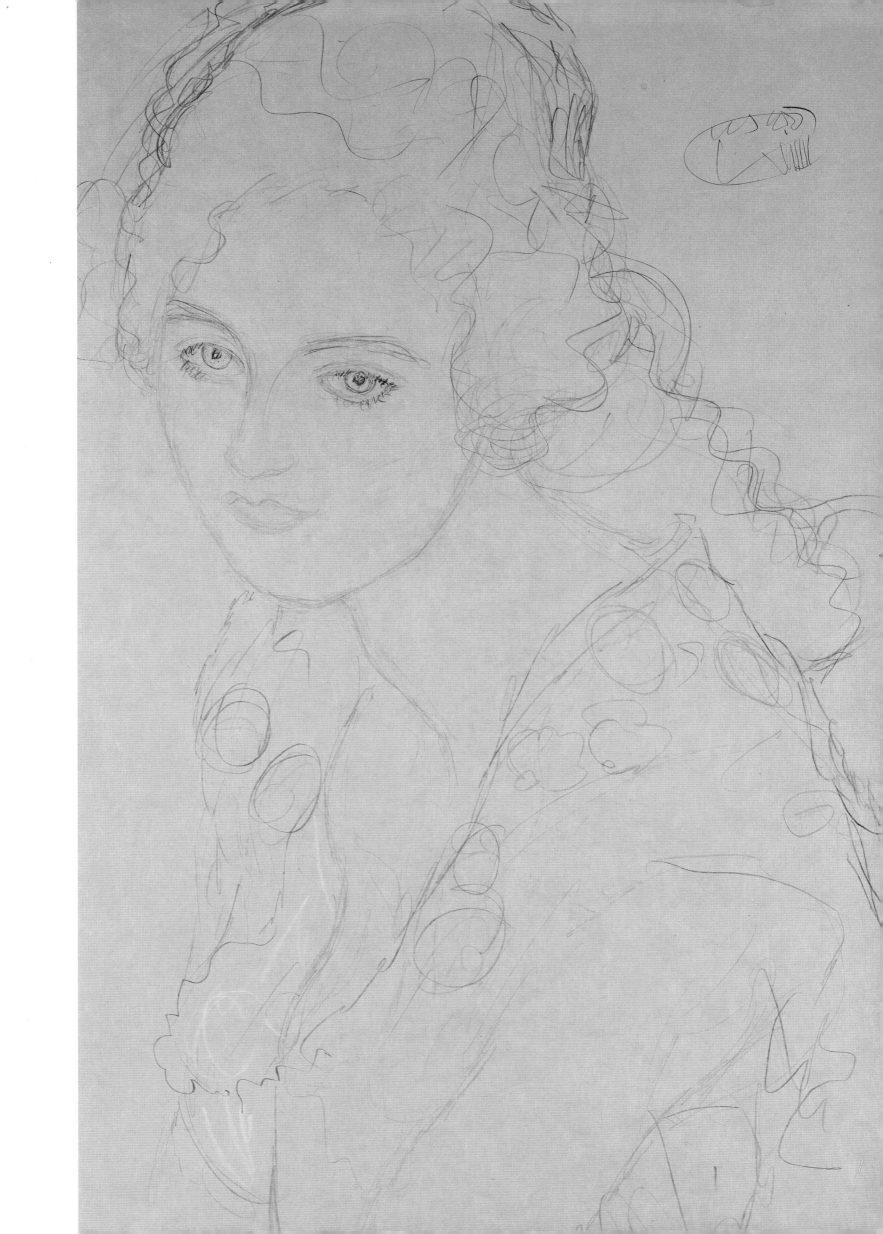

# GUSTAV KLIMT'S COLLECTORS:
## KARL WITTGENSTEIN, THE ZUCKERKANDL FAMILY, THE BÖHLER BROTHERS AND THE BLOCH-BAUERS

*243* Life is a Struggle, *also known as* The Golden Knight *(D.132), 1903. Oil on canvas. 100 × 100 cm. Aichi Prefectural Museum of Art, Nagoya, Japan.*

One of Gustav Klimt's most important patrons and collectors was the industrial magnate Karl Wittgenstein,[1] who played a leading role in the history of Viennese art at the turn of the century. Karl Wittgenstein's grandfather, Moses Mayer, came from Korbach in Westphalia and changed his name to Wittgenstein. His son Hermann Christian was a wholesale wool merchant and married Fanny Figdor, who came from a respected family of the Viennese bourgeoisie and led an active cultural life.

Of his eleven children, Karl Wittgenstein was the most interesting. After an adventurous youth – he ran away from home several times and tried various jobs in America – he studied at the Technical College in Vienna and was employed at the machine works of the state railways. His takeover of the rolling-mills in Teplitz in 1878 marked the beginning of his extraordinary ascent to being an industrial magnate who practically dominated the Austrian iron industry. He founded the rail cartel in Austro-Hungary, incorporated the Teplitz works with the Prague Iron Industry Society in 1886, and shortly afterwards founded the first Austro-Hungarian iron cartel. He had a share in fourteen businesses in the iron and mining industries and was on the boards of the Creditanstalt, the Aussig-Teplitz Railway and the Gelsenkirch Mining Society.

Karl Wittgenstein was a man of quick decisions and a constant readiness to take big risks. He was also completely antibureaucratic and never aspired to official honours. He supported charities on a large scale but anonymously. In the 1880s he acquired the old Prantner Palais at 16 Argentinerstrasse in the IVth district, which had been built to the plans of the architect Friedrich Schachner, and had it furnished in the most opulent of Ringstrasse styles. Academic artists such as Josef Fux, Franz Schönthaler and the Jobst brothers – all long forgotten – decorated the rooms. The best available music was made in the house, for Wittgenstein's wife, Leopoldine Kallmus, was an excellent pianist: Johannes Brahms, Clara Schumann, Gustav Mahler, Bruno Walter, the Joachim Quartet, Pablo Casals and many other celebrities played there.

In 1899, at the age of fifty-two, Wittgenstein took a trip around the world and then retired. From then on he devoted his time to his passions, above all to hunting. He had Josef Hoffmann convert and furnish his hunting lodge in Hochreith near Hohenberg in Lower Austria; apart from a few slight alterations Hoffmann's decor has remained unchanged to this day.

But Wittgenstein was also a patron of the fine arts. It was thanks to him that the Secession, whose honorary president he was, came into being: apparently he gave the Secessionists a large sum of money in 1898 towards the 70,000 gulden needed for the construction of the Secession building. The city authorities allegedly put the building site at their disposal free of charge, although Wittgenstein's daughter Hermine writes in her *Family Reminiscences* that her father paid for the site. In these memoirs (1944), which remained unpublished, she writes:

> The young union (Secession) was looking for patrons and discovered in my father, who joined it as founder, a man after their own heart . . . They also honoured him by putting his name up as the only donor in the Secession building's entrance hall next to the names of the artists Rudolf von Alt and Theodor Hörmann.[2]

And in the Secession catalogue of the Wittgenstein exhibition (1989), we read on p. 110:

> Those of us who know of Karl Wittgenstein's dislike for formal tradition and rigid convention will understand that he, a self-styled innovator in both commerce and industry, had sympathy and understanding for the innovators in art, that is for the Secessionists, who turned their backs on formal petrifaction and 'academicism' . . .

We have already seen that Karl Wittgenstein was one of Gustav Klimt's most important patrons. In the staircase of his palais hung Klimt's paintings *The Struggle of Life* and *The Golden Knight* (D.132), 1903 (Pl. 243). Wittgenstein also commissioned Klimt to paint the portrait of his daughter Margaret Stonborough-Wittgenstein, 1905 (Pl. 246).

Three letters of Klimt's exist, addressed to the Wittgensteins, who had approached him about this portrait:

> Dear Madam, I shall be very happy indeed to carry out your commission, if you can allow me a little time. I shall not be able to make a start before the middle of March; if this should present no problems, I am at your disposal.
> Yours very sincerely, Gustav Klimt. [Before mid-March 1905]

A few months later Klimt wrote:

> Dear Madam, may I now answer a letter I received some time ago? And may I hope that you will forgive me if I say that apart from an almost pathological aversion to writing, I have been postponing the answer from one day to the next because it is difficult.
> Difficult, not because the portrait is still not finished, but because it is still not good – I can therefore only quote you the price of my current full-length portraits, and that is 5000 gulden.[3] Even less can I take advantage of your kind offer to pay for the portrait now, for the reasons given above. I hope to be able to complete the painting after the exhibition is over, and that it will turn out to your satisfaction.
> Once again my apologies – the delay in answering you has greatly weighed on my mind.
> Yours sincerely, Gustav Klimt. [Summer 1905]

This is the third letter:

> Dear Madam, may I borrow my painting *The Golden Knight*, which is in your collection, for the Berlin art exhibition? Also your daughter's portrait, although it is not yet finished? The exhibition will probably last until November – I have to fill a room there and need the paintings urgently.
> Yours sincerely as ever
> Gustav Klimt

Like her father, Margaret played an important part in the art world of those days. She had her brother, the philosopher Ludwig Wittgenstein, build the famous house at 18 Parkgasse in the IIIrd district, and was also active in other cultural domains; she was, for instance, president of the Vienna Arts and Crafts Society, which had parted from the Austrian Arts and Crafts Society in 1920. Margaret's portrait, which has been in the Neue Pinakothek in Munich since 1960, is certainly one of Klimt's best; but according to her son, Dr Thomas Stonborough, his mother never liked it, and banished it to the attic of her summer residence on the Traunsee. It thus shared the fate of Emilie Flöge's portrait (Pl. 283).

Hermine Wittgenstein, in her *Family Reminiscences*, gives a description of Margaret which proves that Klimt did justice to her remarkable personality:

> Tall and slim, physically dexterous and very courageous, with a lively expression in her comely face: so it is that I see her before me, when I think back on her young days; and all this – her kindness, her intelligence, her versatility, her beauty and her impatience with all convention, all this gained in strength

and depth with the years . . . As a child and as a young woman she was interested in everything regardless, and had to try everything out; she worked for a time with Professor Emil Fischer in a chemical laboratory in Zürich, and later she took up mathematical studies and perhaps other things that now escape me.

Had Margaret found something to criticize in the portrait, then Hermine would surely have noted the fact.

Apart from these two, Karl Wittgenstein owned the following paintings by Klimt:

*Water Snakes I*, also *Friends I* (D.139), watercolour, about 1904–1907, Österreichische Galerie, Vienna (Pl. 197)
*Cottage Garden with Sunflowers* (D.145), about 1905–1906, Österreichische Galerie, Vienna
*The Sunflower* (D.146), about 1906–1907 (Pl. 247)
*Schloss Kammer on the Attersee IV* (D.172), 1910

Karl Wittgenstein lived in the palais with his wife Leopoldine Kallmus, whom he had married in 1873. She bore him eight children, of whom the three eldest committed suicide. One son, Paul,[4] became a well-known concert pianist; he lost his right arm in the First World War and inspired famous composers such as Maurice Ravel, Richard Strauss and others to compose pieces for him which he played with great virtuosity with his left hand in concerts. He owned a large collection of valuable old books on natural history and watercolours of plants and animals. Karl Wittgenstein's youngest son Ludwig,[5] the author of the *Tractatus Logico-Philosophicus* and other philosophical

208

*246* Portrait of Margaret
Stonborough-
Wittgenstein *(D.142),*
1905. *Oil on canvas.*
*180 × 90 cm. Bavarian*
*State Paintings Collection,*
*Neue Pinakothek,*
*Munich.*

Opposite:
*244* Left: *Study for the*
*painting* Portrait of
Margaret Stonborough-
Wittgenstein *(AS 1265),*
*1904–05. Black crayon.*
*55 × 35 cm. Graphische*
*Sammlung Albertina,*
*Vienna.*

*245* Below: *Carl Otto*
*Czeschka. Ex libris for the*
*hunting lodge Hochreith*
*(Poldi and Karl*
*Wittgenstein) near*
*Hohenberg, Lower*
*Austria, built by Josef*
*Hoffmann for Karl*
*Wittgenstein.*

works, is considered one of the greatest thinkers of the twentieth century.

Gustav Klimt had several connections with the Zuckerkandl family, the closest being with Berta Zuckerkandl,[6] the daughter of the newspaper tycoon Moritz Szeps.

Berta was a remarkable woman. Her interest in journalism and politics began early in her life, and at the age of eighteen she became her father's 'confidential secretary'. In 1886 she married the thirty-four-year-old anatomist Emil Zuckerkandl, accompanied him to Graz but after two years returned to Vienna,

249 Above: Portrait of Paula Zuckerkandl (D.178), about 1912. Oil on canvas. 190 × 120 cm.

250 Below: *Study for the painting* Portrait of Amalie Zuckerkandl *(AS 2490), 1917–18. Pencil. 57 × 37.5 cm.*

'revolutionary court counsellor'. Shortly after the death of Emil Zuckerkandl in 1910, Berta's mother died. Pulling her family strings, Berta tried to play a part in history during and immediately after the First World War: the brother of her brother-in-law was to help her to obtain a separate peace for Austria. But here she had overestimated her influence. She did much to help the starving population of Austria in the postwar era by organizing food parcels from Switzerland, which earned her the title of semi-official 'cultural ambassadress'. Between the wars she became a well-known journalist, using the initials B. Z., and was also nicknamed the 'Viennese Cassandra'. In 1920 she was present at the inauguration of the Salzburg Festival, and in the 1920s her salon blossomed. As a journalist

where she created her own salon, which soon became a meeting place for the best-known personalities on the art and culture scene of the time. Apart from Gustav Klimt, whom she repeatedly championed as representative of the Moderns, Gustav Mahler and Max Reinhardt, Arthur Schnitzler, Hugo von Hofmannsthal and Karl Kraus frequented her salon. Through her father, proprietor of the *Neues Wiener Tagblatt*, she made the acquaintance of Crown Prince Rudolf; her sister Sophie was married to the brother of the French president Georges Clemenceau. After the birth of her son Fritz, Berta Zuckerkandl again found time to write art reviews for the *Wiener Allgemeine Zeitung* and to take part in daily events. She was soon known as the

212

*251* Portrait of Amalie
Zuckerkandl *(D.213),
1917–18. Oil on canvas.
128 × 128 cm.*

she switched over to the *Neues Wiener Journal*, this time as foreign correspondent. She won an international reputation through her interviews with numerous eminent European politicians. In the 1930s she pursued these activities less and less, and in March 1938 she went to Paris, where she wrote her memoirs which were published in 1939 with the title *Ich erlebte fünfzig Jahre Weltgeschichte* (*I Witnessed Fifty Years of World History*). Oddly enough, Klimt never portrayed her.

Another member of the family played an important part in the art world around 1900, namely the steel

213

*252* Forester's lodge in Weissenbach on the Attersee *(D.182), 1912. Oil on canvas. 110 × 110 cm.*

industrialist Viktor Zuckerkandl,[7] who was a passionate collector, above all of the work of old Viennese artists. He had a particular predilection for watercolour portraits: he built up a collection of miniatures, often bringing them back from his journeys to France and England, and also owned a selection of fine old furniture. In 1916 he moved from Purkersdorf to Berlin-Grünewald and sold a part of his collection, which was auctioned on 26 October by the art dealer C. J. Wawra, at 14 Lothringerstrasse.

It was also Viktor Zuckerkandl who commissioned the former *Sanatorium Westend*, generally known as the

Purkersdorf Sanatorium, one of the most modern constructions from Josef Hoffmann's early period (built between 1903 and 1908 at 72–80 Wiener Strasse).

The following Klimt paintings belonged to Viktor Zuckerkandl:

*Pallas Athene* (D.93), 1898, Historisches Museum der Stadt Wien (Pl. 97)
*Roses under Trees* (D.147), about 1905 (Pl. 248)
*Portrait of Paula Zuckerkandl* (D.178), about 1912 (Pl. 249)
*Avenue in the Park of Schloss Kammer* (D.181), 1912, Österreichische Galerie, Vienna (Pl. 281)
*Forester's Lodge in Weissenbach on the Attersee* (D.182), 1912 (Pl. 252)
*Church in Cassone* (D.185), 1913
*Malcesine on Lake Garda* (D.186), 1913 (Pl. 280)
*Unterach on the Attersee* (D.192), 1915, Residenz Galerie, Salzburg
*Portrait of Amalie Zuckerkandl* (D.213), unfinished, 1917–18 (Pl. 251)[8]

The third large-scale collector of Klimt's work was the Böhler family or rather two sons of this family, neither of whom however worked in the family's industrial firm. The grandfather and founder of the firm, a citizen of Frankfurt, came to Vienna when he was young. The father, Dr Otto Böhler, was a chemist and became an important personality in the iron and steel industries. The whole Böhler family, apart from being art patrons, were great music lovers and regularly attended the Bayreuth Festival.

Dr Heinrich Böhler,[9] who lived at 30 Belvederegasse in the IVth district, was an amateur painter. Through the good offices of Josef Hoffmann he took lessons from Egon Schiele, to whom he sent monthly remittances when he was called up in 1915. Like his cousin Hans he also had Swiss citizenship, and after the end of the First World War he lived in St Moritz in a house built by the Berlin architect Heinrich Tessenow[10] which, despite protests, was demolished in 1989. He owned the following Klimt paintings:

*Lady Wearing a Hat with Roses* (D.169), 1910
*Death and Life* (D.183), before 1911 (Pl. 253)
*Italian Garden Landscape* (D.214), 1917
*Presshouse on the Attersee* (D.217), 1917

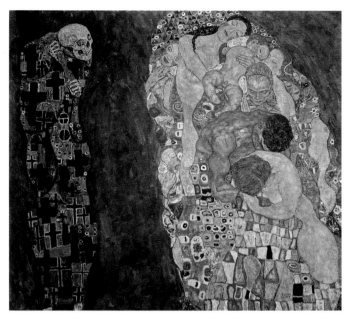

*253* Above: Death and Life *(D.183), before 1911, altered 1916. Oil on canvas. 178 × 198 cm.*

*254* Below: *Study for the painting* Death and Life *(AS 1885), 1908–09. Pencil. 56 × 37 cm.*

Hans Böhler[11] was a well-known Austrian painter. At the age of eighteen he enrolled at the private academy of the pointillist Jaschke – his father had been generous enough to exempt him from work in the firm – and already in 1905 he was showing some of his drawings at an exhibition of the artists' union 'Hagenbund'. The first time he showed a painting was at the 1908 spring exhibition at the Secession: a *Standing Female Nude*.

215

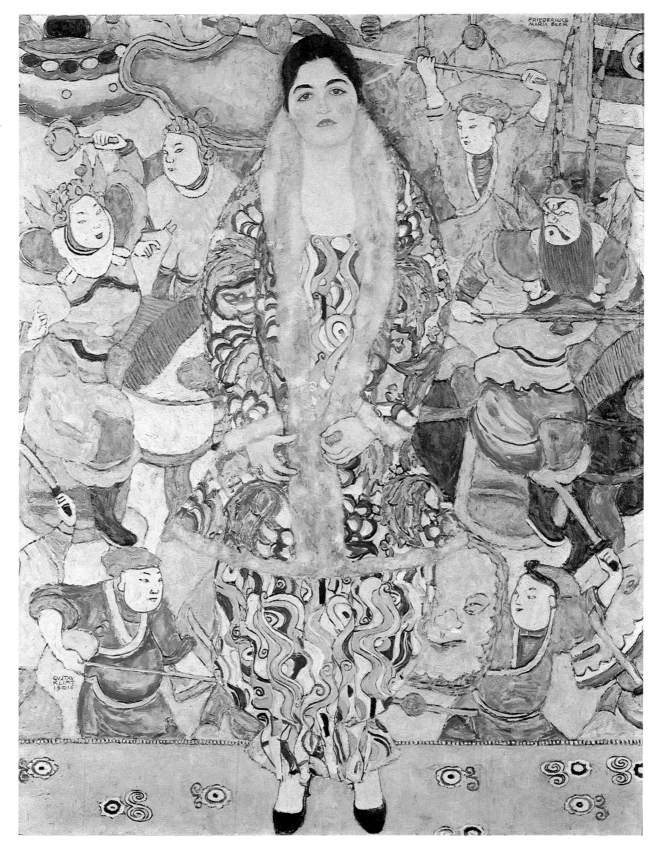

255 Portrait of Friederike Marie Beer (D.196), 1916. Oil on canvas. 168 × 130 cm. The Metropolitan Museum of Art, New York.

256 Opposite: *Study for the painting* Portrait of Friederike Maria Beer (AS 2526), 1916. Pencil. 56.9 × 37.4 cm.

216

*257* Above: *Study for the painting* Portrait of Friederike Maria Beer *(AS 2561), 1916. Pencil. 56.9 × 37.4 cm.*

*258* Below: *Gustav Klimt and Friederike Beer-Monti in Weissenbach on the Attersee. Photograph, 1916.*

*259* Opposite: *Egon Schiele,* Portrait of Friederike Maria Beer, *1914. Oil on canvas. 190 × 120.5 cm.*

drawings from Klimt's estate that were handled by my father. 'If any of them are wrongly stamped, that's my fault!' she once said to me, laughing.

She managed to get her portrait painted by two important artists, Schiele and Klimt, and even Oskar Kokoschka very nearly painted her (1916). At that time, as a result of being wounded in the war, he was lying in the Palais Palffy, then in use as an emergency hospital. But, she told me, the atmosphere there was so oppressive that she would have found it impossible to go there for sittings.

She bought the 1914 Schiele portrait from the artist for the modest sum of 600 crowns (Pl. 259). Strictly speaking, even those who did not know this temperamental, exotic-looking young woman personally, who

In 1909 he joined the 'Neukunstgruppe', among whose members were such important artists as Egon Schiele, Albert Paris Gütersloh, Oskar Kokoschka, Josef Hoffmann and Anton Faistauer. From 1911 he travelled around the world, visiting Japan, Korea, South America and the United States. He painted vividly coloured figurative pictures and was an excellent draughtsman of nudes.[12]

Hans Böhler was a friend for many years of Friederike Beer-Monti,[13] the daughter of the owner of the well-known 'Kaiserbar' in the Krugerstrasse in the Ist district. He never married her, and she went to New York in 1931 where, with a partner, she founded the 'Artist's Gallery'.

Between 1918 and 1920 Friederike Beer-Monti worked in Gustav Nebehay's gallery, where her job, among others, was to apply the estate stamp to those

was then in the prime of her life, must see that Schiele could find nothing better to do than to paint her lying down.

As early as 1923 it was clear to Schiele's friend the painter Anton Faistauer[14] that the portrait was not a success:

> Nor do I agree with those who say that Schiele is the stronger of the two artists because his colour is more brutal and more vivid. The difference can be seen by comparing a portrait of one and the same person painted by them both: Miss Beer. I saw them both hanging side by side. Schiele's painting was from his middle period, that of Klimt one of his last; and the power in his delicacy is immediately convincing as opposed to the barbaric colouring and crude positioning of the Schiele painting. Even the physiognomy in Klimt's portrait is to the highest degree true compared with the other's empty mask. The flesh pulsates and the clothes come mysteriously to life. To relegate Klimt to second-best is a gross injustice . . .[15]

Friederike Beer-Monti told me some twenty years ago that her friend Hans Bühler had asked what she wanted for Christmas: a pearl necklace or a portrait of her by Gustav Klimt. Without hesitation she chose the latter, and one day she stood, her heart fluttering, before Klimt's studio in the Feldmühlgasse. He stepped out in his blue working smock and asked her what she wanted. 'How come?' he said, 'you've only just been painted by Egon Schiele!' But she nevertheless persuaded him, probably not least because, as he said, she was different from the thin, elegant women he usually painted. 'Now you can't say I paint nothing but hysterical women,' he said to her.

It was she who suggested painting her in the lovely Wiener Werkstätte dress, which is incidentally to be seen in the Metropolitan Museum in New York, as is the portrait. At the time – 1916 was a particularly hard war year, defeat was in the offing and there was already much privation – she was very proud of a fur coat she owned which she wanted to wear over the dress. But Klimt preferred the red tones of the Wiener Werkstätte lining, and he asked her to wear the jacket inside out. He also painted the fur grey instead of white. She had to go three times a week to his studio; sittings were strenuous and lasted from 3 to 6pm during which time

219

*260* Above: *Lady with fan (D.203), 1917–18. Oil on canvas. 100 × 100 cm.*

*261* Below: *Study for the painting* Lady with Fan *(AS 2855). Sketchbook 1917, p. 199. Pencil. 16.2 × 10 cm. Detail.*

*262* Opposite: *Study for the painting* Portrait of Adele Bloch-Bauer I *(AS 1109), 1903–04. Black crayon, 46 × 31.5 cm.*

he recited Dante or Petrarch aloud. Klimt, she said, was extraordinarily like some animal: he exuded a peculiar odour. She never dared to look at the painting (Pl. 255), even when he left the studio for a few minutes; she had heard that once, when a sitter had criticized something in her portrait, he had promptly destroyed it!

Friederike Beer-Monti drew my attention to the background of the painting. The scenes of cavalry fighting were motifs from a Korean vase owned by Klimt, and clearly an allusion to the First World War then raging. When the painting was still not complete after six months, Hans Böhler apparently simply took it away from him.

Friederike Beer-Monti took both portraits with her to America and later sold them; with the proceeds she was able to book herself into a retirement home in Hawaii where she lived for many years. One day, apparently drowsy with sleep, she fell to her death from her balcony. She was a remarkable woman: I met her in 1917 in my father's gallery when I was eight years old; for me, she was a sort of fairy who exhaled a wonderfully strong scent. She filled every room she entered with her happy, gurgling laughter.

Last but not least, the industrialist Ferdinand Bloch-Bauer[16] must be called to mind, who twice commissioned Klimt to portray his wife Adele.[17] The first portrait (D.150, Pl. 267) dated 1907, must be considered as a chef-d'oeuvre of his 'golden style' (the malicious Viennese critics at once coined the expression: 'Mehr Blech wie Bloch' – a play on words meaning 'more brass than Bloch'. The portrait is painted against a golden background, the sitter's dress and the surrounding area are made up of geometrical patterns, perhaps inspired by Josef Hoffmann). The second portrait, on the other hand, (D.177, Pl. 268) dated 1912, is entirely different and introduces a change in Klimt's style. Instead of gold and metal, flowers now predominate. Both portraits, incidentally, were donated to the Österreichische Galerie. This is the only instance of Klimt painting a sitter twice: for both portraits he drew a large number of studies. The Bloch-Bauers also owned:

*Birch Wood* (D.136), 1903
*Schloss Kammer on the Attersee III* (D.171), 1910
*Apple Tree I* (D.180), about 1912
*Houses in Unterach* (D.199), about 1916
*Portrait of Amalie Zuckerkandl* (D.213), 1917–18, unfinished (Pl. 251)

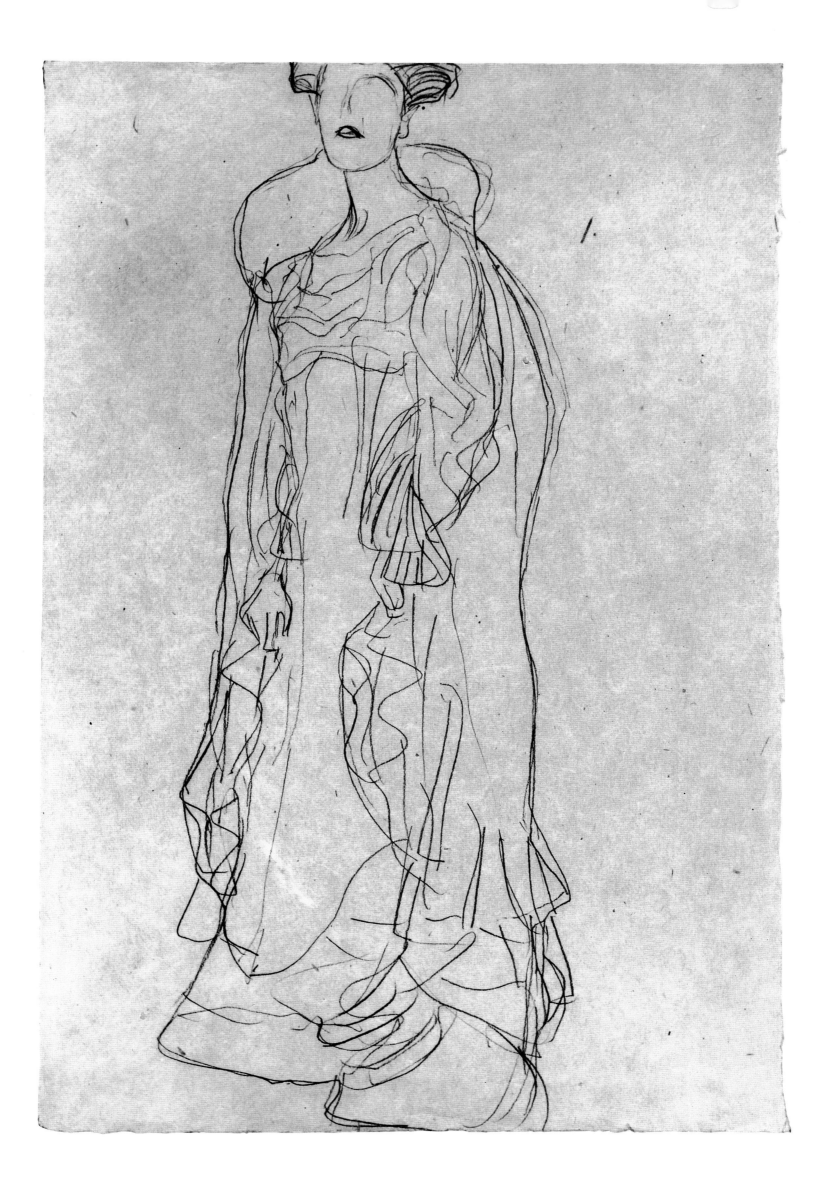

263 Above left: *Study for the painting* Portrait of Adele Bloch-Bauer I *(AS 1119), 1903. Black crayon. 45 × 31.5 cm.*

264 Above right: *Study for the painting* Portrait of Adele Bloch-Bauer I *(AS 1082), 1903. Black crayon. 45 × 32 cm.*

265 Below left: *Study for the painting* Portrait of Adele Bloch-Bauer I *(AS 1060), 1903. Black crayon. 45.3 × 31.2 cm.*

266 Below right: *Study for the painting* Portrait of Adele Bloch-Bauer I *(AS 1088), 1903. Black crayon. 45.3 × 31.7 cm. Graphische Sammlung Albertina, Vienna.*

267 Opposite: *Portrait of Adele Bloch-Bauer I (D.150), 1907. Oil on canvas. 138 × 138 cm. Österreichische Galerie, Vienna.*

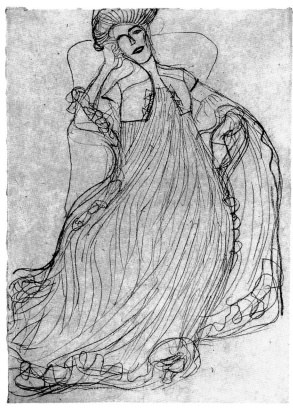

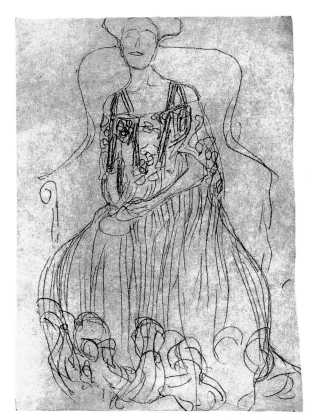

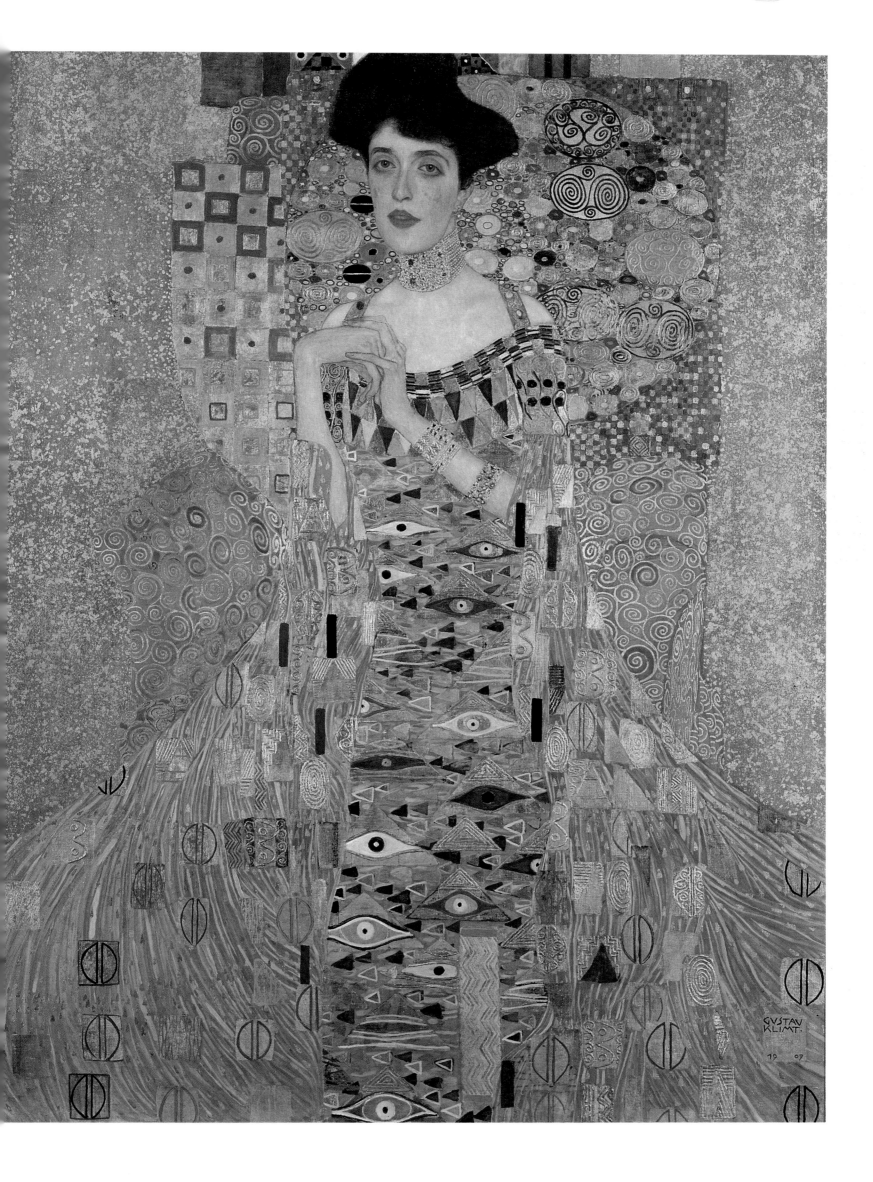

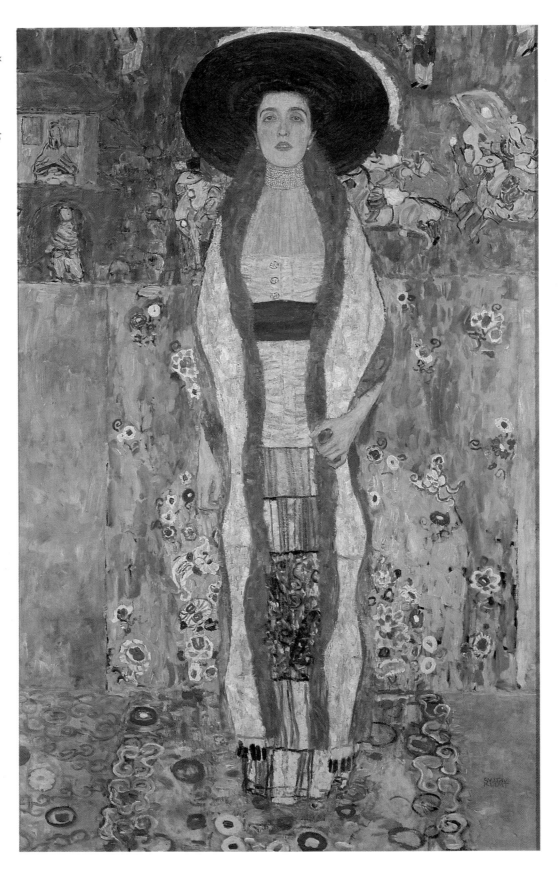

*268* Portrait of Adele
Bloch-Bauer II *(D.177)*,
*1912. Oil on canvas. 190 ×
120 cm. Österreichische
Galerie, Vienna.*

*269* Opposite: *Study for
the painting* Portrait of
Adele Bloch-Bauer II *(AS
2098), 1911. Pencil.
56.7 × 37.2 cm.
Graphische Sammlung
Albertina, Vienna.*

224

1 Karl Wittgenstein, industrialist (1847–1913)

2 These nameplates no longer exist.

3 As mentioned above, Klimt was paid 30,000 crowns for Serena Lederer's portrait: 5,000 gulden were 10,000 crowns. The difference in price is not explicable.

4 Paul Wittgenstein, pianist (1887–1961). I witnessed many of his visits between 1935 and 1938: they were always stormy and basically incomprehensible. He kicked the door open in V. A. Heck's antiquarian booksellers at 12 Kärtnerring in the Ist district, answered no greetings, ran several times round the big centre table and left without saying a word!

5 Ludwig Wittgenstein, philosopher (1889–1951)

6 Berta Zuckerkandl, journalist (1864–1945)

7 Viktor Zuckerkandl was a brother of the urologist Otto Zuckerkandl and of the anatomist Emil Zuckerkandl. His nephew, a son of Otto Zuckerkandl, was also called Victor (1896–1965). He was an eminent musicologist and conductor and a lifelong friend of Arthur Schnitzler.

8 Amalie Zuckerkandl, née Schlesinger, was the second wife of Otto Zuckerkandl (1861–1921). He was a university professor and wrote important textbooks. He was also presumably the owner of the last-named Klimt painting belonging to the Zuckerkandl family, which was later acquired by Ferdinand Bloch-Bauer.

9 Heinrich Böhler's dates are not known.

10 Heinrich Tessenow, German architect (1876–1950)

11 Hans Böhler, graphic artist, painter and draughtsman (1884–1961)

12 See Martin Suppan: *Hans Böhler, Leben und Werke*, Vienna 1990.

13 Friederike Beer-Monti (1891–1980)

14 Anton Faistauer's frescoes, which he painted for the Salzburg Festival House, had to be removed in 1938 but were replaced in 1945.

15 Anton Faistauer: *Neue Malerei in Österreich*, Zürich–Leipzig–Vienna 1923. p. 19

16 Ferdinand Bloch-Bauer (died 8.4.1946) was a sugar magnate.

17 Adele Bloch-Bauer (1882–1925) and her husband lived in Vienna and also near Prague in Schloss Jungfer-Brezan.

270 Portrait of Hermine Gallia (D.138), 1903–04. Oil on canvas. 170 × 96 cm. National Gallery, London.

271 Opposite: *Study for the painting* Portrait of Hermine Gallia (AS 1042), 1903–04. Black crayon. 45.2 × 31 cm.

# GUSTAV KLIMT AND THE ART TRADE

*272 The Secession's settlement of accounts in connection with the Klimt paintings sold at the eighteenth exhibition (Klimt collective), 1904.*

*273* Opposite: *The H. O. Miethke Gallery at 11 Dorotheergasse in the Ist district in the first Wiener Werkstätte exhibition that took place there. Photograph, 1905.*

Vienna's most prominent dealer in modern art around 1900 was Hugo Othmar Miethke. In 1896 he had bought the Palais Nako at II Dorotheergasse in the Ist district from Count Alexander Nako de Szent Miklos and adapted it for his purposes.[1] Most of the better-known Klimt portraits must, however, have changed hands more through the mediation of satisfied clients than through the trade.

Alice Strobl succeeded in gaining access to the Miethke Gallery's customer index, which is in private hands.[2] This provided her with much information about those of Klimt's paintings and drawings that were handled by the gallery. She notes that Klimt got 150 crowns per drawing in December 1906; by 1910 this had doubled to 300 crowns.

The highest recorded price for one of his drawings, the famous *Water Snakes* 1904/07 (Pl. 197), is 8,000 crowns. Its execution is so complete that it is treated as a painting and has been hanging in the Österreichische Galerie since 1950. The first buyer was Karl Wittgenstein.

In 1905 Miethke sold the gallery to Paul Bacher, a sparring partner of Klimt's. It was then that the painter Carl Moll started organizing exhibitions there, and so started the dispute within the Secession which led to the exodus of the Klimt group. Moll left the gallery in 1912. According to Alice Strobl, the gallery must have closed down in 1917, from which time Klimt had no dealer to advise him.

It was only towards the end of his life, in the autumn of 1917, that Klimt made contact with my father Gustav Nebehay. My father and Hans Boerner had, over a span of twenty years, made the Leipzig firm of C. G. Boerner into one of the most prominent in Germany, especially in the field of old prints. Until the outbreak of the First World War in 1914 the firm, on my father's initiative, also dealt in old and rare books, valuable manuscripts from the Middle Ages, autographs and old master drawings. The annual auctions were a special attraction for art and book lovers from all over the world.

The outbreak of the First World War in August 1914 had no immediate consequences for my father: being of a weak constitution, he had never been called up for military service. In 1915 he was summoned by the commission, but even they, pressed as they were by the heavy casualties on the fronts, could not overlook the suspicious enlargement of his heart. He was therefore declared unfit for active service and enlisted as a military clerk.

Alongside his duties he found time to establish his newly founded Gustav Nebehay Art Gallery (at first a branch of C. G. Boerner) in Vienna.[3] He took up his new activities in the old Hotel Bristol (no longer extant) at 12 Kärtnerring – first in several adjoining rooms on the first floor, then, after 1918, in large premises on the ground floor that were accessible from the Ringstrasse, previously the hotel's breakfast rooms. They were then furnished by Josef Hoffmann.

In Vienna he made friends with all the leading artists of the Wiener Werkstätte, that is, with Josef Hoffmann's group; so with time he also got to know the shy and reserved Gustav Klimt. An entry of Klimt's in the second of his notebooks (October 1917)[4] shows that my father paid him 8,000 crowns for several (probably thirty) drawings.

There is a letter to Klimt about this purchase, in my father's handwriting, dated 12 October 1917:

> Dear Professor, I return the drawings to you herewith. I would be grateful if you would write, on those which my wife and I chose, the words 'For Gustav and Maria N.', so that the drawings can be withdrawn from the trade . . . I hope you enjoyed last evening. Yours sincerely, Gustav Nebehay.[5]

The last words in my father's letter probably refer to Klimt's visit to the 'Pechhütte', a cottage at the foot of the 'Roter Berg' in Unter St Veit in Vienna's XIIIth district. We spent the summer months of 1917 in the house, and Klimt had been invited to supper there. On account of the catastrophic traffic conditions at the time – trams at only very long intervals, no taxis because there was no petrol, and cab-drivers refusing to drive their under-nourished horses over long distances – my father arrived very late. My mother, who came from Leipzig and had not yet really settled down in Vienna, was suddenly confronted with this famous guest and stammered apologies; she told me years later, when she was already an old lady, that Klimt had assured her that she need not worry, he would like to play with us children. When my father finally arrived, out of breath, Klimt reassured him: he said it was years since he had spent such a lovely hour as with us children!

I personally have no recollection of that hour. But something happened then which I had not expected. As a child my great passion had been for drawing. When we came to Vienna, I had had to wait six months to start the next school term; so my father had entered me in the class of the famous professor Franz Cizek,[6] and there I spent the next six months. Cizek pioneered the teaching of drawing to children. My father fetched one of my drawings out of a drawer – not, as I would have liked, one of my best – and showed it to Klimt. I heard him ask: 'Look, professor, do you think the boy has any talent?', and then I ran out of the room, red in the face, and never heard Klimt's reply.

The friendship between the two men had clearly deepened, but Klimt's untimely death on 6 February 1918 put a brutal stop to it. In the same year my father published the first ever catalogue of Klimt's drawings, with a foreword by the art historian Alfred Stix.[7] Serena Lederer bought up the whole contents of the catalogue (see p. 197).

As Klimt had remained unmarried, his brother and sisters and his long-standing companion Emilie Flöge (see p. 238) inherited his estate. According to Klimt's

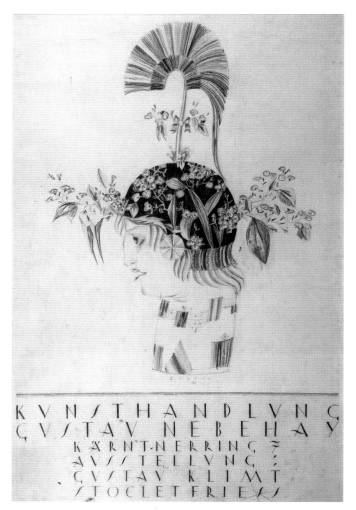

KVNSTHANDLVNG
GVSTAV NEBEHAY
KÄRNTNERRING 7
AVSSTELLVNG :
GVSTAV KLIMT
STOCLET FRIESS

In Austria interest in Klimt began to wane after 1919, since those who had hitherto bought his work were hit by inflation. Of all the works he handled at the time, my father kept no paintings but only some of his finest drawings, which hung in Josef Hoffmann frames on the walls of our house in the XIIIth district, the 'Himmelhof'. It was thanks to them that we children learned to love Klimt.

1 Before Count Nako the palais had belonged to Baron Bernhard von Eskeles, who entertained high society in his salons. It is now the newly founded Jewish Museum. See: Felix Czeike, *Das große Groner Wien Lexikon*, Vienna-Münich-Zürich 1974, p. 463.

2 Alice Strobl, *Gustav Klimt: Die Zeichnungen*. Supplement 1878–1918. Salzburg 1989, p. 223–225.

3 In my book: *Die goldenen Sessel meines Vaters: Gustav Nebehay (1881–1935), Antiquar und Kunsthändler Leipzig, Wien und Berlin* (Vienna 1983); besides the story of his background and life, some amusing details can be found on his methods of circumventing military service.

4 See Alice Strobl's catalogue raisonné of Klimt's drawings, vol. 3, p. 242.

5 The three drawings are registered by Alice Strobl in her catalogue raisonné as follows:

No. 1405. Recumbent pregnant woman, facing right. (1904) Pencil, 34.8 × 54.8 cm. Signed below right 'Gustav Klimt' under the words: 'For Frau Maria Nebehay'.

No. 1864. Old woman, seated, one hand on her forehead. Pencil, 55 × 34.7 cm. Signed, with the note 'For Frau Maria Nebehay with best wishes Gustav Klimt'.

No. 2219. Back view of a nude, seated, facing right. Pencil, 56.5 × 37.3 cm. Signed below left 'Gustav Klimt' (in oval) and designated: 'For Herr Gustav Nebehay with very best wishes'.

6 Franz Cizek (1865–1946). He was against mere copying and in favour of giving the children's talents free rein.

7 Alfred Stix, art historian (1882–1957), director of the Albertina from 1933 to 1938.cp

niece Helene Donner, it was Carl Moll who divided up the drawings.

The group of drawings which were donated to the Vienna City Museum by Franziska Klimt on the death of her husband Georg, Klimt's brother, has remained intact: over 270 drawings. Those owned by Johanna Zimpel-Klimt were nearly all sold to me by her son Rudolf Zimpel. Klimt's holding of drawings by Egon Schiele were sold, along with drawings from the estate of Kolo Moser, through my father's gallery in 1918. He also handled Klimt's estate after his death in 1918: some of his best paintings, the working drawings for the Stoclet frieze (see p. 151 ff) and many fine drawings.

230

# GUSTAV KLIMT AS LANDSCAPE ARTIST

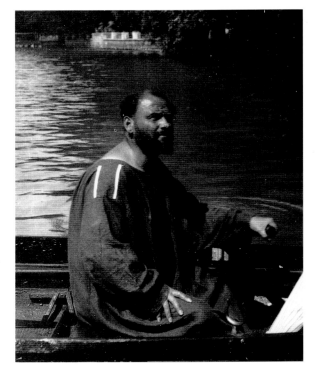

*276 Gustav Klimt in the rowing boat on the Attersee. Photograph by Emma Teschner, about 1910.*

Gustav Klimt found his way to landscape painting relatively late in life. Of his studies (they number approximately four thousand), not one is of a landscape; and in the Novotny-Dobai catalogue raisonné of his oil paintings only fifty-five landscapes are recorded.

The first known landscapes date from the years 1898–1900. They were not painted on the Attersee but in St Agatha, a village near Goisern and the Hallstättersee in Upper Austria. All the other oils were painted on the Attersee with the exception of three in the then South Tirol (*Cassone*, D.185; *Malcesine on Lake Garda*, D.186; and *Italian Landscape*, D.214); one in Gastein 1917 (D.219); and one Viennese view (*Schönbrunn Park*, D.194), 1916.

In 1898 Gustav Klimt was thirty-six years old. Presumably for financial reasons it was only from that moment onwards that he could allow himself summer holidays. He was, as we have seen, an exceptionally shy artist and needed complete peace and quiet for painting. This was provided by the Flöge family.

We know from contemporary reports, and especially from a letter to Maria Zimmermann (see p. 268), that he would go walking with a small ivory tablet in his pocket, and every now and then he would look through a rectangular hole cut into the tablet to see whether a certain section of the landscape might lend itself to painting.[1]

The first to research his landscapes was Maria José Liechtenstein, then working at the Österreichische Galerie.[2] She cites fifty landscapes which were painted in the Salzkammergut, and writes particularly interestingly about the year 1917:

It was in the Salzkammergut that Klimt first began to paint landscapes. In 1898 came the painting *After the Rain*, which was done in an orchard near St Agatha. It was therefore this landscape – and not the Vienna woods – which, together with the example of the Impressionists, inspired him to tackle this genre. For a long time, however, his paintings showed nothing of the characteristics of the landscape from which they sprang: it is impossible to tell from the picture where it was painted, and we are entirely dependent on written or verbal sources. It was only in his later period that Klimt painted regions that he had known for over ten years: only now does he record – naturally in his own style – the features of the villages and houses. It was the soft, misty air of the lake, the play of water, that gave the colour effects which his eye sought, trained as it was by the Impressionists. When, exceptionally, he spent a summer in Mayrhofen in Tirol, he could not produce a single painting in the harsh mountain light: he missed his landscape, the landscape of the Salzkammergut with its lakes and soft light.

And so, as man and artist, he was very specially attached to the Salzkammergut, and it was quite natural that he showed his paintings in the exhibitions of the Upper Austrian Artists' Union of which he was a member.

Klimt took many of his landscapes back from the Attersee to Vienna unfinished, and he usually worked for months to complete them. He endeavoured particularly in his landscapes to achieve the silky, opaque lustre so typical of his paintings – often using inappropriate, fast-drying media in order to subdue the inevitable shine of the oil colours. This led to unpleasant surprises immediately after the war, in the years after 1945, when the technique of air-conditioning was not yet being used for the shipping of paintings to foreign countries.

Just as Klimt's other paintings only bore the unmistakable traces of his hand after 1898, so it was, but even more markedly, with his landscapes. None better than he could evoke the splendour of a cottage garden in full bloom, or of an apple-tree laden with fruit. It is regrettable that his *Golden Apple Tree* perished in its shelter in 1945, for this painting radiated a magic all its own.

Finally, it is worth noting that there were never any figures in his landscapes: nature itself was the object of his interest.

1 The following list of paintings is arranged according to subject and catalogue numbers; the locations are only given for those paintings owned by public institutions, all others being in private collections:

COTTAGES
*Cottage with Rosebush* (D.99), about 1898.
*Cottage in Kammer on the Attersee, with Mill* (D.118), 1901.
*Upper Austrian Cottage with a Farmstead* (D.173), 1911–12. Österreichische Galerie, Vienna.

ORCHARDS
*Orchard* (D.98), about 1898.
*Orchard at Evening* (D.98), about 1899.
*After the Rain*, also *Garden with Hens in St. Agathe near Goisern* (D.107), about 1899, Österreichische Galerie, Vienna.
*Cottage with Birches*, also *Young Birches* (D.110), 1900.
*Fruit Trees* (D.119), 1901.
*Golden Apple Tree* (D.133), 1903, destroyed by fire.
*Pear Tree* (D.134), 1903, Fogg Art Museum, Boston.
*Orchard with Roses* (D.175), 1911–12, Österreichische Galerie, Vienna.
*Apple Tree I* (D.180), about 1912, Österreichische Galerie, Vienna.
*Apple Tree II* (D.195), about 1916, Österreichische Galerie, Vienna.

*277 Gustav Klimt with friends during a summer outing on the Attersee. Photograph, about 1910.*

233

278 Above left: Church in Unterach on the Attersee *(D.198), 1916. Oil on canvas. 110 × 110 cm.*

279 Centre left: *Unterach on the Attersee. Photograph, about 1965. Apart from small alterations, Gustav Klimt gave an exact rendering of the landscape.*

280 Below left: Malcesine on Lake Garda *(D.186), 1913. Oil on canvas. 110 × 110 cm. Destroyed by fire in Schloss Immendorf in 1945.*

281 Right: Avenue in the park of Schloss Kammer *(D.181), 1912. Oil on canvas. 110 × 110 cm. Österreichische Galerie, Vienna.*

## COTTAGE GARDENS AND MEADOWS
*Cottage Garden*, also *Flower Garden* (D.144), about 1905–6, Národni Gallery, Prague.
*Cottage Garden with Sunflowers*, also *Brewery Garden in Litzlberg, Attersee* (D.145), about 1905–06, Österreichische Galerie, Vienna.
*The Sunflower* (D.146), about 1906–07.
*Roses under Trees* (D.147), about 1905.
*Garden Landscape*, also *Field in Flower* (D.148), about 1906.
*Poppy Field* (D.149), 1907, Österreichische Galerie, Vienna.
*Garden Landscape* (D.146), before 1910, Carnegie Institute, Pittsburgh.
*Cottage Garden with Crucifix* (D.174), 1911–12, destroyed by fire.
*Garden Path with Hens* (D.215), 1916, destroyed by fire.
*Garden Landscape with Mountain Peak* (D.216), 1917.

## WOODS
*Pine Forest I* (D.120), 1901.
*Pine Forest II* (D.121), 1901.
*Beech Wood I* (D.122), about 1902, Moderne Galerie, Dresden.
*Birch Wood* (D.136), 1903, Österreichische Galerie, Vienna.
*Beech Wood II* (D.137), about 1903.
*Park* (D.165), before 1910, The Museum of Modern Art, New York.

## POPLARS
*The Big Poplar I* (D.111), 1900.
*The Big Poplar II, also brewing storm* (D.135), 1903.

## WATER LANDSCAPES
*Pond in the Schloss Park in Kammer* (D.108), about 1899.
*The Swamp* (D.109), 1900.
*On the Attersee I* (D.116), about 1900.
*On the Attersee II* (D.116a), about 1901.
*Island in the Attersee* (D.117), about 1901.
*Pond at the Schloss in Kammer on the Attersee* (D.167), before 1910, University of Oklahoma.

## LOCALITIES
## ATTERSEE
*Schloss Kammer on the Attersee I* (D.159), about 1908, Národni Galerie, Prague
*Schloss Kammer on the Attersee II* (D.166), before 1910.
*Schloss Kammer on the Attersee III* (D.171), 1910, Österreichische Galerie, Vienna.
*Schloss Kammer on the Attersee IV* (D.172), 1910, Österreichische Galerie, Vienna.
*Avenue in the Park of Schloss Kammer* (D.181), 1912, Österreichische Galerie, Vienna.
*Forester's House in Weissenbach on the Attersee* (D.182), 1912.
*Country House on the Attersee* (D.189), about 1914.
*Unterach on the Attersee* (D.192), 1915, Residenz Galerie, Salzburg.
*Litzlberg Cellar on the Attersee* (D.193), 1915–16.
*Church in Unterach on the Attersee* (D.198), 1916.
*Houses in Unterach on the Attersee* (D.199), about 1916, Österreichische Galerie, Vienna.
*Presshouse on the Attersee* (D.217), 1917.
*Wooded Slope in Unterach on the Attersee* (D.218), 1917.

## LAKE GARDA
*Church in Cassone*, also *Landscape with Cypresses* (D.185), 1913.
*Malcesine on Lake Garda* (D.186), 1913, destroyed by fire.
*Italian Garden Landscape* (D.214), 1917.

## GASTEIN
*Gastein* (D.219), 1917, destroyed by fire.

## VIENNA
*Schönbrunn Park* (D.194), 1916.

2 Marie José Liechtenstein, 'Gustav Klimt und seine Salzkammergut Landschaften.' In: *Oberösterreichische Heimatblätter* 1951, No. 3–4 (July to December 1951), 5th year, pp. 297–317.

*282 Gustav Klimt with friends on a jetty on the Attersee, behind him Emilie Flöge. Photograph, about 1910.*

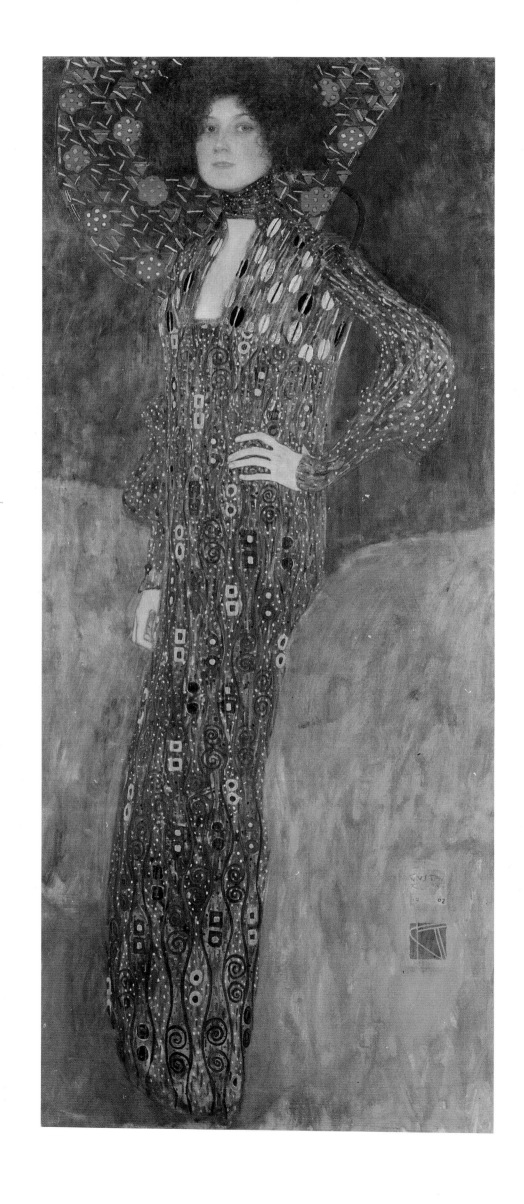

# GUSTAV KLIMT AND EMILIE FLÖGE

In 1905 Emilie Flöge and her sisters Helene and Paula opened, in the 'Casa piccola' at 1b Mariahilferstrasse, the fashion house 'Schwestern Flöge' (Flöge Sisters), which was for over thirty years to be one of the leading salons in Vienna.

The sisters had left their father's apartment in the Gumpendorferstrasse after his death, had lived for a short while at 13 Mariahilferstrasse in the VIth district, and then moved in 1904 to the 'Casa piccola' house. They had a large apartment in the left half of the first floor, and their salon – furnished by the Wiener Werkstätte – in the right half (Pl. 285). They employed up to three cutters and up to eighty seamstresses. They had the courage to furnish the salon rooms in modern style and not in the Victorian style then favoured by most fashion houses. The success of the enterprise was due partly to the salon's address, only a few steps away from the Ringstrasse and therefore easily reached on foot; and partly to the talent of Emilie Flöge, Gustav Klimt's companion of many years. She grew to be an excellent business-woman, was in close artistic contact with the Wiener Werkstätte and Klimt's circle of friends, and travelled

*284 Lines written by Gustav Klimt on a Wiener Werkstätte postcard (No. 69) to Emilie Flöge, dated 7 July 1908: 'Why no flowers? – Tomorrow evening I'm off to Munich, shall be staying at the 4 Jahreszeiten. All the best Gustav.*

annually to London and Paris from where she brought back models to Vienna. While Klimt dominated the Vienna art scene, she had similar success in her own field. She found complete fulfilment in her profession, which per-haps explains why she re-mained unmarried after Klimt's death. After the an-nexation of Austria in 1938 Emilie closed the salon, as her clients had either lost their fortunes or had been obliged to emigrate.

In 1891 Gustav Klimt por-trayed Emilie Flöge for the first time, in pastel colours, half-length in a white dress (Pl. 21). She was eighteen years old at the time. The frame is painted by Klimt with cherry blossom on a gold background. There also exists a study in oils (1893) showing Emilie Flöge stand-ing next to an oleander in flower; Alice Strobl identifies this portrait as a study for Emilie's figure which Gustav Klimt added to Ernst Klimt's painting for the staircase in the Burgtheater, *Buffoon on an Improvised Stage in Rothenburg*. Klimt's alterations, which he made in 1892, were not only limited to Emilie's portrait: a num-ber of his relatives and all the Flöge family can be seen as members of the crowd in the painting.

239

But far more important is Klimt's 1902 portrait of Emilie in a typical blue 'Klimt' dress, with gold ornamentation and arabesques in dark blue. Her left hand is on her hip and she looks straight at the spectator (Pl. 283). Why this portrait, acquired by the City of Vienna Museum as early as 1908, met with the disapproval not only of Emilie's mother but also of herself, is inexplicable – all the more so when it is compared to one of the artistically excellent photographs by the Viennese photographer Dora Kallmus (who adopted the pseudonym d'Ora) (Pl. 287). Klimt apparently promised to paint another portrait of Emilie, but never got round to it.

Strangely enough, there exists not a single drawing of Emilie Flöge by Klimt. He had designed a series of dresses for her in 1907 and photographed her wearing them in the house on the Attersee (Pl. 291); this plate was made from the negatives – still in existence – which Klimt's niece Helene Donner[1] was kind enough to lend me. The photographs show Emilie as a mature, smiling woman, and no longer with the rigid features of the three portraits. The most attractive photograph is that made by Klimt's friend Moriz Nähr in about 1905 or 1906, showing Klimt and Emilie, smiling and posing (Pl. 292).

When I was preparing my *Gustav Klimt: Dokumentation* (1969), I held frequent conversations with Frau Donner during which she denied – unaccountably – that she owned a single manuscript word of Klimt's. She declared, on the contrary, that she and her aunt Emilie had, after Klimt's death, burnt two laundry-baskets full of his correspondence!

In 1987, however, 400 postcards from the Klimt-Flöge correspondence were published.[2] They can only have come from her estate. (The originals are now partly in the Manuscript Department of the Austrian National Library and partly in the possession of the correspondence's editor). The first expectations were, however, followed by disappointment: was it possible that Klimt never wrote more than commonplaces to Emilie Flöge – announcements of his arrival somewhere, or of his return in a short time, or of minor

ailments? This collection of postcards is, of course, valuable, for not only does it help trace his movements more accurately than has been possible until now, but it also provides a number of references to his work, for instance to the meaning of the 'abstract' figure on the end wall of the dining room in the Palais Stoclet (Pl. 180). But the burning question – what was their relationship? – remains unanswered. On the contrary, it is confusing to note that Klimt wrote not a single tender word to 'his' Emilie. The only hint of intimacy in the whole correspondence is the pet name 'Midi' that Klimt uses for Emilie.

One is inclined to suspect that Frau Donner – for reasons that are as inexplicable as they are inexcusable – took it upon herself to act as censor, as has happened with the estates of other famous men (Friedrich Nietzsche's sister is a case in point). Important testimony may therefore have been burnt.

Klimt was no letter writer and he was admirably discreet his whole life long: he would naturally have avoided writing intimacies on postcards. But we see from his correspondence with Marie Zimmermann (see p. 264) that he was quite capable of writing warm, affectionate letters. Perhaps Wolfgang Georg Fischer[3] is right when he maintains that the friendship between Klimt and Emilie Flöge was platonic but very close. The fact remains that Klimt was not buried in the Flöge family grave, but lies alone in the cemetery at Hietzing; it would surely have been worthy of Emilie Flöge's status as Klimt's lifelong companion had she been buried next to him.

The following obituary was written by a man who played an important role in Vienna's art scene at the time and who was an excellent art historian, Hans Tietze:

Klimt's strength was beset by contradictions: he was kindness itself, but stood alone and faced indifference and enmity where what he most needed was sympathy. In order to decipher his strangely profound art, we must try to understand those contradictions . . . His earthbound strength greatly appealed to people and above all to women, indeed he seemed to exude an earthy fragrance. But here too was an inner flaw that stood in the way of his total enjoyment of life: for many years he had

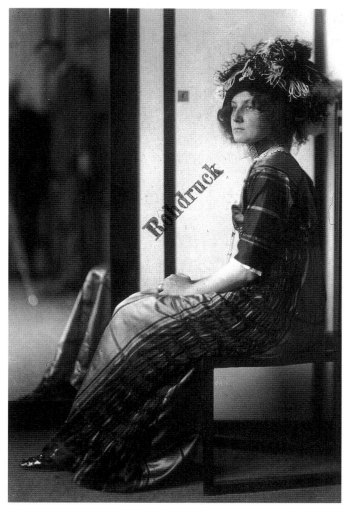

287 Above: *Emilie Flöge in her fashion salon. Photograph by Madame d'Ora (Dora Kallmus), 1910.*

288 Below: *Emilie and Pauline Flöge with Gustav Klimt in a rowing boat on the Attersee. Photograph, about 1910.*

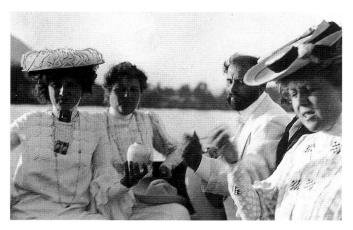

241

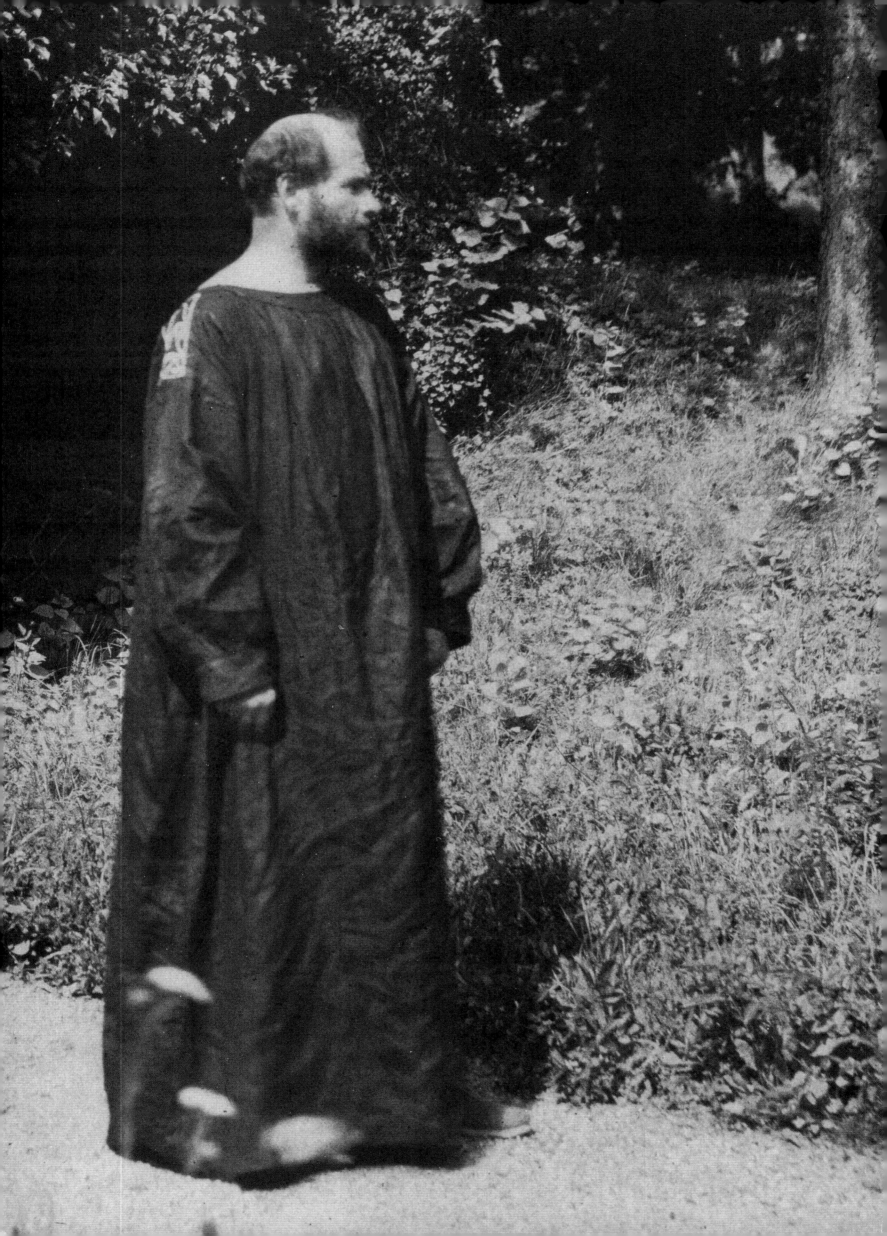

290 *Emilie Flöge on the Attersee (detail). Lumière autochrome-plate by Friedrich Walker, about 1910.*

289 Opposite: *Gustav Klimt on the Attersee (detail). Lumière autochrome-plate by Friedrich Walker, about 1910.*

291 Emilie Flöge in a 'summer dress' designed by Gustav Klimt. Photograph by Gustav Klimt, 1907.

292 Opposite: Gustav Klimt and Emilie Flöge in the garden of Klimt's studio at 21 Josefstädterstrasse in the VIIIth district. Photograph by Moriz Nähr, about 1905–06.

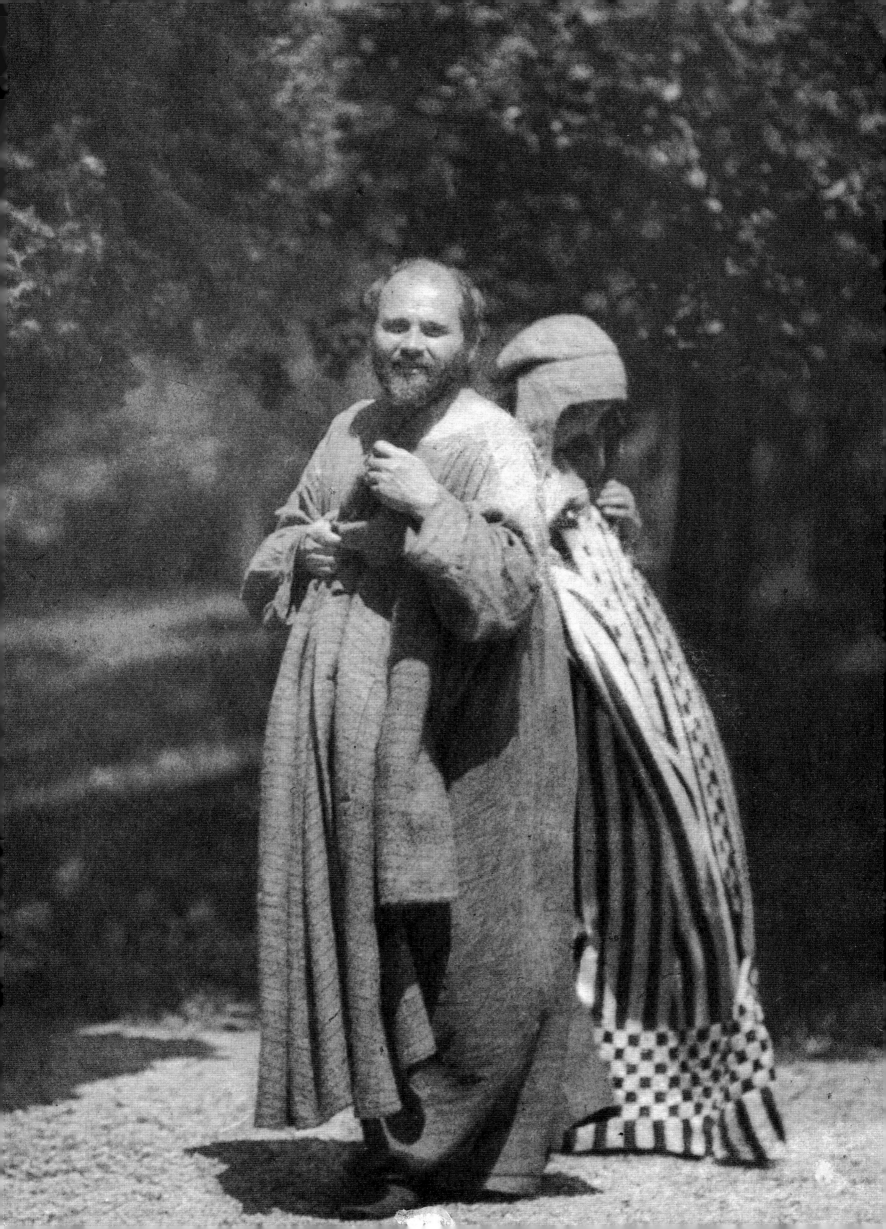

a close relationship with a woman, but here again he could not bring himself to carry things to their logical conclusion . . . Klimt did not have the courage to shoulder the responsibility of happiness; and the woman he loved for so long was left with only one privilege, that of tending him in the hour of his death.

This manifestation of his life-force, veiled as it is, once again calls to mind a name that again and again surfaces when we contemplate Klimt: Franz Grillparzer.[4] He too, firmly rooted in Vienna's soil, his creations nurtured on the sap of Viennese tradition; he too of an almost morbid sensitivity, one for whom the only salvation seemed to be flight into solitude; he too living a bourgeois life in total contrast to the range of his inner urges; Grillparzer was also consumed by his thirst for love and was incapable of slaking that thirst with the heady potion that offered itself, year in year out, to his yearning lips. The

294 Below: *Study for the painting* The Bride *(AS 3096). Sketchbook 1917, p. 9. Pencil. 16.2 × 10 cm.*

295 Above: *Study for the painting* The Bride *(AS 3062), 1917–18. Pencil. 56.5 × 37.5 cm.*

293 Opposite: The Bride *(D.222), 1917–18 (unfinished). Oil on canvas. 166 × 190 cm. Detail.*

Viennese character, so quick to fade into superficialities in lighter natures, here turned in on itself and became a lifelong sickness: that Gustav Klimt suffered deeply from it was apparent to all who looked into his troubled eyes . . .[5]

1 Helene Donner, née Klimt, was the daughter of Ernst Klimt, whose guardianship Gustav Klimt had assumed in 1892.

2 Wolfgang Georg Fischer, *Gustav Klimt und Emilie Flöge: Genie und Talent, Freundschaft und Besessenheit,* Vienna 1987

3 *Ibid.*

4 Franz Grillparzer, poet (1791–1872). Until his dying day he lived in the apartment of his fiancée Kathi Fröhlich without so much as touching her.

5 Hans Tietze, 'Gustav Klimts Persönlichkeit.' In: *Die bildenden Künste,* Vienna 1919, pp. 1–14.

247

# GUSTAV KLIMT, ALMA MAHLER-WERFEL
# AND CARL MOLL

*297 Stamp by Carl Moll, showing Moll's house built by Josef Hoffmann on the Hohe Warte in the XIXth district, Vienna. Woodcut in* Ver Sacrum, *6th year, 1903, p. 265.*

*296* Opposite: *Alma Mahler and her two daughters by Gustav Mahler, Maria and Anna. Photograph, 1906.*

The Mahler-Werfel villa at 2 Steinfeldgasse/17 Wollergasse in Vienna's XIXth district was one of the most hospitable of Vienna's houses in the 1930s. Originally built by Josef Hoffmann for the building contractor Eduard Ast, it stood immediately behind the villa built by Hoffmann for Carl Moll (Pl. 297), and had been financed mostly with Franz Werfel's[1] earnings. Later, in the United States, Alma Mahler-Werfel was a generous hostess to her refugee friends from all over Europe.

In order to learn something about the relationship between the seventeen-year-old Alma (Pl. 296) and the thirty-five-year-old Gustav Klimt, we must turn to her autobiography, Mein Leben (*My Life*), published in 1960.[2]

Alma was the daughter of the eminent Austrian landscape painter Emil Jakob Schindler,[3] to whom success came only in his later years. In her early youth Alma had known brilliant years in Schloss Plankenberg west of Vienna. She travelled widely with her father, who had been commissioned to draw the coastal towns of Dalmatia for Crown Prince Rudolf's book *Die österreich-ische-ungarische Monarchie in Wort und Bild* (*The Austro-Hungarian Monarchy in Words and Pictures*)

(Vienna 1886–1902), and those years had left their mark on her.

The editor of her memoirs, Willy Haas,[4] was a childhood friend of her third husband, the poet and author Franz Werfel. Haas was a critic and essayist, founder and editor-in-chief of the excellent weekly *Die Literarische Welt* (*The Literary World*), which appeared from 1925 to 1933. Alma's book must be considered as an important source for musical, social and art history, especially where Vienna is concerned. Haas calls it 'a vast compendium of great love and kindness, of hate, shrewdness and blindness in one of the most important epochs of German intellectual life'. It is high time that it was published in full. In 1960 Haas had to consider the feelings of many living persons and it is unfortunately not possible to see from his compilation where he abridged the author's text.

Even in this carefully edited edition it is easy to detect Alma's tendency to make hasty and sometimes unjust judgments. This is particularly so in the case of her mother. Not that she lacked respect; but there was an invisible wall separating them. She only mentions her mother in passing and forgets – for reasons known

only to her – that her mother Anna, née Bergen, who came from Hamburg, had been a famous singer before her marriage to Schindler. Perhaps she never forgave her for marrying Carl Moll?

Whoever had the pleasure of meeting Alma's mother – as I was privileged to do in her simple house in Venice as a young man – found a friendly elderly lady, who stood quietly and modestly at her husband's side and was an exemplary housewife. Alma presumably owed her great and dominating love of music to both her parents, for she writes that her father was highly musical: he had a wonderful tenor voice. Her father, to whom she was clearly more attached than to her mother, died when she was only fifteen years old:

> But I felt more and more that I had lost my leader, my guiding star – although no one besides him was aware of it. I had been used to doing everything to please him, my whole ambition had but one fulfilment: the glance from his understanding eyes . . .

Carl Moll (Pl. 298), whom her mother married five years after Schindler's death, had been the latter's pupil, had lived for a few years in the Schindlers' house and himself became an important painter of the Secession years. He is always associated with the 'Vienna Art Spring', if only on account of his untiring activities on behalf of the young art movement (Pl. 302) and – apart from his friendly promotion of young talent – because he organized some important international art exhibitions in Vienna. It was he who persuaded Auguste Rodin to make a bust of Gustav Mahler – a fact which Alma does not mention. The bust was put up in the foyer of the Vienna Opera after Mahler's death, confiscated and melted down during the German occupation, and has since been replaced by a cast donated by Alma after 1945 and is once again to be seen in the Opera.

Alma called him a 'monomaniac for old paintings' but the truth was that he was a collector of old master paintings for as long as he could afford it. As with so many others, he must have lost his capital during the years of inflation in 1918 and 1919, and to have been forced to auction his considerable collection. After the war, when he could find no more takers for his paintings but wanted to go on living in his fine villa on the Hohe Warte, built and furnished by Josef Hoffmann, he began to earn money as a 'marchand amateur', but was not always very judicious in his choices, so that the expression 'Moll's croutes' did the rounds of the trade.

Alma Mahler-Werfel writes:

> Five years later my mother married my father's pupil, the painter Carl Moll. She married a pendulum, whereas my father was a whole clock! . . . Moll's influence now began to make itself felt. He tried his teaching methods on me, which merely aroused my hate, for he was not my guiding star. He looked like a medieval wood-carving of Joseph, was a monomaniac for old paintings and systematically upset my balance . . .

She continues to relate that the first 'catacomb sessions' of the newly founded Vienna Secession took place in her stepfather's house (which, incidentally, has not been proved):

> Gustav Klimt was the first president. As a young girl I made his acquaintance at one of these secret sessions. He was the most gifted of them all, thirty-five years of age, at the zenith of his powers, beautiful in every sense of the word and already famous. His beauty and my youthful freshness, his genius, my talents, the profound life-melody we shared touched the same chords in us both. I was ridiculously ignorant of all things passionate – and he felt and found me everywhere . . .
>
> He was bound by a hundred chains: women, children, even sisters who fought over him. But still he followed me when I was in Italy with my so-called family. It was in 1897 . . . We were all in Genoa, my 'family' and the pursuing Klimt. Our love was cruelly destroyed by my mother: she broke her promise and read my diary every day, so that she knew about the stations of my love. And – horrors! – she read that Klimt had kissed me!
>
> Gustav Klimt was thereupon forbidden to speak to me. We managed to see each other again in the bustle on St Mark's Square in Venice: the crowds who covered us up, his hasty words of love, the oaths he swore that he would free me of everything and come and fetch me, his desperate request that I wait for him, the fear of being seen by Moll . . . it was like getting engaged in secret.
>
> Then we went back to Vienna, and for months I was near to suicide. My adult life started in bitterness . . . Gustav Klimt tried repeatedly to see me again, but I had lost my hold on life. Besides, I had the morals of the times: I thought I had something 'important' to defend . . . I owe Gustav Klimt many tears and, through them, my awakening. My so-called breeding

brought my first love to nought. I turned a deaf ear to all his entreaties to come to him in his studio. When we saw each other later, he would say: 'The spell you cast on me does not fade, it becomes stronger', and I trembled also when I saw him, so that this strange sort of engagement went on for many years, just as he had begged of me years before. A long time afterwards he himself said that we had sought each other a whole life long and never found each other. He was given to playing with human feelings; but as a man he had everything I then – mistakenly – looked for . . .

I must confess that for a long time I was sceptical about Alma's account of her love for Klimt. It seemed to me

to be wishful thinking. But I was wrong. Klimt's letter (Pl. 299) to Carl Moll,[5] stamped 19 May 1899, speaks for itself:

Dear Moll,
Your letter has caused me immense pain, all the more when I reflect that I am giving my very best friends trouble and anxiety. My dear Moll, aren't you seeing things a little on the black side? I think other things have unduly upset you and your dear wife, and that your parental responsibility causes you to put too gloomy an interpretation on the whole thing. Let me in all sincerity go over the events, so that nothing may stand between us. . . . I came, all unsuspecting, to your house. I had met Alma

251

before, at the unveiling of the Schindler monument [made by the sculptor Edmund Hellmer and unveiled in Vienna's Stadtpark in 1895], I liked her, as we painters always like pretty girls . . . I was surprised that you – or for that matter anyone else – had not painted her . . .

Alma often sat next to me and we chatted over this and that, she told me of her passion for Wagner, for Tristan, for music, for dancing – I saw that she was a happy creature and that made me happy, too. I never courted her in the real sense of the word – and even if I had, I would never have hoped for success, there were too many men who visited you and they all paid attention to her – sometimes I drew false conclusions.

Now, this winter, the young lady and I, who have so often sat next to each other at table, found that a written seating plan had separated us. I noticed this, was taken aback and began to think. I thought it could be the young lady who wanted it so, that I was beginning to bore her, I found it natural that we shouldn't always be together, on account of gossip . . . It was only quite lately – the trip to Florence was already planned – that it dawned on me that the young lady must have got to

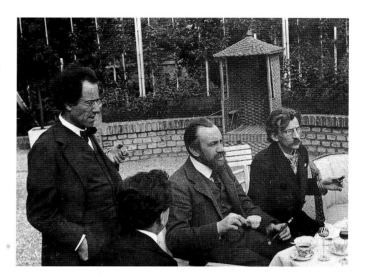

know one or two things about my liaisons, some of them true, some not, I myself am not quite clear about my liaisons, nor do I want to be – I only know that I'm a poor fool – in short, from her pointed questions and remarks I got the impression that these things were of more relevance to the young lady than I had thought. That made me a little nervous, for I fear and respect true love; I came into conflict with myself and with my genuine friendship towards you, but then I consoled myself with the thought that it was just a mood of hers, a game: Alma is beautiful, she is clever and witty, she has everything that a fastidious man can expect from a woman.

. . . perhaps this already bored her, perhaps she wanted a small flirtation, perhaps I was not as I would have been in other circumstances and as all other men were, and perhaps that was what interested her – but even as a game it seemed to me to be dangerous; and here I should have been reasonable, for I am experienced, and that's where my weakness begins.

And so these confused thoughts chased through my head. One thing was clear, nothing must happen . . . On the other hand, it isn't so easy to be indifferent to her . . . Are we men perfect?

Then came your journey to Italy. I was working very hard. The date of the trip to Florence was approaching. Something indeterminate – perhaps my conscience – held me back and told me 'You must not'. I started wavering. Now would have been the moment to show true friendship . . . but the prospect of taking a lovely trip in pleasant company, all that made me waver again – then came your telegram – I followed you – not knowing what I did.

At first everything went well, . . . I noticed your wife's perfectly comprehensible and natural efforts to keep me and Miss Alma apart. When we nevertheless met, things had to be clarified; I had many serious conversations with the young lady, partly in general and partly in specific terms. The conversations

were held privately but could not in any way be described as courting. Both of us were quite clear in our minds: 'So far and no further.' So we backed out. No wrong should be done. There was no choice.

Then came the evening in Venice. I am an embittered man and that sometimes shows itself in a certain malice which has its dangers and which I afterwards deeply regret. So it was there. I had been drinking somewhat faster than was good for me, and I will not excuse myself – I said things that were not as prudent as usual, and those were the ones you probably heard and which led you to conclusions that were too black. Your intervention made it clear to both of us that one has to go through life open-eyed and not in a dream. The situation was quite clear, there was no more doubting.

I hope I may assume that our embarrassing exchange and the letter, which was to be so wounding for both you and me, were no longer necessary. Forgive me, my dear Moll, if I have caused you pain, and I beg your dear wife's forgiveness and Miss Alma's too, I doubt if she will find it difficult to forget. Let us pray that time will heal all . . .

I hope that I may, sometime in the future, frequent your house as harmlessly as I once did . . .
With all good wishes,
Your unhappy friend Gustav Klimt.

We also have a few lines written by Carl Moll about the trip to northern Italy with his family and with Klimt. He seems to have gone ahead and to have arranged to pick Klimt up at the station; but Klimt did not appear at the station exit. Moll got worried, bought a platform ticket and went to look for Klimt, whom he called 'the most unindependent of people', and found him at last, sitting disconsolately on a bench. He said he wanted to

take the next train back to Vienna, for here in Florence he could not make himself understood. The two men had made things up after Klimt's letter of apology and travelled together to Paris and Madrid. Asked how he liked Paris, Klimt had answered: 'Not at all! There's too much painting going on.'

And on a postcard from Spain (Pl. 301) he writes, laconic as ever: 'Neither Spain nor Moll encourage night-life! Gustav.'[6]

To return to Alma Mahler-Werfel and Gustav Klimt: three more extracts from Alma's biography throw light on her relationship with Klimt:

[undated]
Klimt's paintings started life on a grand scale, but then he surrounded them with trinkets and his vision foundered in gold mosaics and ornamentation. He was surrounded by worthless females – and so he sought me, feeling that I could help him . . .

8 December 1917
Why cannot Gustav Klimt, the poor man, in full flower and great artist that he is, paint only parvenues . . . and never some-one beautiful and well-bred . . . ? That was what I asked myself. He has lost the eye for a fine, well-shaped hand.

6 February 1918
Gustav Klimt died on 3 February 1918, and with him a large part of my youth. How I had understood him once! And I never stopped loving him – albeit in a very modified way. I was on the right path. I will write down my recollections of him as they occur to me.

I cannot grasp the fact that he is dead. He was an infinitely delicate colourist. His big University paintings were refused: they were too modern, too digressive, in other words too remarkable. Those giant pictures were the most powerful he ever painted. He had little education . . . but much artistic instinct . . . Oskar Kokoschka is much the stronger of the two, and Klimt had great respect for his talent.

That Klimt never portrayed Alma nor even drew her may have to do with the fact that she always refused to visit him in his studio, and Klimt would certainly have refused to paint or draw her in Moll's house. He needed quiet when working, and there he would not have found it.

Alma was married three times; from 1902 to 1911 to the composer and conductor Gustav Mahler

*301 Postcard written by Carl Moll and Gustav Klimt to Josef Hoffmann from Toledo in Spain, 1909. The text reads: 'Squares are out, naturalism is trumps'. (Josef Hoffmann's friends affectionately nicknamed him 'Square Hoffmann'.) Gustav Klimt adds: 'Spain and Moll no good for night-life'.*

253

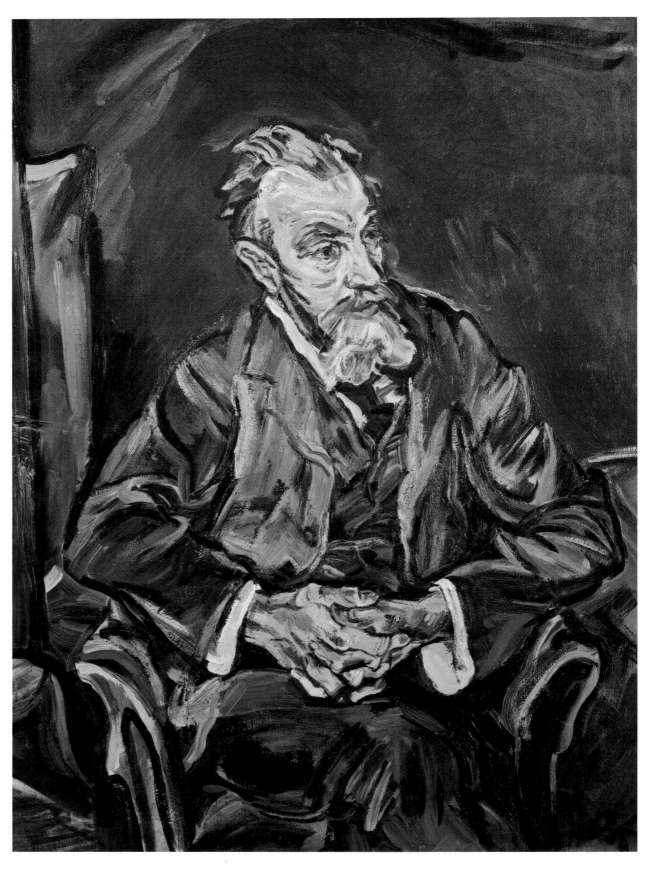

302 Oskar Kokoschka,
Portrait of Carl Moll,
*1913. Oil on canvas. 128 ×*
*94 cm. Österreichische*
*Galerie, Vienna.*

(Pl. 300), who died in 1911 in her arms in a Viennese sanatorium.

Her second marriage, to the German architect Walter Gropius,[7] then just launching his career and creator of the Bauhaus in Weimar (later in Dessau), originated in a love affair between her and Gropius in the last year of her marriage to Mahler. This union lasted from 1915 to 1918, during which time Alma's daughter Manon was born.

During her friendship with Gropius Alma also had a wild three-year love affair with Oskar Kokoschka (Pl. 303), who in 1913 – when the romance was beginning to cool off – painted what is surely his most famous picture, *The Wind Bride*, the title of which was invented by Georg Trakl[8] when he saw the painting for the first time in Kokoschka's studio.

Alma's third marriage was to the Prague poet and author Franz Werfel, which lasted from 1929 to 1945. She followed Werfel when he emigrated; the two arrived in the United States in the nick of time after a hair-raising escape over a frontier pass in the Pyrenees. Werfel was undoubtedly the most successful of the German-language authors: his book *Bernadette* in particular brought him prosperity in the United States. Before fleeing through Spain the two of them had visited Lourdes, which had made a deep impression on Werfel. His death transformed her life: when she left California and settled in New York, she must have known that her heyday was over.

She had an incredible gift for inspiring the men with whom she shared her life and love, and she devoted herself passionately only to artists of genius. She was broad-minded enough to gloss over the weaknesses of the partners she chose, and maintained a superior and critical attitude towards them. She closes thus:

> I had a good life. God granted that I knew the works of our greatest geniuses before they left their creator's hands. And if it was given to me to hold the stirrups of these knights of the light, then my life is justified and blessed . . . Each of us can achieve all things – but we must also be ready to stake all.

303 *Oskar Kokoschka,* Portrait of Alma Mahler *(*The Woman's Face*) from* Columbus bound. *1913. Lithograph.*

She died on 11 December 1964 in New York and had instructed that her remains be transferred to Vienna and buried in her daughter Manon's grave in the cemetery of Grinzing – not in the neighbouring grave of Gustav Mahler nor beside her third husband Franz Werfel, who was buried in Los Angeles but was transferred in 1975 to a grave of honour in Vienna's Central Cemetery.

1 Franz Werfel, author (1890–1945)

2 Alma Mahler-Werfel (1879–1964), *Mein Leben*, Frankfurt 1960. The passages quoted in this chapter are to be found on pp. 26 ff, 28, 86 and 90.

3 Jakob Emil Schindler, landscape artist (1842–1892)

4 Willy Haas, critic and journalist (1891–1973)

5 This letter – the longest Klimt ever wrote – is here reproduced in slightly shortened form.

6 Joint postcard from Carl Moll and Gustav Klimt to Josef Hoffmann from Toledo, autumn 1909; the stamp is illegible.

7 Walter Gropius, German architect (1883–1969)

8 George Trakl, poet (1887–1914)

# GUSTAV KLIMT AND HIS PROFESSIONAL MODELS

*304 Study for a woman striding, her right hand on her shoulder, her features effaced (AS 1564), 1906–07. Pencil. 55.9 × 16.2 cm. It is possible that Klimt – not wishing his model to be recognized – quickly effaced her features as a visitor drew near. The record of his drawings shows no other example of this procedure.*

It is regrettable that after the deaths of Klimt and Schiele, no one thought to seek out their professional models and record what they had to tell: not in order to unearth intimate details, but to give their life stories another dimension.

Very little is to be found in the records about the models of both artists. There does exist a report by the art critic Arthur Roessler, but it was not published until twenty-five years after Klimt's death.[1]

Apparently there was a model called Herma, whose posterior, Klimt vowed in customarily racy language, was more beautiful than the faces of many of his other models. She was one of his favourites, but one day she stayed away. Klimt said she must be ill or have fallen madly in love, and he sent another model out to look for her. She came back to the studio the next day: 'No, Herma's not ill. There's just a bit more of her now!'

That meant she was pregnant. Klimt insisted that she come all the same, as he needed her – which caused much gossip in model circles.

That was the genesis of the famous painting *Hope*, which shows a pregnant young woman: not, however, in the usual discreetly hinting 'family way' style, but stark naked, a living receptacle where the hope of mankind, sheltering in the warmth of the maternal body, awaits the day when it will emerge from the mysterious depths into the light of the world.

Klimt made no effort to react against the flood of hypocritical calumny, uncomprehending indignation, and jealous humiliation; he merely shrugged his shoulders and, ignoring the cackle, calmly worked on. The 'misfortune' of a simple Viennese model had inspired him to create a great work of art. *Hope*, incidentally, was immediately bought by the founder of the Wiener Werkstätte, the appreciative and courageous art lover Fritz Waerndorfer (see p. 140 ff). But Klimt's models, who knew how he came without hesitation to the rescue not only of 'poor Herma' but of others too, would have gone through thick and thin for him.[2]

In the course of our pursuit of Klimt and Schiele, it has often become apparent that Arthur Roessler's reports are not always reliable; and we believe that his coupling of 'Herma' with *Hope* is more a journalistic device than the truth. The reference to *Hope I* (D.129), 1903 (Pl. 160) may be justified; but we are of the opinion that in this painting and in *Hope II* (D.156), 1907–8, Klimt portrayed women who were pregnant by him. For both portraits, especially the first one, radiate a timidity and a fervour that he would hardly have found in a professional model. We have already seen that the portrait, hidden behind the double wings of a gilt frame, was not shown to everybody.

In his article Roessler also writes of an athletic male model who, tired of standing about, started relaxing by wrestling with Klimt. He naturally spared Klimt and was careful not to try any of his tricks on him. But Klimt had a strong physique and broke his arm; generous as he was, he paid the man an indemnity and a second-class bed in hospital, after which the patient, his arm in plaster, sat in the garden of the Josefstadt studio, sunned himself and contentedly smoked his pipe. Roessler goes on to write how generous Klimt was to his models: they adored him and came to him with all their problems, great and small. He was, of course, taken advantage of, but he would say: 'Look, it's always like that. And I would rather give a rascal something than not give anything to a really poor devil.'

By a lucky coincidence I made the acquaintance, long after the publication of my *Klimt Dokumentation*, of a professional Klimt model, Frau Louise Sammer. I invited her to tea together with her taciturn and slightly ailing husband and a giant of a friend. It was an unforgettable afternoon. I had at last discovered a professional Klimt model, to be more exact two models, for her husband had also been a model round about 1905. He had, at the time, had an athletic, muscular body such as Klimt used, for instance, in his portrayal of the couple in the last section of his Beethoven frieze (Pl. 307). Muscular men of this type were much in demand at the time in the Viennese model market, said the couple's friend. A locksmith by profession, he made his points in the animated conversation by waving his huge, powerful hands. He had a brother who had also been a model by profession, the athlete Franz Pankratz,[3] the favourite model of the sculptor Hans Bitterlich.[4] He also sat for Klimt. His brother and Herr Sammer had found a spot in the Vienna Prater where they practised for hours.

*305 Study for the painting* Leda *(AS 2352), 1913–14. Pencil, red crayon. 37 × 56 cm.*

306 Study for figural
compositions in the
Beethoven frieze (AS
3464), 1902. Black
crayon. 31.6 × 44.7 cm.
Alice Strobl assigns this
drawing to the studies for
the last part of the
Beethoven frieze, this
being confirmed by the
presence of the initial R
(for Reininghaus) on the
leaf. The studies for the
frieze, which accompanied
it when it was sold by
Reininghaus to the Lederer
family in 1917, bore this
initial.

Herr Sammer intimated that he had not parted from Klimt on the best of terms, Klimt having wanted to draw him in an ambiguous position. He had met his wife in Klimt's studio and then lost sight of her. Later he performed as a Chinese conjurer, and when they met again after twenty years they married.

Frau Sammer's story was much more interesting. She had grown up in the XIVth Viennese district and an older girl who lived in the same street said to her:

> You're well built, but you're too young. When you're eighteen I'll take you with me to see Klimt. He's a very generous artist, pays a model five crowns an hour, even while you're waiting! You're only allowed to go to where he's painting when he calls you.

Frau Sammer had lost sight of the older girl and started work as a milliner's apprentice, but later she found it hard to get employment. Then, by chance, she met the girl again. This time she did take her to see Klimt.

'What was he like?' I asked.

'Oh, very generous,' came the reply. 'He often drew me. He liked it best when I wore a big straw hat.'

Unfortunately no drawing of her wearing a straw had has been found in Klimt's oeuvre.

'Were you allowed to look at one of his drawings?' I asked.

'Good heavens no! Never!'

At first it was a little difficult to draw Frau Sammer out, but eventually she began to thaw, and looking at me she said: 'You know, I had problems with him.'

And pointing shyly to her bosom, she added: 'He didn't like my bosom. And then he said my skin wasn't white!'

258

For years I pondered what she meant, until by chance, reading a book about Renoir,[5] I found a passage explaining that there must be a certain quality of skin specially agreeable to painters. Renoir tells how unhappy he was in Holland, and then continues:

> But it was in darkest Holland that I found the model who sat for the portrait you see there on the wall; . . . What virginal skin! You can't imagine how full and heavy her breasts were. And the lovely fold with the golden shadow . . . Unfortunately she had little time for sittings on account of her work which she didn't want to give up. But I was so pleased with her aptitude and that skin that reflected the light so well, that I wanted to take her with me to Paris, and I thought, as long as nobody deflowers her and as long as she retains that peach skin, even for a short while. So I asked her mother to entrust her to me and promised to see to it that no men came near her.

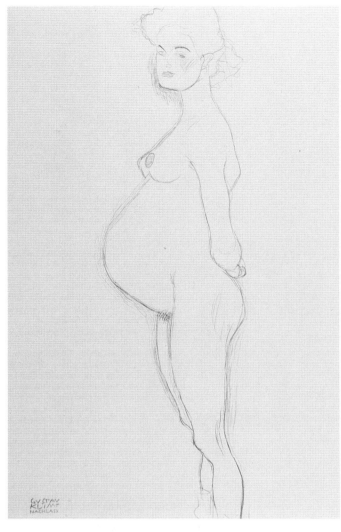

'But what would she do in Paris without "work"?' asked the surprised mother.

It was then that I understood what my so-called virgin's work was! [She was employed in a brothel.] Needless to say, I dropped my project.

When I made a documentary on Klimt on Austrian television in 1975, I asked them to record, for the archives, a conversation with Frau Sammer about her life. She related how she had given up millinery, learned to dance, appeared on the stage in Paris as 'Rosette de Lumière' and then joined the famous 'Tiller Girls' – an English troupe world-famous for their good looks and military precision.

259

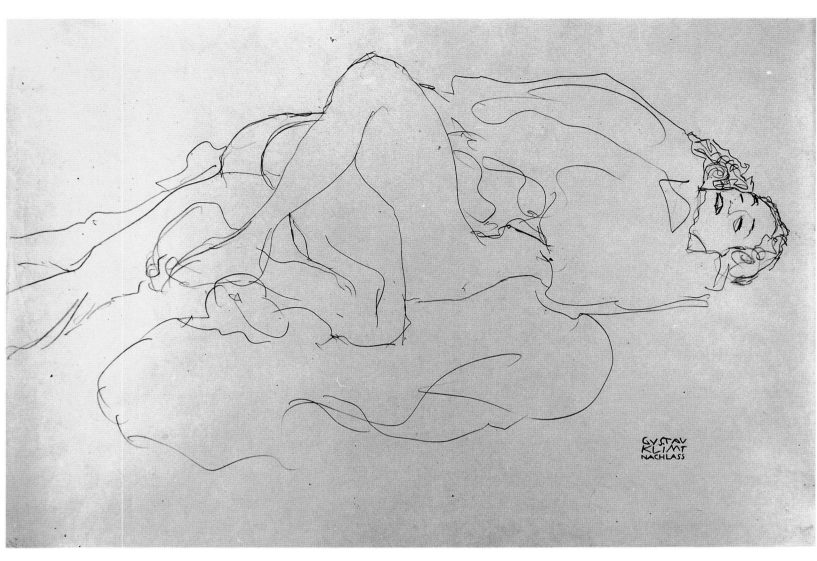

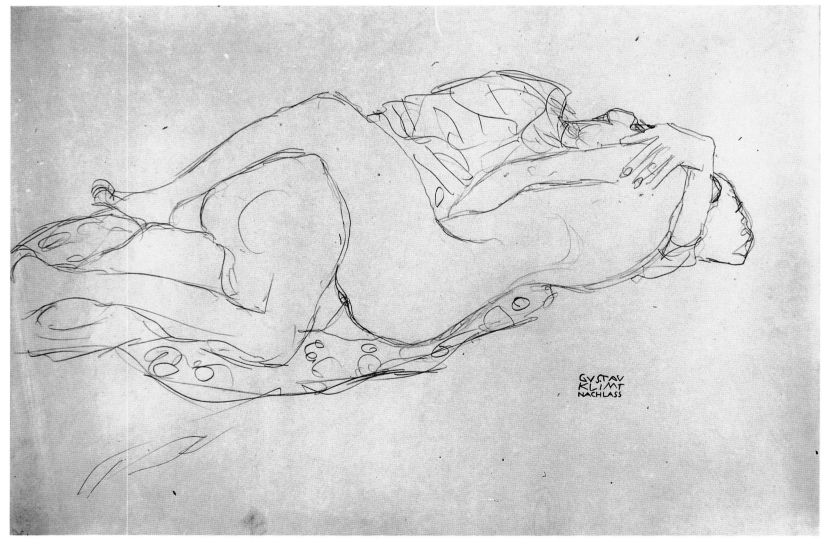

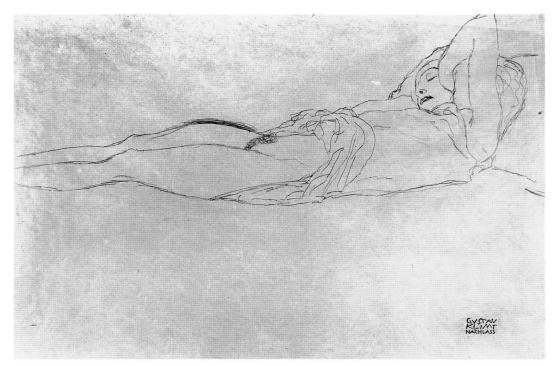

*311* Above: *Study for the painting* Water Snakes II, *also known as* Friends II *(AS 1454), 1907. Pencil. 37 × 56 cm.*

*312* Centre: *Female nude facing left (AS 2435), 1914–15. Pencil. 37.4 × 56.9 cm.*

*313* Below: *Study for the painting* Water Snakes II, *also known as* Friends II *(AS 1453), 1907. Red crayon. 35 × 55 cm.*

Opposite:
*309* Above: *Lovers, facing right (AS 2465), 1914–16. Pencil. 37.3 × 56 cm.*

*310* Below: *Lovers, facing right (AS 2466), 1914–16. Pencil. 37.5 × 56 cm.*

The only drawing showing Gustav Klimt with his models is by his good friend Remigius Geyling.[6] He was a regular participator at Klimt's breakfasts at the 'Meierei Tivoli' near Schönbrunn, where Klimt strolled every morning in the summer, together with his mother and two sisters, from their home at 36 Westbahnstrasse; and he drew Klimt transferring the drawings for *Philosophy* onto canvas – the only document showing this very shy man at work (Pl. 314). The presence of Klimt's models on the drawing is a product of Geyling's subtle humour, for Klimt hated nothing more than to be disturbed while at work: models were to wait in the entrance to his studio and would not have been tolerated here.

*315* Reclining nude facing left *(AS 2325), 1912–13. Pencil, pen and Indian ink, red crayon. 56 × 37 cm.*

*314* Opposite: *Remigius Geyling,* Gustav Klimt transferring the working drawings for his University painting 'Philosophy', *about 1902. Watercolour. 44 × 29 cm. This is the only existing representation of Klimt at work. The two models were a joke of Geyling's, who was a friend of Klimt's and regularly attended his breakfasts at the 'Meierei Trivoli'. Klimt could only work when totally undisturbed. Unoccupied models had instructions to wait, dressed, in the entrance hall.*

1 Since Roessler's conversation was spoken in a broad Viennese dialect, it is reproduced here slightly abridged and in more standard language. It is appropriate to mention here that, according to his niece Helene Donner, Klimt spoke in a distinctly Viennese way, but not in dialect.

2 Arthur Roessler, 'Klimt und seine Modelle'. In: *Arbeiterzeitung*, Vienna 15.8.1953 p. 10.

3 Franz Pankratz, professional model, later sculptor (dates unknown).

4 Hans Bitterlich, sculptor (1869–1949)

5 Ambroise Vollard, *Auguste Rodin*. Berlin 1924, pp. 131–32

6 Remigius Geyling, painter (1878–1974), chief set designer at the Vienna Burgtheater from 1911–14 and 1922–45.

# GUSTAV KLIMT AND MARIE ZIMMERMANN

*316* Schubert at the Piano II *(D.101). Oil on canvas. 150 × 200 cm. Detail showing Maria Zimmermann, who stands on the left of the composer. Destroyed by fire in 1945 in Schloss Immendorf*

Gustav Klimt's correspondence with Marie Zimmermann is a hitherto undiscovered treasure trove. Here we have Klimt as the solicitous, faithful friend of a simple but enchantingly pretty girl of modest origins. He must have known her from 1900 until his death – precise dates are unfortunately not known. When he had to give up his studio in the Josefstädterstrasse in 1914, she moved to Hietzing/Unter St Veit in order to be near him. She bore him two sons, one of whom, Otto, died when only a few weeks old: Klimt made a drawing of him (Strobl I, No. 999). I was told of the existence of a long letter from Klimt to Marie Zimmermann – I was personally unable to see it – in which he explains why he cannot marry her but, apparently, undertakes to support her during his lifetime.

The publication of his correspondence with Emilie Flöge revealed that he wrote her not a single warm or affectionate word (see pp. 240–241). It is all the more surprising that in his letters to Marie Zimmermann he was not only tender but also communicative. He writes of his problems as an artist and of other things that weighed on his mind. These letters were naturally written during his absence from Vienna, when he was on the Attersee with Emilie Flöge, which leads us to speculate about his relationship with Emilie. Was it really only her human qualities that drew him to her? Did he respect her because she was his sister-in-law (see p. 23)? We know that there were always one or two professional models waiting about in his studio, whom he drew when he tired of painting. He could never resist the temptation of a comely female body, so that he not only drew his models but also slept with them. The records show that he had fourteen illegitimate children. It was of these models that he made many of his finest drawings.

The first to suggest that the singer facing the spectator in *Schubert at the Piano* (1890) is Marie Zimmermann was Johannes Dobai in the foreword to the second edition of his catalogue raisonné. But it was not until the discovery of Klimt's autograph letters to Marie Zimmermann (printed below) that Alice Strobl was able to identify the figure in the Schubert painting as Marie Zimmermann. Strobl also succeeded in identifying one or two drawings of Marie Zimmermann, of which the one in the Moravska Galerie in Brünn (Pl. 318) is the most important.

The following are the texts of all the letters, in places slightly shortened, but in the original style.

Autograph letter signed, 4 pp. 8°.[2] From the Attersee
(August 1900?)

Dear Mizzi,
Heartfelt thanks for your congratulations for my name-day [8
August]. Thank you dear Gusterl [his son with Maria
Zimmermann] for sending such good wishes, Papa will bring
you something fine and hand it to you when he sees you again.
Dear Mizzi, letter-writing here is very difficult and trouble-
some. Practically everyone[3] knows to whom you're writing and
who writes to you, it's too silly and annoying. The postman
comes and blows a little trumpet, all the inhabitants run out,
take the letters and pass them on, so that everyone knows where
a letter comes from or where it's going to. So I have to limit my
correspondence to a minimum. Besides, I'm a lazy correspon-
dent anyway, the more so in the country where one is lazier,
that's why my letter takes so long to come, but that needn't vex
you . . . I was glad that your letter started so well, but then it
got less pleasant and there are reproaches that I don't under-
stand, you write of 'pride' and 'you know anyway', I don't
understand that either, but I don't want any explanations, we'll
make that up in Vienna or when I come back to Vienna, where
it's easier to correspond . . . [conclusion missing]

Autograph letter, signed, 3 pp. 8°. From the Attersee
(August 1900?)

Dear Mizzi
In all haste and expecting the postman who should be coming
soon, I write to say that I can unfortunately not come to Vienna
until Saturday late in the evening – shall be with you on Sunday
morning. These last days are awful – I must make a great effort
to be half-way ready – it's almost like opening a new exhibition
– so I've practically lost this last week of my holiday.
I thought of Gusterl's birthday just after sending the post-
card off, and thought I would get this letter off sooner than is
the case – so my good wishes come a little late but are no less
affectionate for that. I'm naturally in favour of your leaving
because it is good for you and necessary (for safety's sake I
enclose ten gulden in case you only have enough till Saturday).
Looking forward to seeing you again and best greetings and
kisses to you and to your dear brothers.
Gustav.

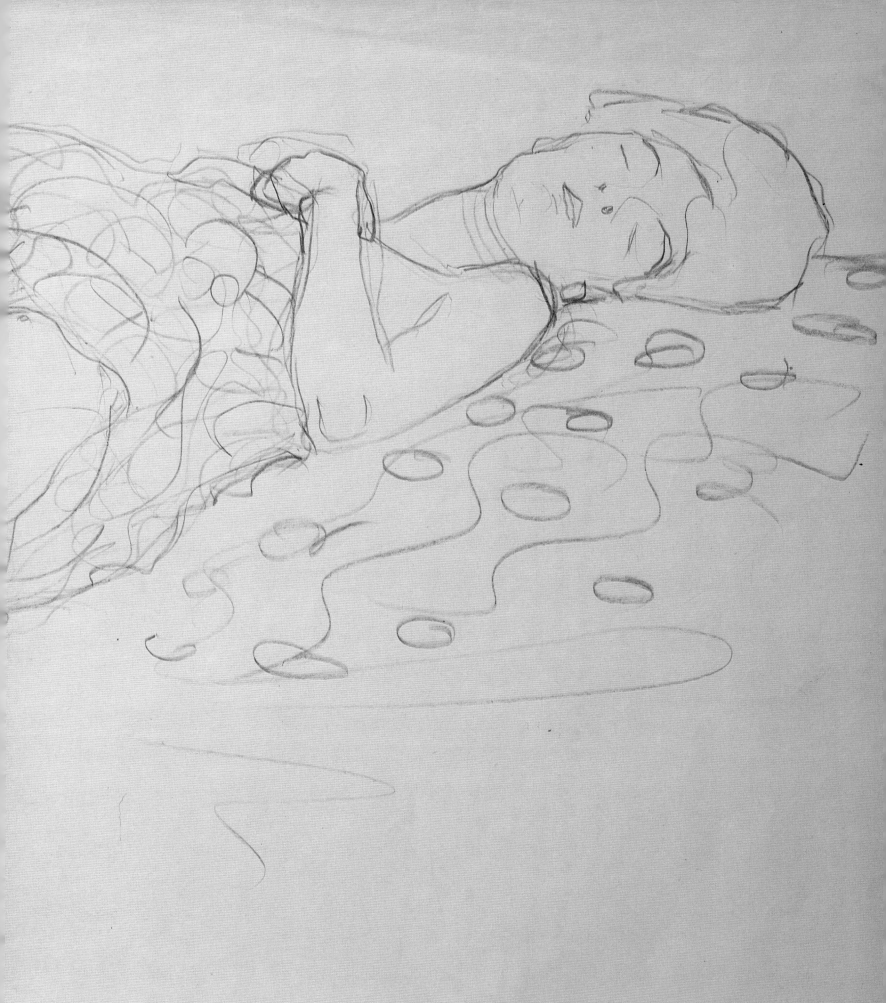

Autograph letter, signed, 4 pp. 8°. From the Attersee (end of August 1900).

Dear Mizzi best greetings, my stay here is nearly over. I shall probably be in Vienna again on Monday the 3rd. I'm working here at 5 paintings and a 6th canvas is still empty, maybe I'll bring it back home empty. I hope to be able to finish the other 5. A lake,[4] a bull in a stable,[5] a marsh,[6] a big poplar,[7] then young birches;[8] those are the subjects of the paintings. My will to work unfortunately increased dangerously as I progressed. I'm pretty restless and would like to be in Vienna because of the large painting[9] for which I have terribly little time left. Otherwise all is well. I hope the same goes for you and that you'll have a good birthday.

I'll let you know exactly when I'm due back. Affectionate greetings to you and to our dear one-year-old. Farewell Gustav.

My dear Gusterl, Heartfelt congratulations for your birthday and best wishes for the future. You're a year old now, and that means you're already a little man who can walk, and say or learn to say Papa and Mama, and ask for things by name which up to now you took without naming them.

I'll be interested to see whether you manage all this so that they can say you're a fine boy. My very best wishes again.

Autograph letter, signed, 4 pp. 8°. From Vienna (1900?)

Dear Mizzi,
In spite of your well-meant warning I'm doing things this way again, I've already explained why. Besides, one shouldn't send money in a registered letter . . .

It's even more risky than using a normal letter which you can simply throw into a letter-box – and as to the small amount, 5 times twenty adds up to a hundred. I don't like to risk more than twenty because then the envelope is too thick – but then you get it more often – Your windows are always tightly closed, I don't pass by[10] very often because I work more in the Florianigasse[11] – tomorrow I'm at last starting on the big painting,[12] it's high time. All the best to you both
Gustav.
Enclosed: twenty [gulden].

Autograph letter, signed, 6 pp. 8°. From the Attersee (September 1902?)

Dear Mizzi,
If I were to wait for proper leisure and the right mood to write you a proper letter, I'd have to wait for a long time – so I'm stealing a half-hour to answer you . . . Glad to hear

you're both well apart from the little one's[13] rash, which probably isn't very important. It's a good thing the boy's naughty and lively, that's a sign of temperament and is much better than having a good, quiet mite, I'm sure you're glad that he keeps you busy.

I've no doubt that you're finding painting difficult[14] – you ought to take a good rest and learn to look, that's the first thing – later on you'll be able to find more time for painting. My dear Mizzi, I know better than anyone that painting is very, very difficult, I had to work very hard in the country and I'm bringing five paintings back that are nearly finished, but I'm not quite satisfied with them, and must hope for better results next year, God willing!

I'm glad you enjoyed the country excursion and I'm glad when you can find distraction. All the best and kisses to you and Gusterl.

If the weather stays good until the beginning of October stay out there, the longer the better, it'll do you both good . . . Your windows in the Tigergasse have been wide open lately, I don't pass by very often, the street is quite deserted and open windows look friendlier. Enclosed are twenty gulden, I hope it doesn't arrive too late, I'll send the rest by telegram on Monday morning to keep your landlady quiet. If the weather stays good you could stay there, the air will make Gusterl hungry, on the other hand a Viennese doctor might be more reliable than a country one. You'll know best.

Goodbye, and fond good wishes and see you soon.
Gustav.

Autograph letter, signed, 4 pp. 8°. From the Attersee (early August 1903)

Dear Mizzi,
Best wishes and congratulations to my dear Gusterl for his name-day. I already wrote to you that I'd arrived here, I feel very well except for my right forearm which is still a bit painful, I hurt it when I was doing dumb-bell exercises[15] in Vienna.

I did no work during the first days of my stay here, I did what I had intended to do, I lazed, looked through a few books, studied Japanese art, and in the early morning, during the day and in the evening I went about with my 'finder'[16] [here Klimt makes a small drawing to illustrate what he means], that's a piece of cardboard with a hole cut into it, looking for landscapes to paint, but I found nothing. Today I want to start work again in earnest – I'm looking forward to it because doing nothing is boring in the long run, although even when I'm doing nothing I have enough to think about – thoughts about art and non-art would be a real relaxation for me – but they don't come. So here I am working in another studio and hoping to achieve something – there is always hope so long as the canvasses are empty. I take a good deal of

exercise in the open air, or rather I hold . . . [The letter breaks off here]

## Autograph letter, signed, in pencil, 4 pp. 8°. From the Attersee (August 1903)

Dear Mizzi,
I still haven't filled my fountain pen, so I have to write with a pencil . . .

I was very sorry to hear of your illness and to see how ill you look – but I must blame you for your carelessness – don't you think, dear Mizzi, that it's time you took more care of yourself? . . .

I'm well, and already working hard.

You ask for a sort of timetable – how the day goes by – well, that's very simple and quite regular. Early in the morning, mostly about 6 o'clock, sometimes earlier, sometimes later, I get up – if the weather's good I go into the nearby wood – I'm painting a small beech wood there (in the sun), dotted with a few evergreens,[17] that'll take me to 8 o'clock, then comes breakfast, then a swim in the lake, carefully of course – then I paint again a little, perhaps a view of the lake by sunlight, or if the weather's dull a landscape[18] from my window – sometimes I drop this morning painting and study my Japanese books in the open air. Then comes midday, after lunch I sleep a little or read, and before or after tea another swim, not always but mostly. After tea I'm painting again – a big poplar at dusk with a storm brewing[19] –or else, instead of this evening painting, a game of skittles in the neighbouring village – but that is seldom – then comes the dusk – supper – and it's early bed and the next day early to rise. Every now and then I fit a bit of rowing into the day's programme, in order to limber up. [Pl. 276]

I'm glad to hear that little Otto[20] has come to his senses and was good – Gusterl will take more time . . . I hope he's cheerful and well. The weather here is very changeable – not very warm and broken up by showers – but my work keeps me busy in all weathers, and that is a good thing. And now, dear Mizzi, I bid you farewell and send my best wishes to you and your rebellious little army.
Gust.

## Autograph letter, signed, 4 pp. 8°. From the Attersee (end of August 1903)

Dear Mizzi,
Fine weather at last today – otherwise we've had only rain and mist, drives you to desperation. My holiday is nearly over and I've been able to do almost nothing outside – this is the last fortnight, and I'm terribly nervous because I've got so little done – it means hard times in Vienna, not very pleasant.

If only the weather would stay fine, then I'd pick up courage again at once, but it looks as if it's going to cloud over again – and on dull days I'm awfully depressed. But I don't want to yammer, it's always the same wretched tale, you know it well.

Otherwise nothing new. The gentleman from the Cottage district[21] wanted to have my studio redecorated at his expense as a surprise – I wasn't to know about it – the concierge wouldn't allow it but asked me – I had all the trouble in the world stopping the whole thing, which was well meant – with all the work I have at present and my nervousness I can't have anything like that going on, and the project was put off until after the exhibition.[22] Forgive me, dear Mizzi, for complaining, I'll be better soon.

I hope you and Gusterl[23] are well – I'll try to work hard in order to quieten down. Best wishes and kisses!
Gustav.

## Autograph letter, signed, 2½ pp. 8°. From Vienna (1903), with autograph envelope: 'Wolgeboren (Ms) Marie Zimmermann in Villach Hotel Fischer "zum Goldenen Lamm" Carinthia.'

Dear Mizzi,
If you like it in Villach, then I think your idea isn't a bad one – at the moment I'm really only a slogger, and on top of everything I was unwell on Saturday, fortunately I got better and am now all right, except that I'm a bit overtired – I was afraid of really falling ill, had a temperature and all sorts of disagreeable symptoms – everything is over now and I'm very glad.

I probably won't be ready by the 5th of November,[24] and don't know whether I'll get a few days' grace – anyway you'll be coming back then with the enfant terrible.

The weather here is fine again, but cool. Oh Lord, I must go back to work – alas – but I really must. All good wishes and kisses.
Gust.
[Written in the inner margin] Enclosed twenty [gulden]

## Autograph letter, signed, 3 pp. 8°. Undated.

Dear Mizzi,
A bit late, but here is what I promised you. The story with the portrait[25] turned out very badly. Also on Sunday or Monday this week a hundred-gulden banknote was stolen from my wallet – I can't think how – my poor concierge fell off a ladder in my garden and broke a rib – so everything's fine as you see.

Today at last I want to begin on the small drawing for the big painting – it's high time. The weather's fine again and looks as if it might remain so – I haven't yet got the letter I was

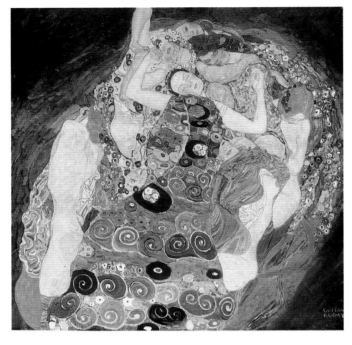

320 Above: The Virgin (D.184), 1913. Oil on canvas. 190 × 200 cm. Národni Galerie, Prague.

321 Below: *Study for the painting* The Virgin *(AS 2276), 1913. Pencil. 56 × 36.7 cm.*

waiting for, our letters must have crossed. I hope you're both well – I am too – that business of the portrait rankles, let's hope it turns out well after all. As I've had no news from you yet I assume you want to stay for Sunday, but I think you should come back at the beginning of the next week.

Goodbye and kisses

Gust

Enclosed twenty [gulden]

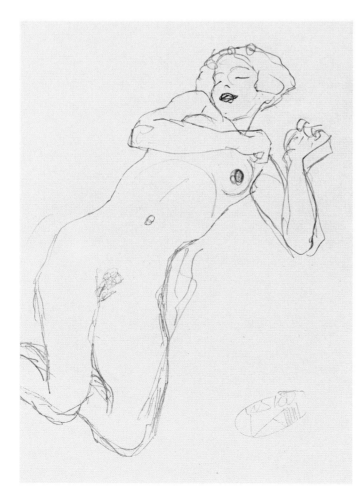

1 The correspondence with Marie Zimmermann was published complete for the first time by the author in 1978 in an essay entitled 'Gustav Klimt Writes to his Mistress' in the *Österreichische Galerie Report.*

2 pp. 8° stand for pages in octavo format.

3 Allusion to the Flöge family with whom Klimt spent his summers on the Attersee.

4 Either *Am Attersee I* or *Am Attersee II*, both to be dated 1900. See Fritz Novotny/Johannes Dobai, Gustav Klimt. Salzburg 1967, cat. nos. 116, 116a.

5 *The Black Bull* (D.115), 1900.

6 *The Marsh* (D.109), 1900.

7 *The Big Poplar I* (D.111), 1900.

8 *Young Birches*, also *Farm with Birches* (D.110), 1900.

9 *Philosophy* (D.105) or *Medicine* (D.112).

10 Marie Zimmermann lived for a time at 38 Tigergasse in the VIIIth district. Klimt's second studio was from 1892–1914 at 21 Josefstädterstrasse in the VIIIth district.

11 From 1898 to 1906 Klimt had rented an attic at 54 Florianigasse in the VIIIth district, where he could paint his University paintings.

12 Presumably *Medicine* (D.112).

13 Gustav Zimmermann, Klimt's natural son.

14 Marie Zimmermann apparently tried her hand at painting.

15 Klimt was an enthusiastic gymnast and regularly practised with the dumb-bells.

16 Klimt must have later used an ivory tablet, made to order, for a similar purpose.

17 Presumably *Beech Wood I* (D.137), about 1903.

18 *Golden Apple Tree* (D.133) and *Pear Tree* (D.134) are two of the landscapes painted in 1903.

19 *Big Poplar II* and *Storm Brewing* (D.135), 1903.

20 Klimt's second son by Marie Zimmermann, who died young.

21 Could this be Fritz Waerndorfer, the co-founder of the Wiener Werkstätte? He was the owner of the painting *Hope* (D.129), 1903, now in the National Gallery of Canada, Ottawa.

22 At the eighteenth Secession exhibition from November to December 1903 the big Klimt collective was shown, in which his three University paintings were to be seen for the first time.

23 Gustav Zimmermann, Klimt's son born in 1899.

24 Presumably the opening date of the eighteenth Secession exhibition (Klimt collective).

25 It is still not clear to what this refers.

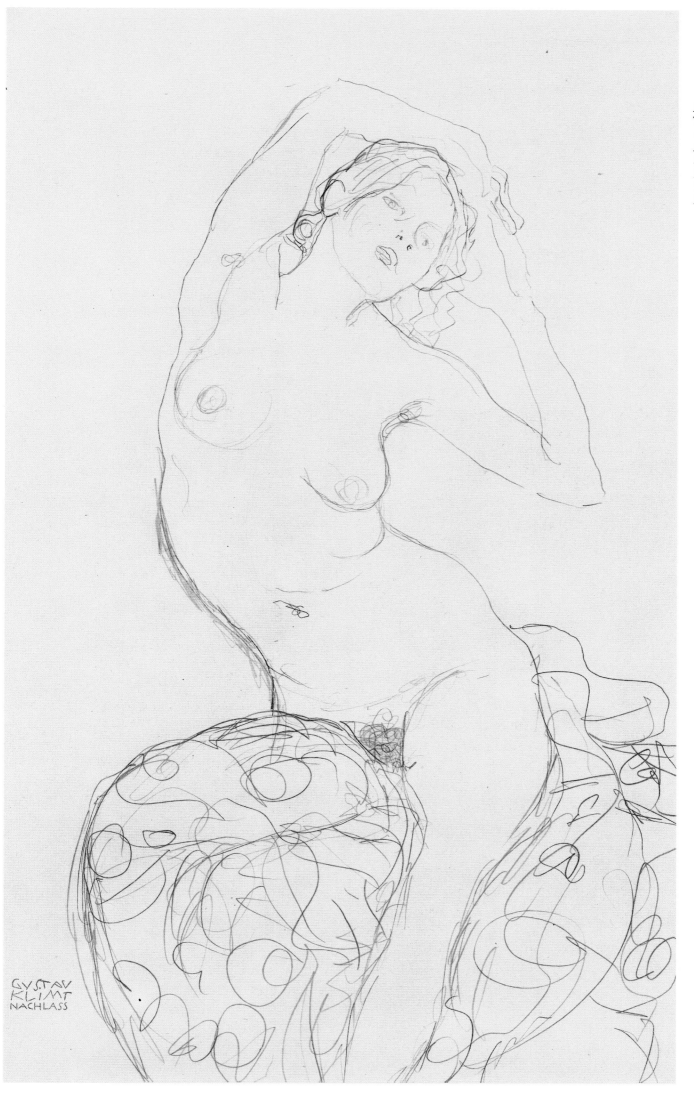

322 Study for the painting
The Virgin *(AS 2272),*
*1913. Pencil. 56.9 ×*
*37.3 cm. Graphische*
*Sammlung der*
*Eidgenössischen*
*Technischen Hochschule,*
*Zürich.*

# GUSTAV KLIMT'S SON GUSTAV UCICKY

*323 Gustav Ucicky (seated) on set while shooting a film. Photograph by Lothar Rübelt, about 1930.*

Jean Renoir,[1] the French film author and producer, had undoubtedly inherited his artistic talent from his father, the painter Auguste Renoir. It is less well known that one of Gustav Klimt's fourteen natural children had likewise inherited his talent from his father.

Gustav Ucicky[2] left three of Gustav Klimt's early paintings to the Österreichische Galerie in his will, and had small labels affixed to their frames: 'Donated by Gustav Ucicky in memory of his father Gustav Klimt' (D.97, D.110, and D.195).

Gustav Ucicky was born to one of Klimt's numerous models – presumably a washerwoman. After spending his childhood and youth in poverty he succeeded in 1916 in getting a job as cameraman with Count Sascha Kolowrat's[3] newly formed 'Sascha Film Company'. He possibly distinguished himself while shooting scenes of the funeral of the emperor Franz Joseph I. His first production dates from 1927; and in 1937, with his production of Kleist's *Der zerbrochene Krug* (*The Broken Jug*), with Emil Jannings playing the lead, he scored his first big success.

With this film, which is worth seeing to this day, and with what is agreed to be his best film *Der Postmeister* (*The Postman*) (1940), with Heinrich George in the lead, he produced remarkable examples of German film-making at a time when the keynote was propaganda and not artistic excellence. He steadfastly refused to turn out inflammatory national-socialist films. He told me how difficult he found it towards the end of the Second World War, and that in spite of threatened sanctions he refused to bend to the will of the 'Reichsfilmkammer'. His film *Am Ende der Welt* (*At the End of the World*) with Attila Hörbiger was banned in December 1943 and not even accepted after repeat takes and modifications.

Gustav Ucicky had melancholy eyes and – like his father – a furrowed brow. He always spoke softly and was overwhelmingly kind. He was fifteen years older than me but looked much older when I met him in the last years of the Second World War. I was told that in later years, when he still lived in Berlin and not in Vienna, two or three women whom he had left had committed suicide. At that time he was married to a much younger woman called Inge who came from Leipzig and who bore him a daughter whom he adored as he did his wife. Now he was at the top of his career, honoured as an artist and earning much money, for each of his films during the war brought him at least

272

100,000 marks. But he never squandered money. During those years he began to collect drawings and paintings by his father, of whom he always spoke affectionately although he had little to tell, apart from a visit to him in hospital just before he died.

When young he lived with his mother Maria Ucicka, who came from Prague. A drawing of her exists, crayon on canvas (1897–98, Strobl IV 3315). Towards the middle of the Second World War he built himself a bungalow in Schlagl above Gloggnitz in the Semmering region, from which he had a wonderful view over the Rax and the Schneeberg.

As a soldier on leave I visited him several times there and voiced my doubts as to whether that particular region was safe in view of the end of hostilities. In fact, he had to flee to Tyrol with wife and child, for Schlagl was twice under occupation until the Russians finally triumphed.

I met Gustav Ucicky several times more immediately after the end of the war. His wife had left him and married an American officer. He was broken and prematurely aged, his scanty hair grey. But he never quarrelled with his fate. It was sad to see this man, spoiled as he was, having to grapple with the occupation forces, and how long he took to start earning money again in a small way. He once invited me to an attempted come-back: a film on Anton Wildgans'[4] epic *Kirbisch*, with Paula Wessely in the role of the maid Cordula. *Cordula* was also the title of the film. I met him before it started: 'You'll see, it's no good!' he said gloomily. And he was right. In spite of renewed attempts, he was never successful again as a film producer.

Gustav Ucicky died in Hamburg. His remains were brought back to Vienna, where he lies in the cemetery at Hietzing, in grave No. 57/124 which he had acquired for his mother Maria Ucicka, and which is not far away from that of his father Gustav Klimt.

1 Jean Renoir, French film maker and producer (1894–1979)

2 Gustav Ucicky film producer (1894–1961)

3 Count Alexander Kolowrat-Krakowsky, pioneer of Austrian films (1886–1927)

4 Anton Wildgans, author (1881–1932)

*324 Caricatured self-portrait by Gustav Klimt (AS 887), about 1902. Blue crayon. 44.5 × 31 cm. Detail.*

# CURRICULUM VITAE

In 1893 Gustav Klimt applied for the job of professor at the 'Special School for Historical Painting' in Vienna. He drew up a curriculum vitae with which we open this chapter:

(1862–1882)
Born on 14 July 1862 in Baumgarten near Vienna,[1] Catholic, unmarried. In 1867 I came to Vienna and there I attended eight classes in secondary school. In October 1876 I was accepted at the Arts & Crafts school of the Museum of Arts and Industry, where I attended the preparatory class for 2 years under professors Rieser,[2] Minnigerode[3] and Hrachowina;[4] I then attended Prof Ferdinand Laufberger's technical painting class and stayed there until his death, after which I continued in the same class under Prof Berger for 2 years. After these first 7 years I set up a studio[5] in 1883

325 Gustav Klimt's birth and christening certificate, issued by the parsonage at Baumgarten in the XIIIth district.

with my fellow students Prof Matsch and my brother Ernest Klimt. In our last student years Prof Franz Matsch and my brother and I had already been entrusted with commissions which we duly carried out: in 1880 ceiling paintings for a palais on the Schottenring,[6] further ceiling paintings for the pump-room at Karlsbad;[7] in 1881 ceiling paintings for the Palais Ziehrer[8] after studies by Prof Berger; in 1882 ceiling paintings and, together with Matsch and my brother, the curtain at the Reichenberg Theatre.[9]

326 Above: First page of Gustav Klimt's hand-written curriculum vitae, 1893.

327 Opposite, top: The house where Gustav Klimt was born in the XIVth district (the XIIIth district until 1938) at 247 Linzerstrasse, which was demolished in 1967. Photograph, about 1900.

331 Opposite, below: Professor Ferdinand Laufberger's class at the Vienna Arts and Crafts School. Front row: Ferdinand Laufberger, Gustav and Ernst Klimt. In the third row (wearing a dark suit) Franz Matsch. Photograph, about 1880.

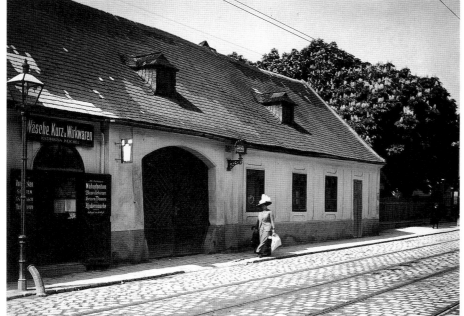

[1883–1884]

In 1883 I started to work independently.[10] Ancestral portraits, tapestry designs and old master copies for the King of Rumania[11] for his summer residence; ceiling paintings for the theatre in Fiume;[12] and for the Karlsbad theatre ceiling paintings and, together with Matsch and my brother, the curtain.[13] A year later, again with Matsch and my brother, a large ceiling painting for the imperial hunting lodge in Lainz.[14]

[1886–1888]

In 1886 Baron Hasenauer commissioned me to decorate the new Hofburg Theatre. I executed four large paintings: *Dionysos Cultus, Strolling Actors, The Theatre in Taormina* and *the Shakespeare Theatre in London*.[15] After completion of this work I was awarded, in 1888, the Gold Award of Merit with Crown.

328 Above: *Anna Klimt (1836–1915), Gustav Klimt's mother, in an armchair given to her for her seventieth birthday by the Wiener Werkstätte, 1906.*

329 Above: *Ernst Klimt senior (1834–1892), Gustav Klimt's father, wearing a Dutch costume, 1892. Oil painting by Ernst Klimt, and 330 below, a door plate engraved by Ernst Klimt senior.*

332 *Certificate of attendance at the Vienna Arts and Crafts School for Gustav Klimt, signed by Professor Ferdinand Laufberger, 1879. Klimt Archives, Graphische Sammlung Albertina, Vienna.*

[1888–1890]

In 1888 I was commissioned by the Vienna City Council to paint a view of the auditorium in the old Burgtheater with about 150 watercolour portraits.[16] This painting earned me the Emperor's Prize of 400 ducats at the annual Künstlerhaus exhibition in 1890. In between I made a few short journeys to Munich and Venice, and on returning I painted, in the staircase of the Kunsthistorisches Museum, 13 spandrel motifs representing the Florentine Quattrocento and Cinquecento (David, Venus and Amor), Roman and Venetian Cinquecento, Greek Antiquity and ancient Egyptian and Italian art. On completion of this assignment I had the honour of being congratulated by the Emperor.[17]

275

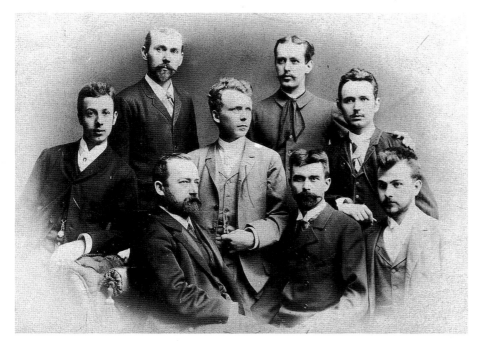

[1891–1893]
In the same year I began painting, for Count Nicolaus Esterhazy, a view of the auditorium of the Schlosstheater in Totis, with about 80 portraits in oils. The unfinished painting was shown at the Künstlerhaus annual exhibition in 1893 and I was awarded the silver state medal.

*333 Gustav Klimt. Photograph, about 1890.*

*334* Above right: *Gustav Klimt (centre) between Hermann August Flöge, the father-in-law of his brother Ernst Klimt (1864–1892) and a stranger. Photograph, about 1898.*

[1893]
At present I am working on several portraits and on the decoration of a music room.[19] Apart from these major assignments I have made a number of drawings for paintings and several [?] portraits for miniatures or in watercolour or oil, also small decorative work and easel paintings in various techniques.

CONTINUATION AND COMPLETION OF THE CURRICULUM VITAE

1890
First traceable journey to Venice

1891
Joins the Viennese Artists' Union (Künstlerhaus)

1892
Gustav Klimt, Ernst Klimt and Franz Matsch together take a studio at 21 Josefstädterstrasse in the VIIIth district.
Death of his father.

276

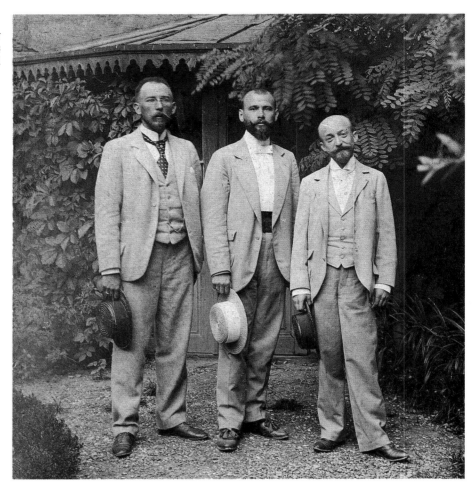

*335* Below left: *Allegory* Tragedy *for* Gerlach's Allegories, *new series, No. 66, 1897.*

*336* Below right: *Allegory* Junius *for* Gerlach's Allegories, *new series, No. 53, 1896.*

*337* Opposite: *Ex libris for the Vienna Secession, designed by Gustav Klimt, about 1900.*

Death of his brother Ernst on 9 December and gradual breaking up of his partnership with Franz Matsch.

1896
Klimt and Matsch present their programme for the decoration of the University's great hall – the studies had already been accepted in 1894.

1897
Under protest Klimt walks out of the general meeting of the Künstlerhaus association and subsequently withdraws his membership. The 'Vienna Secession' is founded; Klimt is its first president.
Summer spent in St Agatha, Hallstättersee. Klimt begins to paint landscapes for the first time.

*338 Gustav Klimt's cover for* Ver Sacrum, *1st year, 1898, No. 5–6, May–June 1898, using his poster for the Secession's first exhibition.*

1898
First appearance of the new Secession's journal *Ver Sacrum* (in all, six years were published). Klimt designs two covers and various initials.
Joseph Maria Olbrich builds the Secession building.
From March to June the first and highly successful Secession exhibition in rooms rented from the Vienna Gartenbaugesellschaft. Klimt designs a poster but has to overprint it as the censor objects to Theseus' nakedness. His portrait of Sonja Knips (D.91) could not be shown at this first exhibition as it was not yet dry.
*Music II* (D.89), *Pallas Athene* (D.93), *Schubert at the Piano II* (D.101).

*339 Gustav Klimt. Photograph, found in a sketchbook belonging to Sonja Knips. Original size. See also 334 opposite. About 1898.*

## 1899

Klimt rents an attic at 54 Florianigasse in the VIIIth district, where he paints, in succession, the three University pictures.

In March Klimt's *Schubert at the Piano II* (D.101) is exhibited. At the same time he finishes the decoration of the music room in the Palais Dumba and 4 Parkring in the Ist district (not preserved).

Klimt portrays Serena Lederer (D.103) for a fee of 35,000 crowns. The Lederers become his chief patrons.

*Nuda Veritas* (D.102) is acquired by Hermann Bahr.

## 1900

Presentation, together with the portrait of Sonja Knips, of the first University painting *Philosophy* (D.105) (although not quite finished) at the Secession's seventh exhibition.

Eighty-seven university professors sign a petition to the Minister of Education protesting against the installation of the painting in the university's great hall. Franz Wickhoff, art historian and professor at the University of Vienna, defends Klimt in a lecture entitled 'What is ugly?'

First summer holidays on the Attersee, where Klimt, well received by the Flöge family, is to spend many summers. It is at the Attersee that many of his landscapes were painted.

Participation at the World Exhibition in Paris.

*340 Project for a poster for the Paris World Exhibition 1900 (AS 711). Blue crayon. 45.5 × 31.5 cm. Detail.*

## 1901

Presentation of the University painting *Medicine* (D.112) at the tenth Secession exhibition, once again with great public success (over 30,000 visitors). Renewed protests against the painting and press attacks; on 20 March a motion is brought in Parliament regarding the purchase of the picture. The title of professor is refused Klimt for the second time.

*Judith I* (D.113).

## 1902

Max Klinger's *Beethoven* sculpture is given a splendid reception in the Secession's fourteenth exhibition.

*341 Above: The hall of Gustav Klimt's studio at 21 Josefstädterstrasse in the VIIIth district, used by Klimt until 1914. Furnished by Josef Hoffmann. In the foreground is a cabinet in which he kept his paints, against the wall is his painting* Hope II. *Photograph, about 1910.*

*342 Below: Gustav Klimt in the garden of his studio in the Josefstadt. Photograph by Moriz Nähr, about 1910.*

Opposite:
*343 Above left: Ver Sacrum, 4th year, 1901, No. 6, p. 1.*

*344 Above right: Ver Sacrum, 5th year, 1902, No. 10, Cover.*

*345 Centre: Gustav Klimt. Photograph, 1903.*

*346 Below left: Ver Sacrum, 6th year, 1903, No. 22 (dedicated to Gustav Klimt). Cover.*

*347 Below right: Ver Sacrum, 6th year, 1903, No. 22, p. 373.*

278

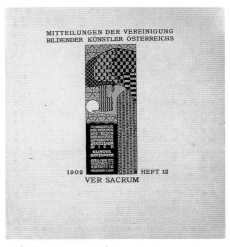

348 *Ver Sacrum, 5th year, 1902, No. 12, cover (after Alfred Roller's poster for the fourteenth Secession exhibition devoted to Max Klinger's* Beethoven *statue).*

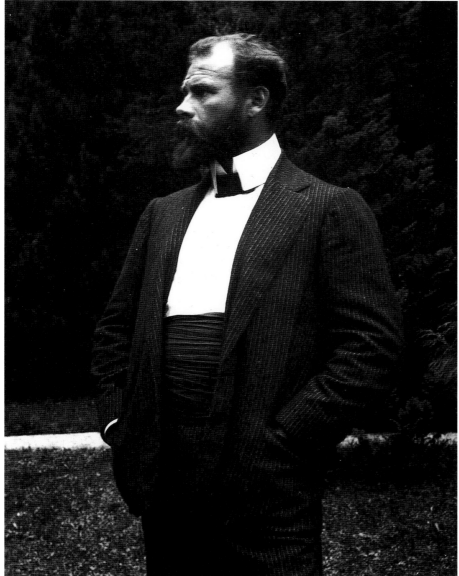

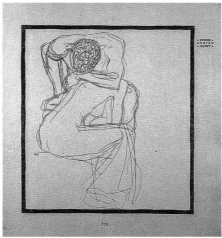

## 1903

Foundation of the Wiener Werkstätte by Josef Hoffmann, Kolo Moser and Fritz Waerndorfer. Discontinuation of the journal *Ver Sacrum*.
Two visits to Ravenna in spring and winter, also to Venice and Florence.
Work started on the third University painting, *Jurisprudence* (D.128).
Ferdinand Hodler spends six weeks in Vienna and makes friends with Klimt, whose *Judith I* he acquires.
From November to December the eighteenth Secession exhibition presents eighty Klimt paintings (Klimt collective).

## 1904

Thirty-one Hodler paintings are shown in the nineteenth Secession exhibition.
Josef Hoffmann is entrusted by the Belgian industrialist Baron Adolphe Stoclet with the construction of a palais in Brussels. Klimt is to execute the marble frieze in the dining room (D.153).
Klimt is now using Japanese paper instead of packing paper for his drawings.
Inauguration of the fashion salon 'Schwestern Flöge' (Flöge Sisters) at 1b Mariahilferstrasse in the VIth district.

## 1905

On 3 April Klimt withdraws his University paintings and, with the help of his patron August Lederer, refunds the advance made to him by the state. August Lederer acquires *Philosophy*. Klimt is definitively refused the title of professor at the Academy.
After internal quarrels the Klimt group withdraws from the Secession.
*Portrait of Margaret Stonborough-Wittgenstein* (D.142).

1906

To Brussels in connection with the Stoclet frieze, then to London with Fritz Waerndorfer. In December a sojourn in Florence.
Klimt is appointed president of the newly founded Künstlerbund (Artists' Union).
*Portrait of Fritza Riedler* (D.143).

349 Above: *Nine amateur photographs of the Klimt family, in a brass frame by Georg Klimt, with the inscription 'Gutta. Fortunae. Prae/dolio. Sapientiae', about 1905. Left to right: I. Johanna Klimt-Zimpel with her son Gustav on her arm, Hermine Zimpel, Gustav Klimt, below Eleonora Zimpel-Knauf; 2. Emilie Flöge, Gustav Klimt, Gustav Zimpel; 3. the same; 4. Georg Klimt; 5.*

*Fanny Klimt, Georg's wife, née Pachersdorfer; 6. Julius Zimpel with his sons Rudolf and Julius; 7. Gustav Zimpel; 8. Fanny and Georg Klimt; 9. Julius, Rudolf and Gustav Zimpel, Eleonora Zimpel-Knauf.*

352 Below: *Gustav Klimt. Photograph (with oval Klimt signature) by Moriz Nähr, 1908.*

350 *Gustav Klimt's exhibitor's season ticket for the Imperial Royal Austrian Exhibition in London, 1906.*

1907

*Die Hetärengespräche des Lukian* (*Lucian's Hetaira Dialogues*), translated by Franz Blei, are published with reproductions of Klimt's drawings selected by the publisher.
In September to Berlin to see the University paintings shown by Keller and Reiner.
Portrait, *Adele Bloch-Bauer I* (D.150), *The Kiss* (D.154).

351 Lucian's Hetaira Dialogues. With fifteen drawings by Gustav Klimt. *Leipzig: Zeitler 1907. Wiener Werkstätte binding designed by Gustav Klimt.*

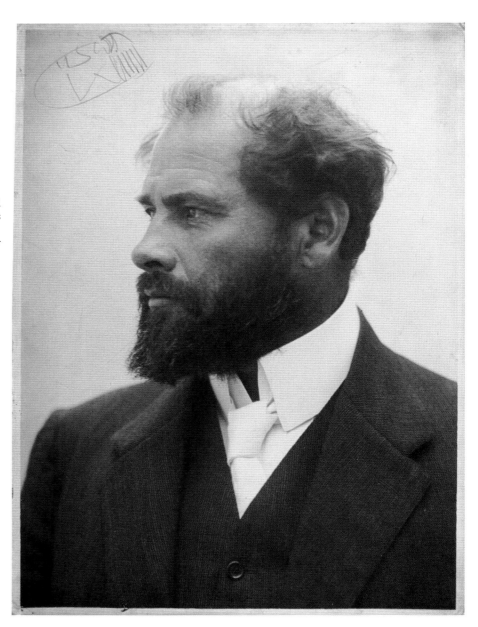

280

353 Above: *The Palais Stoclet in Brussels. A page from the jubilee volume* The Wiener Werkstätte 1903–1929: Modern arts and crafts and its progress. *Vienna, Krystall Publications, 1928.*

354 Below: *Almanac of the Wiener Werkstätte, edited by Max Mell, designed by Josef Hoffmann, Vienna–Leipzig, Rosenbaum Brothers, 1911. pp. 10–11 with reproduction of a drawing by Gustav Klimt.*

355 Above right: *Josef Hoffmann's building for the Kunstschau Wien 1908. Photograph, 1908.*

356 Below right: *View of Room V (the Klimt room) in the Austrian pavilion at the International Art Exhibition, Rome 1911. Page from the catalogue designed by Josef Hoffmann.*

**1908**
The Kunstschau is held by the Klimt group on the (as yet unoccupied) site of the Vienna Konzerthaus, in pavilions improvised by Josef Hoffmann. Oskar Kokoschka is given a small gallery in which he can exhibit without having to submit to the jury's decision.
Start of publication of *Das Werk Gustav Klimts* with collotypes by the Austrian State Press.
The Österreichische Staatsgalerie (now Österreichische Galerie) acquires Klimt's masterpiece *The Kiss* and the Galleria d'Arte Moderna in Rome his painting *The Three Ages* (D.141).
In December sojourn in Florence.

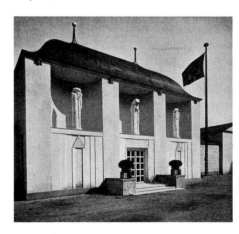

**1909**
The Klimt group's second exhibition, the International Kunstschau, shows a survey of European art, works by Gauguin, van Gogh, Matisse and many others. Egon Schiele and Oskar Kokoschka are both given small rooms.
In May to Prague, in October to Paris and Madrid with Carl Moll.

**1910**
Successful participation in the ninth Biennale in Venice.

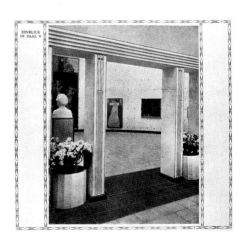

**1911**
To Brussels to mount the Stoclet frieze. Inauguration of the completed palais.
In March to the International Art Exhibition, Rome.

1912
First cure in Gastein.
Portrait, *Adele Bloch-Bauer II* (D.177).

1913
Klimt participates in the exhibition organized by the Austrian Artists'
Union in Budapest.

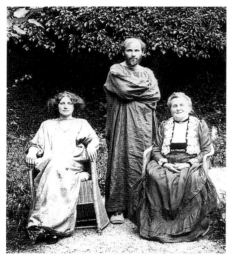

*357  Gustav Klimt, Emilie Flöge and her mother
Barbara in their garden on the Attersee.
Photograph, 1912.*

*358* Above right:  *Gustav Klimt. Photograph by
Moriz Nähr, 1917. One of the last photographs
of Klimt.*

Klimt is on the jury of the Reininghaus Competition for which Egon Schiele
has entered his painting *Meeting*, which against all expectations wins no
prize but is subsequently acquired by the collector Carl Reininghaus.
Second cure in Gastein, summer spent in Malcesine on Lake Garda.
*Church in Cassone* (D.185), *Malcesine on Lake Garda* (D.186).

1914
Klimt participates in exhibition organized by the German-Bohemian
Artists' Union in Prague.
To Brussels. Cure in Bad Gastein.
Josef Hoffmann furnishes Hodler's apartment in Geneva.
Outbreak of the First World War.

1915
Sojourn and work in Györ, Hungary, at the Lederers' home.
Cure in Bad Gastein.

1916
Participation in the exhibition of the Austrian Artists' Union in the Berlin
Secession.
Summer in Weissenbach on the Attersee, cure in Bad Gastein.
Portrait, *Friederike Beer* (D.196), *Church in Unterach on the Attersee*
(D.198)

1917
Klimt is elected honorary member of the Academy of Fine Arts in Vienna
and Munich. Sojourn in Rumania, then to North Bohemia.
Cure in Bad Gastein, summer in Mayrhofen in the Zillertal, Tirol.

*359* Below:  *The vestibule of Gustav Klimt's
studio at 11 Feldmühlgasse in the XIIIth district,
which he occupied from 1914 until his death.
Photograph, about 1915.*

Opposite:
*360* Above:  *Gustav Klimt's funeral on 9
February 1918 at the cemetery of Hietzing.
Among the mourners were Josef Hoffmann, Berta
Zuckerkandl, Anton Hanak, Gustav Nebehay,
Ludwig Heinrich Jungnickel, Julius Tandler,
Arnold Schönberg and Alban Berg.*

*361* Centre left:  *Obituary notice for Gustav
Klimt, dispatched by the Union of Austrian
Artists, February 1918.*

*362* Centre right:  *Gustav Klimt's grave (group
5, No. 194/195) in the cemetery of Hietzing.
Photograph, 1957.*

*363* Below:  *Josef Hoffmann. Project for a
sarcophagus for Gustav Klimt (not realized).
About 1935.*

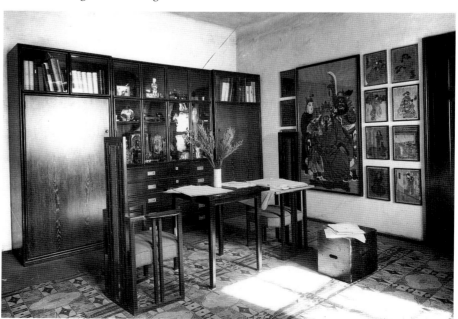

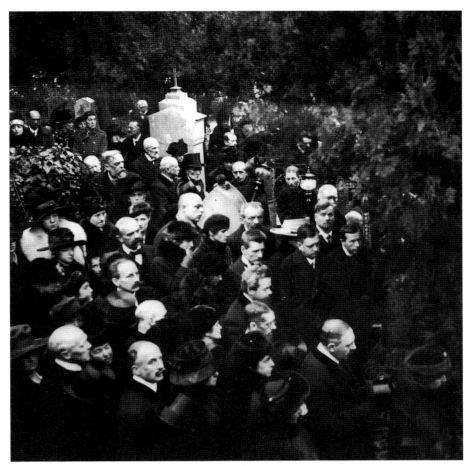

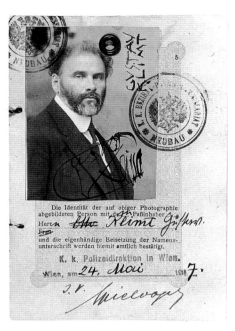

*364 Gustav Klimt's last passport, dated 24 May 1917.*

**1918**

On 11 January Klimt suffers a stroke which paralyzes him on one side. He is taken into the Fürth sanatorium, later into the General Hospital. Dies on 6 February 1918 at 6am. He is buried on 9 February in the cemetery of Hietzing; the grave is in group 5 (No. 194/195). The family refuses an honorary grave. The grave is marked with a marble slab (presumably designed by Josef Hoffmann) which bears his name.

*365 Gustav Klimt's death-mask. Historisches Museum der Stadt Wien.*

283

## KLIMT ON HIMSELF

Gustav Klimt only spoke once about himself as a painter:
I can paint and I can draw. I believe this and a few others also say that they believe it. But I'm not sure it's true. Only two things are true:
1. There is no self-portrait of me. [Klimt forgot the self-portrait in the stairway of the Burgtheater, Pl. 18] I'm not interested in myself as a 'subject for a painting' but rather in others, above all in women, and even more in other phenomena. I'm convinced that as a person I'm not particularly interesting: there isn't much to see in me. I'm a painter, who works every day from morning till night. Figures and landscapes, less often portraits.
2. I'm not much good at speaking or writing, especially when I have to speak or write about myself or my work. Even when I have to write a simple letter I get as frightened as if I were going to be seasick. So it's no good hoping for a literary or artistic self-portrait. Not that that matters much. Whoever wants to know something about me as an artist – and that's the only thing that matters – must look attentively at my paintings and try to glean from them who I am and what I want.

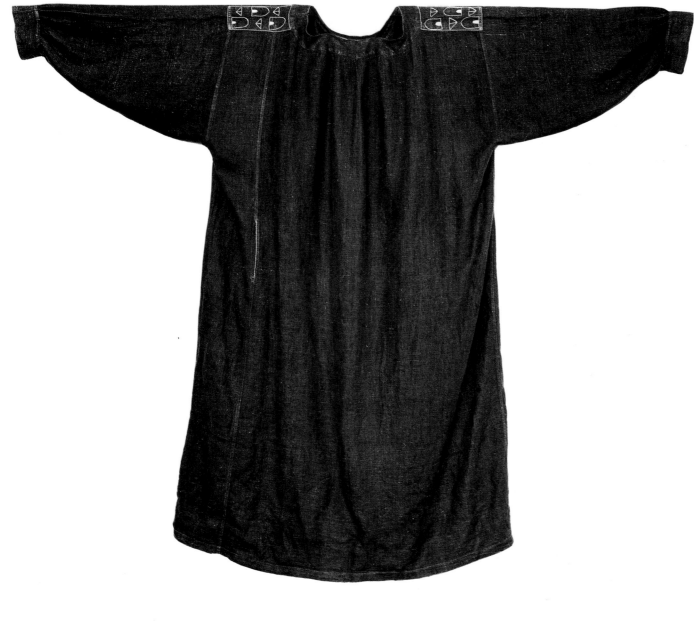

368 Above: *Gustav Klimt's working smock. Historisches Museum der Stadt Wien.*

369 Below: *Gustav Klimt's signature, used from about 1907 onwards.*

1 The exact address is 247 Linzerstrasse. For reasons that cannot be explained the simple, low-built house was demolished in 1967. Baumgarten has belonged to the XIIIth district since 1892 and to the XIVth since 1938.

2 Michael Rieser, historical and portrait painter (1828–1905)

3 Ludwig Minnigerode, genre and portrait painter (1847–1900)

4 Karl Hrachowina, professor of freehand drawing and ornament design (1845–1896)

5 8 Sandwirtgasse in the VIth district. On the fourth floor landing there is a ceiling painting: an angel in flight blowing a bugle, painted by one of the three friends. Not mentioned in Dobai.

6 *Poetry–Music–Dance–Theatre* (D.1–4), 1880. *House of the builder Johann Sturany*, 21 Schottenring in the Ist district.

7 *The Music of Nations* (D.5), 1880. Ceiling painting in the pump-room at Karlsbad.

8 Decorative paintings in the former Palais Ziehrer (D.6), Argentinierstrasse 25–7, IVth district, 1881–82.

9 Ceiling painting in the Reichenberg theatre (D.7–8), 1882–83.

10 The Künstlerkompagnie was founded, together with Ernst Klimt and Franz Matsch, in 1883.

11 Ancestral portraits in the former royal castle Pelesch (D.10), Sinaia, Rumania, 1883.

12 Not mentioned in Dobai.

13 Homage to the art of theatre (D.31), 1886, curtain in the Karlsbad theatre.

14 Ceiling painting in the 'Hermesvilla' in Lainz (D.23), VIIIth district, 1885.

15 This refers to the paintings *Altar of Dionysos* (D.40), 1886–88, *Thespiskarren* (D.38), 1886–88, *Theatre in Taormina* (D.41), 1886–88, and *Shakespeare's Theatre* (D.39), 1886–88.

16 Auditorium in the old Burgtheater (D.44), 1888.

17 D.46–57.

18 Auditorium in the theatre of Esterhazy Castle in Totis (D.62), Hungary, 1893.

19 Dumba music room at 4 Parkring, Ist district.

*370 Gustav Klimt, holding one of his cats, in front of his studio at 21 Josefstädterstrasse in the VIIIth district. Photograph by Moriz Nähr, about 1912.*

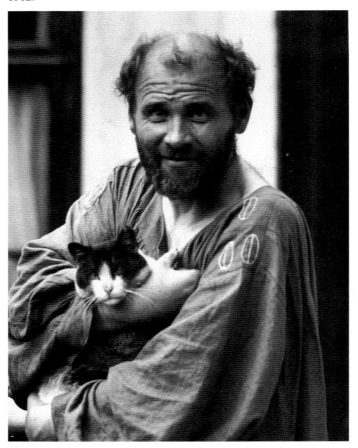

# BIBLIOGRAPHY

## BOOKS

Altenberg, Peter: *Wie ich es sehe.* Berlin 1896
Altenberg, Peter: *Bilderbögen des kleinen Lebens.* Berlin 1909
Altenberg, Peter: *Märchen des Lebens.* Berlin 1911
Altenberg, Peter: *Was der Tag mir zuträgt.* Berlin 1921 (published posthumously)
Asenijeff, Elsa: *Max Klingers Beethoven. Eine kunsttechnische Studie.* Leipzig 1902
Bahr, Hermann: *Gegen Klimt.* Vienna 1903
Bahr, Hermann: *Rede über Klimt.* Vienna 1901
Bahr, Hermann (ed.): *Gustav Klimt. 50 Handzeichnungen.* Vienna-Leipzig 1922
Czeike, Felix: *Das große Groner Wien Lexikon.* Vienna-Munich-Zürich 1974
Eisler, Max: *Gustav Klimt.* Vienna 1920
Engelhart, Josef: *Ein Wiener Maler erzählt.* Vienna 1943
Faistauer, Anton: *Neue Malerei in Österreich. Betrachtungen eines Malers.* Zürich-Leipzig-Vienna 1923
Fischer, Wolfgang Georg: *Gustav Klimt und Emilie Flöge. Genie und Talent, Freundschaft und Besessenheit.* Vienna 1987
Friedell, Egon (ed.): *Das Peter Altenberg Buch.* Vienna 1922
Grieser, Dietmar: *Schauplätze österreichischer Dichtung.* Munich-Vienna 1974
Hevesi, Ludwig: *Acht Jahre Sezession. (März 1897–Juni 1905). Kritik-Polemik-Chronik.* Vienna 1906
Hevesi, Ludwig: *Altkunst-Neukunst. Wien 1894–1908.* Vienna 1909
Hirsch, Sharon L.: *Ferdinand Hodler.* Munich 1981
Kallir, Jane: *Egon Schiele. The Complete Works.* New York 1990
Kallir, Otto: *Ein Skizzenbuch von Egon Schiele.* New York 1967
Klimt, Gustav: *Das Werk Gustav Klimts.* Vienna 1918
Klimt, Gustav: *Eine Nachlese* (supplement). Edited by Max Eisler. Vienna 1931
Klimt, Gustav: *Foreword to the catalogue of the Kunstschau.* Vienna 1908
Klimt, Gustav: *25 Handzeichnungen* (Facsimile edition). Vienna 1919 ˙
Klinger, Max: *Exhibition Catalogue. Museum der bildenden Künste.* Leipzig 1970
Kuh, Anton: *Von Goethe abwärts. Aphorismen-Essays-Kleine Prosa.* Vienna 1921
Mahler-Werfel, Alma: *Mein Leben.* Frankfurt 1960
Nebehay, Christian M.: *Katalog Nr. 6.* Vienna 1963
Nebehay, Christian M.: *Gustav Klimt Dokumentation.* Vienna 1969
Nebehay, Christian M.: *Egon Schiele. Leben,*
*Briefe, Gedichte.* Salzburg 1979
Nebehay, Christian M.: *Die goldenen Sessel meines Vaters. Gustav Nebehay (1881–1935), Antiquar und Kunsthändler in Leipzig, Wien und Berlin.* Vienna 1983
Nebehay, Christian M.: *Secession. Kataloge und Plakate. 1898–1905.* Vienna 1986
Nebehay, Christian M.: *Gustav Klimt, Egon Schiele und die Familie Lederer.* Berne 1987
Nebehay, Christian M.: *Egon Schiele. Von der Skizze zum Bild. Die Tagebücher.* Vienna-Munich 1989
Novotny, Fritz / Dobai, Johannes: *Gustav Klimt* (with catalogue raisonné). Salzburg 1967
Österreichische Akademie der Wissenschaften (ed.): *Österreichisches Biographisches Lexikon 1815–1950.* Graz-Cologne 1957
Roessler, Arthur: *In memoriam Gustav Klimt.* Vienna 1926
Roessler, Arthur: *Der Malkasten. Künstler-anekdoten.* Vienna 1924
Roessler, Arthur: 'Erinnerungen an Egon Schiele'. In: Fritz Karpfen, *Das Egon Schiele Buch.* Vienna 1921
Roessler, Arthur: *Briefe und Prosa von Egon Schiele.* Vienna 1921
Salten, Felix: *Gustav Klimt.* Vienna 1903
Salten, Felix: *Geister der Zeit. Erlebnisse.* Vienna 1924
Schwarzwald, Genia: 'Ein ehrliches Begräbnis.' In: Egon Friedell, *Das Peter Altenberg Buch.* Vienna 1922
Salles, Georges A.: *The Adolphe Stoclet Collection.* Brussels 1956
Schweiger, Werner J.: *Wiener Werkstätte. Kunst und Handwerk 1903–1932.* Vienna 1982
Secession: Catalogue of the fourteenth exhibition, Foreword by Ernst Stöhr. 1902
Segantini, Giovanni: *Sein Leben und Werk.* Published by the Ministerium für Kultus und Unterricht. Vienna 1902
Sekler, Eduard F.: *Josef Hoffmann. Das architektonische Werk. Monographie und Werkverzeichnis.* Salzburg 1982
Singer, Hans Wolfgang: *Max Klingers Radierungen, Stiche und Steindrucke.* Berlin 1909
Strobl, Alice: *Gustav Klimt. Die Zeichnungen 1878–1918.* Catalogue raisonné vols. 1–4 Salzburg 1980–1989
Suppan, Martin: *Hans Böhler. Leben und Werke.* Vienna 1990
Thieme-Becker: *Künstlerlexikon.* Leipzig 1907–1953 (Supplement)
Vollard, Ambroise: *Auguste Rodin.* Berlin 1925
Weigel, Hans: *Karl Kraus oder die Macht der Ohnmacht.* Vienna 1968

Weixelgärtner, Arpad: 'Gustav Klimt'. In: *Die graphischen Künste.* Vienna 1912
Tietze, Hans: *Gustav Klimt. Neue Österreichische Biographie.* Vienna 1926
Zuckerkandl-Szeps, Berta: *Zeitkunst. Wien 1901–1907.* Vienna 1908
Zuckerkandl, Berta: *Österreich intim.* Frankfurt 1970
Zuckerkandl, Berta: *Ich erlebte fünfzig Jahre Weltgeschichte.* Paris 1939

## NEWSPAPERS/MAGAZINES/PERIODICALS

Amiet, Cuno: 'Die Ausstellung der Secession in Wien. Januar-Februar 1904'. In: 'Hodler und Wien'. *Neujahrsblatt der Zürcher Kunstgesellschaft,* 1950
Ankwicz-Kleehoven, Hans: 'Hodler und Wien'. In: *Neujahrsblatt der Zürcher Kunstgesellschaft,* 1950
*Fremdenblatt.* 15. 5. 1900
*Illustrirtes Wiener Extrablatt.* 28. 3. 1900
Kraus, Karl: *Die Fackel.* 1900/36. 1901/73. 1903. 1910/41.
Liechtenstein, Marie José: 'Gustav Klimt und seine Salzkammergut Landschaften'. In: *Oberösterreichische Heimatblätter,* Linz 1951/3–4
Moll, Carl: 'Erinnerungen an Gustav Klimt'. In: *Neues Wiener Tagblatt.* 24. 1. 1943
Nebehay, Christian M.: 'Gustav Klimt schreibt an eine Liebe'. In: *Mitteilungen der österreichischen Galerie.* Vienna 1978. Nr.66/67
*Neue Freie Presse.* 28. 3. 1900
Neuwirth, Walter Maria: 'Die sieben heroischen Jahre der Wiener Moderne'. In: *alte und moderne Kunst.* Vienna 1964/9
Rod, Edouard: 'Les Salons'. In: *Gazette des Beaux-Arts* 1891/Ser. III, 16
Roessler, Arthur: 'Klimt und seine Modelle'. In: *Arbeiterzeitung.* Vienna. 15.8.1953
Schiele, Egon: 'Nachruf auf Klimt'. In *Der Anbruch.* Vienna 1918/3
Strobl, Alice: 'Zu den Fakultätsbildern von Gustav Klimt anläßlich der Neuerwerbung einer Einzelstudie zur Philosophie durch die Graphische Sammlung Albertina'. In: *Albertina Studien.* Vienna 1964/4
Tietze, Hans: 'Wiens heiliger Frühling war Klimts Werk. Ein Nachruf'. In: *Kunstchronik.* Leipzig 1918, 1. 3. 1918
Tietze, Hans: 'Gustav Klimts Persönlichkeit. Nach Mitteilungen seiner Freunde'. In: *Die bildenden Künste.* Vienna 1919
Weixelgärtner, Arpad: 'Gustav Klimt'. In: *Die graphischen Künste.* Vienna 1912
Zuckerlandl, Berta: 'Als die Klimtgruppe sich selbstständig machte'. In: *Neues Wiener Journal.* 10. 4. 1927

# INDEX

288